Political Theology

POLITICAL THEOLOGY

Executive Editor
Graeme Smith (Oxford)

Assistant Editor
Alison Webster (Social Responsibility Officer, Worcester)

Book Reviews Editor
Helen Stanton (Social Responsibility Officer, Bath and Wells)

Editorial Board
Marcella Althaus Reid (Edinburgh); Robert Beckford (Birmingham); Inderjit Bhogal (Sheffield); Julie Clague (Glasgow); Duncan Forrester (Edinburgh); Ian Linden (London); Ian Markham (Liverpool); Bernadette O'Keefe (Cambridge); Martin Palmer (Manchester Metropolitan); Martyn Percy (Sheffield); Ian Randall (Spurgeon's College); Christopher Rowland (Oxford); Norman Shanks (The Iona Community); Elizabeth Stuart (King Alfred's College); Robert Song (Durham); Heather Walton (Glasgow).

International Editorial Board
Walter Brueggeman (Columbia Theological Seminary); Jean Bethke Elshtain (University of Chicago); Clark Gilpin (University of Chicago); John W. de Gruchy (University of Cape Town); Martin Robra (WCC, Switzerland); Max Stackhouse (Princeton Theological Seminary).

Political Theology is published twice a year in May and November
Sheffield Academic Press (*A Continuum Imprint*)
The Tower Building, 11 York Road, London SE1 7NX and 370 Lexington Avenue, New York, NY 10017, USA

Manuscripts should be submitted in accordance with the guidelines supplied at the back.

Information for Subscribers
For information about Sheffield Academic Press and Continuum books, please log on to www.continuumbooks.com; for journals, please log onto www.continuumjournals.com

Subscription prices for the current volume (volume 4) are:

	UK/Europe/Rest of World	The Americas
Individuals	£25.00	$40.00
Institutions	£50.00	$80.00

Canadian customers/residents please add 7% for GST onto the Americas price. Prices include second-class postal delivery within the UK and air mail delivery elsewhere.

Postmaster: Send address changes to Orca Book Services, Stanley House, 3 Fleets Lane, Poole, Dorset BH15 3AJ
Sample Requests, New Orders, Renewals, Claims/Other Subscription Matters: Contact the Journals Subscription Administrator, Orca Journals, Stanley House, 3 Fleets Lane, Poole, Dorset BH15 3AJ (tel: +44 01202 785 712) (fax: +44 01202 666 219); or journals@orcabookservices.co.uk. Cheques should be made payable to: Orca Journals. Claims for missing issues must be made no later than three months after publication.
Advertising: For details contact: jrnladvert@continuumbooks.com or write to the Journals Advertising Manager, The Tower Building, 11 York Road, London SE1 7NX
Microform: This journal is available in microform from the Serials Acquisitions Department, Bell & Howell Information and Learning, 300 North Zeeb Road, Ann Arbor, MI 48106, USA
Back Issues: Available from Orca Journals, 3 Fleets Lane, Poole, BH15 3AJ. Prices upon request.

Indexing and Abstracting
This journal is abstracted in Religious and Theological Abstracts, PO Box 215, Myerstown, PA 17067, USA (www.rtabst.org) and is indexed and abstracted in the *Religion and Philosophy Collection* and *Academic Search Premier*, published by EBSCO Publishing (www.epnet.com).

© The Continuum Publishing Group Ltd, 2002
ISSN 1462-317X. Printed and bound by MPG Books Ltd, Bodmin, Cornwall, UK.

Volume 4 Number 1 November 2002

CONTENTS

List of Contributors

Ian Bradley is Reader in Practical Theology and Church History in the School of Divinity at the University of St Andrews. He is the author of over 25 books, the most recent of which is *God Save the Queen: The Spiritual Dimension of Monarchy* (London: Darton, Longman & Todd, 2002), and is a regular journalist and broadcaster. He is a minister in the Church of Scotland.

Nick Brown graduated in 1999 with a Degree in Theology and Religious Studies from the University of Cambridge. Since then he has worked as a lobbyist in Westminster and has run a political pressure group affiliated to the Conservative Party. He will shortly be taking up a graduate scholarship at the University of Harvard where he will be studying politics and theology.

The Reverend Dr Graham K. Blount studied Law at Glasgow University before training for the Church of Scotland ministry at St Andrews University. Since 1976, he has been Parish Minister at Linthouse St Kenneth's (Glasgow), Bridge of Allan Chalmers (with Stirling University Chaplaincy), and Falkirk Old & St Modan's. He was Honorary Secretary of the Kirk's Committee on Church and Nation for two years before being appointed the first Scottish Churches Parliamentary Officer in September 1998, with the remit from Action of Churches Together in Scotland of establishing the ecumenical Scottish Churches Parliamentary Office.

Wesley Carr has been Dean of Westminster since 1997. He had previously been Dean of Bristol and before then Canon Residentiary of Chelmsford Cathedral. Much of his ministry has been concerned with the role of the clergy and their education. He has degrees from Oxford, Cambridge and Sheffield, as well as a Certificate of Ecumenical Studies from Geneva and an Honorary DLitt from the University of the West of England. He has also had a long association with the Group Relations Programme of the Tavistock Institute, directing conferences and consulting to organizations and individuals both here and overseas. He has written a number of books and many articles on ministry, pastoral studies and the connection between the behavioural sciences and theology, as well as numerous reviews.

Susan Durber is a minister of the United Reformed Church in Oxford. She has a PhD from Manchester University on Derrida and parable interpretation. She was co-editor of *Silence in Heaven: A Book of Women's Preaching* (London: SCM Press, 1994).

Leslie Griffiths trained at Wesley House, Cambridge, for the Methodist ministry. He spent much of the 1970s as a minister in Haiti either in community development work or in education. Since his return to the UK in 1980 he has served the Church in a variety of posts in or around London. Since 1996 he has been superintendent minister at Wesley's Chapel. He is a writer and broadcaster. His latest book, *Voices from the Desert* (Rowan Williams's 2003 Lent Book) will be published in November by Canterbury Press.

John Hey has recently retired from teaching Religious Studies at the University of Derby.

Kathryn Hey is about to retire from teaching English in FE colleges. From the 1980s on, reading Iris Murdoch's novels has made a significant impact on her thinking.

Paul Hughes teaches theology at St Augustine's College in Trowbridge.

Dr Cliff Marrs is a Quaker who tutors in Political Theology at the universities of Oxford, Cambridge and London (Birkbeck College). He is an Associate Tutor at the Woodbrook Quaker Study Centre in Birmingham where he is also a 2002 Eva Kock Research Fellow. He has published articles on theology, protest, terrorism and globalization in Quaker periodicals on both sides of the Atlantic.

Jo Saunders is Social Responsibility Officer in the Diocese of Oxford.

Graeme Smith is part-time lecturer at Oxford Brookes University. He is researching the relationship between social and political theology and liberal political theory.

Kevin Tingay is Inter Faith Advisor at the Diocese of Bath and Wells.

[*PT* 4.1 (2002) 7-10]
ISSN 1462-317X

EDITORIAL

Alison Webster

As I write, the bunting from the Queen's Jubilee celebrations still flutters outside pubs and shops, the Buckingham Palace pop concert is still ringing in our ears, and the beacon on top of the Malvern Hills where I live is still smouldering. Rather like the debate on the future of the monarchy. Did people have such a great party in June 2002 because, deep down, we are all monarchists still? Is the monarchy the new 'big tent' that can shelter citizens of all races, class backgrounds and age groups? Or is it what those of a republican bent have been asserting for some time: an outdated, overly expensive, innately conservative anachronism that has had its day? Certainly the timing of the Jubilee celebrations was important. How could one fail to be impressed by the emotional toughness and resilience of the Queen, facing as she has the biggest and most exhausting round of parties in her life within weeks of the deaths of her mother and sister? The festival of football, the World Cup, added an extra dimension. The fear was that it would compete with the Jubilee for the attentions of the people, but as it happens it seems to have complemented it beautifully. It seems that the World Cup and the Jubilee conspired to give us the excuse, post 11 September, for a much-needed party.

It is appropriate then that four of the articles in this issue of *Political Theology* have been specially commissioned to provide a focused reflection on issues surrounding the monarchy. In particular, the editors were interested in promoting some debate about the next coronation. For the coronation of the monarch is a political, cultural and religious event. Its ritual and symbolism express something of how the monarchy sees itself and how it views contemporary society. There is no established liturgy for a coronation, so the question arises: what might be appropriate next time round? Will the liturgy reflect Charles's stated desire to be a 'defender of faiths' and/or will it reflect his patronage of the Prayer Book Society? Might we expect Downing Street to have a major input and if so, assuming no change of government, can we imagine a New Labour coronation? How will the funeral of Diana, Princess of Wales, impact on official state liturgy? Will Sir Elton be called upon to perform?

Wesley Carr, Dean of Westminster Abbey, explores in detail the specifics of

previous coronations, in particular that of Queen Elizabeth II in 1953, and notes that each coronation has included developments that reflect the political state of the nation: 'Every coronation is contextual and that context cannot be predicted.' He cites recent extensive changes to the House of Lords as being particularly important, along with the increasingly important religious and ethnic plurality to which social reality points. He argues that there remain hints of the mediaeval doctrine of the divine right of kings in the coronation ceremony—an idea which, he suggests, commands little or no support in modern society. He suggests that there has developed a theory more of divine duty than divine right, which perhaps will call for liturgical expression.

Ian Bradley echoes Carr's sense of the importance of the coronation: 'In the absence of a written constitution in the United Kingdom the coronation service carries another very important layer of meaning, providing the nearest that we have to an assertion of national values and ruling principles.' He continues: 'Packed with religious symbolism and imagery, it exudes mystery and magic, binds together church and state through the person of the monarch and clearly proclaims both the derivation of all power and authority from God and the Christian basis on which government is exercised, justice administered and the state defended. Here, if anywhere, we find the divinity which, as Shakespeare so rightly observed, hedges around the English throne.' Bradley quotes Shils and Young, secular sociologists who analysed the coronation in 1953, observing that it constituted: 'a great act of national communion'; an 'inspiration'; a 're-dedication of the nation'; a ceremony which 'touched the sense of the sacred' in people. Bradley asks whether the elements they identified as being important then, could be important now: 'can the country as a whole still collectively be touched in any meaningful sense by an intensive contact with the sacred? And can a future coronation be left to the Church of England to stage manage?' He then explores the ten elements in the coronation service in order to see how they might be appropriately recast for our modern context.

Our other two monarchy-centred articles range beyond the coronation. Leslie Griffiths brings his personal perspective of a Welsh working-class upbringing, saying: 'There we were, living in abject poverty, in a socialist haven, hating Whitehall bureaucracy, clinging to our trade unions, yet avidly pro-royal. Very odd.' Charting the fate of monarchy over time, he concludes, 'in our own day, scandals and petty royals have produced their *anni horribile* and heaped scorn on the House of Windsor. But the wretched thing won't die. It continues to grow. It seems impossible to put it down.' Reflecting on the lessons learned through watching the funeral of the Queen Mother he concludes that the function of royalty is to bring *continuity* to a fast-changing world. He says, 'And if I didn't think so before, then the Queen Mum's funeral has now made all that as abundantly clear as daylight. She may have

been a spoiled brat, a self-indulgent, self-regarding and over-privileged woman but a million people stood waiting for her on the day of her funeral and half a million filed for hours to pay their respects and sign books of remembrance.' If much of that can be put down to nostalgia, then the future of the monarchy depends upon it being inclusive rather than backward-looking: 'I believe that the reign of Queen Elizabeth II and her successors will need constantly to remind itself, in a pluralistic age and in postmodern times, of the appeal it needs to make to the widest possible spread of society... Who will see to it that the other faiths and the non-established Christian denominations, people from other backgrounds and cultures in this variegated land of ours, can feel included by the symbolism of monarchy?'

Complementing Leslie Griffiths's Welsh perspective on the monarchy is Graham Blount's assertion that Scotland, too, is 'a bit different'. He takes a Scottish sense of exclusion as a way into a more widely inclusive vision of monarchy. He explores two distinctively Scottish models—of sovereignty and of being a national church—and offers these as bases for exploring the shape of a coronation that tries to express who we all are.

Alongside these four articles on the monarchy, our remaining contributors return us to several ongoing important political and theological themes.

Cliff Marrs focuses on globalization, reminding us that: '11 September was a kairos day for the rich, fatalities at the World Trade Centre currently stand at 3,045 with another 500 missing presumed dead, but for the world's poor it was just another day of death... On 11 September c. 45,000 died, most from preventable causes and diseases: malnutrition, diarrhoea, measles, malaria, TB, AIDS, polluted water and air, and poor sanitation. Guy Dauncy observes: "the pain of death in New York is no different from the pain of death [elsewhere]...our hearts all suffer in the same way"'. A forthcoming edition of this journal will return us to in-depth discussion of the implications of 11 September for international politics.

Susan Durber offers a timely political reading of the biblical stories of Jesus and the Samaritans in a way that strives for relevance in the contemporary political context of Israel–Palestine. She speaks personally: 'It has been my experience that reading them [biblical passages] within the context of contemporary events in Israel–Palestine is both fascinating and illuminating... It does make a difference to read the story of the woman at the well when you know that the Israeli government have sometimes cut off the road and the water supply to Nablus. It makes a difference to read the parable of the Good Samaritan if you have tried, and failed, to make the complicated journey between Jerusalem and Jericho (now part of the Palestinian territory). It makes a difference to read the story of the Samaritan leper when you have observed at first hand the difference between the smartest hospital in West Jerusalem and the work of the Palestinian Medical Relief Committee.'

Finally, Nick Brown's provocative short piece explores parallels between radical Christian thinkers and Conservative thinkers, in a way which will no doubt infuriate both: 'Radical Christian thinkers like Richard Holloway promote a spiritual individualism which involves a strong, sometimes vociferous critique of institutions and of course most notably the Church.' He likens this to the perspective on personal freedom espoused by Conservative politicians such as David Willetts and Damian Green. 'As with radical Christian thinking, so in Conservative thought the love of freedom and opposition to overbearing institutions brings with it a call for individual responsibility.' This gives rise in both systems of thought, he argues, to a creative tension between promoting individual freedom and respecting tradition and institutions, concluding, 'These observations are of note because they counter two assumptions which are fundamental to the majority of debates surrounding the interaction between politics and theology. The first is that radical Christian reformism is inherently and exclusively socialist in outlook. The second is that the interaction between Conservatism and Christianity is limited to the Christian Right's obsession with social authoritarianism.'

Readers may want to respond to Nick Brown's (or indeed, any of our contributors') assertions. The editors welcome your comments.

[*PT* 4.1 (2002) 11-24]
ISSN 1462-317X

THIS INTIMATE RITUAL: THE CORONATION SERVICE*

Wesley Carr
wesley.carr@westminster-abbey.org

ABSTRACT

Although it may appear unchanging, in fact every coronation ceremony is a
fresh service, which is a product of its time. It is likely, for instance, that at any
future coronation television will be a major new factor compared with 1953.
But political and social changes—for example, reform of the House of Lords
and the increasing religious and social complexity of modern British society—
will also have an impact. This article introduces the coronation ritual, in par-
ticular describing the coronation of Her Majesty The Queen. The religious
legitimacy of the monarch remains important. The theory of divine right may
have weakened, but only in favour of divine duty.

This article is, as the lawyers would say, 'without prejudice'. I have no spe-
cial knowledge about the coronation service. But I do have at Westminster
Abbey a good library and an excellent librarian. Nothing here can be taken
to say what will in due course happen when there is another coronation, a
day which at the Abbey we pray will be years ahead.

With the celebrations of the Golden Jubilee of Her Majesty the Queen's
accession in 1952, people's minds have turned again to the coronation cere-
mony. But the last coronation was a long time ago and many cannot remem-
ber it. The world in 1953 was also different. For some (including me) there
are childhood memories of a nation trying to inject some cheerfulness into
the post-war greyness. The Festival of Britain with its exhibition on the
South Bank and funfair at Battersea (the two were not confused then) held
out the prospect of a new world. And even on the day of the coronation the
dramatic news that Mount Everest had been conquered by a British-led
expedition vied for top place in the headlines. There were flags and street

* I am indebted to Dr Tony Trowles, Librarian of Westminster Abbey, for data and
advice. The phrase 'intimate ritual' comes from Kenneth M. Wolfe, *The Churches and the
British Broadcasting Corporation 1922–1956* (London: SCM Press, 1984), p. 497.

parties; children were given commemorative mugs. The omens were that this was to be a new Elizabethan age.

But ultimately the most significant change was the small, flickering black and white picture on a screen in the corner of the room—the television. There was neither colour nor choice of programme. But it was an historic moment: as neighbours and friends gathered round it with their packed lunches, for the first time in British history the ordinary people observed the coronation of their sovereign.

The coronation of George VI had been broadcast on the radio and the venture, greatly helped by F.A. Iremonger's commentary, was also widely appreciated. Even then, though television was in its infancy, the question of televising the ceremony was discussed. The Earl Marshal would not allow cameras into the Abbey, much to the regret of Lord Reith. But it was a sign of things to come.

In 1953 the BBC assumed that the ceremony was likely to be televised and was very surprised when the Archbishop, the Earl Marshal and the Dean and Chapter of Westminster were all opposed. The sole concession was to allow cameras to the west of the organ screen, only processions would be seen. Film cameras, however, were to be allowed to film the coronation itself. Churchill, too, was against televising the coronation: he wanted to pre-serve the mystery from the prying eyes of the populace. There was a major debate in the press. A full-scale demonstration of TV equipment was set up in the Abbey for the Archbishop and the Dean. They were surprised and both, though innately conservative, saw the value in the proposed broadcast.

> The effect of the coronation on the nation was enormous: the cameras had conveyed this intimate ritual to the vast majority of the population. The well publicised reservations of the church leaders were buried behind the wide-spread esteem which television had accrued following the cluster of pro-grammes around the great day itself.[1]

In the end, television won and we watched the ceremony live, although the most solemn moment of anointing was shielded from public gaze. But that precedent gives the major clue to what is likely to be most different about any future coronation—not so much a major liturgical breakthrough but the impact and technology of television. It is reckoned that the funeral of Diana, Princess of Wales, was watched by 31.5 million people in Great Britain, which is 59 per cent of the population (22m watched the Princess's wedding and 19m Churchill's funeral). The service was sent live to 45 countries and via the BBC World television to another 142.[2] If that was the

1. Wolfe, *The Churches*, p. 497.
2. Source: *Guardian*, 8 September 1997.

response to a funeral, albeit of a person who fascinated many, what will be the impact of a coronation?

But what is a coronation? It is not the accession: Queen Elizabeth had been sovereign for 18 months before her enthronement. Saint Dunstan, Archbishop of Canterbury, drafted the first English coronation service for the crowning of Edgar in Bath Abbey in 973 CE. But he, too, had been the first King of All England since 959, although he had not been anointed at that time. However, the basic structure of all subsequent coronations can be seen in this original rite. As at modern coronations there was a procession, an oath or promise, the anointing and investiture, followed by the Mass. Notice that there is no reference to the crowning. Only later was this popularly believed to be the core of the rite. And after all, 'coronation' means 'crowning'.

William the Conqueror used the rite devised by Dunstan when he was crowned in Westminster Abbey on Christmas Day 1066. Harold, Edward's successor, had defeated the Norwegian Harald Sigursson (also known as 'Havrada') at Stamford Bridge. But at Hastings (in fact, Pevensey) he met his match in William. Harold was killed and William assumed the throne, claiming to be the lawful successor of the Saxon King Edward the Confessor. It was, therefore, appropriate that he should be crowned 'near Edward's grave' in the Abbey.

It was, as with several subsequent coronations, a fiasco. There was a confused response to the recognition, because the question was put in French and English. The soldiers outside thought the consent sounded hostile and began to set fire to buildings. The Abbey filled with smoke and the congregation fled. A rushed coronation was completed and the anxious king left with relief. His immediate successors were also crowned in the Abbey. This laid the foundation of the right of Westminster Abbey to be the coronation church of the kings and queens of England. Since the twelfth century the consecration and crowning has also been exclusively performed by the Archbishop of Canterbury, unless the see is vacant or he is incapacitated, when a bishop will perform it.

Most of what follows is based on records that relate to the last coronation, that of Queen Elizabeth II in 1953. It should be noted, however, that, although the basic ceremony is deeply rooted in tradition, each coronation has included alterations and developments that reflect the political state of the nation, changes in liturgical understanding and other factors. For example, with the recent extensive reform of the House of Lords, and especially of the role of hereditary peers, it seems likely that with regard to the lords and their homage the political and social context of the coronation will have an impact on the liturgy.

The basic given structure is that of the Eucharist according to the Book

of Common Prayer, within which the coronation occurs. There has never been a non-eucharistic coronation. Whether there can be such a ritual is a question that cannot be treated hypothetically. As with all such questions, it can only be raised seriously when the coronation service is actually being prepared. This is not merely a courtesy to the reigning monarch, although there is that important dimension. It is also that every coronation is contextual and that context cannot be predicted. This is, I suspect, especially true when the new monarch succeeds after a long reign.

The key elements of the rite include the recognition by the people and the oath, the anointing or 'sacring', the investiture, the crowning, the enthronement and the homage. There have over the years been changes. But many of those proposed have been rejected. In both 1937 and 1952, for example, more than one scholar argued in vain that the homage should be returned to its original secular context and be made a separate ceremony in Westminster Hall. It did not happen in 1953, although there was some pressure to revert to this tradition. It may, therefore, yet come: for to use Westminster Hall before a procession to the Abbey might be a suitable way for the Crown to affirm the religious and ethnic plurality to which social reality points within the continuity that the nation seeks. There is a continuity but also a discontinuity in this aspect of the ritual. The homage, more than any other part of the service, and especially in its traditional wording ('liege man of life and limb'), raises the question as to what extent the coronation should continue to reflect a mediaeval tradition of knightly or chivalric service. An additional factor at any future ceremony must be provision for women to do homage. And it always seems more difficult to find the right words when women are doing something to or for men.[3] Nevertheless, women are bound to be involved in the ceremony in a new and, we might hope, vibrant way.

This is the point to bring in the issue of 'defender of the faith'. Prince Charles recently suggested that he might wish to be known as 'defender of faith' rather than of 'the' (*sc.* Christian) faith. Theoretically *fidei defensor* means either 'defender of the faith' or 'defender of faith' (in general) and thus by association: 'defender of faiths'. But this relies on decontextualized Latin. I suspect that we cannot translate it as either of the last two and that it must refer to the Christian faith. The title *fidei defensor* was assigned to distinguished people by the Pope. In 1521 Leo so designated Henry VIII for his refutation of Luther. After the Reformation the monarch continued to claim the title as one of the royal titles. They would be defenders of the

3. An extreme example of this stance was that of an Oxford Professor who argued seriously against women priests that they could scarcely administer Communion with the words 'This is my Body' because of the sexual overtones.

Christian faith as found now in the Church of England and not the Church of Rome. But while the scope of the title probably cannot be enlarged, some aspects of the suggested ceremony in Westminster Hall could allow for the various religious groups and ethnic bodies that now constitute the nation to recognize their sovereign and offer a form of homage. The new monarch would then in the Abbey be able to present himself as carrying the unity of the nation as the basis on which the specifically Christian coronation would follow.[4]

With the death of the sovereign there is, of course, no lapse in the governance of the nation: 'The Queen is dead: Long live the King.' The Prime Minister announces the sovereign's death to the House of Commons and business is suspended. A Coronation Commission is formed which has overall organizational responsibility.[5] In 1953 the Commission further established a Coronation Joint Committee, 'joint' referring to the United Kingdom and the Commonwealth. This was chaired by the Earl Marshal and had over 30 members. Among these were the Archbishop of Canterbury, the Queen's private secretary, the Dean of Westminster and other representatives from the Royal Household, the government and the Commonwealth.

The Archbishop of Canterbury, the Dean of Westminster and the Dean and Chapter of Westminster are the key religious participants in the ceremony, which, because of its liturgical setting, is essentially Christian. The Dean instructs the sovereign in preparation for the coronation; fills the ampulla with oil on the morning of the coronation, hands the regalia to the Archbishop, and invests the new sovereign in the coronation robes. The Archbishop of Canterbury celebrates the Eucharist and crowns the monarch. But apart from the Bishops of Durham and of Bath and Wells, who have the ancient right of supporting the sovereign, no other bishop (including the Archbishop of York) has any right to take any part in the service. In practice, however, the senior bishops (London and Winchester) as well as the Archbishop of York, are involved. The special privileges enjoyed by the Dean and Chapter of Westminster at coronations are held in succession to those originally assigned to the abbot and convent, and derive partly from their ancient right to have the custody of the regalia.

By tradition the Archbishop of Canterbury in office at the time of the coronation is responsible for drawing up the order of service. Unlike most other royal ceremonies there is no precedent for having an order 'on file'. In any case, this could only be for the use of whoever was archbishop at the

4. This suggestion is an extension of the argument regarding the need for religion to be represented in parliament and the realization that such religion must be specific: it cannot be multifaith. See, e.g., the writings of Tariq Modood.
5. It was chaired in 1952–53 by the Duke of Edinburgh.

time of the coronation. No future archbishop would be under any obligation to make use of an order drawn up by his predecessor. In 1953 Geoffrey Fisher convened a small committee to consider the shape of the service. This consisted of the Archbishop, the Dean of Westminster and two historians who were particularly expert in the history of the coronation liturgy and its development.

The Archbishop is also responsible for providing music at a modern coronation. He appoints, subject to the approval of the Coronation Committee, a Director of Music. Since 1902 this has always been the Organist and Master of the Choristers of Westminster Abbey. The Master of the King's/ Queen's Musick is associated with the Director in the discharge of his responsibilities. In 1953 the choir numbered approximately four hundred: the choirs of the Abbey, the Chapel Royal, St George's Windsor and St Paul's, together with representative singers from other choral foundations and some Commonwealth representation. The orchestra consisted of 61 players.

The Earl Marshal is placed 'in possession' of the Abbey in order to make the necessary internal preparations. In 1953 this involved building galleries to change the seating in the Abbey from its customary 2,000 to 8,000. The Dean and Chapter and their surveyor remain responsible for the safety of the fabric and the treasures which it contains. But a day or two before the ceremony the keys to the Abbey are delivered to the Earl Marshal whose possession becomes absolute. It is the most practical reminder that a royal peculiar is the sovereign's church.[6] But in 1952–53 the Dean and Chapter assumed another task. While the Abbey was closed to the public, the clergy and other members of the College did what they could to explain to the general public the significance of the coronation service. It will be interesting to see whether such a task could even be conceived for a future coronation, given the pervasive function of the modern media.

The Service

The Order of Service has been revised and altered many times, taking into account various constitutional and religious changes through the centuries. The late fourteenth-century revision is found in the illuminated *Liber Regalis*, or royal book, which is preserved in the Abbey Library. The last coronation performed (mostly) in Latin was that of Elizabeth I in 1559.

6. The term 'royal peculiar' refers to those churches that are subject to a 'peculiar' jurisdiction (i.e. one outside the mainstream systems of the Church) and are essentially the property of the monarch. The royal peculiars are Westminster Abbey, St George's Windsor and the Chapels Royal.

The traditional procession from the Tower of London on the eve of the service was discontinued by James II and the lavish banquet in Westminster Hall afterwards was last held in 1821. Coronations have not always been performed with elegance and order. The service, long in any case, has sometimes been infuriatingly so. It has often included a sermon and many participants seem to have been confused.

At the recognition of Charles I, for example, something went wrong and there was a silence. The congregation had to be told to shout 'God save King Charles'. The text for the sermon was also unwise or prophetic: 'Be thou faithful unto death and I will give thee a crown of life.' At Queen Victoria's coronation in 1838 only she and the Sub-Dean of Westminster, Lord John Thynne, seemed to know what to do. Careful preparation and rehearsal for the next coronation, that of Edward VII in 1902, ensured that some dignity returned to the ceremony, although the Archbishop put the crown on the wrong way round.

Music plays an important part in the service. Many of the texts have been used over several centuries, although to different settings. 'I was glad' from Psalm 122 was first sung at the coronation of Charles II in 1661; 'Veni Creator Spiritus' ('Come, Holy Ghost') appears in the *Liber Regalis* and 'Zadok the Priest' was sung in 973, although it only received its famous setting by Handel in 1727 for the coronation of George II. A congregational hymn, 'All people that on earth do dwell', and the National Anthem at the end of the service were both introduced at the coronation of the Queen in 1953.

The Setting

Beyond the Quire in the Abbey is an area called 'the Lantern' over which the tower rises. It is for most purposes an odd space that makes regular liturgy awkward. On either side are the transepts; to the west a fairly narrow aisle runs between pews in collegial style for the choir, the Dean and Canons and other members of the College. The end is marked by the organ screen. To the east is the Sacrarium, the sanctuary and the High Altar, before which is spread the Cosmati pavement.[7] Behind the altar lies the shrine of St Edward the Confessor. The sovereign has to come through to the shrine to change vestments. But at a coronation all three—Quire, Lantern and Sacrarium—unite to create a coronation theatre and the large space comes

7. The pavement dates from 1286 and with the work at Anagni Cathedral in Italy is regarded as the best of its type. It tells the story of the universe. 'If the finer reader wittingly reflects on all that is taken down, he will discover the end of the universe.' See R. Foster, *Patterns of Thought* (London: Jonathan Cape, 1991).

into its own. Three seats are provided for the monarch: the Chair of Estate, the Coronation Chair and the Throne. The Chair of Estate, in which the sovereign sits at the start of the service, is placed on the south side of the Sacrarium (the sanctuary area). A raised platform or coronation theatre is erected in the Lantern and on this is placed the Throne used at the homage. The latter two items are newly made for each coronation. The most important seat is the Coronation Chair.

Made in 1300 on the orders of Edward I, the chair was specifically designed to contain the Stone of Scone, which he had taken from the Scots, to symbolize the union of England and Scotland under one king. The stone was a sort of relic guarded with care, first by the Abbot and Convent and then by the Dean and Chapter of Westminster. After they had looked after it for over seven hundred years, suddenly and with only a day's notice before the decision was announced in the Commons, the stone was returned to Scotland in 1996. It is understood that it will be returned to its place in the chair for future coronations. On only two previous occasions has the stone been moved outside the Abbey. In 1657 Cromwell had the chair with the stone taken across to Westminster Hall for his installation as Lord Protector. And in 1950 the stone was stolen and delivered to Arbroath Abbey as a statement about Scottish Nationalism. It is difficult to assess what the symbolism of such a union might mean in today's circumstances. The stone having gone, there may be resistance to restoring it. Certainly it would constitute a stronger rallying cry to nationalism at the time of a coronation than if it had remained in the setting which was designed for it. The two previous removals of the stone in 1657 and 1950 were each a powerful political statement.

The chair is brought out for the coronation service and the monarch faces the High Altar. For much of its history this symbolic artefact has been left lying around the Abbey. As a result it has been altered and sometimes even repainted. Boys from Westminster School used to try and spend nights there. One carved 'P. Abbott slept in this chair 5.6 July 1800'. The mediaeval colours have long gone; the chair looks battered and plain. Perhaps it should be by now. For as it is, it still moves visitors when they see such a remarkable symbol of historical continuity.

The Liturgy

The main elements of the service as held on 2 June 1953 were as follows:

Before the service the Dean and Chapter and the Minor Canons of Westminster process from the Jerusalem Chamber to the High Altar with the regalia, which has been brought to the Abbey early the previous day. The Queen's scholars from Westminster School accompany them and the choir

sings the Litany. The Dean, to whom is entrusted the safe keeping of the oil and its provision, puts the special coronation oil into the ampulla (a vessel shaped like an eagle) and it is laid on the altar. This oil is prepared to a secret recipe, known only to the Dean and the Royal Apothecary, but contains oils of orange, roses, cinnamon, musk, ambergris, among others. It is kept consecrated.

Once the Abbey clergy have returned, the sovereign's procession enters through the west door, the choirs beginning the anthem 'I was glad when they said unto me, We will go into the House of the Lord'. Psalm 122, from which most of the words are derived, is a gradual hymn sung by pilgrims as they climbed the ascent to Zion. It establishes the immediate theme of 'king/queenship' and the governance of the nation is rooted in the Jewish–Christian tradition. The mix of Old Testament notions of kingship and its divine associations and the belief that the highest rule on earth itself stands under the judgment of the ultimate rule of the 'king of kings' is a constant theme through coronations. The monarch sitting in King Edward's Chair, may have time to read the inscription above the High Altar in the Abbey: 'The kingdoms of this world are become the kingdoms of our God and of his Christ.' The responsibility of rule derives from the deep rooting of British tradition in the Old Testament and on the fact that the sovereign faces the same judgment of God as his or her subjects when the world's wisdom comes to its end.

With this in mind, the various symbols of office—the regalia—are carried in the procession. As the sovereign comes through the screen and enters the Quire, the Scholars of Westminster shout 'Vivat Regina Elizabetha, Vivat! Vivat!' ('Long Live Queen Elizabeth'). She makes her way to the Chair of Estate and the service begins.

The next major enactment is the recognition. The monarch to be crowned stands beside the Coronation Chair, the Archbishop presents her to the people on all sides of the theatre as their undoubted sovereign. He then questions the Queen and administers the oath. We might note that in a democratic system, whatever the head of state (royal or presidential), the formal recognition is in fact mutual. The people recognize the monarch as their 'undoubted Queen' and she in turn recognizes them to remind all that a constitutional monarchy is based on the will of the people. It is important to be clear at this point because the question of the oath is widely discussed. This is already being regarded by some as a point where the ceremony must be changed. The oath is a series of answers to questions put by the Archbishop. He asks if she is willing to take the oath and, upon her assent, then asks whether she will govern the United Kingdom, the Commonwealth and the Empire. She also promises to reign by law, justice and mercy. No exception seems likely to be taken to these.

But then the Archbishop asks: 'Will you to the utmost of your power maintain the Laws of God and the true profession of the Gospel? Will you to the utmost of your power maintain in the United Kingdom the Protestant Reformed Religion established by law? Will you maintain and preserve inviolably the settlement of the Church of England, and the doctrine, worship, discipline, and government thereof, as by law established in England? And will you preserve unto the Bishops and Clergy of England, and to the Churches there committed to their charge, all such rights and privileges, as by law do or shall appertain to them or any of them?' And the sovereign replies, 'All this I promise to do'.

In view of the public discussion of this topic, it is worth careful attention. First, we may note that the monarch promises to 'maintain' the specific Church rather than churches and religion in general. This does not, so far as I can see, imply the denigration of others and certainly is not to devalue them. The coronation itself, where these questions are asked, is held in a prominent Christian Church and focal point for the Church of England, which is, whether we like it or not, privileged within the British scene. This could be an occasion to work at a different form of ecumenism and at relations with other faiths, rather than just incorporate some form of words. The bishops, for example, might mobilize their assigned religious (not especially Christian) function in the nation by being represented in the House of Lords as a way of ensuring representation of religions. There would then be no need to embark on a highly controversial course of rewriting the oath. For it seems still to have some mileage: the oath when taken as a whole is wider than religious. The sovereign promises to govern her peoples according to law. However, in the current changes in the structure of the House of Lords, it is difficult to foresee the consequences for the oath.

The sovereign's next act, however, is Christian. At the Altar she lays her hand on the Bible and says, 'The things which I have here before promised, I will perform and keep. So help me God.' She kisses the Bible and signs the oath. The Holy Bible, 'the most valuable thing that this world affords', is presented by the Moderator of the Church of the Scotland (1953 was the first time he performed this duty) with the words 'Here is Wisdom; this is the Royal Law; these are the lively Oracles of God.' The Bible is then returned to the Altar. Again there may be pressure to associate the Bible with other religious books. But once again there is the problem of where you draw the lines and whether such central religious texts could be used in a Holy Communion service of the Church of England.

The beginning of the Communion Service follows according to order of the Book of Common Prayer. But after the Creed comes the anointing, the 'intimate ritual' itself. Seated in the Coronation Chair the monarch is anointed with oil 'as Solomon was anointed king by Zadok the priest and

Nathan the prophet'. The anointing is in the form of a cross on the palms of the hands, the breast and the head. A canopy is held over the monarch to shield her from view. For this (and not the crowning, as is often supposed) is the most sacred part of the service.

The monarch puts on the robes of cloth of gold. The ceremonial spurs and sword (symbolizing knighthood and chivalry) are presented. She offers the sword at the Altar and is then invested with the armills, 'the Bracelets of sincerity and wisdom', the stole and the robe royal (symbols of the divine Office of Kingship). The orb is presented with the words 'remember that the whole world is subject to the Power and Empire of Christ'. She is invested next with the coronation ring, 'the Ring of kingly dignity and the seal of the Catholic faith', receives the sceptre with the cross, 'the ensign of kingly power and justice', and the rod with the dove, 'the Rod of equity and mercy'.

All is now ready for the coronation itself. The Archbishop blesses St Edward's Crown and places it on the sovereign's head. The people shout 'God Save the Queen'. The princes and peers put on their coronets, the trumpets sound and at the Tower of London a salute is fired. The Archbishop says 'God crown you with a crown of glory and righteousness, that having a right faith and manifold fruit of good works, you may obtain the crown of an everlasting kingdom by the gift of him whose kingdom endureth for ever'. After the Benediction the Queen makes her way to the Throne for the homage. The Archbishop, the royal princes and senior peers of each degree ascend the steps to the Throne and pay their homage to the monarch. Then the drums and trumpets sound and the people shout: 'God Save Queen Elizabeth. Long Live Queen Elizabeth. May the Queen Live for Ever.'

The Communion Service resumes. While the hymn is sung the Queen removes her crown and makes her way to the altar. She offers the bread and wine to the Archbishop and makes her offering of a pall or altar cloth and an ingot of gold. After the Prayer of Consecration the Queen and the Duke of Edinburgh receive Holy Communion. The Queen resumes her crown, takes up the sceptre and rod and returns to the Throne. The choirs sing *Gloria in excelsis* and the Archbishop gives the Blessing. The rite concludes with the singing of the *Te Deum*.

The Queen processes into St Edward's shrine behind the altar and delivers St Edward's Crown and the rod to the Archbishop. Assisted by the Dean and her ladies in waiting she changes into the robe of purple velvet and puts on the Imperial Crown and carries the sceptre and orb as her procession leaves the Abbey while the National Anthem is sung.

Discussion

For the reasons already given, there is little that can be usefully discussed until a coronation has to be prepared. Yet obvious points occur. Since 1953 the United Kingdom has become a more multiracial and multi-ethnic society—although concentrations of members of various racial and religious backgrounds may give a false sense of the depth of this mix. This will need to be recognized. At the same time the level of public religious commitment and corresponding understanding has also declined. Any religious ceremony, however, has to be specific. And this poses a problem for a coronation. It is, at least has historically been, Christian. Indeed it is set in the most decisively Christian liturgy, which is both unifying and divisive— the Eucharist. But if the bulk of the nominal Christians in Great Britain do not know what this is, and the members of other faiths feel that something of their tradition should be recognized, there will be a problem. The Church which is responsible for the coronation will sound curmudgeonly if it tries to represent the tradition for which it stands against this confused religious background and what the new King might wish. To plan a coronation without the Eucharist would require a massive break with history. That alone would imply a long study of the intention behind a coronation at all, its venue and basic structure.

It is not useful to speculate too much. Curiously, among those who defend the idea of monarchy there is the widespread assumption that it needs to become secularized.[8] The Queen has made reference in two recent Christmas messages to her own personal faith and public attendance at Church. In this respect, however, the two leading members of the royal family, the present Queen and the future King, both have high profiles as spiritual people and churchgoers.

Among political changes, two stand out. The first is the removal of power from the House of Lords. The aristocracy remains, but quite which aspect of it attends the coronation and pays homage is becoming less clear. Should it be working peers or hereditaries? The second factor is the devolved parliaments of Wales and Scotland, possibly eventually Northern Ireland also and the regions. But it is clear that one of the uniting factors in the nation which culminate in the unifying act of crowning the sovereign has come loose, and no doubt there are others too.

One significant point, however, is overlooked by many. Queen Victoria's coronation was the last one intended almost exclusively for the people of

8. See I. Bradley, *God Save the Queen: The Spiritual Dimension of Monarchy* (London: Darton, Longman & Todd, 2002).

the United Kingdom. The four coronations of the twentieth century were in practice or (in 1953) in spirit imperial ceremonies. Dignitaries came from the countries of the Empire, and they represented other ethnic and religious backgrounds. Some, of course, were diplomatic representatives of foreign states. But others had come to witness the coronation of their own sovereign and their head of state. They were not so much foreigners invited to witness but subjects themselves taking part in the Recognition and being recognized. Large contingents of colonial and commonwealth troops also participated in the processions.

This will not recur: the Empire has gone and the Commonwealth has flourished. We might inadvertently overplay the importance of this point (and the colonial aspect gives it an unfashionable edge). But it is a fact that while participation of people from other ethnic or faith backgrounds in the ceremony itself would be an innovation, their attendance at it, and their participation in the wider celebrations, is so well established that it hardly merits comment.

Another relevant factor is the modern obsession with 'legitimacy by participation'. The argument runs, in terms of the coronation, that religious or ethnic groups cannot be expected to feel committed to a new monarch unless they have been involved in his inauguration. Yet, it is worth noting that British Jews (probably the largest ethnic grouping until the immigration of the 1950s) have long been content to accept and serve monarchs inaugurated in a Christian coronation ceremony in which they (the Jews) have not participated.

The main issue, however, as we consider the ceremony as it has been, is the assumption of the connection between kingship and the divine. The mediaeval doctrine of the divine right of kings was invoked afresh in the post-Reformation and restoration theories of rule. It was important politically to establish the legitimacy of the monarchy both in civil terms of the succession and in religious terms against any claim by the Pope to jurisdiction. When the monarchy needed it, this doctrine was promulgated, not least by the monarchs themselves. It was one of the two main responses to the political turmoil in seventeenth-century Europe, the other being based on natural law. It held that certain kings were chosen by God and were accountable only to God. So long as belief in constitutional monarchy as a way of governance is sustained, then such doctrine (at least in its firmest form) does not need to be articulated. But there remain hints of it in the coronation ceremony.

At the presentation of the Bible we find the words: 'to keep your Majesty ever mindful of the Law and the Gospel of God as the Rule for the whole life and government of Christian Princes'. Obviously the anointing is the most overtly religious act. During it the Archbishop says: 'Bless and sanctify

thy chosen servant Elizabeth, who by our office and ministry is now to be anointed with this Oil and consecrated Queen...' And the ring: 'Receive the Ring of kingly dignity, and the seal of Catholic Faith: and as you are this day consecrated to Be our Head and Prince, so may you continue steadfastly as the Defender of Christ's Religion...'

But clearly even a hint of divine right commands little (we can be reasonably certain, no) support in a modern society. Today the relationship between kingship and the divine is a grey area that is probably only explored briefly at an accession and coronation, which brings the nature of sovereignty under public scrutiny. There has developed a theory more of divine duty than divine right. That has been the public stance of the present Queen, who has not made a secret of her personal belief in her vocation and its religious undergirding, without impinging upon the notion of a constitutional monarchy.

But when there is another coronation—and that still seems probable—it will have to link to the history of the nation; and without religion that linking currently seems impossible. One is always ready for unexpected change. But for an event which is so massively in the people's consciousness as an idea, it is difficult to think where else the king might be crowned than at Westminster Abbey.

For these reasons alone we may be sure that much work will go into preparing the next coronation. We may also be certain that after the oddities of coronations past any future one will be carefully planned and rehearsed to that level of faultlessness that a sovereign deserves and now people rightly expect.

[*PT* 4.1 (2002) 25-43]
ISSN 1462-317X

THE SHAPE OF THE NEXT CORONATION—
SOME TENTATIVE THOUGHTS

Ian Bradley
icb@st-andrews.ac.uk

ABSTRACT

This article considers the meaning and symbolism of the United Kingdom coronation service. After surveying the impact of recent royal ritual, it explores the detailed structure of the coronation service and makes and proposes a number of alterations and reforms in the shape and structure of the next coronation. It also advocates the introduction of a new ceremony of enthronement and homage, separate and discrete from the coronation, and to be held outside London.

It is the coronation service more than any other institution or event that underlines the essentially spiritual character and sacred nature of British monarchy. Packed with religious symbolism and imagery, it exudes mystery and magic, binds together church and state through the person of the monarch and clearly proclaims both the derivation of all power and authority from God and the Christian basis on which government is exercised, justice administered and the state defended. Here, if anywhere, we find the divinity which, as Shakespeare so rightly observed, hedges around the English throne. This has been as true in recent times as in the heyday of divine right theory in the seventeenth century. On the day of the coronation of Queen Elizabeth II in 1953 the Archbishop of Canterbury, Geoffrey Fisher, solemnly announced that England had been brought closer to the kingdom of heaven.

In the absence of a written constitution in the United Kingdom the coronation service carries another very important layer of meaning, providing the nearest that we have to an assertion of national values and ruling principles— the kind of statement that in other countries lies in the preamble to the constitution. This is especially true of the coronation oath in which the monarch promises to govern the peoples of his or her realms according to their respective laws and customs and to cause law and justice, in mercy, to be executed in all of his or her judgments. What is significant about these promises is that they are made as much to God as to the people and in a context which is

transcendent and metaphysical. The coronation service clearly embodies the notion of the monarch's covenant with the people—it is there in act of the recognition with which the service begins and in the act of homage towards the end. Essentially, however, the coronation is a religious service in which the initiative is divine rather than human and the key covenant is made between the monarch and God. In the words of the perceptive religious commentator, Clifford Longley:

> The Coronation of our Queen was an act of God performed by human hands, and the assembly held its breath at the mystery and wonder of it. It was one of the central acts of statehood, the moment whereby all temporal authority in the realm flowing from the king was legitimised and sanctified.[1]

At their coronations kings and queens are not simply crowned and enthroned but consecrated, set apart and anointed, dedicated to God and invested with sacerdotal garb and symbolic insignia. Often following after the accession of a new monarch by a year or more, coronations are primarily religious services rather than constitutional ceremonies. In several early accounts they are described as benedictions or ordinations. At the heart of every coronation in England for more than a thousand years has been the act of anointing the new monarch with holy oil, a ritual which is directly based on and compared to the anointing of Solomon and accompanied by the singing of verses from 1 Kgs 1: 'Zadok the priest and Nathan the prophet anointed Solomon king; and all the people rejoiced and said: God save the king, Long live the king, May the king live for ever. Amen. Hallelujah.'

Modern commentators have generally been united in pointing to the strongly mediaeval and mystical feel of the 1953 coronation, although they have reacted to it in markedly different ways. For the political journalist Tony Howard, it was 'little more than a glorified medieval pageant'. For the sociologists, Edward Shils and Michael Young, by contrast, 'the coronation was the ceremonial occasion for the affirmation of the moral values by which the society lives. It was an act of national communion.'[2] Their seminal article in the *Sociological Review* in 1953 was based in part on their observation of the coronation's impact on 'ordinary' people. They noted that it was frequently spoken of as an 'inspiration' and a 're-dedication of the nation'. The ceremony had 'touched the sense of the sacred' in people, heightening a sense of solidarity in both families and communities. They pointed to examples of reconciliation between long-feuding neighbours and family members brought about by the shared experience of watching the coronation and noted that the crowds lining

1. *Daily Telegraph*, 29 June 1994.
2. 'And all the people rejoiced', *Church Times*, 2 March 2002; E. Shils and M. Young, 'The Meaning of the Coronation', *Sociological Review* NS 1 (1953), pp. 63-81 (67).

the streets of London on Coronation Day were not idle curiosity seekers but 'looking for contact with something which is connected with the sacred'.

Shils and Young argued that Queen Elizabeth II's coronation had enabled people to affirm moral values, notably 'generosity, charity, loyalty, justice in the distribution of opportunities and rewards, reasonable respect for authority, the dignity of the individual and his right to freedom'.[3] The sacred properties or charisma of the Crown strengthened the moral consensus prevailing in Britain:

> The monarchy is the one pervasive institution, standing above all others, which plays a part in a vital way comparable to the function of the medieval church...the function of integrating diverse elements into a whole by protecting and defining their autonomy.[4]

What is remarkable about these statements is that they came not from churchmen or monarchists but from two leftwards-leaning academic sociologists. Shils was Professor of Sociology at the University of Chicago and Young a former research secretary of the Labour Party. Both men were particularly struck by the morally cohesive effect produced by the actual form of the coronation ceremony: 'The Coronation Service itself is a series of ritual affirmations of the moral values necessary to a well-governed and good society. The key to the Coronation Service is the Queen's promise to abide by the moral standards of society.'[5] In addition to the oath, which they singled out as being especially important in this regard, the act of anointing and the investiture with the bracelets of sincerity and wisdom, the orb and the sword were also identified as being not just symbolic but transformative in bringing Queen and people 'into a great nation wide communion'.[6] 'The Coronation', they concluded, 'provided at one time and for practically the entire society such an intensive contact with the sacred that we believe we are justified in interpreting it as we have done in this essay, as a great act of national communion.'[7]

Fifty years on this language seems strangely dated and certainly not what one would expect from the ranks of *Guardian*-reading academic sociologists who are now more likely to espouse secular republicanism. Is it remotely possible, let alone desirable, for the next coronation to carry anything like this kind of metaphysical meaning and constitute a great national act of communion? We are a much more secular society now than we were in 1953 and significantly less touched by a sense of the sacred. Churchgoing has more than halved in the last half-century and where there is strong religious belief and

3. Shils and Young, 'The Meaning of the Coronation', p. 65.
4. Shils and Young, 'The Meaning of the Coronation', p. 79.
5. Shils and Young, 'The Meaning of the Coronation', p. 67.
6. Shils and Young, 'The Meaning of the Coronation', p. 71.
7. Shils and Young, 'The Meaning of the Coronation', p. 80.

observance now in Britain, it is as likely to be among new house churches and fellowships or among adherents to non-Christian faiths as within the traditional established churches. We are also a much more pluralistic and diverse society in terms of religious allegiance. There are now considerably more Muslims than Methodists within the United Kingdom, and more Sikhs than Baptists. On any Sunday morning there are also almost certainly more Roman Catholics in church than Anglicans in England or Presbyterians in Scotland. This state of affairs prompts two questions: can the country as a whole still collectively be touched in any meaningful way by an intensive contact with the sacred such as Shils and Young argued was achieved by the coronation of 1953, and can a future coronation be left to the Church of England to stage manage?

Two significant royal events in the last five years perhaps encourage a more positive answer to both these questions than might have been forthcoming ten years ago. It is clear that in their very different ways the funerals of Diana, Princess of Wales, in 1997 and Queen Elizabeth, the Queen Mother, in 2002 both touched the nation deeply. They also both had at their centre the traditional ritual and liturgy of the Church of England. The traditionalism of the Queen Mother's funeral, with the Croft setting of the burial sentences and the lessons from the Authorized Version, was more obvious. Yet Diana's funeral too had Croft and Purcell and 'The King of Love', 'Guide Me, O Thou Great Jehovah' and 'I Vow to Thee My Country' alongside Elton John's 'Candle in the Wind'. Watching video recordings of both these events what I find more striking than anything else is their deep Anglican traditionalism, reinforced by their settings in Westminster Abbey and St Paul's Cathedral respectively and their use of state ceremonial, gun carriages and military bearer parties.

It is true that the public mourning for Diana in particular also inspired other less official and traditional rituals, notably the piling up of flowers, candles and other votive offerings around the London palaces and parks. Even in this respect, however, the mourning rituals being acted out were essentially mediaeval rather than modern in character. The Queen Mother's lying-in-state in Westminster Hall evoked an even more mediaeval atmosphere, with the officers of the Life Guards standing at each corner of the catafalque, their plumed helmets bowed and their arms resting on their swords, looking for all the world like characters from illustrated children's books about ancient Arthurian chivalry and knightly virtues.

Important recent academic work has highlighted the significance of royal funerals. John Wolffe's book *Great Deaths* (Oxford: Oxford University Press, 2001) points to the 'religiosity of public grief' and the way in which the deaths of famous people, and particularly of royalty, continue to evoke a response that finds its popular expression in religious language and observance. It testifies to the Church of England's success in providing and managing funeral rituals for national figures and so sustaining and nurturing the nation's metaphysical

imagination. This is exactly what happened in the ceremonies that followed the Queen Mother's death. The extraordinarily powerful effect produced by her funeral and that of Diana, Princess of Wales, should make us pause before dismissing the contemporary impact of civil religion and mediaeval ritual stage managed by the established church.

Funerals are one thing, however. It is all very well to have highly traditional national ceremonies to express the sense of a nation in mourning, but can an essentially mediaeval coronation service really adequately convey the expectations and concerns of people looking forward to a new reign? In order to begin to answer this question, it is necessary to isolate the discrete and very disparate elements that go to make up the coronation service and explore the function and symbolism of each. There are essentially ten different elements in the coronation service—the recognition by the assembled congregation of their sovereign, the administration of the coronation oaths, the presenting of the Holy Bible, the anointing with holy oil, the investiture with the royal regalia, the putting on of the crown, the benediction, the enthronement, the homage and the celebration of the sacrament of Holy Communion in which the whole service is set. I propose to consider each in turn and to suggest how it might be adapted and changed to remain relevant and effective today.

1. The Recognition

The recognition derives from the days when there were disputed successions and it was important to establish popular acceptance of the person being presented for coronation as the legitimate and rightful ruler. It is worth retaining today and keeping as the opening element within the coronation service because it clearly expresses the monarch's relationship with the people and dependence on popular support as well as on divine grace. The recognition bears witness to the contractual or covenantal character of constitutional monarchy in the United Kingdom.

There is, perhaps, something to be said for prefacing the act of recognition at the next coronation with a preamble to be read out expressing the constitutional basis of the United Kingdom monarchy as resting on popular consent and existing to further the good governance of the realm. There is also surely an overwhelming case for ensuring that the recognition involves a much wider and more representative section of the population than has been the case in previous coronations. The 1953 coronation order speaks of 'The People' signifying 'by loud and repeated acclamations' their willingness and joy to do homage to their 'undoubted' monarch, who is presented to them by the Archbishop of Canterbury, Lord Chancellor, Lord Great Chamberlain, Lord High Constable and Earl Marshall. In reality, this act of recognition and affirmation has been restricted to the peers of the realm seated around the 'theatre' erected

in Westminster Abbey where the coronation takes place. At the next corona-
tion, the recognition should involve representatives of the House of Commons,
local government, the judiciary, armed forces and police and the governments
and legislatures of the Commonwealth.

2. The Coronation Oaths

This is the element of the coronation order which has been most changed over
the centuries, notably in 1689 when a new oath was framed requiring the
monarch to promise to maintain not just the laws of God and the true pro-
fession of the gospel but also 'the Protestant Reformed Religion established by
law'. This was further extended by an article in the 1707 Treaty of Union
between England and Scotland to include a promise 'to maintain and preserve
inviolably the settlement of the Church of England and the doctrine, worship
and government thereof'.

At the last coronation the Queen took three oaths. The first two covered the
principles governing the exercise of her rule and stipulated that it should be
according to the respective laws and customs of those countries over which
she ruled and so as to cause law and justice, in mercy, to be executed in all
judgments. There is much to be said for recasting and expanding these first
two oaths to embody a fuller expression of the fundamental principles on
which Britain is governed and the values which are seen to be at the heart of
the nation's life and well-being. In particular, there is a strong case for having
the monarch promise to maintain and defend the traditions of tolerance and
fairness which the Queen singled out in her Jubilee Address to Parliament in
May 2002 as being central to the character of the British people and nation. In
an age of mission statements, and in the absence of a written constitution, here
is a supreme chance for a solemn public declaration of the key core principles
and values not simply by which the nation is governed but through which it
defines itself.

The third oath taken at the last coronation bound the Queen to maintain
the laws of God and the true profession of the gospel and to maintain in the
United Kingdom the Protestant Reformed religion established by law. It also
required her to promise to maintain and preserve inviolably the settlement,
establishment and privileges of the Church of England 'as by law established'.
The first part of this oath raises interesting questions which have been taken
up in recent years by campaigning Christian groups. In March 1999 a petition
to the Queen was organized by Dr Clifford Denton, supported by Jesus is
Alive Ministries and the National Council for Christian Standards, who
declared themselves 'deeply concerned by the steady erosion of our historic
Christian faith and the surrender of the commanding heights of the country to
the advance of secular humanism and to a turning away from God'. It called

on the Queen to remember her coronation oath, which had been framed 'to ensure that Britain's people would be governed and led by the ways of Almighty God'.[8] The petitioners suggested that the Queen had broken the central part of the oath, where she had sworn that she would maintain the laws of God and the true profession of the gospel in the nation, by signing 'the law that legalised abortion, the law that liberalised censorship, laws which liberalised divorce and laws which have led to an escalation of gambling in the nation'.[9]

The petition drew this reply from the Home Office:

> I can assure you that the Coronation Oath is regarded as a solemn undertaking of the Sovereign which is binding throughout her reign. However in a constitutional monarchy such as we have in the United Kingdom, it is imperative that the Sovereign is politically impartial. The Queen therefore acts on the advice of Her Ministers, who would not wish to advise Her Majesty to sign into law any provision which contradicted the Oath. It follows that it is Government Ministers who are responsible to Parliament and the electorate for the matters to which your petition refers.[10]

Given the constitutional position outlined in this reply, is there actually any point in further sovereigns promising to maintain the laws of God? It may be that this particular phrase should be deleted from the coronation oaths, especially if there is a broader statement of principles by which the nation understands itself to be governed embodied in the first oath. Quite apart from the constitutional point raised in the Home Office reply, there is the further problem that no clear consensus exists among contemporary Christians as to the extent to which recent legislation in the areas mentioned in the petition is, in fact, contrary to the Word of God.

The second part of the third coronation oath, which binds the monarch very specifically to the defence of Protestantism, has already come in for a good deal of criticism and there have been widespread calls to change it so that the next monarch will promise to uphold the Christian faith as a whole rather than just its Protestant branch. David Hope, the Archbishop of York, has suggested that the phrase 'Protestant Reformed religion' should be changed in the oath to 'Christian religion' in order to end 'negative' attitudes to Roman Catholics.[11] As we have already noted, this part of the coronation oath has been changed more than once and it would be open to Parliament to amend the Coronation Oaths Act of 1689 to produce a more inclusive form of words.

8. *The Christian Standard* 5.2 (Summer 2000), p. 2.
9. *The Christian Standard* 5.2, p. 2.
10. *The Bulletin* (National Council for Christian Standards) 4.2 (Autumn/Winter 1999), p. 8.
11. *The Times*, 27 December 1999.

The question is how inclusive. Should the next coronation oath continue to favour Christianity over other religions? The report of the Commission on the future of multi-ethnic Britain set up by the Home Secretary, which was published in 2000, cited the coronation oath alongside daily prayers in the Westminster Parliament, the law of blasphemy and the Christian character of national memorial events as being discriminatory against other faiths. Is there a case for changing the wording of this part of the oath so that it reflects the monarch's resolve to stand for openness, tolerance and respect for all faiths as articulated in the Prince of Wales's remark that he would rather be known as Defender of Faith than Defender of the Faith? I suspect that there may well be, and that there would be nothing self-contradictory about such a commitment being embodied in an oath which was still concluded with the phrase 'so help me God' and followed by the presentation of the Holy Bible.

Such a promise would not be incompatible with the monarch remaining as supreme governor of the Church of England, a constitutional office which could be exercised in conjunction with the symbolic role of being Defender of Faith. Indeed, it would fit well with the notion of 'hospitable establishment' put forward by the Archbishop of Canterbury in his 2002 St George's Day address at Lambeth Palace and with the understanding of the established church, and the monarch, being charged with a particular responsibility to stand for and defend religious faith and the dimension of the spiritual and the sacred in general terms as well as being loyal to its Christian witness and tradition.

The rest of the third oath, which binds the monarch to 'maintain and preserve inviolably the settlement of the Church of England and the doctrine, worship, discipline and government thereof as by law established', clearly stands or falls on whether the Church of England remains established. That question is strictly speaking outwith the bounds of this article. I have myself argued elsewhere the case for a new form of re-establishment, ecumenical in nature, and possibly following the Scottish rather than the English model. There is now a welcome and lively debate on the merits or otherwise of church establishment. It will be good to see the fruits of this debate incorporated into the drafting of the next coronation oath.[12]

3. Presentation of the Holy Bible

This is a relatively recent innovation, having been introduced for the coronation of William and Mary in 1689. In another innovation, introduced in 1953,

12. I. Bradley, 'National churches that stand for communal values', *Guardian*, 15 October 1990; 'A force for gentleness in national life', *Church Times*, 16 July 1993; *Marching to the Promised Land: Has the Church a Future?* (London: John Murray, 1992), pp. 22-23, 32, 212-17. See also P. Avis, *Church, State and Establishment* (London: SPCK, 2001).

At coffee
Loving everyone
He died juggling for everyone... He loved the world and things he juggled,
He loved the people he juggled for.[24]

Rastelli is revered as a juggler whose 'clubs and flames and hoops / Moved around him like planets...' He did not need to manipulate objects to answer to his will; rather, '[h]e moved all things according to their natures: / They were ready when he found them / But he moved them according to their love'. The poem highlights the way that Rastelli recognized his place in the world, how it led him to see himself as a part of creation, and how this reflects the Creator, discovering that grace is both reciprocal and cyclical:

Seeing the world was willing to dance,
Rastelli fell in love with creation,
Through the creation with the Creator,
And through the Creator again with creation,
And through the creation, the Lord.[25]

The closing poem to the sequence reflects upon the components of a circus, as it asks the reader to consider the effects of when the circus begins and ends. The poem suggests that the notions of what it means to be human that are held by those involved in the circus as well as those who witness the circus are not left unchallenged. The sequence itself, in its depiction of the circus as a fluid paradigm for living in, with and through grace—may cause the reader's notions of grace, sacred/secular, human/divine, natural/supernatural—to be moved. This recognition reflects postmodern a/theologian Mark C. Taylor's claim regarding carnivalesque play:

By upsetting traditional hierarchies, carnivalesque play inverts inherited values andestablished meanings This inversion does not leave opposites unmarked. The reversal enacted in festive celebration dissolves the original identity of the exclusive opposites that have defined the poles of most Western theology and have formed the foundation of Western society and culture.[26]

The sequence of poems depicts a wide variety of circus characters, using various talents to give glory to God, and, in turn, to give joy and

24. Lax, 'The Circus of the Sun', in *Love Had a Compass*, pp. 90-91.
25. Lax, 'The Circus of the Sun', in *Love Had a Compass*, pp. 90-91.
26. Mark C. Taylor, *Erring: A Postmodern A/Theology* (Chicago: University of Chicago Press, 1984), p. 161.

fulfillment to the audience and themselves. This interplay of grace and ethics is revealed through the depiction of a world that is structured around play and entertainment, skill and risk. The circus does not contain the hierarchies of a capitalist society, where money and power determine human relations. The characters in the sequence and the readers themselves are left to consider:

> Have you known such a thing?
> That men and animals
> Light and air,
> Graceful acrobats,
> And musicians
> Could come together
> In a single place...[27]

This place of community is likened to a 'wedding' as the sequence concludes in a dialogic, inclusive fashion; the persona asks the reader a question which involves them in the text of the poem in a more overt fashion. This question can also push the reader to consider if they have witnessed such an event as the circus, and the celebratory atmosphere it encourages: 'Have you seen the noon-day banners / Of this wedding?' Lax's circus conveys that relations between human beings that are not dominant and an economy based on grace and ethics is possible to attain in contemporary society.[28] In addition to figuring ethical action in relation to grace, Lax's body of work, like that of Merton, addresses the pressing moral and religious issues and dilemmas of our time.

Resituating the Self: Lax's Introspective Poems

Lax and Merton seek to redefine the self, moving away from the autonomous subject, to the religiously centered, ethical subject. Though Christian faith is often viewed to be the antithesis of postmodernity, it is actually quite consistent with the state of living with ambivalence, the intellectual and volitional demands of negative capability, and a hermeneutics of suspicion and desire. According to Merton, modern civilization is heralding

27. Lax, 'The Circus of the Sun', in *Love Had a Compass*, p. 94.

28. See works by another contemporary author who conveys a similar sentiment: Wendell Berry, poet and recipient of a 1999 Thomas Merton Center Award (presented at Duquesne Univeristy in Pittsburgh, Pennsylvania). Berry encourages readers to envision a society where the environment and responsibility for the Other are concerns that affect the way people plan, grow and live. Berry's verse gives an ecological vision to grace, where a grace economy replaces the cash nexus of capitalist society. His poetry, like that of Lax, illustrates how such a world is possible.

the reign of individualism, where there is an 'abuse of subjectivism—
imprisoned in ourselves we become paralyzed'. The resolution, Merton
asserts, to such individualism is 'faith'.[29] Lax's work, reflective of many
contemporary religious thinkers including Merton, locates a selfhood that
is realizable when God and the human Other are privileged and priori-
tized. In a tribute poem on Merton, Lax wrote: 'the closer he came to
knowing God, the closer he / came / to knowing himself, his true self...'[30]
This realization is a common theme in the writings of both men of faith.

Identifying a notion of subjectivity in conjunction with the affirmation
of God may seem to be incompatible with contemporary theories. In the
period many define as postmodern, notions of truth, metanarratives, and
Western concepts of man, God, male, female, nature, time, the autono-
mous individual, are being problematized. Primarily a phenomenon of
Western culture, postmodernism has resulted in the refutation of the
claim that truth is universal, transcultural and ahistorical. Postmodern
discourse is influenced by such thinkers as Nietzsche (who declared for
the twentieth century that 'God is dead'), Freud (who decentered the
individual), Marx (who decentered history), and Saussure (who decen-
tered language); consequently, for thinkers of the twenty-first century,
truth has been destabilized. As contemporary thinkers informed by
twentieth-century figures such as Derrida, Lacan and Saussure, 'we can
no longer understand the signifier to be preceded by an anterior truth...
the presence of a signified whose existence ultimately necessitates a
transcendental signified (God, Man, the Mind, etc.) to which all truths
can be referred'.[31] Indeed, deconstruction will no longer allow the as-
sumption that God is a given. Notions of God, as with any conceptual-
ization, are necessarily culturally and discursively relative. Therefore,
the God that Nietzsche pronounced 'dead', according to Merton, never
was 'alive' in the first place. In his foreword to a modern interpretation
of a medieval mystical treatise, *The Cloud of Unknowing*, Merton addres-
ses the 'furor about the "death of God"':

> God was never 'out there' or 'up there' or anywhere in a particular place.
> In fact anyone who is acquainted with theological tradition is well aware
> that the God who has supposedly died in the minds of these new men is

29. Thomas Merton, *Contemplative Prayer* (New York: Doubleday, 1996), p. 40.
30. Lax, 'Harpo's Progress', p. 39.
31. Jacques Derrida, 'Difference', in *Speech and Phenomena, and other Essays on
Husserl's Theory of Signs* (trans. David B. Allison; Evanston, IL: Northwestern Univer-
sity Press, 1973), p. 49.

a god who never lived in the first place. Like the god demolished by athe-
ism, he is a shadow and a contradiction.[32]

Throughout his poetry written while in self-exile in Greece, Lax
locates an in/direct dialogue with God — be it through an experience that
is of dimensions that are mystical, contemplative, praise or prayer — as a
source for the nourishment of the faith and the ethical response to the
human Other. His poetry articulates a faith exploration that reflects
Merton's mystical and ethical sensibilities: (1) poetics of unknowing;
(2) internal dialogue: resituating the self through finding the self in the
divine Other; through engaging in prayer and praise.[33]

Lax's prolific writings from the last few decades of his life (which are
stored at the Lax archives of St Bonaventure University) acutely convey
his passion for searching for the holy in all things, including the self, as
Lax locates God as the source of the realization of selfhood and of the
call of that self to responsibility for the Other and the world. Such a posi-
tion disallows the claim that there is *nothing but* culturally constructed
frameworks in human experience. Lax's poetry provides resituations of
notions of the self that locate faith, the spirit and encounters with God as
real-life experiences and perceptions that transcend cultural, historical
circumstances, while, paradoxically, remaining wholly immanent within
human experience.

Contemporary theologians and religious thinkers examine all dimen-
sions of human experience for yearnings and expressions of religious
faith. And, reflective of spirituality in the contemporary American cul-
ture, they do so in a manner that appreciates more subjective experiences
of the divine. The contemporary skepticism towards the grand narrative,
and its heightened appreciation for ambiguity, pluralism, dialogue and
community, contribute to a valuing of more subjective experiences of
religious faith, as well as an openness to the wisdom of other religious
traditions, and a recognition of the pluralistic nature of one's own reli-
gious tradition. The religious faith that is explored in much contempo-
rary American poetry reflects these concerns while it hesitates to use
tropes of the past that tend to be dogmatic, didactic, and presuppose a
narrative background of traditional religious expression. Such religious
thought that explores the nourishment of religious faith is not the
antithesis to ethical response. The ethics and faith which both Lax and

32. Thomas Merton, foreword to *The Mysticism of the Cloud of Unknowing: A Modern
Interpretation by William Johnston* (St Meinrad, IN: Abbey Publications, 1975), p. x.

33. I presented a version of this section on 'Poetics of Unknowing' at Rivier Col-
lege's *Thomas Merton and Dorothy Day Symposium* (April 1998, Nashua, New Hamp-
shire).

Merton embody and convey are reflective of contemporary resituations of notions of self, language, meaning and truth that have given way to the resurfacing of topics such as faith, religion, mysticism, contemplation and prayer in ways that privilege the *Other* as opposed to the self.

Merton and Lax acknowledged in their work and lives how contemporary perspectives can provide productive critiques and revisionings of Christian thinking. However, they both defend their Christian faith against those assumptions prevalent within strains of contemporary philosophies that discredit and/or disregard Christianity. They both defend Christianity against the view that the role of religion in society as a cultural institution is one which determines, coerces and controls the subject and the subject's behavior, identifying the church, evangelism and witnessing as the apparatus by which the subjects conform. However, both Merton and Lax would agree that contemporary theories have been profoundly significant for ethical conversations in its recognition of the cultural, historical, material circumstances that determine individuals and communities within a society. However, their lives and work reveal that dominant strains of Marxist, feminist and post-structuralist thought neglect or reject the true value of religious traditions, finding that religion is merely an 'opium of the people' (Marx), that Christianity merely serves to maintain the oppression of women and other culturally subordinated peoples, and that the very idea of a realizable self (in and through relation with God) that religious traditions insist upon is completely illusional.

Contemporary religious thinkers such as Merton and Lax, and liberation theologians, such as Gustavo Guitierrez, Rosemary Radford Reuther and Juan Luis Segundo, have been influenced by Marxist thought in particular, as it recognizes the pervasive and determining effects an environment has in the constructedness of a human subject. However, in contrast to much Marxist thought, these religious thinkers locate the 'Spirit' — which is a presence of the divine Other in human experience that both transcends and infuses human experience — as that which mediates between the human and the world, which assists that human in discerning between the just and the unjust, the true and the false, the spirit-centered and the self-centered. This reliance upon the Spirit (prominent among liberation theologians) for guidance and discernment in the world does not suggest that faith does not confront uncertainties, ambiguities and paradoxes; for, according to Christian belief, human life on earth can only see through a 'glass darkly'.

Some of the most significant religious thinkers of the twentieth century have opened up more direct ethical conversations in Christian thought (while responding to such philosophies as the death of God), by

locating religious faith as a source for the realization of selfhood. Many religious thinkers, particularly from Judeo-Christian traditions, refute the prominent notion of the self as merely a matrix of ideological and social constructs. It is important to recognize that a location of self-actualization within the encounter with the human and the divine does not suggest individualism, isolation or a self in opposition to the world or to the Other or to community.

In prayer, contemplation and meditation, as Merton asserts in his final testament, *Contemplative Prayer*, the person should not earnestly seek a method or style, but should 'cultivate an "attitude", an "outlook": faith, openness, attention, reverence, expectation, supplication, trust, joy'. It is in such a state humans know God in 'unknowing', and realize their selves fully, truly in God. This encounter with God, which is certainly not a sporadic or rare occurance, is available to the human subject: this 'kind of dialogue', Merton claims, 'brings us deeper and deeper into the conviction that God is our all'[34]. All forms of prayer, reading, meditation (*lectio, meditatio, contemplatio*), and all activities in the world that result in a spiritual life 'are aimed at *purity of heart*, an unconditional and totally humble surrender to God, a total acceptance of ourselves and of our situation as willed by him'. Purity of heart, Merton continues, 'means the renunciation of all deluded images of ourselves, all exaggerated estimates of our own capacities, in order to obey God's will as it comes to us in the difficult demands of life in its exacting truth'.[35]

Lax's poetry implicitly problematizes the claims of religion merely being an 'opium of the people', that any notion of an authentic self is an illusion, and that all human experiences or personal beliefs are exclusively historically and ideologically determined. Indeed, religion can become merely an 'opium of the people'; however, religious experience and religious communities *need not necessarily be* a controlling, manipulative force that maintains the status quo and confines and conforms subjects. Contemporary religious poetry provides a space to wrestle with notions of the self in ways that help to dislodge the humanist notion of an autonomous self from our Western minds, allowing for the resituation of notions of the self that prioritize the Other.

As the Spirit is being embraced by liberation theologians and is resurfacing in contemporary discussions of theology and ethics, other sources of 'knowing' in the world are being identified and valued by apophatic, negative theologians (such as Merton) at a time that is often characterized as indeterminate and uncertain. The mystical practices that are

34. Merton, *Contemplative Prayer*, p. 35.
35. Merton, *Contemplative Prayer*, p. 68.

being revalued in contemporary societies, combined with the resurfacing of mystical treatises and writings particularly throughout the Western world, and the insights of contemporary theologians, locate a dimension of human experience that urges thinkers to move beyond the self, to notions of the Other and God in ways that surpass reason and logic.

The Mystical Dimension: Poetics of Unknowing

As the humanist notion of the subject has been displaced in contemporary theories, as a human being is no longer assumed to be the source and center of meaning and knowing, such disruptions have opened up the return of, or newly arrived at understandings of, knowledge, logic, reason and their limitations. Post-structuralist theories have exposed the falsehood of the notion of 'mastery' of knowledge of a subject, of arrival at indisputable certainties in studies presumed to be exact sciences. Such recognitions of the limits of knowledge in all disciplines and life experiences, and the inadequacy of reason and logic, and cause and effect rationale, have opened up a space for the return of or the renewed manifestation of other forms of 'knowing' (such as what is referred to in the apophatic tradition as 'unknowing'). 'Unknowing', or forms of knowing within negative theology, recognize that there are limits to human knowledge, and that any attempt to arrive at certainty or possess the ultimate knowledge of the divine will fail; the most authentic knowing of the divine is in 'unknowing', according to the tradition of negative theology that is present in all religions in their dimensions of mysticism that have historically been received either as religious expressions, experiences which range from the only true authentic encounter, or as orthodox, alternative, or even threatening to the status of the church and the status quo.

Though mysticism has always been a part of religious traditions, it has had a resurgence in the Western world in the twentieth century and up to the present. Perhaps it is due to its insistence on the essence of the divine as unknowable, and to its location of a space that transcends individuals, differences and language itself; or, in other words, due to its application of negative theology, and its emphasis upon unity and a space that transcends differences, as opposed to discrimination, marginalization and categorization. Since mysticism focuses on one individual's union with the divine, and affirms the essentially unknowable and unnameable condition of the divine (the basic premise of negative theology), this religious experience moves beyond language, theories and practices. The fifth- or sixth-century philosopher Pseudo-Dionysius, who is the basic source of Western mysticism, claims, 'Indeed the inscrutable One is out of the reach of every rational process'. *The Cloud of Unknowing,*

a treatise on mystical prayer by an anonymous English monk of the late fourteenth century, is the foundational treatise on the practice of un-knowing in the Western tradition.[36] *The Cloud of Unknowing* author writes: 'So set yourself to rest in this darkness as long as you can, always crying out after him whom you love. For if you are to experience him or to see him at all, insofar as it is possible here, it must always be in this cloud…' In fact, for Merton, as he states in his foreword to a modern interpretation of *The Cloud of Unknowing*, 'the "knowing" of God in "un-knowing", far from being unreal and uncertain, possesses the highest reality and certainty of any experience accessible to man'. An under-standing crucial to negative theology includes the ineffability of mystical experience, as well as the condition of the ultimately unthematizable, unnameable divine. This basic condition Pseudo-Dionysius addresses throughout his corpus: 'Nor can any words come up to the inexpressible Good, this One, this Source of all unity, this supra-existent Being. Mind beyond Mind, word beyond speech, it is gathered up by no discourse, by no intuition, by no name' (1.1). According to Pseudo-Dionysius, God must be given all names, and must also be denied all names; therefore, naming God must involve affirmation and negation, where the negation serves to acknowledge that the Divine is unknowable, incomprehensible, unnameable.

The contemporary climate that values more subjective religious experi-ences embraces such practices as mysticism. However, all too often mys-tical practices are viewed to be or constructed in a way that is in opposi-tion to ethical action; when, on the contrary, many mystical theologians (including Martin Buber, Thomas Keating and Thomas Merton) will attest that mysticism aims to unify living beings, and values the individual lives of people, as manifestations of divine love and peace. Moreover, Eastern and Western mystics alike will contend that the true root and true re-sponse of mystical practice is love or care for one's neighbor through responsible treatment of the other. Mysticism has become significant in much contemporary discourse (including theology and philosophy), due to its negative theological principles which parallel the Keatsian notion of negative capability.

Mystical poetry acknowledges the limits of knowledge and reason to obtain certainty of the divine, embraces otherwise than knowing or

36. The author of *The Cloud of Unknowing* was quite familiar with Dionysius's works; he translated *The Mystical Theology*, and utilizes the Dionysian concept of the 'unknowing' and Dionysian negative theology within his treatise on centered prayer. The edition cited in this study *The Cloud of Unknowing* (preface Simon Tugwell, OP; The Classics of Western Spirituality; Ramsey, NJ: Paulist Press, 1981).

'unknowing', the Spirit, and prayer as sources of knowing, and utilizes negative theology as God is named and unnamed, and concepts of the Holy are affirmed and negated. I find a poetics of unknowing to be more pervasive in twentieth-century poetry than the mystical verse of any other literary period, increasing in prevalence in recent decades. Contemporary American poets John Berryman, Robert Lax, Denise Levertov and Anne Sexton all provide examples of poets who utilize a poetics that affirms and negates notions of the divine, regarding 'unknowing' as the most authentic form of knowing that human beings are capable of having in this life. In the sparse amount of criticism on twentieth-century mystical verse, little attention has been given to the postmodern significance of a poetics of 'unknowing' that is prevalent in much contemporary religious poetry—Christian or otherwise.

Mystical tropes of an 'unknowing' nature—or, what I refer to as a poetics of unknowing—has become widespread in contemporary religious poetry. The mystical writing that has been most thoroughly studied and discussed in literary criticism is that of the medieval period. Indeed, the medieval period is widely known for its prolific mystical writers. The lyric or religious verse writings of the medieval period reflect the pervasively religious culture of the time; I would characterize this mystical verse as more of 'knowing' mysticism, which presupposes a narrative background in the doctrine and dogma of the Christian religion. Most medieval mystical lyrics based upon the doctrine of Christianity are of a more 'knowing' nature, invoking imagery of Christ or of significant biblical figures. This content encourages a 'knowing' of God, through reflection on what has been revealed to humanity through Christ and the scriptures. Because these lyrics are mystical—in that the experience of union with the divine is in itself ineffable—the effect of a mystical lyric, inevitably, is of an 'unknowing' nature—a 'knowing' that surpasses reason and intuition. Yet, medieval mystical lyrics tend to ground this unknowing in texts that privilege the 'knowing' of an agreed upon narrative.

In *The Cloud of Unknowing* treatise, the author dwells upon the belief central to Pseudo-Dionysian theology: 'God is ultimately and essentially incomprehensible to the human mind and that if we want to "know" God in this life, we must divest ourselves of all our ideas about the reality that we call "God"'.[37] The thrust of this prayer treatise is a practice of negative capability: every name, mental image, and concept that is affirmed of God is also negated, as it emphasizes that the divine is

37. Karen Armstrong, *Visions of God: Four Medieval Mystics and their Writings* (New York: Bantam, 1994), p. 52.

ultimately unthematizable. This medieval prayer treatise that is becom-
ing more widely known in contemporary circles embodies negative
theological impulses which I find serve as a model for a 'poetics of
unknowing'.

The mystical writings — particularly the treatises that embody a negative
theology — of medieval thinkers are 'reflowering' in the contemporary
climate, due to such contributions as those of Merton. This reflowering
of a spirituality that embraces negative theology reinforces the more
subjective and transrational spiritual pilgrimages that individuals are
seeking in postmodern times, times which resemble the reflowering of
mysticism in other periods throughout history (such as the late Middle
Ages). As Karen Armstrong argues, 'the author of *The Cloud of Unknow-
ing* gives a much more honest, humble, and thought-provoking answer
to the question, "What is God?" He simply replies that he hasn't the
faintest idea'.[38] *The Cloud of Unknowing* author, through his treatise on
'centered' prayer, leads the reader 'to the apex of all love, in God', and
instructs the reader on how to approach an inexplainable union, a
momentary connection with God. A practice or a poetics of 'unknowing',
therefore, insists upon faith rather than reason. Faith, as a transrational
understanding or conviction, is confidently affirmed, while human rea-
son is thoroughly negated. *The Cloud of Unknowing* author 'can be read as
teaching us all something of what it means to take God seriously', ac-
cording to Simon Tugwell, a scholar on the book. He continues, 'And
one of the first things is that we must take our own pious practices much
less seriously. This is because, strictly speaking, there are absolutely no
"means" by which to "get God". It is God who stirs our will to himself,
"without means either on his side or on thine". No "means" can bring us
to this point; "all good means depend on it, and it on no mean". "Mean
unto God get thee none but God" '.[39]

Practices (including poetry) that are mystical acknowledge the limits
of knowledge and reason to obtain certainty of the divine, embrace other-
wise than knowing or 'unknowing', the Spirit, and prayer as sources of
knowing, and utilize negative theology as God is named and unnamed,
and concepts of the Holy Other are affirmed and negated. '[W]hen it
comes to communicating some of the delights of contemplation', Merton
claims, 'the poet is, of all men, the one who is least at a loss for a means

38. Karen Armstrong, *Visions of God*, p. 50.
39. Simon Tugwell, *Ways of Imperfection* (Springfield, IL: Templegate Press, 1985),
pp. 182-83.

to express what is essentially inexpressible'.[40] Just as *The Cloud of Un-knowing* author through his treatise on 'centered' prayer, leads the reader 'to the apex of all love, in God', and instructs the reader on how to approach an inexplainable union, a momentary connection with God, the mystical poem has these preparatory capacities as well. The type of poem that fulfills this role, what I refer to as 'poetry of unknowing', prepares a state of mind that is appropriate for a person who is seeking to 'reach out' to the Divine, to enter into the 'cloud of unknowing'. A poetics of 'unknowing' (a description that I derive from Dionysian negative theology) is appropriately paradoxical: poetry of unknowing uses what is known to get at the unknown, and acknowledges that the unknown cannot be known. The joint effect of these paradoxical conditions, which reflects the methodology of the meditative process described in *The Cloud of Unknowing*, can provide the reader with a 'centered' contemplation, a heightened appeal to the senses and emotions (as opposed to the intellect), a preparatory phase for attaining the proper state of humility and restraint, a 'forgetting' of one's self, sin, and the world, and, ultimately, an experience of the 'love' expressed in the mystical poem.

A poetics of unknowing involves various literary techniques that enable the poet to fulfill conditions of affirmation and negation. Lax, like fellow contemporary American religious poet Denise Levertov, frequently utilizes a poetics of unknowing in his mystical verse. Utilizing a poetics of ambiguity, plural text, open form and free verse, Lax conveys a spirituality that has postmodern sensibilities. While his poetry is affirmative of faith, it resists absolute truth claims and refrains from arriving at certaintites or monistic visions. His poetry features *both* obligations to the affirmation and the negation of a divine Other. In other words, as Pseudo-Dionysius argues, the divine must be given all names, and must also be denied all names; and so, poetics of 'unknowing' results when the poet uses what is known in order to give an understanding of the unknown, while, at the same time, acknowledging that the divine, is unknowable, incomprehensible, unnameable. While some of the features of the two conditions overlap, and some may be similar, as I describe it, the first condition primarily serves an affirmative role, while the second serves as a negation.

Mystical poetry throughout literary history names God in affirmative and negative ways. The names that poets tend to draw upon in their mystical verse throughout literary periods reflects a negative theology which in the Western tradition is rooted in the work of Pseudo-Diony-

40. Thomas Merton, 'Poetry and the Contemplative Life', *Commonweal* 44 (July 1947), pp. 281-86 (286).

sius. Negative theological ways of naming God are prevalent in much
contemporary religious poetry as well, though the poetic forms may be
less traditional than the names they articulate. In the affirmative condi-
tion, the names traditionally designated for God, according to Pseudo-
Dionysius's negative theology, are the following: scriptural names (such
as Power, Righteousness, Salvation, Redemption, names of greatness and
smallness, King of Kings, Lord of Lords, God of gods, Holy of Holies),
'all the affirmations we make in regard to beings' (therefore, a multiplic-
ity of names), the names of his effects (since God is known through his
effects: good, light, beautiful, love, ecstasy, zeal), unified names of the
entire Godhead (One, Good), names with a Causal sense (Creator), names
of three persons (expressing distinctions of Father, Son, Spirit), names of
the Son as incarnate, 'participated' terms (such as Wisdom, Life, Being),
and conceptual names of God (attributes such as Beauty and Love).
Dionysius's list of names moves from the general to particular: he begins
with Good (which pre-contains affirmation and negation, for the general
contains Being and Non-Being), then Being, Life, Intelligence, Omnipo-
tence; the particular names he gives God are combinations of great and
small names (concepts of God manifested in all activities, not limited to
scriptural names or those attributes normally associated with God, such
as 'Worm'), and sensible objects in the world. In addition, Dionysius
designates 'Ancient of Days', and 'New' as names that convey the notion
of the primacy of God's being, which reveals that 'he goes forth from the
beginning of the world through all things until the very end'.[41] Thus,
Dionysius states, 'in those sacred revelations of himself during mystical
visions he is depicted as ancient and new'.[42]

While, in the negative condition, all the names of God, according to
Dionysius's negative theology, must be denied of God, because God is
above understanding, is above naming; God is not any of his effects. To
suggest this, God must be either not named, or, when he is named, the
names that refer to God must acknowledge that he surpasses any con-
cept by having a negation implicit within them (such as names that
begin with the prefix 'hyper' and 'super'). There are two privileged
names Dionysius does isolate as names of God that are not negated —
Good and One. Good and One are the only privileged names for Diony-
sius, for goodness is the effect of God that includes all other effects. In
other words, 'Good' is the one name which reveals all the emanations,
processions of God. And, however diverse his effects are, there is a uni-
fied 'One' that is indivisible; it is existence alone and has no essence. In

41. Pseudo-Dionysius, 1.1-8.
42. Pseudo-Dionysius, 10.2.

addition, names that include the word 'itself' (such as Life-itself, Being-itself) which are affirmations of God, contain within the name an acknowledgment of his surpassing these concepts; they are participated terms that resist essentializing God.

These two conditions of the poetics of unknowing appeal to the senses and emotions, as opposed to the intellect, though the experience of unknowing, according to Pseudo-Dionysius and *The Cloud of Unknowing* author, begins at the volitional level — the 'will' — which is characterized as not located at the level of the senses and emotions; furthermore, the cloud of 'forgetting' of the self and the world results in the ultimate 'divine ecstasy' in which human love is united with the 'yearning' of God. Pseudo-Dionysius finds (though he affirms and negates this as well) that 'yearning' draws God away from his transcendence, and this produces an answering ecstasy in humans. This is the end of the process: a union superior to understanding. Like Pseudo-Dionysius, *The Cloud of Unknowing* author finds this last step to be not one of intellect or the physical, but of 'love' on both sides. Therefore, it is 'love' alone that penetrates the Cloud of Unknowing. In consideration of this, in order for poetry to be a preparatory 'unknowing', as I describe it, there has to be one constant that is not negated (for it is not an understanding, is not comprehensible): the poetry of unknowing must result in an expression of love, in reverence and awe. This joint endeavor that both affirms and negates notions of God creates an effect of centered contemplation. A poetics of unknowing in contemporary mystical poetry, particularly that of Lax, embodies postmodern sensibilities: deprivileging logic, reason and rationality; privileging contemplation, ambiguity, paradox, mystery and other 'marginalized' ways of knowing.

The very form of Lax's verse is appropriate for its meditative, mystical content. His verse is centered columns of short lines, some lines containing only a syllable or a word or letters. As contemporary American Language poet Susan Howe describes, Lax's poems 'seem one mystical whole... So many people can't pull off the simple one word line down the page, but [Lax] manage[s] to make it vibrate and sing, and fill with wind like a sail'.[43] Lax's 'simple' approach is an appropriate one. Dionysius explains that God is simple, meaning that he cannot be broken down into parts. An entity which is complex is made up of many parts; whereas, God is not: he is complete, unified. Therefore, Lax's text suggests that to aim at eloquence would presume that a level of intellect or a concern for ornamentation was necessary in order to address God, when

43. From Susan Howe and Robert Lax correspondence (1983), Lax archives, St Bonaventure University.

Pseudo-Dionysius and *The Cloud of Unkowing* author would insist that this is not so.

Lax's verse which is ever searching, ever desiring, ever yearning for God, reflects *The Cloud of Unkowing* treatise and Pseudo-Dionysian line of thought, because 'love' itself was not something either could explain, it could only be felt, or experienced through one's will, which cannot be forced or caused; for, in the words of *The Cloud of Unkowing* author, they are a natural reaction to the impulse caused by the 'Yearning', which results in such a human reaction as a 'tear'. According to *The Cloud of Unknowing* author, someone new to the experience of 'the cloud of unknowing' will at first be in 'darkness', and it is only when the person has responded to the impulse of the 'Yearning' that he will experience love for God. *The Cloud of Unknowing* author emphasizes that the yearning that brings the person into union with God is a 'sudden impulse', and that the 'fall' out of the cloud of unknowing, out of the centered prayer, will be just as sudden. In *21 Pages, The Hill, Dialogues, Notes* and *Psalm*, Lax depicts the inability of a person to stay focused, to maintain meditation.[44] The inability to remain centered is described by *The Cloud of Unkowing* author. In order to attempt to overcome falling out of centered prayer, *The Cloud of Unkowing* author explains, a 'cloud of forgetting' is necessary to achieve for the entrance into the cloud of unknowing; this cloud of forgetting is an erasure of one's awareness of all circumstances and beings.[45]

Lax uses this common postmodern poetic of interrogative text in his poem 'what's God'.[46] Lax's interrogative text serves as a poetics of 'forgetting' in its defamiliarization of notions of God, the Unknowable. Though, he uses questioning in his poem in order to celebrate the unknown as he playfully conveys his confidence in the power and presence of God.

Lax opens his minimalist verse with the question: 'what's God / gonna do / this after / noon / ?' The question is broken into several short lines forming a column, and additional space is left with the blank lines in the text, creating an effect which values simplicity. Also, the space on the page contributes to an effect of negation, through the absence of words. The speaker does not attempt to provide any clear or precise answer to the opening question, rather, he allows his answer to explore further the

44. Robert Lax, *21 Pages* (Zürich: Pendo Verlag, 1984); *idem, The Hill* (ed. Paula Diaw; Zürich: Pendo Verlag, 1999); *idem, Dialogues* (Zürich: Pendo Verlag, 1994); *idem, Notes* (Zürich: Pendo Verlag, 1975); *idem, Psalm* (Zürich: Pendo Verlag, 1991).

45. *The Cloud of Unkowing*, p. 128.

46. In *A Thing That Is* (ed. Paul J. Spaeth; New York: New York Press, 1997), p. 40.

unknown. The speaker characterizes God as one who is 'unmoved', who will 'move / something'. The speaker continues to ponder the actions of God, emphasizing that 'he'll move…every / thing'. The speaker's declarations are ambiguous and suggestive, rather than definitive and final. He suggests that God will move everything

 in
 a special
 way
 always the same ways,
 but always
 with a dif
 ference
 some dif
 ference
 some where[….]

This apparent contradiction of God's actions being described as both same and different fulfills in these lines an affirmation and a negation. Naming God's actions as 'same' and 'different' has significant implications in Dionysian negative theology: according to Dionysius, 'God is transcendently, eternally, unalterably, and invariably the "same"'. For, in 'him there is no change, decline, deterioration, or variation'. However, Dionysius claims, ' "difference", too is ascribed to God since he is providentially available to all things and becomes all things in all for the salvation of them all… "Difference" means that the many visions of God differ in appearance from one another and this difference must be understood to indicate something other than what was outwardly manifested'.[47]

Lax concludes his expression of curiosity in this poem by again addressing the reader with the same colloquial diction he uses throughout. But, rather than addressing the reader with a question as he did in the opening, the speaker ends with the suggestion to the reader that encourages anticipation and awe:

 wait till
 you see.

Lax's poem has features that create a subtle centering and a symmetry through the visual column that is formed, and through the rhythm, internal rhyme, repetition and alliteration. Its ambiguity and lack of definition and detail reflects the content of the poem: Lax's poem can be explored in limitless ways, just as his verse suggests of God. The poem

47. Dionysius (9.5) in *The Divine Names*, p. 116.

symbolically begins with the bold two-word line 'what's God' and concludes with an undetermined two-word answer 'you see'.

'One of the chief problems of mystical theology', Thomas Merton asserts, 'is to account for a loving, unitive and supernatural love of God that is beyond concepts, and to do so in language that does not in one way or other become completely misleading. The mystical theologian faces the problem of saying what cannot really be said'.[48] And, indeed, this is also true for the poet. Therefore, 'poetry of unknowing', that both affirms and negates notions of God, recognizes in its negation that its own act will fail, its own efforts are futile to name God and/or to transcribe a mystical experience. Lax conveys this, as he fills volumes of notebooks in an archive with his attempts, as he tries and fails theologically, and yet poetically succeeds.

Internal Dialogue: Resituating the Self

In the thought of Merton as well as Lax the self is not understood as an autonomous, isolated subject, nor is God understood as an object apart from humanity and the world. Lax's verse situates God within the self, where the search for self-fulfillment and the search for God are conflated, disrupting traditional dichotomies within Western religious thought. The intimate dialogues with God in Lax's poetry that are conveyed problematize prevalent notions of the self, prayer and faith that are harmful to an individual or community through thwarting human desires and through misleading believers with the misconception that prayer has no relevance to true ethical action.

Lax shares the assumption common among twentieth-century theologians and religious thinkers, including Merton, that a human being has the a priori capacity to seek and receive a relation with God, where the self is realizable in the union with God; and, also reflective of contemporary thought, they qualify that the full self cannot be known until one is fully united with God in the afterlife. Such an understanding of the self found in and through God reflects twentieth-century Catholic theologian Karl Rahner, as well as Merton, as they locate God as the source and fulfillment of selfhood. The poetry characterized by its internal dialogue with God can be described, in the words of Lax, as a 'readiness to recognize' God; 'that's all' we 'bring to the encounter'.[49] Such an encounter between an individual with God reflects the shift that has taken place within the American religious climate toward more subjective experi-

48. Merton, foreword to *The Mysticism*, p. 16.
49. Lax, *21 Pages*.

ences of the divine, relying less upon the confirmation of tradition, doctrine, and sanctioned rituals.

In works such as *21 Pages, The Hill, Dialogues, Notes* and *Psalm,* Lax locates an internal dialogue with God as a source for the nourishment of the faith and the ethical response to the human other.[50] Much of Lax's verse is meditative, as it finds the self in God and finds God in the self, as his persona engages in an internal dialogue. This resituation of the self is poignantly illustrated in Lax's metaphor for the self — the 'celery stalk' growing toward the light:

> Sometimes I think it's like celery stalks growing in
> darkness. Stalks reaching up toward the light. My
> waiting for you is like a plant that grows up toward
> the light. Doesn't veer from its path. No wind can
> turn it. I wait & am aware of waiting.[51]

Lax's book-length sequence of prose poetry *21 Pages* contains postmodern theological impulses in its search of self in God and search for God in the self. The text is fragmented, open, predominantly interrogative, is self-conscious, self-reflexive, confessional, spontaneous, organic and personal. The persona throughout the text refers to the process of meditation and of recording meditative verse, including attempts to focus, to silence the mind and to be physically still while meditating. The reader is made ever aware of the process of constructing the poem, as the author persona intrudes with such declarations as 'I ought to be able to say it better than that. But how? By not trying? I'll try not to try. I'll try to say it the way it is, the way I see it. But I won't try too hard. Trying too hard gets me off the track. I know where I am now. I know I can get some part of it said'. Reflective of the apophatic tradition of religious expression (which deprivileges reason and logic, and privileges mystery and ambiguity), and the postmodern suspicion of absolutes, Lax's persona resists claims of certainty regarding his self and God; the only certainties are his acknowledgements of his pressing desire to be fulfilled by God. When the text is declarative, often the text folds back on itself: each declarative statement is made unstable by the fragment or statement that follows, such as in the passage:

> My fallen state, if that's what it is. My dark night of the soul, if
> that's what it is. My long night's waiting, if that's what it is. I
> saw a lot more then, on those nights of sleeping, not sleeping
> under bridges, sleeping, not sleeping on benches, under

50. I presented a version of this section ('Robert Lax: Internal Dialogue with God') at the Festival of Faith and Writing 2000, Calvin College.

51. Lax, *The Hill.*

trees, in barn or on church step than I'm seeing now. No
matter. I continue to watch.

The meditative sequence delves deep into the human psyche of the
author persona, as he searches for God and searches to find himself.
Often the search of self and the search for God is conflated, as illustrated
in this opening sequence, which suggests that at their core the destina-
tion of the two searches are inseparable:

> Searching for you, but if there's no one, what am I searching
> for? Still you. Some sort of you. Not for myself? Am I
> you? Need I search for me? For myself? Is my self you? I
> know: Self. Is that you? Is it me? Why search? I seem to
> be built to [...]

The entire sequence is reflective of the postmodern theological tendency
to stress desire rather than truth or other forms of absolutes, to arrive at
understandings based upon faith rather than reason, to claim desire
rather than absolutes as the *raison d'être*. The sequence affirms the desire
and longing of the human being to encounter something other than
himself/herself as he/she knows it, in order to find a fulfilled self in
relation with God. Lax's text implies throughout the sequence, and
frequently makes explicit, the notion that the human being was 'Made,
put together, invented, born for that single, singular purpose: to watch,
to wait'. This desire that fuels the entire meditation for the persona, as he
concludes, is what the persona has 'known...from the beginning'.

Faith, for Lax, as he defines it in *Psalm*, is a 'falling toward' God. The
persona declares that he 'made one choice, a long time ago', and that
'since then' he has 'been falling' toward God.[52] Lax's verse depicts reli-
gious desire and belief in a way that emphasizes the particularity of the
religious experience without being didactic:

> It is you yourself
> who urges me
> to find you.
>
> I believed you
> when you spoke.
>
> I believed myself
> when I answered.
>
> I can't remember
> exactly what you
> said

52. Lax, *Psalm*, p. 20.

I can't remember
what I said either
exactly.[53]

The religious experience for the persona is a mysterious and ambiguous experience (which is central to postmodern sensibilities), while there is a sincere certainty in his faith:

...I remember
that there was a moment of trust—a long,
full moment of trust that passed, that existed
between us.

If that is true, I have found you:
you are within me
urging me to look.[54]

The certainty of Lax's religious belief is not derived from absolute truth claims or universal principles, but the 'desire' for God that 'never abates' and the conviction that, as he addresses God: 'If I cannot see you it is because you are / within me. / You are the spirit urging me to find you'.

Indeed, Lax is a prolific writer of meditative verse that locates the self in God, and God within the self. Lax's situating of the self in God and God in the self has ethically responsible implications, as the following passage from Lax's book of meditative verse, *Notes* exemplifies:

Thinking that the source of each person's life is
something within him or her—as the seed—as
source of the tree—contains the life of the tree from
the beginning. The seed contains the life, but is
dependent on air, water, sunlight, earth to fulfill the
promise it contains. Without the life that's in the
seed there'd be no flower, no tree. But life needs
materials & forces from outside to come to full
growth.

G-d the Holy Spirit dwells within us, as life within
the seed. But He is outside and beyond us, too,
encouraging, sustaining the growth of the seed.

Still, let us think of Him as being within—He is
within—and let us honor Him, too, in ourselves and
in others.[55]

53. Lax, *Psalm*, p. 22.
54. Lax, *Psalm*, p. 24.
55. Lax, *Notes*, p. 8.

This religious and ethical notion of honoring God within other human beings is also emphasized in a later passage in *Notes*: the persona utilizes apophatic language (language reflective of negative theology) to explain that 'our movements', 'our thoughts', and 'our desires' can be traced 'down to the "Nothing" from which they arise'. That 'Nothing' of God, the persona claims, 'is to be reverenced, honored, in ourselves and in all who live'. Lax cites as an example the sacred acts of the Hindu to illustrate this reverence of the divine in the human Other:

> Hence Hindus put their hands together and bow
> their heads in saluting—in greeting—each other.
>
> They are making a sign of reverence to the Holy Life
> which dwells within the being—of themselves, and
> of the person greeted.[56]

The poetry of Lax qualifies that the full self cannot be known, until one is fully united with the divine in the afterlife. In Lax's *Psalm*, he asserts that 'the spark of life which is in the seed is one which has come from Him & returns to Him'.[57] In *Dialogues*, Lax's persona boldly states, 'you'll never / find out / who you / are'; 'it can't be / known'.[58] In *Dialogues*, he also claims, 'the / way / to / be / your / self / is / to / for / get / your / self'.[59] Locating God as the source of self problematizes the humanist notion of free will, as Lax's verse illustrates: 'what / are / you / go / ing / to / do / with / this / mo / ment / ? / what / is / this / mo / ment / go / ing / to / do / with / me?'.[60]

The poetry of Lax resituates the self not only by finding the self in God and finding God in the self, but by engaging in prayer and praise, as the following section explores; his poetry reflects the human need to pray to and praise God, as well as *God's need*, as many Christian thinkers (including Merton) as well as Jewish thinkers insist, for human prayer. In the contemporary climate where ethics is becoming of central concern in discussions on politics, religion, education and society, twentieth-century religious thinkers contend prayer is central to our being, and they insist that prayer has ethically responsible implications.

56. Lax, *Notes*, p. 10.
57. Lax, *Psalm*, p. 34.
58. Lax, *Dialogues*, pp. 10, 12.
59. Lax, *Dialogues*, p. 6.
60. Lax, *Dialogues*, p. 72.

Poetics of Prayer and Praise

Throughout the centuries, religious believers of various backgrounds have grappled with concepts of prayer and action, setting them up often as dualistic practices. Many religious thinkers throughout history, Jewish and Christian alike, have sought to undo such dualisms, and to value prayer as a significant component to being a responsible believer. In the contemporary climate, when American individuals in particular are seeking more subjective experiences of religious faith, prayer has become valued for its personal, private nature, as well as for its public consequences or concerns, as matters of prayer throughout religious traditions are matters that concern other people and the world. In other words, the act of prayer is an encounter with God (alone or with thousands of people), that is not dictated or determined by doctrine or religious sanction, but are responses that a responsible believer(s) makes to the concerns of the world.

Prayer is not a pressing issue in typically secular conversations. The mention of prayer in conversations on such issues as war, peace, terrorism, violence, education, and other aspects of our contemporary society, may cause one to wonder, what relevance prayer has? How is it that prayer or reflection is not merely self-indulgent, self-focused and oppositional to ethics? Often activists are suspicious of prayer, as it seems to avoid action. Whereas, according to Merton, who is widely known for his personal integrity as a Trappist monk, theologian, poet and peace activist, prayer is not 'simply an evasion of the problems of real life', he asserts that 'the humility of faith…will do far more to launch us into the full current of historical reality than the pompous rationalizations of politicians who think they are somehow the directors and manipulators of history'.[61] In fact, for Merton, prayer is 'never something which we can claim as though by right and use in a completely autonomous and self-determining manner according to our own good pleasure, without regard for God's will'. 'The gift of prayer', Merton continues, 'is inseparable from another grace: that of humility, which makes us realize that the very depths of our being and life are meaningful and real only in so far as they are oriented toward God as their source and their end'. The self, for Merton, is only illusional when we 'seem to possess and use our being and natural faculties in a completely autonomous manner, as if our individual ego were the pure source and end of our own acts', causing our acts, 'however spontaneous they may seem to be, [to] lack

61. Merton, *Contemplative Prayer*, pp. 112, 113.

spiritual meaning and authenticity'. Our true selves, therefore, are 'hidden in obscurity and "nothingness", at the center where we are in direct dependence on God'.[62] Such an awareness of the center of our being, for Merton, quite simply is an argument for prayer and contemplation. Merton locates prayer as fulfillment of one's needs and the world's needs, disrupting the dichotomies between the contemplative and the world, and between prayer and ethical responsibility. Such a disruption is illustrated in the poetry of prayer by Lax.

Lax's *Psalm*, which is named for the scriptural prayers to the Lord, is devoted to personal meditations on God and the self in dialogue. Much of Lax's poetry is highly meditative, as his persona vigorously searches the self using an internal dialogue to know the purpose of the self, and the realization of the self in God. In much of his poetry, Lax links the natural occurances, behaviors, and inclinations that human beings have — such as waking and singing — with the divinely inspired impulses that cause a human being to seek, desire, to pray to, and praise God. In a passage from *Psalm*, Lax's persona contemplates the relation between the acts of waking and singing and the desire to pray and praise, as distinctions between a natural act (such as waking from sleep) and a chosen act (such as praising) are conflated: 'Is waking one act with singing? / Is beginning to wake beginning to praise, / to pray, to sing?'[63]

If, indeed, a 'readiness to recognize' God is all we 'bring to the encounter', as Lax aptly states in *21 Pages*, a readiness for an in/direct dialogue with God — in the act of prayer, and in the ethical response to the human Other — is a disposition that prioritizes God and the human Other. Such a disposition, as it is conveyed in the poetry of Lax and in the prolific writings of Merton, displaces the self as center, allowing for the privileging of the human Other and the divine Other. Furthermore, prayer, for Lax as well as Merton, is the very source of peace, for that which is within, and throughout the world. For Lax, he found the peace most satisfying on the Greek island of Patmos.

Voices and Visions from Patmos

how	make	
ac	peace	
quire		
	with	with
		in

62. Merton, *Contemplative Prayer* p. 70.
63. Lax, *Psalm*, p. 50.

the	eve	
	ry	you
spi		
rit	voice	
of	that	
peace	cries	
?64		

While living simply on the island of Patmos, and earlier on Kalymnos, Lax produced more than 300 published works of poetry, journals and essays, in addition to hundreds of pages of unpublished works and photos which are stored at the Lax archives at St Bonaventure University, near Olean. I had the privilege of being the last to interview Lax in May 2000 at his home on the legendary Greek island of Patmos, where, in the Christian tradition, St John received and wrote the Revelation. Since his settling on the Greek island of Patmos, the landscape, the people, the way of life, the history and the tradition of the island influenced and shaped Lax's writing; Lax was moved by its simplicity, wisdom and sincerity. Once he arrived on Patmos, Lax recalled that he realized he had found the place he had been searching for. He found that 'every-body, particularly the farmers and fishermen, the people who are "unlet-tered" here, reaffirmed my beliefs since childhood, because they are permeated with the wisdom of the island'. Lax explained that there are many islands in Greece, but 'Patmos is the only one that has been com-pared to Jerusalem as the Western holy city'. Lax confirmed, and I would agree after my month's stay on the special island, 'It is with good reason'.

The island of Patmos is the site of pilgrimage for many people who seek discovery, meaning, adventure or rest. It is here where St John wrote: 'I, John, both your brother and companion in the tribulation and kingdom and patience of Jesus Christ, was on the island that is called Patmos for the word of God and for the testimony of Jesus Christ' ([NKJV] Jn 1.9). Though the island has become more commercialized with the increase in tourism over the past decades, there remains levels of rever-ence within the island, in the natural beauty, the inspiring presence of the mountaintop Monastery of St John the Theologian and the hillside cave of the Monastery of the Apocalypse, the hundreds of chapels, and, in the Patmians, in their respect for God, for life, for others and for the island.

Lax poignantly describes the landscape and atmosphere of Patmos in 'A Greek Journal', stating that arriving at the island is like being

64. Untitled poem taken from Lax, Notebook 1 October 1999, in Lax archives, St Bonaventure University.

'awakened to a ritual, a performance': 'as the traveller approached the island he could see the calm hills, the quiet houses, the broad, domed church that stood above the harbor, the sweetness, the meekness of the island spoke to him, scarcely spoke to him...' (p. 61)

Lax considers the seasons and cycles and admiringly identifies the 'rituals' of the island:

> if spring in this moment graced the hills, would not a dry wind follow, and white sun later, and winter rains?
> the day was the common property of the people; the people, the common property of the day
> waiting for nothing. hoping for nothing. expecting nothing. aware, none-theless, of the change of light, the change of the seasons
> on the west face of each house, the levelling light
> the hills stand up to sing (an anthem of evening)
> sun's formal fatherly leave-taking into the sea
> last instructions: prescription for ritual of arising
> (the quieter the land, the more apparent its rituals)
> are we not to learn from the seasons; from season after season, to learn & learn...[65]

Lax finds Patmos to be a holy place. He traces how this place remains the island of revelation, in its biblical and historical sense, as well as in its contemporary meaning and relevance. He refers to 'patmos, holy patmos', stating, 'i've never come here without the feeling, at least on the first few days, that the island is holy'. He describes the island: 'the bend of the walk around the bay. the view of the monastery up on the hill (a citadel) as seen from far end of the bay. the terracing of the hill. a feeling, real feeling, of peace in the air'.[66] The apocalyptic atmosphere of the island is never far from Lax's poetic consciousness:

> a walk this afternoon out on a (familiar) high road by the sea. beautiful, volcanic rocks at roadside: apocalyptic-looking: sculptured [...] strange majesty, strange intimacy too — they talk in a familiar voice: apocalyptic presences. (someone who wrote to me last week at kal said 'those stones (in greece) really speak'. now i know what he means.) and i felt all today as I did yesterday that peace, deep feeling of peace is here. that here is where i should stay at least for a while [...] that here things would grow, things would speak. [...] that here the days would go as though nothing were happening, but something would be happening. that i would do nothing all day long, but toward the evening of every day i'd write (&slowly become) more articulate: almost every time i've been here the days have

65. Lax, 'A Greek Journal', *Love Had a Compass*, pp. 238-40.
66. Lax, 'A Greek Journal', *Love Had a Compass*, pp. 224, 225.

gone that way: i've felt as though nothing were happening; yet at the end
of the year i've found that the work i did at patmos was (often) work that
stood.[67]

The vision of the apocalypse surfaces throughout Lax's Greek Journal.
Lax often refers to the apocalyptic landscape of Patmos, such as the rocks
which are predominantly scattered across the island: 'rocks scattered
helter-skelter on the hillside, as though after an explosion, as though
after an apocalypse: yet each one "perfect" in its place. […] patmos rocks
are magical, mystical, holy.'[68]
He likens the rocks to the prophet himself who heard the revelation:

the rocks look like a person who has 'suffered' a great revelation
like a prophet
after the spirit
has set him
free

And, furthermore, Lax locates himself within this holy place:

when i am alone on the road with the rocks, the whole world falls away,
and i am alone & 'contained' in a familiar place.
the color of the rocks is the color of fire (the color of pomegranantes)
if a rock by the roadside is shaped for sitting, it is well-shaped for sitting
(& well-placed, too, for meditation)
the rocks at patmos are vertical rocks; and the hill at patmos rises high
the holiness of patmos is priestly, prophetic, ecclesiastical holiness.[69]

The atmosphere of Patmos and the surrounding islands Lax describes
in terms of grace, order and purpose. He refers to 'islands set out with
care & grace (as though for a tea ceremony)'.[70] Moreover, he details the
people of the island as purposeful in that order. This can be seen in Lax's
highlighting of the monastery which is on the mountaintop of the island,
overlooking the port city of Skala, where Lax lived. The Monastery of St
John the Theologian is a significant feature in the minds and lives of the
people of the island, as he makes clear: of 'mama's' children, 'yerasimos
is the most favored. though he lives at the monastery, they also keep a
nobly furnished room for him at the house'.[71] However, Lax does not
neglect the various layers of reality of the island and the monastery:
though most of Lax's references to the monastery are appreciative and
mystical, Lax quotes a local Patmian who felt that the monks 'had turned

67. Lax, 'A Greek Journal', *Love Had a Compass*, p. 227.
68. Lax, 'A Greek Journal', *Love Had a Compass*, p. 232.
69. Lax, 'A Greek Journal', *Love Had a Compass*, p. 233.
70. Lax, 'A Greek Journal', *Love Had a Compass*, p. 232.
71. Lax, 'A Greek Journal', *Love Had a Compass*, p. 229.

the monastery into a tourist attraction'.[72] Lax does record, nonetheless, times that he would 'go up to the monastery and listen to the liturgy', and he even wondered if 'merton would be there?'.[73] Lax also found himself led, by Patmian friends, to attend chapel, which was certainly not lacking on the island of over 400 chapels, where many families had built their own chapels to pass down into generations.

Patmos deeply affected Lax's faith experience. He claimed that the people of Patmos, namely the fishermen, farmers, carpenters, others who live and work on the island, and those who come to stay for a while, 'reaffirmed my trust in the most high, the one thing to lead me to where I should go, and just as much to lead all the people on the island to the same degree of trust'. Lax continued, 'They're finding that they have experiences that leave them gasping with wonder, the beautiful way things can unfold, lives can be creatively meshed with each other'.

Before living in Greece, Lax had lived in New York City, where he felt burdened by the modern way of life. As he records in 'A Greek Journal',

> night seems lighter, less heavy, here [on Patmos] than in kalymnos, and considerably less heavy than in new york. the weight of people sitting around at night, the weight of their thoughts, the weight of their plans seem to create a physical pressure in the air above all the cities: creates, that is, a psychological pressure so strong that it seems tangible, physical, bears down like a weight on the shoulders.[74]

Lax continues,

> it would be hard to imagine a similar weight bearing down on so small an island, being gathered even from the nocturnal fantasies (for so much of it rises from fantasies) of so small a community. perhaps it could. but just as new york seems heavier than kalymnos, and london perhaps even heavier than new york, the size itself of the city, and the number of perambulant dreamers within it seems to affect the magnitude of the weight that hangs above it and presses down.[75]

Lax contrasts the city and the village life of the island, locating a key difference between the two, stating,

> there are paradoxes to be discerned here, because although life in a city seems to be constantly changing, each violent occurrence within it, each brutal fact, seems to be permanent, seems to be part of its unchanging face; in an island village the opposite is true: the hills about it are permanent, the seasons come and go in a stable rhythm; houses are built to stand till

72. Lax, 'A Greek Journal', *Love Had a Compass*, p. 230.
73. Lax, 'A Greek Journal', *Love Had a Compass*, p. 232.
74. Lax, 'A Greek Journal', *Love Had a Compass*, p. 242.
75. Lax, 'A Greek Journal', *Love Had a Compass*, p. 242.

they fall; children carry the names of their forebears, and within this mostly comic framework, incidentals in the life of man seem smaller, more ephemeral.[76]

Despite his embrace of village life, Lax maintains hope for the cities of the world, God's cities. Reflective of his *The Circus of the Sun* verse which embodies a vision for how humanity could interact in a way which better fosters an atmosphere of worship and praise, Lax envisioned the city as a potential garden of Eden: he stated in our interview:

> My view of the city is a form of a garden of Eden. A real city should be green and blossoming, with beautiful things; it should be a blossoming city, right here on earth. This earth was not created for nothing. All we should do is make it grow, make it be what it was meant to be before the fall. Earth was created because heaven was so full of love that it wanted someone to share that love with, to enjoy it; that is how it came into being.

Whether in the city or the village, however, it is the ability to walk in stride that Lax finds remarkable about Merton. Lax recalls Merton's steady walk on Fifth Avenue when they had arranged to meet, as well as his firm footing in the monastery. While in Greece, Lax found a source of wisdom and spiritual direction in the life and work of Merton. Lax records in his journal that Merton is often the 'guru' in his mind and imagination 'who tells me other wisdoms: usually the wisdoms of abstinence & avoidance; of retreat, prayer & preparation, of non-attachment, of 'sitting quietly doing nothing', of seeking smallness, not greatness, or of seeking nothing at all'.[77] A reason that Lax remained in Greece was 'to learn' and to contemplate and to write. He admired the certainty and stability he had observed in Merton:

> [Merton] had one quality, particularly in the last years, but even (to a large degree) from always, from even before he (formally) became a catholic: a certainty of tread.
>
> that might sound as though he plonk plonk plonked like a german soldier as he walked down the street. actually, he didn't: he danced (danced almost like fred astaire: bang bang bang; or bojangles robinson, tappety bam bam bam) but he knew where he was dancing.
>
> he did walk with joy. he walked explosively: bang bang bang. as though fireworks, small, & they too, joyful, went off every time his heel hit the ground.

76. Lax, 'A Greek Journal', *Love Had a Compass*, p. 242.
77. Lax, 'A Greek Journal', *Love Had a Compass*, p. 209.

[...] it was true the last time i saw him bang bang banging down a long hallway at the monastery. he walked with joy. he knew where he was going.[78]

It is appropriate that Lax concludes 'A Greek Journal' (*Love Had a Compass*) with a praise poem, followed by poetic thoughts of God and the hereafter. In his praise poem, Lax 'praise[s] the Lord / for the beauty / of the sun [...] for the sound / of the wind [...] for the movement of the trees [...] the dancing of the sun'. He concludes the collection *Love Had a Compass*, contemplating a time and place 'in another land', when

[...] with my
own compasses

I will not look
further for
righteousness

I will understand
you only in your
absences

Lax's life and work exemplifies that love, indeed, has a compass afterall.

Throughout his travels, Lax was drawn toward certain groups of people that he could 'quite happily relate to', such as taxi drivers, who Lax referred to as 'receptacles of everything in the world; they are a crowd like gypsies—in New York or in Paris—they have a similar wisdom'. He was also drawn toward jazz musicians: 'especially after the crowd leaves, the jam sessions they have for themselves and the kind of collaboration they have, the way they do their best to bring the best out of the other players; they set it up for him to come in with his instrument'. These instrumental people in Lax's life remind me of the role he fulfills as a poet. The taxi driver, jazz musician, fisherman, farmer, carpenter, in light of Lax's insight into human life, are each apt metaphors for the poet. However, though I find the description to be fitting, Lax would likely prefer not to be remembered most as a poet, pilgrim or prophet. Rather, as he stated simply in our interview on Patmos, he wants to 'stick around and bring the earth to flower'. Through his volumes of writing and in the minds of his faithful readers, he does just that.

78. Lax, 'The Greek Journal', pp. 208-210.

[TMA 15 (2002) 61-76]
ISSN 0894 4857

The Healing Silence: Thomas Merton's Contemplative Approach to Communication

Gray Matthews

Thomas Merton wrote often and with rich, critical insight about the problems of mass media and our growing culture of noise, but his death in 1968 unfortunately left us without his direct counsel regarding how to cope with the proliferation of computers and personal communication technology. Yet, this does not mean that Merton's pre-digital era writings are rendered irrelevant today. Quite the contrary, Merton left us with much contemplative wisdom regarding how to steer a course through the electronic cultural wilderness. Merton's recognition of the extent to which 'genuine communication is becoming more and more difficult' led him to declare with mission-like zeal: 'When speech is in danger of perishing or being perverted in the amplified noise of beasts, perhaps it becomes obligatory for a monk to try to speak'.[1]

Throughout his critique of mass communication, in particular, Merton emphasizes spiritual experience (silence, solitude and contemplation) as a legitimate position from which to evaluate and transcend the effects of mass media. His chief concern regarding mediated communication concerns its effect on the individual's ability to discover one's true self, and consequently one's relationship to God or the Ground of Being. Merton criticized the mass media for fostering propaganda, fragmentation and alienation — destructive forces that terrorize the individual's natural inclination to unity with oneself, with one's neighbors and with one's God.

Today, however, there are new mediated barriers to contend with: if we are not busy being distracted by mass entertainment, we are prob-

1. Thomas Merton, *Seeds of Destruction* (New York: Farrar, Straus & Giroux, 1965), p. 243.

ably on one of a number of personal communication devices. The mass information society we live in now has both public and private dimensions; no area of our personal lives is free from the clamor of constant messages. A ringing telephone used to interrupt our day, now it is silence that seemingly disturbs us in the midst of our noisy lifestyles. For Merton, when silence is obliterated we lose our ability to communicate. 'For language to have meaning', he explains, 'there must be intervals of silence somewhere, to divide word from word and utterance from utterance. He who retires into silence does not necessarily hate language. Perhaps it is love and respect for language which impose silence upon him. For the mercy of God is not heard in words unless it is heard, both before and after the words are spoken, in silence'.[2]

In this article, I wish to illuminate Merton's contemplative approach to communication, one that I will argue is much needed as we move to confront the communication problems of the twenty-first century. Merton has much to say about our fundamental problems of communicative relatedness — of how to repair our relations with others, with nature, with God and with our innermost selves — because he has much to say about *silence*. I will proceed by first briefly examining Merton's perspective of the relationships between silence, symbols and communion. I will then elaborate on that understanding by discussing how Merton's perspective of communication functions as a social critique of our culture of noise, and how this critique suggests creative requisites for restoring authentic communication in a broken world.

Merton understood the significance of the transformative values of genuine communication, and it was this understanding that led him to embrace *communion* as the essence and goal of communication. Ultimately, Merton leads us to an awareness of the *communicative power of listening to silence*, which can help us rescue our everyday social relations from further suffering in a fractured culture perpetuated by the illusions of noise as speech, email as connectiveness, and recorded phone messages as presence. Our noisy, fragmented existence, however, is not merely an external phenomenon, encompassing our broken relations with others, but involves an internal fracturing as well, as the perpetual erosion of silence threatens to sever our abilities to reflect, to rest and to understand our true self. The recovery of silence, though, is not for its own sake, but is necessary for the restoration of authentic communication. Merton understood the problem clearly, for he realized that the loss

2. Thomas Merton, 'Notes for a Philosophy of Solitude', in *idem, Disputed Questions* (New York: Harcourt Brace Jovanovich, 1960), pp. 177-207 (195).

of silence—its disconnection from communication—can only result in noise and consequently prohibit genuine contact and communion:

> The constant din of empty words and machine noises, the endless booming of loudspeakers end by making true communication and true communion almost impossible. Each individual in the mass is insulated by thick layers of insensibility. He doesn't care, he doesn't hear, he doesn't think. He does not act, he is pushed. He does not talk, he produces conventional sounds when stimulated by the appropriate noises. He does not think, he secretes clichés.[3]

Thus Merton's contemplative approach to communication rests in this acknowledgment and deep understanding of the healing virtues of silence. He provides aid and guidance for the contemplative person who must 'withdraw into the healing silence of the wilderness, or of poverty, or of obscurity, not in order to preach to others but to heal in themselves the wounds of the entire world'.[4] Merton's claim, though, is that we will find in this healing silence that our ability to communicate with others, and our capacity for communion, is healed as well.

Silence, Symbols and Communion

Silence pervades, envelopes, extends and transcends communication. It is the environment in which speech is enabled to be seen and heard. Silence is inherent in our beingness and helps foster our soul-connection to others. Merton understood these vital connections — these paradoxical, symbiotic relationships — between silence, symbols and communion. His life was a celebration of deep connectiveness, standing as a spiritual guide at the intersection of speech and silence, the crossroads of solitude and community. Merton's contemplative approach to communication is based upon two assumptions: (1) communication is the active human link between silence and communion, and (2) communication becomes *inactive* when uprooted from silence and severed from its true aim, communion.

Silence to Communication

There are at least six commonplace themes in his writings through which Merton links silence and communication: (1) silence and monasticism; (2) silence as the language of God; (3) listening in/to silence; (4) silence and recollection; (5) silence and compassion; (6) silence and the inner

3. Thomas Merton, *New Seeds of Contemplation* (New York: New Directions, 1961), p. 55.
4. Merton, 'Notes', p. 194.

self. As a phenomenon, silence is clearly multidimensional for Merton, possessing numerous values and characteristics, many of which are described in his article 'Creative Silence'.[5]

Merton is closely aligned with the views of Swiss philosopher, Max Picard (1888–1965), in understanding silence to be autonomous, positive, creative, distinct from speech and integral to the structure of human beings. In fact, the two writers are in such close harmony on the subject of silence that one could mistake many statements by Picard as the words of Merton. Consider, for example, Picard's description of love being filled more with silence than speech, and how 'through the silence that is in love, language is taken out of the world of verbal noise and bustle and led back to its origin in silence. Lovers are close to the beginning of all things, when language was still uncreated, when language could emerge at any moment from the creative fullness of silence'.[6]

Both Picard and Merton view silence as preceding human speech and language, while human communication, ideally, is meant to proceed out of silence and then return to rest in silence. In a culture of noise, however, communication never rests, and rarely do we. Yet, in addition to relaxation and the need to get away from the noise and busyness of modern life, Merton explains that there are deeper motives for the Christian seeking silence, for silence is a place where one can listen to God:

> We are perhaps too talkative, too activistic, in our conception of the Christian life. Our Service of God and of the Church does not consist only in talking and doing. It can also consist in periods of silence, listening, waiting. Perhaps it is very important, in our era of violence and unrest, to rediscover meditation, silent inner unitive prayer, and creative Christian silence.[7]

Hidden beneath our fear of silence is the fear of our selves, which is further submerged in our fear of God. Merton alludes to Picard's notion of the 'flight from God' that orchestrates so much of our noise into an escape from the realities we fear within us, the ones we may only face in silence.[8] We make retreat, we rest in silence, therefore by withdrawing from the fury of the flight, but not from ourselves or other people. It is here where Merton tells us silence can be so healing and creative: 'Not only does silence give us a chance to understand ourselves better, to get a truer and more balanced perspective on our own lives in relation to the

5. In *idem, Love and Living* (ed. Naomi Burton Stone and Patrick Hurt; New York: Harcourt Brace Jovanovich, 1979), pp. 38-45.

6. Max Picard, *The World of Silence* (Washington: Gateway, 1948), p. 96.

7. Merton, 'Creative Silence', p. 39.

8. Max Picard, *Flight From God* (Washington: Gateway, 1951).

lives of others: silence makes us whole if we let it. Silence helps draw together the scattered and dissipated energies of a fragmented existence'.[9]

Merton argues that silence and communication are not mutually exclusive phenomena; to the contrary, silence so pervades and envelopes communication that it is vitally essential to every act of expression. In essence, we need silence in order to communicate properly. There are at least four ways in which we can readily understand this intimate relationship between silence and speech. First, silence exists *before* an utterance is made. Human beings did not invent silence; we invented speech. As Picard puts it, 'the absence of language simply makes the presence of Silence more apparent'.[10] Second, silence exists *after* an utterance is made. We know someone has spoken to us not simply because they have spoken, but because they have stopped speaking. Third, silence exists *within* utterances as pauses between words, or as spaces between letters and words on the printed page. Finally, silence *is* communicative, serving as a message or form of expression itself.

The loss of silence, therefore, harms or limits our ability to communicate. As we shall see, silence is important to Merton because *symbols* are important; when communication is severed from silence, symbols become useless for sharing meaning, hence communication becomes useless as a means for communion.

Symbols to Communion
Merton's essay, 'Symbolism: Communication or Communion?' is his clearest explication of the nature of symbols and their role in leading to the experience of communion. Merton takes a spiritual perspective, of course, in treating the sacramental function of language and symbols in general: 'The true symbol does not merely point to some hidden object. It contains in itself a structure which in some way makes us aware of the inner meaning of life and of reality itself'.[11] Merton draws a parallel between the degradation of symbolizing (expressing/communicating) and the spiritual decay of culture. For Merton, then, an ordinary act of communication between two people potentially involves more than a transaction of exchanged messages, for the very use of symbols implies a deeper, spiritual dimension of relation.

Symbols become degraded when they are utilized as, or believed to be, 'totalist'. A totalist symbol—as opposed to a creative, living or

9. Merton, 'Creative Silence', p. 43.
10. Picard, *The World of Silence*, p. 15.
11. In *idem, Love and Living*, pp. 54-79 (54).

spiritual symbol — is one that is used only to call attention to itself as an exclusive, self-contained universe of meaning. Thus when cut off from a reality outside itself, from what sustains it, a symbol may function in divisive and destructive ways that counter the aims of authentic communication. Merton contrasts, for example, the living symbols used in peace negotiations with the totalist symbolic statement of an intercontinental ballistic missile. 'Man cannot help making symbols of one sort or another', he writes, for we are symbol-using beings, but contemporary symbolic communication is more symptomatic 'of a violent illness, a technological cancer' than the product of spiritual experience.[12] Merton explains the vital, spiritual role of authentic symbols in this way: 'To express and to encourage man's acceptance of his own center, his own ontological roots in a mystery of being that transcends his individual ego'.[13] But as Kilcourse rightly observes, language is a communication medium that is of utmost humane concern to us because it 'can unite or divide human persons. It can be used well or badly'.[14] Consequently, Merton issues a call for wisdom and discernment in communication: we must distinguish between living symbols that direct action to wholeness and unity, and 'pathogenic and depraved symbols [that] divert man's energies to evil and destruction'.[15] To discern the differences, however, one must be capable of interior response, which is why our appreciation and experiences of silence are so essential.

Merton is not attacking language when talking about the degradation of the symbol as much as he is lamenting the human inability to transcend language. In other words, the phrase 'degradation of the symbol' refers chiefly to our misuse of language in ways that separate the symbol from the sacred. In his essay on 'Free Speech' (*parrhesia*) in *The New Man*, Merton explains, 'words lose their capacity to convey the reality of holiness in proportion as men focus on the symbol rather than on what it symbolizes'.[16] He claims that the primary function of the symbol, or the word, 'is a contemplative rather than a communicative statement of what exists', adding that 'the word is a kind of seal upon our intellectual communion with Him, before it becomes a means of communication with men'.[17] Merton traces the basis of human communication to our original relationship with the Divine when 'the primary function of

12. Merton, 'Symbolism', pp. 78-79.
13. Merton, 'Symbolism', p. 65.
14. George Kilcourse, Jr, *Ace of Freedoms: Thomas Merton's Christ* (Notre Dame: University of Notre Dame Press, 1993), p. 172.
15. Merton, 'Symbolism', pp. 62-63.
16. Thomas Merton, *The New Man* (New York: Noonday, 1961), p. 87.
17. Merton, *The New Man*, p. 88.

language was to bear witness to the hidden meaning of things rather than "talk about" them'.[18] Hence Merton provides us with an eloquent defense of *communion* as the primary aim of human communication.

Essential to Merton's perspective, overall, is the understanding that true communication *uncovers* rather than constructs communion. 'The function of the symbol', he says, 'is to manifest a union that already exists but is not fully realized'.[19] Thus the symbol is 'new' whenever it discovers a new depth or dimension to what is already present. 'The symbol awakens awareness, or restores it. Therefore, it aims not at communication but at communion. Communion is the awareness of participation in an ontological or religious reality: in the mystery of being, of human love, of redemptive mystery, of contemplative truth.'[20] Merton summarizes his view in this way: 'The symbol is an object which leads beyond the realm of division where subject and object stand over against one another. That is why the symbol goes beyond communication to communion. Communication takes place between subject and object, but communion is beyond the division: it is a sharing in basic unity.'[21] Thus communion occurs between true persons communicating authentically:

> The deepest level of communication is not communication, but communion. It is wordless. It is beyond words, and it is beyond speech, and it is beyond concept. Not that we discover a new unity. We discover an older unity. My dear brothers, we are already one. But we imagine that we are not. And what we have to recover is our original unity. What we have to be is what we are.[22]

Merton is critical, therefore, of the obliteration of silence and the degradation of symbols, a situation that forces communication to become self-destructive and thereby prohibit communion. This situation, when raised to cultural levels, becomes a social environment that conditions us to the normalcy of noise. In *Cables to the Ace*, Merton describes our situation in this way: 'The saying says itself all around us. No one need attend. Listening is obsolete. So is silence'.[23] As we have seen thus far, Merton is concerned with silence because he is concerned with communication, and he is concerned with communication because he is concerned with communion. The basis for such concerns is made even more paramount through his critique of our culture of noise.

18. Merton, *The New Man*, p. 89.
19. Merton, 'Symbolism', p. 68.
20. Merton, 'Symbolism', p. 68.
21. Merton, 'Symbolism', p. 73.
22. Thomas Merton, *The Asian Journal of Thomas Merton* (New York: New Directions, 1973), p. 308.
23. Thomas Merton, *Cables to the Ace* (New York: New Directions, 1968), p. 3.

Merton's Critique of a Culture of Noise

Merton appeared to foresee our predicament today, but not without a sense of humor. Consider the following prophetic insight when, after commenting on communication as being 'the worst problem today' in *Vow of Conversation*, Merton turns to offer this visionary satire of twenty-first century telephone activities: 'Wives of astronauts talk by radio with their husbands in outer space. A priest of St. Meinrad's in Peru can call Jim Wygal and talk to him on the phone he has in his car while he is driving around Louisville. And what do they have to say? Nothing more than "Hi, it's a nice day, hope you are feeling good, I am feeling good, the kids are feeling good, the dog is feeling good," etc'.[24]

In just the last few years, a number of scholars from diverse intellectual disciplines have slowly begun to also see through the illusory glories of an information society, finding many reasons, like Merton, to criticize our growing addiction to speed and noise. For example, media scholar David Shenk's guide to surviving the information glut reminds us that too much of anything is still not a good thing.[25] British communication scholar John Locke offers reasons why we are becoming a society of strangers despite the plethora of technological communication devices.[26] Media consultant Ed Shane attempts to disillusion us further about ceaseless connectivity.[27] Social critic Morris Berman goes so far as to claim in *The Twilight of American Culture* that our only way out of this cultural and spiritual morass is to become like 'monks', withdrawing from society in order to preserve what is good and honorable.[28]

American cultural critic Neil Postman further revealed and clarified our addiction to distractions in *Amusing Ourselves to Death*, explaining in his follow-up solution to our predicament, *Building a Bridge to the 18th Century*, that we took a wrong turn as a society in the nineteenth century and why we need to return to the balanced models of social life of the Enlightenment period.[29] It is disappointing to note that after mentioning

24. Thomas Merton, *A Vow of Conversation: Journals 1964–65* (ed. Naomi Burton Stone; New York: Farrar, Straus & Giroux, 1988), p. 187.

25. David Shenk, *Data Smog* (San Francisco: HarperSanFrancisco, 1997).

26. John Locke, *Why We Don't Talk to Each Other Anymore* (New York: Touchstone, 1998).

27. Ed Shane, *Disconnected America: The Consequences of Mass Media in a Narcissistic World* (New York: M.E. Sharpe, 2001).

28. Morris Berman, *The Twilight of American Culture* (New York: W.W. Norton, 2000).

29. Neil Postman, *Amusing Ourselves to Death* (New York: Penguin, 1985); and idem, *Building a Bridge to the 18th Century* (New York: Vintage, 1999).

the possibility of our turning back further to the wisdom of the ages for guidance (namely to 'Confucius, Isaiah, Jesus, Muhammad, the Buddha, Shakespeare, Spinoza and many more'), Postman dismisses them as irrelevant to our immediate era:

> The words of the sages can calm and comfort us. They offer perspective and a release from the frenzy of speed and ambition. Very useful, I would say. But, of course, they are very far away from us in time and cultural conditions, and their advice is so abstract that it is difficult to see how we can turn much of it into practical and coherent instruction.[30]

Perhaps Postman would find what he is looking for, and much more, if he read Thomas Merton's views on the still-relevant wisdom of the ages.

As valuable as these scholars' insights are, however, I find Merton to be more instructive, not only because his criticism goes deeper into our problems (probing the spiritual depths of human nature as well as social structures), but because he is able to offer practical counsel and true spiritual guidance. Merton's critique of mass communication is centered on his understanding of silence as not only a mode of communication, but also a mode of knowing.[31] For Merton, it is our loss of silence that has led to the breakdown of communication, and consequently to the *loss of communion*, which is the grave danger we face, and the reason why we must work to restore authentic communication with one another: 'To live in communion, in genuine dialogue with others is absolutely necessary if man is to remain human'.[32] Merton teaches us that true communication on the deepest level 'is more than a simple sharing of ideas, of conceptual knowledge, or formulated truth. The kind of communication that is necessary on this deep level must also be 'communion' beyond the level of words, a communion in authentic experience which is shared not only on a 'preverbal' but also on a 'postverbal' level'.[33] Merton was critical of superficial communication because he was convinced that 'it is necessary that there be genuine and deep communication between the hearts and minds of men, communication and not the noise of slogans or the repetition of clichés' in order to experience the spiritual nature of our being.[34]

Our true self struggles against the noise in order to make its presence felt, but too many people are persuaded to disconfirm its presence and

30. Postman, *Building a Bridge*, p. 11.
31. For a good, systematic treatment and defense of silence as an authentic mode of knowing, see George Kalamaras, *Reclaiming the Tacit Dimension* (New York: State University of New York, 1994).
32. Merton, *New Seeds*, p. 55.
33. Merton, *The Asian Journal*, p. 315.
34. Merton, *Seeds of Destruction*, p. 243.

prefer the noise of distractions: 'Let us frankly face the fact that our culture is one which is geared in many ways to help us evade any need to face this inner, silent self', sending us reeling instead into the noisy 'commotion and jamming which drown out the deep, secret, and insistent demands of the inner self'.[35] According to Merton, these problems explain our failed attempts at communion, and indicate our desperate need for silence:

> In silence we face and admit the gap between the depths of our being, which we consistently ignore, and the surface which is untrue to our own reality. We recognize the need to be at home with ourselves in order that we may go out to meet others, not just with a mask of affability, but with real commitment and authentic love. If we are afraid of being alone, afraid of silence, it is perhaps because of our secret despair of inner reconciliation.[36]

It is interesting to note William Shannon's observation that 'there is nothing in the monastic rule, Merton points out, to prepare the monastery for the arrival of the television addict'.[37]

Essentially, Merton reveals to us the illusions of connectivity and community fostered by the mistaken identification of surface noise as communication depth. Silence, then, becomes first of all a form of protest against the noise, and secondly as a path to communion:

> We live in a state of constant semi-attention to the sound of voices, music, traffic, or the generalized noise of what goes on around us all the time. This keeps us immersed in a flood of racket and words, a diffuse medium in which our consciousness is half diluted: we are not quite 'thinking', not entirely responding, but we are more or less there.'[38]

Merton concludes, therefore, that: 'The greatest need of our time is to clean out the enormous mass of mental and emotional rubbish that clutters our minds and makes of all political and social life a mass illness. Without this housecleaning we cannot begin to *see*. Unless we *see* we cannot think. The purification must begin with the mass media'.[39] He ends that statement, however, with the potentially life-altering challenge and question of 'How?'

We must not forget that Merton's critical stance toward the media is adopted from the position of silence, which is exactly what Inchausti

35. Merton, 'Creative Silence', pp. 40, 41.

36. Merton, 'Creative Silence', p. 41.

37. See William Shannon, *Thomas Merton's Dark Path* (New York: Farrar, Straus & Giroux, 1987), p. 105.

38. Merton, 'Creative Silence', p. 40.

39. Thomas Merton, *Conjectures of a Guilty Bystander* (Garden City, NY: Doubleday, 1966), p. 77.

concludes in his excellent overview of Merton's intellectual contribution to modern thought. According to Inchausti, Merton perceives our social problems as stemming from a 'general, psychological migration, since the late Renaissance, away from any identification with our silent selves'; Merton's 'antidote' to this state of cultural confusion is 'a return to contemplative living'.[40] Instead of merely attacking the content of media messages, or striking at the technological vehicles themselves as propagandistic, Merton encourages us to turn our critical gaze away from the media, not merely to ignore them, but in order to disconfirm their legitimacy and to embrace silence as more valuable for authentic communication. As we have seen, Merton's critique begins with a return to silence: 'Let those who can stand a little silence find other people who like silence, and create silence and peace for one another'.[41] It is not the negative dismissal of media, but the positive embrace of silence that provides Merton with such rich contemplative insights.

Hypercommunication and Messaging
Ultimately, the problem with the mass media, for Merton (and myself), is that it perpetuates a culture of seemingly limitless communication that actually makes true communication difficult, and consequently prohibits true communication and community. Communication scholars are well aware of the fact of how communication (i.e. other messages) can function as noise within a particular context. Hence the paradox of communication as noise. Noise can be defined as any distraction or disturbance in the flow of direct communication. In following Merton, therefore, we are led to realize that because our culture has become so inundated with the technical reduction of communication — radio, faxes, cellular/mobile phones, television, billboards, books, compact discs, magazines, newspapers, computers, worldwide web, etc. — we have created a cultural lifestyle that makes it increasingly *difficult to find the silence needed in which to communicate* with another person. We mindlessly perpetuate this difficulty because, as Julia Ann Upton observes, 'we are so culturally adapted to having someone else fill in all our silent spaces'.[42] We manufacture so much noise that we cannot hear each other, nor hear ourselves, let alone God. To make up for the loss of authentic communication we

40. Robert Inchausti, *Thomas Merton's American Prophecy* (Albany: State University of New York, 1998), p. 148.

41. Thomas Merton, *Bread in the Wilderness* (Philadelphia: Fortress Press, 1953), p. 311.

42. Julia Ann Upton, 'Humanizing the university: Adding the Contemplative Dimension', *The Merton Annual* 8 (1996), pp. 75-87 (80).

experience consciously or unconsciously on a daily basis, we simply increase the amount of messaging, thus conforming to the cultural norm of pumping up the volume. In essence, we resort to *hyper*-communication.

I employ the term hypercommunication as a label for a variety of communication forms that serve to accelerate interactions and exacerbate our communication anxieties, multiplying the effects of a noisy culture— mobile phones for endless gossip and chatter, constant staging of pseudo-events, increased advertising in all venues, more talking doors, more talking car alarms, more talking subways and elevators, musical greeting cards, talking stuffed animals, Muzak everywhere, televisions turned on in retail stores for customers' pleasure—any form of communication we use to overload the air/void with the seeming necessity of more messages. Like a person hyperventilating, desperately breathing rapidly in pursuit of deep, saving breath, we live in a state of hypercommunication: desperately transmitting and receiving messages as much and as rapidly as possible in pursuit of communion. What we fail to realize is that we need silence to breathe as well as to communicate, for according to the teachings of the Kaushitaki Upanishad: 'When a man is speaking, he cannot be breathing; this is the sacrifice of breath to speech. And when a man is breathing he cannot be speaking; this is the sacrifice of speech to breath'.[43]

Our hypercommunication has led to the emerging phenomenon of *messaging*, by which I mean the almost obsessive process of sending and leaving messages without concern for how (or whether) they are received or understood. We *message* each other rather than take the time to fully communicate. Messaging is not communication. Living in a state of hypercommunication, we do not have the luxury of time, we tell ourselves, and so we sacrifice the virtue of patience to merely leaving messages for each other. We then make the fatal error of assuming we have communicated with the other person because we sent them a message. Messaging will not lead us to communion.

Hypercommunicators see silence only as an empty hole that must be filled with messages and more messages. Hypercommunicators know only that it is better to send than to receive, to be heard than to hear. To hypercommunicators, silence is, indeed, *weird*.

Yet, the culture of noise perpetuated by hypercommunication is still *not the primary problem*; it is only a symptom of a much deeper problem: spiritual disconnectiveness, which is only exemplified by the loss of con-

43. Juan Mascaro (trans.), *The Upanishads* (New York: Penguin, 1965), p. 105.

nection between silence and utterance, and the reduction of communicating to messaging.

Kierkegaard, of course, recognized all this in 1846. In *The Present Age*, Kierkegaard explains that 'a revolutionary age is an age of action; ours is the age of advertisement and publicity. Nothing ever happens but there is immediate publicity everywhere'.[44] In this present age, writes Kierkegaard, there are no relationships between people, only tensions, and because there is no direct, genuine communication between people, only abstract chatter, there is no true action. The end result is a talkative culture created by 'doing away with the vital distinction between talking and keeping silent. Only some one who knows how to remain essentially silent can really talk—and act essentially'.[45] Peter Fenves presents an intriguing critique of Kierkegaard's notion of talkativeness, accusing Kierkegaard of engaging in the same kind of discursive activities that he is criticizing, and concluding that Kierkegaard and his argument (picked up by other writers) is hypocritical.[46] The point would be well taken except that I think Fenves misses Kierkegaard's essential concern. For Fenves, the issue is differentiating chatter from true communication (what does it look like?); but for Kierkegaard, the issue is not which type of discourse is better, but whether silence is valued for the cultivation of inwardness. Busyness is the illusion of action, he reasons, and talkativeness is the illusion of communicative action. Merton would definitely agree.

Communication Wisdom
The transformative vision and critique of contemporary society by Merton strongly suggests the first step toward healing ourselves and our culture: the renewal of our appreciation for, and experience with, silence. Merton suggested many creative, though not fully developed, ideas during the last few years of his life about how to communicate silence (in)to the world. Parallel to this concern is Merton's focus on the spiritual restoration of symbols. In surveying the violence, noise and technological dominance of cultural life today, Merton reasons, 'the only remedy for this is in a return to the level of spiritual wisdom on which the higher symbols operate.

Monasteries and retreat houses have existed for centuries as places where one can withdraw from the world of noise to a sanctuary of

44. Søren Kierkegaard, *The Present Age* (New York: Harper, 1962), p. 35.
45. Kierkegaard, The Present Age, p. 69.
46. See Peter Fenves, *'Chatter': Language and History in Kierkegaard* (Stanford, CA: Stanford University Press, 1993).

silence for recollection and restoration. But is that enough to reduce the noise? As Merton reminds us, even monasteries can be quite noisy, which is why he shares with us a journal entry describing a day when he 'was glad to get back to the healing silence of the hermitage' after a busy day with his monastic community.[47] Merton appeared to feel, toward the end of his life, that there were greater possibilities open to transforming relations between the monastery and the world, between cloistered silence and the cultural noise. The compassion surging throughout Merton's social critique aims toward a more proactive strategy in assisting non-monastics in their encounters with the healing silence. Instead of merely maintaining a standing invitation for visitors to the monastery, Merton sensed an obligation to take the message of silence and communication wisdom back into the world. Gradually, Merton came to believe that contemplation was for everyone, and was never more prophetic than when he said, 'the world was full of people who are looking for meditation and silence'.[48] Those who are sensitive to this situation are exhorted to stay close to communication wisdom for the sake of all: 'If the contemplative, the monk, the priest, the poet merely forsake their vestiges of wisdom and join in the triumphant, empty-headed crowing of advertising men and engineers of opinion, then there is nothing left in store for us but total madness'.[49]

As a whole, Merton's writings can be understood to function as one lengthy advisory concerning communication wisdom. First and foremost, Merton provides a model for reconnecting our own selves to silence. Clearly we should establish and safeguard a period of silence every day, as well as follow a spiritual discipline in maintaining that silence. Furthermore, communication wisdom entails encouraging others to experience silence in two ways: by admonishing them to take advantage of quiet moments whenever they arise, and by withdrawing our own presence (and noise) on occasion to enable them. How can others experience silence when we are always interacting with them?

Communication wisdom involves, also, the reduction of our consumptiveness of constant messages by simplifying our cultural lifestyles. By reducing the clutter of unnecessary noise—subscriptions, messages, video rentals, more television channels, etc. — we are likely to regain our senses to communicate more fully when most necessary. Such cultural asceticism, therefore, should enable us to understand further the spiritual

47. Merton, *A Vow of Conversation*, p. 196.

48. Thomas Merton, *The Springs of Contemplation: A Retreat at the Abbey of Gethsemani* (Notre Dame, IN: Ave Maria, 1992), p. 19.

49. Merton, 'Symbolism', p. 79.

nature of human communication in general, which may lead us to realize more deeply, and to experience more often, the epiphanies of being in contact with the hidden wholeness of a world of living relations.

Discernment is key to Merton's conception of communication wisdom, and one of the most primary distinctions we need to make is between *being* and *doing* in terms of our fundamental orientation to communication. A *doing* perspective throws us headlong into the stream of noise as we busy ourselves with sending and receiving messages, whereas a *being* perspective reminds us to be still, silent and to seek communion over and beyond the transmission of messages. The fundamental idea of communicating beings should lead us to prioritize communion in our daily interactions and strive to cultivate a listening heart. In the words of David Steindl-Rast, 'listening with my heart I will find meaning. For just as the eye perceives light and the ear sound, the heart is the organ of meaning'.[50] Such communication wisdom is a vital step to restoring meaning and meaningfulness to our everyday communication.

Conclusion

In the end, Merton stands as a spiritual guide to help us navigate our way through the labyrinth of a noisy culture. From Merton we can see that communication is essentially and ultimately spiritual in nature. Human communication is a spiritual nexus; it is our point of contact and connection with the world within and all around us. To be sure, we can create reality through the social constructiveness of speech, but Merton shows us that what we create is only a partial reality. He reminds us that there is more to reality than we can possibly say, that we are also being (re)created by a reality not of our own making, a reality that seeks to communicate with us, ever present, ever speaking through silence. Merton tries to help us see that 'if our life is poured out in useless words we will never hear anything in the depths of our hearts, where Christ lives and speaks in silence'.[51] Thus, when we reduce all communication to human fabrications and mediated realities, we reduce communication to noise, and severely reduce all prospects for communion.

Yet, if we attend to the silence that anchors and enlivens communication, we regain a sense of the whole and increase the prospects for genuine contact, connection and communion. Merton presents an alternative

50. David Steindl-Rast, *A Listening Heart: The Art of Contemplative Living* (New York: Crossroad, 1983), p. 10.

51. Thomas Merton, *No Man is an Island* (New York: Harcourt, Brace, Jovanovich, 1979), p. 260.

orientation to communication, one that views communication as an act of being, and not merely a process of doing. This alternative orientation emphasizes silent listening as the proper starting point for all communication, which stands in stark contrast to the hyper-talkative perspective that hustles to indoctrinate millions of people every day. True communication runs deeper than the mere transmission of messages, for it extends to the level where we share an understanding of each other as persons, not just messengers.

In the final analysis, we are communicating beings, not mere transmitters of data. Merton's alternative perspective restores an absolutely vital element to communication: *presence*. Noise prohibits presence. Re-membering presence underscores the central spiritual, hence fully human, dimension of our communication with others, that crucial aspect so often disregarded as inconsequential in an era of authorless texts, answering machines and funerals on websites (why be there when you can pay your respects in virtual reality?).

Merton reminds us that if we could just learn to listen first—listen in and to the silence—we would realize that we are not alone in our solitude, and we would be able to develop our latent capacity to understand and live life more deeply, more contemplatively, and communicate more wholly and authentically at the level of communion.

The voluminous works of Thomas Merton represent a resounding silence spoken into a fragmented culture of noise. Merton speaks *in* silence, *of* silence, *from* silence and *with* silence; yet it is his intimacy with the mystery of how silence serves as the ground for speech, that empowers him to *speak to our silence*. At times, listening to silence can be deafening, but there is a grand paradox here: silence enables us to both truly hear and truly communicate. Thus we find in Merton's words a transformative perspective of communication for the twenty-first century: a contemplative approach from which to draw vital insights for healing our relations with others through the restoration of genuine communication.

[TMA 15 (2002) 77-102]
ISSN 0894 4857

Merton and Basho:
The Narrow Road Home

Leonard J. Biallas

While Thomas Merton consistently used superlatives to register his enthusiasm for authors who provided him great satisfaction, he often retracted his opinion just days or weeks later. In *The Other Side of the Mountain*, for example, he found B.F. Skinner important, but then dismissed him as boring. Lenny Bruce 'almost blows his mind', yet less than a month later, was excessively delusive and self-destroying. Kierkegaard was fascinating, but then deeply disturbing. One notable exception was Matsuo Basho (1644–94), probably the best known of all the Japanese *haiku* poets. While the purity and beauty of Basho's travel writings 'completely shattered' Merton and gave him a whole new view of his own life, the attraction was also perhaps due to the many similarities in their lives.[1]

Desire for Solitude
In 1965, Merton moved full time to his hermitage in the woods about a mile from the monastery: 'bright hermitage settled quietly under black pines' (5 Jan). This change of place symbolized a deep inner change: what mattered was silence, meditation and, only secondarily, his writing. He needed the silence and the emptying. He was resentful when those he encouraged to come into his world actually did so and took up

1.　In *The Other Side of the Mountain: The End of the Journey* (Journals, 7; 1967–1968; ed. Patrick Hart; San Francisco: HarperSanFrancisco, 1998) Merton cites Basho three times: 28 Nov., 2 Dec., and 19 Dec. 1967. He read Basho in the Penguin edition: *The Narrow Road to the Deep North and Other Travel Sketches* (trans. from the Japanese with an introduction by Nobuyuki Yuasa; New York: Penguin Classics, 1966). All quotes by Merton in this article, unless otherwise noted, are from his journal entries of 1968 in *Other Side*.

too much time and space. He complained that real solitude was less and less possible: 'too much noise, too many people, unwelcome curiosity seekers' (23 June).

Basho, too, retired to take up Zen meditation in a small hermitage house, far removed from an urban setting on the outskirts of Edo (ancient Tokyo). Captivated by a basho (banana) tree presented to him by his disciples, he took his final pen-name from the tree. This tree outside his door symbolized his very being: the tree did not bear fruit, its trunk had no practical use, it was easily torn by wind and rain, and yet its wide leaves fluttered in the breeze and provided plenty of shade.

In his hermitage Basho wished to evade worldly involvement, hoping to discover and define a perception of himself which linked the beauty and simplicity of the countryside together with his poetry. Yet, because of his reputation as a master poet, he found himself deeply involved in worldly affairs. His large circle of friends and disciples provided financial support, invited him to splendid dinner feasts, and arranged verse-writing parties in his honor. He had to lock his gate to escape the many demands made upon his time. He firmly resolved to live a life with just the ephemeral morning glory for a friend. *Only for morning glories I open my door – During the daytime I keep it Tightly barred.*[2]

Dissatisfaction with Writing

Often during his last year Merton questioned whether to give up his writing, dismissing it as provisional and inconclusive. Whether on politics, monastic problems, communion with God, social justice or interfaith dialogue, frequently he considered it trivial and dissatisfying. All the business of filing and cataloguing every little slip of paper was a comedy. 'Files too full. Shelves too full. Boxes' (20 Aug). Although he wanted to be liberated from what he considered a useless activity, his writing was like an addiction that he could not break.

Basho also felt there were many times when he was ready to drop the pursuit of writing: ever since he began to write poetry he never found peace with himself, always wavering between doubts of one kind or another. His writing was *mere drunken chatter, the incoherent babbling of a dreamer.* Poetry was a worldly temptation that prevented him from reaching an enlightened state of non-attachment. Still, the enchantment of poetry cast a spell so great that poetic sentiments invariably stirred his

2. Following the usual custom in Japanese literary criticism, I do not cite the exact source for Basho's *haikus*, merely placing them in italics. All the *haikus* here are taken from *Narrow Road*.

heart and something flickered in his mind. He thought he could attain total equanimity of mind by means of his poetry, but ironically, it was poetry itself that always unsettled his mind.

Desire to Travel

Merton wrote tantalizingly of his desire to travel — not so much to give seminars, retreats or conferences, but to find a site for a new monastery, to find the real Asia, to experience the great compassion (*mahakaruna*) of Buddhism. As much as the hermitage had meant to him, he needed to get away from Gethsemani — a distancing long overdue. Gripped with a sense of destiny, he was happy that he would finally be on the way after so many years of waiting and wondering. 'Two daiquiris in the airport bar. Impression of relaxation. Even only in the airport, a sense of recovering something of myself that has been long lost' (6 May). His travels in the last year of his life took him to New Mexico, California and Alaska, and finally, during the last few months, to holy places in India (Mahabalipuram), Sri Lanka (Polonnaruwa) and Bangkok. 'If I am to begin a relatively wandering life with no fixed abode, that's all right' (29 July).

Merton went to Asia as a pilgrim with a completely open mind, without special illusions. He had visited the East so many times in word, thought and imagination, preparing himself both spiritually and intellectually. He had read commentaries, critical literature and textual interpretations, and now it was time for the 'great adventure'. Now he could meet real Eastern Masters in their own monasteries and learn from them about their own spiritual traditions. He was buoyed by the possibility of attaining complete enlightenment, not after death, but in this life. On the day he left for the Orient, he was filled with joyful enthusiasm: 'The slow ballet of big tailfins in the sun. Now here. Now there. A quadrille of planes jockeying for place on the runway. The moment of take-off was ecstatic. The dewy wing was suddenly covered with rivers of cold sweat running backward. The window wept jagged shining courses of tears. Joy. We left the ground' (15 Oct).

Basho felt possessed by wanderlust and could not stop dreaming of roving. Roadside images invited him from every corner, and it was impossible to stay idle at home. After a massive fire destroyed his hermitage, he decided to expose himself literally to the ravages of the weather. He surrendered everything familiar and left home, hoping to emulate the example of the ancient monks who traveled thousands of miles and to attain absolute delight under the pure sky. Basho spent half of the last decade of his life traveling across Japan teaching and writing, returning to Edo only for short visits. He made short but happy sojourns in the houses of his disciples, leaving behind autographed texts that became

treasured family heirlooms. He celebrated the start of his journeys by scribbling on his hat *Nowhere in this wide universe have we a fixed abode.*[3]

Although there were times when Basho wanted to have an official post or live in a monastery, he continued his travels, motivated only partially by practical concerns, such as finding students, composing poetry with others or visiting acquaintances. He relished mainly the opportunity to wander where poets and sacred pilgrims of the past had walked and to visit famous places hallowed by natural beauty. He traveled most of all to renew his own spirit and to show his poetic mastery over the landscape. By deliberately planning his pilgrimages to remote areas, he renounced worldly concerns and absorbed the shocks and intrusions of life's uncertainties. *A traveler by that name will I be called, amidst first showers.*

The Self and Zen Buddhism

Both Merton and Basho pinpointed the human dilemma in our selfish cravings, our desire for pleasure and thirst for success and control. In our human frailty, we feel a compulsive need to be validated by the external trappings of money, power and leisure, thus alienating ourselves from our fellow humans, from nature and from who we really are. Though pleasure, success and control are impermanent and cannot provide us with lasting serenity and contentment, we continue to strive and crave for material things to prove our existence and guarantee happiness in life. How can we overcome this dilemma of our human frailty and selfish ego and thus live authentically? At this point, they took different approaches to the self (for Merton, the True Self; for Basho, the Real Self).

Merton looked to the contemplative life as the way to develop a new consciousness and awareness of the True Self. Through contemplation, he advised, we could realize our human interdependence and harmonious relationship with all that is in the world, thus overcoming the poisons of craving, hatred and ignorance of the illusory ego-self. His meditative experiences led him to envision the True Self as one who abandoned attachment to a particular ego for the service of others. Through opening ourselves to a loving relationship with others, which comes as a gift of God's grace, we humans can experience the spark of divinity in others.

Through his contemplative meditation Merton saw Christ's self-emptying in the event of the Incarnation as the perfect experience of absolute

3. Cf. the classic opening lines of *Narrow Road*: '*Days and months are travellers of eternity. So are the years that pass by. Those who steer a boat across the sea, or drive a horse over the earth till they succumb to the weight of years, spend every minute of their lives travelling. There are a great number of ancients, too, who died on the road. I myself have been tempted for a long time by the cloud-moving wind — filled with a strong desire to wander*'.

love and compassion, of ready willingness to be moved by love of 'the other', rather than one's own desires. Indeed, if Christians were to take the doctrine of the Incarnation seriously, they would find Christ living in them in such a way that the self is somehow 'no longer I'. They would find the divine presence in all persons, regardless of their race, culture or geographical location.

Through his familiarity with Zen Buddhism during the last decade of his life, Merton gradually expanded this notion of the True Self.[4] In correspondence with D.T. Suzuki he reflected on the Zen experience of emptiness (*sunyata*) and the search for direct perception of reality. He had a deep spiritual kinship with Thich Nhat Hanh, the Vietnamese Buddhist monk and social justice activist, who taught the practice of mindfulness as the path to greater compassion and inner peace. Merton felt a special bond with the Tibetan Dalai Lama who helped him to a deeper ground of consciousness.[5]

Merton found in Zen Buddhism an approach to reality undiluted by philosophical systems or formulas of belief, an experiential approach which transformed his life. He came to the realization that nothing exists by itself alone. All things 'inter-are', arising in mutual interdependence. He located the essence of Zen Buddhism in the capacity to see life freshly, to look intuitively into the nature of things. This is *satori*, a direct experience of reality, a recognition of the ordinary because in fact, nothing is ordinary. *Satori* is the enlightened state where the True Self acts spontaneously without thinking, reasoning or planning. The self is both awake and aware, fully accepting and savoring the present moment. The self is merely a locus in which the dance of the universe is complete from beginning to end.[6]

4. For Merton's writings in the spirit of Zen, see *The Way of Chuang Tzu* (New York: New Directions, 1965); *Mystics and Zen Masters* (New York: Farrar, Straus & Giroux, 1967); and *Zen and the Birds of Appetite* (New York: New Directions, 1968).
5. See Roger Corless, 'In Search of a Context for the Merton–Suzuki Dialogue', *The Merton Annual* 6 (1993), pp. 76-91, for a discussion of Suzuki's ambiguity as a leading Zen figure. See also Robert King, *Thomas Merton and Thich Nhat Hanh: Engaged Spirituality in an Age of Globalization* (New York: Continuum, 2001). Merton described his visits with the Dalai Lama (4, 6, 8 Nov) though he had already admitted that Tibetan Buddhism, with its ferocity, ritualism, superstition and magic did not exactly interest him (23 July).
6. Merton's attraction to Zen Buddhism has been extensively explored, especially in relation to the question of the True Self. For a fine bibliography of writings about Merton and his relationship with Buddhism, see Roger Corless, 'The Christian Exploration of Non-Christian Religions: Merton's Example and Where It Might Lead Us', *The Merton Annual* 13 (2000), pp. 105-122.

Before he returned to Basho's *Narrow Road*, Merton realized that in Zen Buddhism the True Self was the empty self, the self that is perfectly open in compassion to what is there, even something as simple as opening and closing a door. Going back to Basho he detected multiple examples of this emptiness and openness as the way out of the human dilemma.[7]

Basho found the Real Self, the everlasting self, not in meditation, but in writing his poetry. This self attains a freedom, detachment and wisdom that encompass all of nature, all living beings. The way beyond our human frailty is through identification with nature, out of great compassion (*mahakaruna*). The Real Self celebrates the beautiful in daily experience, just as rain quietly soaks the roots of trees. Intensely alive to the preciousness of everything that shares our world, the Real Self lets the present moment quietly penetrate inner sensibility. *Learn about pines from pines, and about bamboos from bamboos.* As the Real Self becomes one with the object, the sense of separate selfhood disappears in the immediacy of the direct experience of the delicate life and feelings of nature.

The Real Self identifies with the 'greater life' of the universe and is sensitive to the vibrating moments and profound suggestiveness of nature. Whether looking at mountains or flowers, listening to thunder or songs of birds, walking on smooth roads or in the mud, enjoying the falling blossoms or scattering leaves, the Real Self takes the universe as companion. All sense of separate selfhood disappears. *Real poetry is to lead a beautiful life. To live poetry is better than to write it.* Indeed, the Real Self is the poet, the one who recognizes ever-changing reality and is not attached to any particular aspect of it.[8]

Narrow Road

Basho is best known for his travel journals. The last and greatest of these, *The Narrow Road to the Deep North (Oku no hosomichi)*, is an artful and

7. Cf. Merton's early homage to Basho where he already indicated many of the themes that he would find so germane to his new vision of the True Self: 'When we are alone on a starlit night; when by chance we see the migrating birds in autumn descending on a grove of junipers to rest and eat; when we see children in a moment when they are really children; when we know love in our own hearts or when, like the Japanese poet Basho we hear an old frog land in a quiet pond with a solitary splash — at such times the awakening, the turning inside out of all values, the 'newness', the emptiness and the purity of vision that make themselves evident, provide a glimpse of the cosmic dance' (*New Seeds of Contemplation* [New York: New Directions, 1961], pp. 296-97).

8. See *Narrow Road*, p. 28, the Real Self is not the soul, but poetry: *Everything we do has a bearing upon the everlasting self which is poetry.*

carefully sculpted diary, rich in literary and Zen allusions. Basho record-ed the poignant feelings and perceptions that he encountered on his journeys of self-discovery to the wild northern provinces of Japan.[9]

The Japanese title *Oku no hosomichi* is very significant. Literally, it is the slender, delicate path far within. It alludes to Basho's 'narrow mind' which focuses on and penetrates to the depths of reality, beyond per-sonal emotions and aesthetic sentiments. He points his finger at the mystery of life while avoiding any attempt to analyze it. While his jour-ney takes him to an unsettled area in the north, the book primarily records his deep and difficult spiritual journey within. Basho's life and poetry are a spiritual journey—a journey charged with obstacles, but a journey that is its own reward in spiritual fulfillment.[10]

Basho gives us glimpses of those sharp moments of deep intuitive insight out of which poetry is born spontaneously. He shares moments of tranquil-mind-in-nature—moments of 'no mind', where not even a razor's edge splits his mind from what he writes. The temporal and visible, the eternal and concealed: all are real. With a mind so slender that it enters anything with plenty of room to spare, he discovers a vision of eternity in fleeting things, at once a celebration of the world and a whisper of his own mortality. When he observes a commonplace event and describes it with spareness, he makes us aware of a simple distilled moment, snatched from time's flow. *The secret of poetry lies in treading the middle path between the reality and the vacuity of the world.*

Basho's *Narrow Road* journeys into the interior of the self, where the landscape is both rugged and smooth. With firm resolve, he enters the Buddhist's path, searching for new perspectives on nature, the seasons and the carriers of poetic and cultural memory. He critically distances himself from the world of everyday life in order to purify himself from the attachments that tie him to this impermanent world. His destination is not as important as the journey itself to discover the sacred in the world of nature, whether visiting religious shrines or tradition-laden

9. In addition to recounting the journey on *The Narrow Road to the Deep North* (1689) which lasted over five months and covered more than 1500 miles, the slim vol-ume actually records four other journeys. These include *The Records of a Weather-Exposed Skeleton* (1685), *A Visit to the Kashima Shrine* (1687), *The Records of a Travel-Worn Satchel* (1688) and *A Visit to Sarashina Village* (1689). Literary re-creations of his actual journeys, with some details deliberately altered and incidents invented, they were published only posthumously in 1702. Over the centuries they have inspired countless travelers to follow in his footsteps.

10. Cf. Merton: 'Our real journey in life is interior: it is a matter of growth, deepen-ing and of an ever greater surrender to the creative action of love and grace in our hearts' (*The Road to Joy* [New York: Farrar, Straus & Giroux, 1989], p. 118).

mountains, whether moon-watching or cherry-blossom watching. He elicits joyful tears as the world of everyday life and the world of the spirit constantly hint at and reinforce each other. *The thought of the three thousand miles before me suddenly filled my heart, and neither the houses of the town nor the faces of my friends could be seen by my tearful eyes except as a vision.*

Travel in Basho's day was very precarious and uncomfortable: jagged topography, howling winds, pouring rain, leaking roofs — and especially the lice. *Shed of everything else, I still have some lice I picked up on the road — Crawling on my summer robes.* Though the miles his *Narrow Road* covered were very arduous, he always lived with the thought that everything should be welcomed. Sun or rain, kindness or animosity, food or famine, smiles or frowns, vitality or sickness, loneliness or fellowship, sadness or extreme pleasure — all were greeted equally. Cold winter rains, pine forests, and islands all shared their secrets with him. Flowers and birds, rocks and waterfalls transformed his self-conscious mind into a meditative mind that accepted and celebrated things just as they are.[11]

He infused his writings with deep sensibility, sharp perceptions and startling revelations. In silence, awe and self-forgetfulness he pointed to the very heart of nature in order to get us to stop looking, and to begin seeing. *Few in this world Notice those blossoms: Chestnut by the eaves.*

The Haiku

The *haiku* is the most recognizable of Japan's classical literary forms, enjoying a place of honor with other cultural settings such as the tea ceremony, flower arrangements, calligraphy and various forms of theater. It is a poem, in a three-line stanza with a 5-7-5 syllable pattern, which evokes the mystery of nature or the human condition, usually with a reference to the seasons. Altogether Basho wrote more than 1000 *haikus*, with his brilliance often breaking away from the straightforward conventional requirements to give new freedom and energy to the form.[12]

11. Modern variations in translations of *Narrow Road* reveal the many ways in which great art may intensify and illuminate our engagements with the real. Among the many impressive recent interpretations are Cid Corman and Kamaike Susumu, *Back Roads to Far Towns* (Fredonia, NY: White Pine Press, 1986); Robert Hass, *The Essential Haiku: Versions of Basho, Buson, and Issa* (Hopewell, NJ: The Ecco Press, 1994); and Donald Keene, *The Narrow Road to Oku* (Tokyo: Kodansha, 1996).

12. In Japan during Basho's time the *haiku* was just one aspect of a technique of writing known as *haikai*, where several poets linked verses together in a sportive and playful, fresh and uninhibited manner. The verses carried cultural associations largely embodied in nature, historical objects, geographic places and the landscape. In

In *Narrow Road* Basho mastered the art of writing *haibun*, that literary technique which combines a descriptive sketch with a *haiku*, so that they completely illuminate each other — like two mirrors facing each other. On seeing a waterfall, for example, he ingeniously explained the relationship between the incessant sound of the rapids and the falling petals of yellow mountain roses: 'The stream leaps with tremendous force over outthrust rocks at the top and descends a hundred feet into a dark green pool strewn with a thousand rocks. In the foreground he saw something lovely and delicate; behind it, he heard the powerful, violent force of nature. *One after another In silent succession fall The flowers of yellow rose — The roar of tumbling water'.*[13]

The language of Basho's *haikus* is quite mundane and its imagery tends to be modest: *Avoid adjectives of scale — you will love the world more and desire it less.* Nothing is gratuitous or unassimilated: everything counts. There is no intellectual interpretation nor emotional artifice. He does not so much compose *haikus* as become them — dusty roads, bird songs, cool breezes, even a frog jumping into a pond. His *haikus* capture those moments of openness in which the inner reality and unobtrusive beauty of primitive nature assert themselves. With a sense of discovery and wonderment, Basho makes nature's secrets transparent, thus returning us to the reality that we neglect most of the time.

Contented Solitariness

Buried deeply in Basho's writings are subjective elements which have their roots in the Buddhist view of the transience of human existence. Three of these — 'contented solitariness', 'non-attachment' and 'lightness' — find their way into Merton's *Other Side*.[14]

America since the 1960s *haikus* have thrived as a literary genre, and currently there are more than 50 English-language *haiku* magazines in print and online. See William J. Higginson, 'Less is More: *Haiku* is Flourishing in the Internet Age', *The Writer* 114.9 (September 2001), pp. 20-23. Scholars such as Nobuyuki Yuasa and Daisetz T. Suzuki, *Zen and Japanese Culture* (Princeton, NJ: Princeton University Press, 1970) argue for terse style in their translations. They are opposed to any rigidity of form, such as the use of flush-left alignment, slashes, punctuation marks and number of lines and syllables. Here, I try to keep the rhythm flowing and the sense more intelligible by placing Basho's *haikus* in italics and indicating the line breaks with capitalization.

13. Compare how Merton described a waterfall: 'Driving rain, and a long spectacular thin waterfall down the side of the mountain becomes, in a concrete channel outside the house, the fastest torrent I have ever seen. It must be running fifty miles an hour into the choppy bay' (27 Sept).

14. Many Japanese literary critics have provided commentaries on these aesthetic devices. See, e.g., Sam Hamill, *The Essential Basho* (Boston: Shambhala, 1999); Haruo Shirane, *Traces of Dreams: Landscape, Cultural Memory, and the Poetry of Basho* (Stanford,

'Contented solitariness' or 'quiet loneliness' is the usual translation of the Japanese poetic principle, *sabi*. *Sabi* alludes to the natural poignancy and beauty of temporal things: cherry blossoms fading, leaves falling, the harsh sounds of hail spattering on Basho's traveling hat. *On a bare branch A crow has settled down to roost In autumn dusk*. Basho crystallizes this tranquil acceptance of our human transience in the powerful image of a crow opting for a bare tree. Even a bird that soars in the boundless sky singing of the beauty of nature has to rest somewhere, no matter how briefly. This lonely bird evokes a great Beyond. All things come out of an unknown abyss of mystery, and through every one of them we can glimpse into that abyss. We remain silent. We grow pensive over our human destiny: we are no more enduring than the rest of nature. Crows, frogs, cicadas, even the seasons – all are transient, ending in death. Life is but the disappearing dream of a moment. The indifference of the universe prevails. We are lonely. *Spring departs – Birds cry; fishes' eyes Fill with tears.*

Like a frog, Basho's *haikus* plop into the timeless, endless pond of our minds, expanding over the surface in an ever-widening series of ripples to encompass the entire cosmos. *'The old pond; A frog jumps in – Plop.'*[15] Basho brings together the finite and the infinite in one profound experience: the pond has been there for centuries, yet the tiny splash disappears in a moment. The sound stirred up by the jumping frog grabs us with its immediacy and works on our sensibility. An insignificant change in nature suggests a weighty loneliness – the sound of water deepens the sense of surrounding quiet. Like Hakuin's sound of one hand clapping, the sound of the water is there and it is not there. Basho captures a

CA: Stanford University Press, 1998); Ueda Makoto, *Basho and his Interpreters: Selected Hokku with Commentary* (Stanford, CA: Stanford University Press, 1992); Lucien Stryk, *On Love and Barley: Haiku of Basho* (New York: Viking Press, 1985); Robert Aitken, *A Zen Wave: Basho's Haiku and Zen* (New York: Weatherhill, 1978). Also note the studies by Ihab Hassan, 'In the Mirror of the Sun: Reflections on Japanese and American Literature, Basho to Cage', *World Literature Today* 69.2 (Spring 1995), pp. 304-311; Richard B. Pilgrim, 'The Religious-Aesthetic of Matsuo Basho', *The Eastern Buddhist* 10 (1977), pp. 35-53; and James H. Foard, 'The Loneliness of Matsuo Basho', in Frank E. Reynolds and Donald Capps (eds), *The Biographical Process* (The Hague: Mouton, 1976), pp. 363-91.

15. There are more than 100 translations of Basho's most famous *haiku*. Here are just a few:

The old pond; the frog. Plop!
The old pond – A frog leaps in, And a splash.
The old pond, ah! A frog jumps in: The water's sound!
The old pond; A frog jumps in – The sound of the water;
Breaking the silence Of an ancient pond, A frog jumped into water – A deep resonance.

moment in which eternity manifests itself and, the next moment, there is stillness again. All is ambiguity, and there is no explanation.

Basho often expresses *sabi* in the lonely atmosphere of a cicada's raucous cry. *In the utter silence Of a temple, A cicada's voice alone Penetrates the rocks.* The fragile life of the little creature is fulfilled within the immense arena of the cosmos. The cicada sings out its life with hardly a hint of its imminent death. Its vigorous cry is loud and noisy, and its sound deepens the stillness by passing deep into our hearts. No other sound is heard. Listening to the cicada's cries, our minds attain tranquillity and our human desires disappear. We feel a loneliness as we encounter nature at its fullest and realize its quiet rhythm. Perceiving that all living things are evanescent is depressing; still, we are struck with a sublime feeling when we see a tiny creature enduring that sadness and fulfilling its destiny.

Basho shows how deeply he understands himself and his mortality in his *haikus* on the melancholy transience of the seasons, especially autumn, and at the New Year. *I could not help feeling vague misgivings about the future of my journey, as I watched the fallen leaves of autumn being carried away by the wind.* Autumn is as much the autumn of life as it is a season, and the journey is symbolic as much as geographic.[16] Today becomes tomorrow in swirling petals, fading flowers and falling leaves. Today is about to waste away, and we remain silent because no words are adequate to explain the 'emptiness' or 'suchness' of things. *Buddha's death day – Old hands Clicking rosaries.* Unwilling to part with the passing year, Basho drinks till late on the last night of the year. Waking only in the afternoon on New Year's Day, he is too late to join in the early morning festivities: *On the Second Day I'll be more careful – Flowering spring.*[17]

16. The Zen Buddhist would naturally claim that every *haiku* is the best *haiku*, but here are just a few which evoke the existential loneliness of autumn:

This road! With no one going – Autumn evening.
This autumn Why am I aging so? To the clouds, a bird.
This autumn eve, Please turn to me I, too, am a stranger.
First day of spring – I keep thinking about The end of autumn.
Hot radish Pierced my tongue, While the autumn wind Pierced my heart.
Still alive I am At the end of a long dream On my journey, Fall of an autumn day.

17. Merton echoed Basho's melancholy at the New Year: 'Only New Year's Day was bright. Very cold. Everything hard and sparkling, trees heavy with snow. I went for a walk up the side of Vineyard Knob, on the road to the fire tower, in secret hope of 'raising the sparks' (as the Hassidim say) and they rose a little. It was quiet, but too bright, as if this celebration belonged not to the new year or to any year. More germane to this new year is darkness, wetness, ice and cold, the scent of illness. But maybe that is good. Who can tell?' (3 Jan). This was for the New Year 1968, a year that

We should not confuse Basho's awareness of the transience of life with a premonition of death. True, he sold his house prior to his departure on the Narrow Road. Perhaps he did not expect to return from his journey, but more importantly, he was prepared to perish alone and leave his corpse to the mercies of the wilderness if that was his destiny. *Determined to fall A weather-exposed skeleton I cannot help the sore wind Blowing through my heart.* Even at the beginning of his journey, he imagined the coming hardships and he was ready to die. He could not prevent the brisk autumn wind from penetrating and chilling his mind. Basho traveled the Narrow Road seeking a vision of eternity in the things that are, by their own very nature, destined to perish. He was keenly aware that human life is ephemeral: *A thicket of summer grass Is all that remains Of the dreams and ambitions Of ancient warriors.*

When Basho was shown some strands of the white hair of his mother who had died a few months previously, the loneliness of old age quietly wrapped his world with its shadow. He plunged his personal sorrow into a more universal melancholy by imagining that the cluster of hair was frost, part of ever-changing nature. *Should I hold it in my hand It would melt in my burning tears – Autumnal frost.*[18] Again he made us sublimely conscious that nature and humanity are one. No one can avoid the anguish of death. Even in his last *haiku*, written as death neared, Basho expressed the lonely, helpless feeling of someone who had fallen asleep during a journey. He wanted to travel, but his body was restricted by illness; only his dreams were free to fly to the sky. *Ill on a journey My dreams over withered fields Meander.*[19]

he felt was going to be hard all the way and for everybody (21 Jan), the year that he felt would be a beast of a year, when things would finally and inexorably spell themselves out (6 April).

18. Compare Merton's pathos when he heard about his Aunt Kit's drowning in a ferry-boat accident in New Zealand: 'What can be said about such things? Nothing will do. Absurdity won't. An awful sense that somehow it had to be this way because it was, and no one can say why, really. And yet 'what did she ever do to deserve it?' Such a question does not make sense, and the God I believe in is not one who can be 'blamed', for it is he who suffers this incomprehensibility in me more than I do myself (25 April).

19. Merton, too, was keenly aware of human mortality and transience. 'Bleak leap-year extra day. Black, with a few snowflakes, like yesterday (Ash Wednesday) when no snow stayed on the ground but there was sleet and the rain-buckets nearly filled. All the grass is white with, not snow, death' (29 Feb). He did not expect anything to go wrong on his journey to the East, but he acknowledged that he might not come back (29 July). Death was present to him: he understood that he would simply not continue to exist as a self. The fullness of life he aimed for came from honestly and authentically facing death and accepting it without care. He recalled the words of

While we can in no way escape human transience, we can overcome loneliness by following the way of nature. Basho evokes *sabi* so that we can experience what he realized: we should never attempt to be other than ourselves. If we wish to maintain equilibrium, we have to dissolve the ego—that root of all agonizing longings—by immersing the self in the impersonal life of nature, in the every day world of the vast, powerful, magnificent universe. *Journey's end – Still alive, this Autumn evening.*

Non-Attachment

Basho taught that those who take delight in the beauty and simplicity of all worldly things while recognizing their frailty and impermanence are living with a spirit of non-attachment, or *wabi*. This moral principle expresses the longing in the depths of the human heart to go as far back to nature as human existence will permit and to be at one with it.[20] *Wabi* means enjoying a leisurely life free from worldly concerns such as wealth, power, or reputation. It means living quietly in a modest hut, for example, but providing a tea ceremony when friends come and arranging a fresh bouquet of flowers to enhance their serene afternoon. *Wabi* is the inexpressible quiet joy of a monk sipping his tea and savoring flowers. *For his morning tea A priest sits down In utter silence – Confronted by chrysanthemums.*

D.T. Suzuki describes *wabi* as 'transcendental aloofness in the midst of multiplicities'.[21] Those who practice *wabi* appreciate primitive simplicity and seek beauty in plain, simple, artless language. Recognizing the impossibility of escaping the transience of life in the world, they stand apart, taking a calm, carefree attitude to daily life. Indifferent to worldly

Meister Eckhart: 'Blessed are the poor in heart who leave everything to God now as they did before they ever existed' (30 June 1966).

20. Merton recognized the importance of this spirit of non-attachment and desire for oneness with nature and cited Basho at length: 'All who have achieved real excellence in any art, possess one thing in common, that is, a mind to obey nature, to be one with nature, throughout the four seasons of the year. Whatever such a mind sees is a flower, and whatever such a mind dreams of is the moon. It is only a barbarous mind that sees other than the flower, merely an animal mind that dreams of other than the moon. The first lesson for the artist is, therefore, to learn how to overcome such barbarism and animality, to follow nature, to be one with nature' (19 Dec. 1967). Note that in quoting Basho (from the Penguin edition of the *Narrow Road*, pp. 71-72), Merton is not exact.

21. Suzuki claims that 'In some ways, *wabi* is *sabi* and *sabi* is *wabi*; they are interchangeable terms' (*Zen and Japanese Culture*, p. 285). *Sabi* refers more to individual objects and the environment, whereas *wabi* is more subjective and points to living a life ordinarily associated with poverty and imperfection.

involvements, they feel at home in the world and radically affirm it with peace of mind. They are deeply aware of things modest and old, and they appreciate the simple and the ordinary. Satisfied with a little hut, a room or two, a dish of vegetables picked in the neighboring fields, perhaps listening to a gentle spring rainfall, they never entirely fail to interject a simple Ah! *Ah, it is spring, Great spring it is now, Great, great spring – Ah, great.*

Basho expresses non-attachment in many different *haikus*, for example, when he views pine trees, snow, flowers and, especially, the moon. He finds a sense of emancipating emptiness under the full moon on a clear night: we are free even of ourselves. Solitary and heavenly, the moon is a perfect object for contemplation, and there is no pleasure greater than enjoying the light of the full moon. There is something pure and authentic about sitting for a long time in utter silence, watching the moonlight trying to penetrate through the rifts made in the hanging clouds. In the emptiness of the new moon we can observe it keenly and listen to our still minds in the dark. *As I bent my ears to the noise of wooden clappers and the voices of the villagers chasing wild deer away, I felt in my heart that the loneliness of autumn was now consummated in the scene. I said to my companions, 'let us drink under the bright beams of the moon'.*

The pine tree, fresh and ever green amid winter's harshest storms, is true and beautiful because, like everything in nature, it has its own fulfillment. It leads its own life, and invariably pursues its own destiny. A pine tree does not have a selfish ego; it is a classical symbol of the vast silence, the 'suchness' of Zen. Basho, contemplating the beauty of pine trees on an island, marveled at their fascinating shapes. They are more beautiful and captivating than words can describe. *Pine islands, ah! Oh, Pine Islands, ah! Pine Islands, ah!* With a sense of awe and respect, Basho asks who else could have created such beauty but the great god of nature. His pen strives in vain to equal the superb creation of divine artifice. He declares that if anyone should dare to write more poems on the beauty of pine trees it would be like trying to add a sixth finger to the hand. *As I stood there, lending my ears to the roar of pine trees upon distant mountains, I felt moved deep in the bottom of my heart.*

Basho, stumbling into a country inn at nightfall, totally exhausted after long hours of traveling, is never too tired to admire a wisteria vine, drooping its delicate lavender blossoms over the veranda. He wants us to share his experience, to live it. He beckons us to travel over lonely, fatiguing mountain roads and to suddenly discover smiling violets along the roadside. Regard the flowers with awe, he tells us—regard their stems, their fresh green leaves, just as they are, bright in the sun. The flowers whisper the secret of the traveler's heart: modesty, gentleness

and simplicity are the truly beautiful things. *How I long to see Among dawn flowers, The face of God.*

Lightness

A third characteristic that Basho advocates late in his life and poetry — *karumi* — stresses simplicity and leanness. His poetry is not heavy — that is, conceptual — as he deliberately avoids abstraction, allegory or symbolism. *Eat vegetable soup rather than duck stew.* He focuses on everyday life of common people — harvesting radishes, planting bamboo, eating and drinking, having parties to view cherry blossoms. Expressing the familiar in simple, sometimes humorous, language, he leaves little to the imagination — and beauty emerges. With the playful spirit of a child, he sees the world with new eyes and a relaxed expression. *Beneath the trees In the soup salad, everywhere Cherry blossoms.*

Nodding with a puckered smile, Basho takes the cosmos on its own terms. Mixing humor with the loneliness of growing older, he expresses his heartfelt sentiments for the sake of poetic rapture. He awaits snowfall with eager expectation, for example, and would gladly go out for snow-viewing until he tumbles. *Come, let's go Snow-viewing Till we're buried.*

Equipped with the playful spirit of Zen Buddhism, he was open to chance encounters. With nowhere permanent to stay and no interest in keeping treasures, he traveled very lightly with few possessions — a raincoat, writing supplies, medicine, departure gifts, and a lunch basket. He accepted all things as they came, even smiling away an encounter with a robber. He remained in the mundane world with flexibility of mind, feeling neither anger nor sorrow, exuding instead the crackle of light-hearted humor. *There was a night, too, When a robber visited my home – The year end.*

Early in his travels Basho did not feel the need to share his experiences with others or to express compassion. For example, seeing a small abandoned child crying pitifully on the river bank, he felt the child could not ride through the stormy waters of life and was destined to have a life even shorter than that of the morning dew. Though he gave the fragile child what little food he had with him, he felt that this child's undeserved suffering had been caused by the irresistible will of heaven. Feeling powerless, he moved along, leaving the child behind, crying to heaven. He could only recall the heart-rending shriek of a monkey: nothing is more plaintive or pathetic. *The ancient poet Who pitied monkeys for their cries What would he say, if he saw This child crying in the autumn wind?*[22]

22. Note how Merton similarly dramatized his despair and awful emptiness in an encounter with a young child in Calcutta. 'The little girl who suddenly appeared at

It was only later in Basho's travels that the lightheartedness of *karumi*, with its undercurrent of compassion, came out in his poetry. Only later did his sense of the Real Self expand to include his relationship to other persons. He began to note the unexpected refinement of village urchins and farm-wives, and he began to praise the inherent honesty of inn-keepers and rural guides. He urged his young poetry students to be childlike, to rush out and make merry during a hailstorm. *For those who proclaim they've grown weary of children, there are no flowers.*

On one occasion when Basho's servant dozed off while riding precari-ously atop a horse and almost fell headlong over a precipice, Basho was at first terrified. On reflection, though, he perceived that we are all like the servant, wading through the ever-changing reefs of this world in stormy weather, totally blind to the hidden dangers. Surely the Buddha would feel the same misgivings about our human fortune: *It was as if the merciful Buddha himself had taken the shape of man to help me on my wandering pilgrimage.*

Basho thus only gradually came to realize the heart of compassion, the essence of the *bodhisattva*, the ideal of Mahayana Buddhism. The *bodhisattva* forsakes entering Nirvana out of compassion for other persons and returns to the realm of the ordinary people to help bring them to enlight-enment. The *bodhisattva* resides amid humans with 'bliss bestowing hands'. The Real Self is not only one with the world of nature, but also with other persons: when sad, the universe is sad; when glad, the whole universe is glad. Basho thus turns his energy outward. *One needs to work to achieve enlightenment and then return to the common world.*

One anecdote that well illustrates the lightness, humor and compassion of *karumi* is Basho's encounter with two courtesans. One night he had to listen to the whispers of two prostitutes in the next hotel room until fatigue lulled him to sleep. The next day, these complete strangers ap-proached him to ask if they could walk with him: 'If you are a priest as your black robe tells us, have mercy on us and help us to learn the great love of our Saviour'. After a moment's thought he replied that it was not possible, but that if they trusted in the saviour they would never lack divine protection. Just as the moon and flowers keep distance from each other, yet share their destiny, so too Basho and the women. *Under the same roof We all slept together, Concubines and I – Bush-clovers and the moon.*[23]

the window of my taxi, the utterly lovely smile with which she stretched out her hand, and then the extinguishing of the light when she drew it back empty. I had no Indian money yet. She fell away from the taxi as if she were sinking in water and drowning, and I wanted to die. I couldn't get her out of my mind. Yet when you give money to one, a dozen half kill themselves running after your cab' (17 Oct).

 23. Cf. Merton's story about the attractive college girl who starts a conversation

Other Side

Scholars often contend that *Other Side* has a fragmentary quality that Merton intended to revise after he put time and distance between himself and his Asian experience. Merton, they suggest, did not have the luxury to carefully refine his travel notes because of his untimely death; the jottings are not reflective and the intimate glimpses not polished. Actually Merton himself did not say that he had to rewrite his notes. He intimated only that he still had to reassess his whole Indian experience in more critical terms; for his journal notes, he wanted to leave everything and permit everything (30 May; 17 Nov).[24]

In fact, *Other Side* is not always haphazard and in need of editing. Merton is a poetic visionary providing us with roughly hewn gems, crisp and sharp. He shares his 'whole new view of his own life' (28 Nov) with us in an imaginative and ingenious manner. In his refreshing juxtaposition of images he very much writes *haibun* — prose written in the spirit of *haiku* — after the fashion of Basho. Basho, despite continually revising his original scribblings right up till publication, claimed that writing *haikus* had to be spontaneous and impressionistic. *Composition must occur in an instant, like a woodcutter felling a huge tree, or a swordsman leaping at his enemy.* What Merton provides us in *Other Side* is his mature spiritual vision, made with minimal finesse. Freshly stimulated as he traveled, he often exhibited Basho's *haiku* themes of contented solitariness, non-attachment and lightness in his journal.[25]

with him on a plane. He buys her a couple of drinks to make the smalltalk easier. He concludes in a humorous vein: 'A priest on a plane seems to be fair game for anyone' (26 Aug). Merton also retells a story about a Sufi at a reception where a courtesan had hastily been concealed behind a curtain so as not to give scandal when visitors arrived. She finally becomes tired, comes out and recites a pretty verse to the effect, 'I am what I appear to be. I hope you are the same' (30 Oct).

24. For a small representative sampling of commentaries on Merton's experiences in Asia, see Michael W. Higgins, *Heretic Blood: The Spiritual Geography of Thomas Merton* (Toronto: Stoddart, 1998); William H. Shannon, *Something of a Rebel: Thomas Merton, his Life and Work. An Introduction* (Cincinnati: St Anthony Messenger Press, 1997); Ron Seitz, *A Song for Nobody* (Liguori, MO: New Triumph Books, 1993); Alexander Lipski, *Thomas Merton and Asia: His Quest for Utopia* (Kalamazoo, MI: Cistercian Publications, 1983); Anthony Padovano, *The Human Journey: Thomas Merton — Symbol of a Century* (New York: Doubleday, 1982).

25. For some years Merton had celebrated his natural surroundings — the sweet-smelling air full of brilliant light, the monastery woods, the distant blue hills rising above the rolling Kentucky countryside. His terse observations of life around his hermitage — the shape of rocks and trees, train whistles, dogs barking, constellations

Contented Solitariness

For Merton the world is transitory and nothing has any value whatever, until it is connected to the totality of being and embraced by divine grace. He echoes the futility and solitariness of Basho's crow settling on a bare limb on an autumn evening: 'Chickens in the evening roosting in a line on a branch over the drinking fountain. No use' (30 May). A pervading sense of isolation emerges through his imagery of nature, especially the weather. 'Damp, leaden darkness. Falling snow (small wet flakes). Accidents' (6 Jan). There is a quiet beauty in solitariness, a depth of awareness beyond subject-object consciousness. 'Frost shines on the ground in the light of the setting moon. Very cold, very silent, when I was out during meditation – only a distant train – to have only one far noise is now equivalent to silence' (12 Feb).

Snow covers and subdues the muted colors of nature. 'The year struggles with its own blackness. Dark, wet mush of snow under frozen rain for two days' (3 Jan). In the evening, under a new moon, the hard snow crackles and squeals under his rubber boots. 'Snowflakes meet on the pages of the Breviary. Empty belly' (29 Feb). The hidden power of the universe that manifests itself in the human world with no concern for the welfare of its inhabitants makes him feel insignificant, lonely – the very crux of *sabi*. The intense icy loneliness of a cold night chills every part of his body. The sound of the frigid silent world penetrates his heart: 'I lay awake and listened to the hard ice cracking and hardening some more in the rain-barrel outside' (22 Feb).[26]

Non-Attachment

Yet Merton celebrates the high in the low, the spiritual in the mundane. Watching a butterfly soaring above the fields in the sunlight, he is filled with wonder. He attests that a butterfly, fluttering on a white flower,

of stars – read like enigmatic and ironic *haiku* poetry. 'Extraordinary purple in the north over the pines. Ruins of gnats on the table under the lamp' (14 Oct. 1966). He especially enjoyed writing his two long poems *Cables to the Ace* (1967) and *The Geography of Lograire* (published posthumously, 1969) because they got him away from self-consciousness and introversion. Of all the works in *The Collected Poems of Thomas Merton* (New York: New Directions, published posthumously in 1977) these two best reveal his 'new way of seeing' that the True Self necessarily embraces and shows compassion for the natural world as well as other persons.

26. Note the similarity with Basho's *haikus*: *Tonight, the wind blowing Through the Basho tree, I hear the leaking rain Drop against a basin.* And again: *The sound of a water jar Cracking on this icy night As I lie awake.*

proves the real value of elements seemingly useless in nature. He finds serenity as a butterfly appears in the bright sunlight, zigzags across the view, hovers and settles briefly, and then vanishes. There is a sense of self-detachment reminiscent of Chuang Tzu's dream: was he only dreaming that he was a butterfly, or was he really a butterfly, dreaming that he was human? 'The dream changes. Two white butterflies alight on separate flowers. They rise, play together briefly, accidentally in the air, then depart in different directions' (5 Nov).[27]

Like the butterflies, birds are tokens of love, providing Merton that touch of surprise and childlike joy which are characteristic of *wabi*. He exclaims his wonder as a towhee makes a discreet, questioning chirp in the rose hedge or a mockingbird patrols the hedge to keep other birds from nesting there. He delights as crows wheel in the sky, their dance mingling with the movements of their own shadows on the bare hillside. He is enchanted as a white crane stands in sunny water and briefly shakes herself while another flies low over a green paddy and alights. He is amused by golden crowned kinglets playing and feeding on the saplings, flipping and hanging upside down, almost somersaulting in the air. 'A flight of excited starlings passes in front of the moon' (23 Mar). Simple joys in our transitory complicated world.[28]

Lighthearted birds, Merton marvels, 'listened without protest to my singing of the antiphons. We are part of a menage, a liturgy, a fellowship of sorts' (13 Feb). A fellowship indeed between the birds and the monk. They delight in the woods, constantly travel in search of some unspoiled place, and enjoy a vast panoramic view of the world. They seek shelter in the shade of trees, where they can stay quiet in the sun for a long time and enjoy warmth and peace. Sparrows frolic and play in the blossoms, oblivious to any unease inherent in the world. Birds have no desire for wealth, power, and reputation — and yet they possess the highest spirit. Chirping innocently, spontaneously, and naturally, birds are a gift from heaven. Cheerful and expansive, they cling to nothing and lead a happy,

27. When a young woman named Butterfly hands Basho a small piece of white silk and asks him to write a poem choosing her name as the subject, he compares her to a butterfly whose wings are perfumed by an orchid's fragrance. He joins together exquisite beauty and sensual dignity. *A Butterfly Poised on a tender orchid, How sweetly the incense Burns on its wings.*

28. Nothing is missing, nothing left over in Basho's *haikus* on birds: *The cry of the cuckoo Goes slanting — ah! Across the water.* Just that sound — out of nowhere. Not even a bird, only the cry, totally vivid. *A lightning flash — And, piercing the darkness, The night heron's cry.*

unrestricted life. 'Song sparrows everywhere in the twisted trees —
neither accept nor reject anything' (13 May).

Lightness

For Basho, *karumi* was a poetic device to stress simplicity and leanness of
language and to exhibit a sense of humor. More than this, it gradually
broadened his understanding of the Real Self to include compassion and
oneness with other persons. For Merton, lightness takes a different turn.
Merton too finds his themes in familiar things and expresses them in un-
complicated language. He avoids abstract philosophical argumentation
and allows beauty to emerge, especially when he records his reflections
and experiences with animals such as rabbits, squirrels and woodchucks.
He finds deer particularly fascinating. As they stand motionless out in
the middle of the field, watching him, he perceives that they reveal to him
something essential, something profound, about the True Self. Gradu-
ally, Merton's notion of the True Self expands: in his new way of seeing,
it extends outward to embrace and show compassion for the natural
world as well as for other persons.

While Merton identified closely with birds and deer, he also felt a spe-
cial kinship with other animals, such as dogs and frogs. He was amused
and entertained that dogs liked to go for walks, run from the guest
house, chase cats away from their food, and jump on his bed with enor-
mous tail wagging and saying 'I love you — *feed* me' (26 Dec. 1967). He
reveled in a neighbor's dog that 'ran on the melting ice, rolled in the
manure spread over the pasture (rolled twice!), came out of the brush
with her tail full of dead leaves and in a final paroxysm of energy chased
a cat into the cow barn. A completely successful afternoon for *her* any-
way!!' (26 Jan). He enjoyed the small nation of frogs that chanted bliss-
fully at night in praise of the spring rain and sang in the afternoon after
the sun melted the ice.

Merton expresses his imaginative spirit of *karumi* not only in his com-
passionate solidarity with nature and animals, but in his energetic humor
and youthful playfulness. He takes pleasure in dislocating accepted
perceptions and purposely breaking with normal images and atmos-
phere. 'In the east, blue and purple clouds laid on lightly as if with a dry
brush — and clear blue sky above them. The field is heavy with frost. Gas
is getting low in the tank' (4 Feb). He juxtaposes humans and nature in
an unexpected way. 'Today the plumbers finished installing bathroom
fixtures, but they don't work yet — no septic tank. The white irises are
beginning to bloom. The grass is deep and green' (4 May). When he
hears a quail whistling in the field, he exclaims that 'perhaps it's that

mother gathering in her five 'civilized' ones. Hope she tells them a thing or two about people' (27 July).

Merton peppers his journal with humorous *haiku*-like poetry once he departs on the airplane for Asia. 'Flight yoga. Training in cosmic colors. Dull, concise bronze of ginger ale... Ginger ale has in it perfume of stewardess' (17 Sept). In Calcutta, he is jarred by 'three big, blue buffaloes lying in a patch of purple, eating the flowers' (22 Oct). He places the noble side-by-side with the simple: 'Gandhiji's broken glasses — Johnson has stopped the bombing. Two magpies are fighting in a tree' (3 Nov). Just prior to his first visit with the Dalai Lama, the incongruity greatly entertains him: the Lama's private chaplain 'was wearing tinted glasses. The usual rows of little bowls of water. A tanka. Marigolds growing in old tin cans. Artificial flowers in a Coke bottle' (3 Nov).

Clarity

The Narrow Road to Basho's Real Self and Merton's True Self leads them to contented solitariness, non-attachment to the world, and a sense of humor and compassion for other persons and for nature. The road culminates — after much travail — in an inner clarity that is most evident in their experiences and descriptions of mountains and religious shrines.

For Basho, each mountain had its message of patience, with its pines bearing the marks of many long years, its moss lying on piles of massive rocks and ancient soil, its snows shining forth in purple robes. The quiet, lonely beauty of the peaks soaring above the horizon, rising into heaven, like swords piercing the sky, purified his heart. At the mysterious moment of daybreak, he prays: *God of this mountain, May you be kind enough To show me your face Among the dawning blossoms?*

With reticent tears Basho bemoaned that he could not speak of the holy secrets that mountains contain. He found Mount Fuji especially spiritually enhancing, with its beautiful formation and covering of spotless snow. He never tired of viewing it — in the crisp air of autumn, as it stood out boldly against the dark sky; in winter, when it appeared like a dream of white in a sky of palest blue; or even on a rainy day, when it remained deeply buried behind the clouds. On days when the clouds lifted only momentarily, the whole mountain still filled him with sacred awe. *In a way It was fun Not to see Mount Fuji In foggy rain.*[29]

29. Here are two more translations of this *haiku* that attempt to express Basho's fascination with this mountain:
A day when Fuji Is obscured by misty rain! That's interesting.
Heavy falling mist — Mount Fuji not visible, But still intriguing.

Merton too was overwhelmed by mountains — the vastness, the snow-covered peaks, the patterns of glaciers. In California, he found the distant presence of the peaks like great silent gods, white and solemn. In Alaska he could not keep his eyes off the Chugach Range, struck by their beauty and terror. He found them sacred and majestic, ominous and enormous, noble and stirring. 'Dangerous valleys. Points. Saws. Snowy nails' (24 Sept). Even before he saw them, the Himalayas revealed a landscape that was interior, yet there: the unforgettable valleys with rivers winding at the bottom, the rugged peaks above, and the pines twisted as in Chinese paintings. 'O the mountains of Nepal... In the Mountains of Nepal, no trains... O the Mountains of Nepal' (19 July).

The mountains of his dreams were far from the reality of his first encounters with Kanchenjunga, though, and he was far from being astounded at its 28,000-foot height. 'On being tired of Kanchenjunga. On the mountain being mercifully hidden by clouds' (17 Nov). He is annoyed by its big crude blush in the sunrise. 'Fog hides the mountains. Fog gets in the sore throat. No matter' (17 Nov). A few days later, however, Merton does what he has done so often throughout his writings: he retracts his feelings and modifies his relationship with the mountain. 'There is another side of Kanchenjunga and of every mountain — the side that has never been photographed and turned into postcards. That is the only side worth seeing' (19 Nov). This sacred mountain, even hidden by massive clouds, is transparent and symbolizes opposites in unity: impermanence and patience, solidity and nonbeing, existence and wisdom. 'The full beauty of the mountain is not seen until you too consent to the impossible paradox: it is and is not. When nothing more needs to be said, the smoke of ideas clears, the mountain is SEEN' (19 Nov).

In the majestic mountain silence, broken only occasionally by the sound of a goatherd's flute drifting up from a pasture below, Merton heard what was written within him: 'Thou art that'. He heard a prolonged 'OM' in the quietly droning monotonous humming of a Tibetan man trekking up the mountain. Perhaps he had found this ancient syllable long ago in the rocks, perhaps it had been born with him. The mountainside experience made him realize that he did not yet fully appreciate his exposure to Asia. Still, the mountains did bring him clarity, as he would repeat like a mantra several times.

Merton had clarity that mountains, firm and awesome, are divine incarnations in stone, and their peaks rising above the clouds are conduits through which sacred energy passes into our world. For him mountains are mandalas, centered on the divine presence, where heaven and earth are reunited. Mountains create a new inner vision, where we see a presence larger than ourselves, a spiritual landscape existing within the

physical landscape. Beholding mountains, we experience moments of triumph for our True Selves as we realize that the whole universe is a gift issuing forth moment by moment, ever fresh, astounding in its richness and beauty. Here we enjoy moments of discovery of the awesome glory of God. More than this, we experience those moments of transfiguration as we learn what it means to be human most fully and to recognize the divinity in each of us. It has been there all along, but we do not perceive or appreciate it until such moments. Such clarity does not lead us to disengage from the world, but to follow the path of compassion back down the mountain to share the sacred experience to others.

In addition to mountains, pilgrimage shrines brought moments of clarity to Basho and Merton. As Basho bowed reverently at a shrine of the Buddha, he felt the purifying power of the holy environment pervading his whole being. *The tall statue of Buddha, originally six feet and six inches tall had become covered with green moss save for the divine face that shone forth.* The bells from the temple struck deep to the innermost part of his being, his Real Self. A shrine's radiance was so awesome and extensive that he could forget the troubles and hardships he had suffered on the road to visit it.

The statues of Buddha evoked for Basho a sense of dignity, solemnity and refinement. When exquisite chysanthemums were set around the lonely appearance of old Buddhist images, the scent awakened nostalgic sentiments. The refined fragrance of flowers, like the pure and strong smell of incense, represented the Buddha and vice versa. *Chrysanthemum's scent – In Nara, many ancient Buddhas.* Basho rejoiced in the utter happiness at the joyful moments when he could visit a pilgrimage shrine. Here, he could overcome 'otherness', whether this otherness was the living memory of his ancestors, or nature with its crumbling mountains on the horizon, or the otherness within himself. This victory was his traveler's reward, moving him to joyful tears.

As with the mountains, clarity regarding the pilgrimage shrines did not come to Merton without much travail. He had been suffering inner turmoil for some time. Evaluating his short time in Asia, he chided himself: 'Too much "looking for" something: an answer, a vision, "something other". And this breeds illusion' (17 Nov). He had a definite feeling that philosophical dialogues with Buddhists were a waste of time. To talk about impermanence was one thing, to experience it another.

He came to realize that direct experience, rather than dialogue, was the way to dissolve his illusion about Asia. He was able to communicate with Buddhist monks and share with them an essentially spiritual experience which was somehow in harmony with Christianity. This was a very significant discovery: it was only by actually being in Asia that he could

adjust his perspectives. 'The sun is warm. Everything falls into place. Nothing is to be decided; nor is 'Asia' to be put in some category or other. There is nothing to be judged'. (17 Nov) Direct experiences of the follies of tourism are a catalyst in his process of coming to clarity. Visa problems, waiting for hours in strange airports, staying in hotels of faded splendor, not finding a decent drink in messy and smoky bars, being overcharged by the druggist—all this is the 'real Asia'. The illusion is gone. He is ready for Polonnaruwa.

In a narrative that has become classic, Merton describes his visit to three colossal stone figures of the Buddha at Polonnaruwa, a city of ruins in Sri Lanka.[30] Admiring their artistic beauty, he approached the Buddhas barefoot and undisturbed. Merton felt gratitude at the obvious clarity and fluidity of the shape of the figures. Just as Basho had proclaimed that no one could dare to describe the beauty of pine trees, so Merton felt that he could never write adequately about this experience. He stood in awe at the design of the monuments composed into the rock shape and landscape. 'The silence of the extraordinary faces. The great smiles. Huge and yet subtle' (4 Dec).

The Buddha statues pulled him suddenly away from his ordinary outlook on nature, and an inner clarity became evident, as if bursting from the very rocks themselves. 'Clarity' was not a new metaphor for Merton. Many times he claimed that a 'vision' of the ordinary things of life in an extraordinary way brought him clarity. At such moments he saw beyond illusion to reality, and looked at the daily world around him with freshness and wonder. This was a 'virginal experience'—a moment of awe and inexpressible innocence—when he realized the presence of God within very ordinary, familiar and natural events. Such a profound experience got beyond the shadow and the disguise: it was what he had been obscurely looking for.[31]

What made the shrine at Polonnaruwa so powerful and energizing for Merton was that he discerned there the ultimate unity of all reality. He discovered it not in a moment of meditation, not in a moment of compassionate recognition of the unity of all people—but in the sudden illumination triggered by the statues. The Buddha statues were icons—windows into eternity—pulsating with divinity, reality and life. Merton

30. For an insightful commentary on Merton's transfigurative experience at Polonnaruwa, see Gary Commins, 'Thomas Merton's Three Epiphanies', *Theology Today* 56 (April 1999), pp. 59-73.

31. 'Something he had been looking for' is a signature statement for moments of profound experience, a marker of Merton's personal transformations. See William H. Shannon, *Silent Lamp: The Thomas Merton Story* (New York: Crossroad, 1992), p. 278, for other times when Merton uses this expression.

experienced what the statues asserted: all problems are resolved and everything is clear, simply because what matters is clear. The rock, all matter, all life—everything is emptiness and everything is compassion. In this experience he realized that the gate of heaven is in everything as well as everyone. With this, illusion was dissolved. That is why he could declare that surely with Polonnaruwa (and earlier at the shrine at Mahabalipuram) he had found the true way on his pilgrimage to the East. The world—self, others, nature—was transparent. Merton had found the Narrow Road back home.

Homecoming

It is curious that only after one journeys to a strange land, a new country, that the inner voice guiding one's search is fully revealed. Just as fascinating is the fact that the one who reveals the significance of our journey is so often a stranger from another culture and religious tradition.[32] Through our travels we discover treasures buried in the most secret recesses of our very being that perhaps would have remained hidden if we had stayed at home. Paradoxically, our commitment to the journey and our recognition of our transitoriness are the very paths for us to know at last our Real, our True, Selves. This is the genuine homecoming, arriving not where we started geographically, but at the very heart of our being.

And so it was for Basho and Merton. Basho was beckoned by roadside images from every corner, and it was impossible for him to stay idle in his hermitage. On the *Narrow Road* he found his Real Self in his poetry about the ever-changing aspects of nature. He was 'at home' with nature, with himself and with others. Dwellings—normally associated with home—were only temporary lodgings on life's journey. For him, *the journey itself is home. Each step is the first step, each step the last. Everyday is a journey, and the journey itself is home.*

Merton, as he left for Asia, sensed that his real homecoming was just about complete: 'I am going home, to a home where I have never been in this body' (15 Oct). Through his direct contact with the *Other Side* of the mountains and pilgrim shrines he found his True Self within himself, in that true sanctuary of his 'Father's house'. He felt he had come a very long way to where he really belonged and he was convinced that his revelatory experience at Polonnaruwa had something to do with his 'going home'. Gethsemani 'is my monastery and being away has helped me see it in perspective and love it more' (17 Nov).

32. See Leonard J. Biallas, *Pilgrim: A Spirituality of Travel* (Quincy, IL: Franciscan Press, 2002) for more on Merton as pilgrim and on the pilgrim's homecoming.

Merton found nothing in his travels that he essentially could not have found back home. 'The country which is nowhere is the real home' (30 May). Home, indeed, is not so much a place, but a simple being-alive, a basic presence, the way animals so beautifully seem to fill their skins, trees their bark, and rivers their banks. The True Self is not distant, but present, inside him. His real home is in his heart, the center of his memories and imagination that helps him focus his energy at the signature moments of his life. His real home roots him in eternity and his homecoming concludes his inner journey along the narrow and holy way. Home and homecoming are the symbol of his final fullness and wisdom, where he achieves that harmony in God which alone makes life worth living. He finally realizes that all the countries of the world are one under the one sky, and he no longer needs to travel.

The sweet taste of freedom in Merton's heart when he travels makes him feel wonderfully alive and uninhibited. He is free from trying to construct an image for others, unbound by illusion and pretense—'no room left for masks'. He breaks through the lamentable crust of ruins, decadence and misery, and sees things clear and complete as they really are—'the real Asia'. Discerning gifts worth cherishing, he has come home to a greater cosmic self in compassionate communion with others and with nature. He is at home everywhere. Home is the subtle energetic milieu, where everything around him extols the spirit.

Such is the magic of travel. Merton appreciates and responds with awe and wonder to all of life and pours out his nothingness to God in gratitude. As he had proclaimed when he had first encountered Basho on his spiritual journey many years earlier, he could now 'cast our awful solemnity to the winds and join in the general dance'.[33] In his homecoming Merton thus completes the journey he began long before in *The Seven Storey Mountain*:

> In one sense we are always travelling, travelling as if we did not know where we were going. In another sense we have already arrived. We cannot arrive at the perfect possession of God in this life, and that is why we are travelling and in darkness. But we already possess Him by grace and therefore in that sense we have arrived and are dwelling in the light. But oh! How far I have to go to find You in Whom I have already arrived![34]

33. Thomas Merton, *New Seeds of Contemplation* (New York: New Directions, 1961), p. 297.

34. Thomas Merton, *The Seven Storey Mountain* (New York: Harcourt Brace, 1948), p. 419.

[TMA 15 (2002) 103-120]
ISSN 0894 4857

'Hiding the Ace of Freedoms': Discovering the Way(s) of Peace in Thomas Merton's *Cables to the Ace*[*]

Lynn Szabo

'You leave behind a vision of yourself when you go,
and a new one is created along the way' — Bob Dylan[1]

In one of the last of the cantos that comprise Thomas Merton's collage of prose and poetry, *Cables to the Ace* (or *Familiar Liturgies of Misunderstanding*) (1968), the poet declares: 'I am about to... / Set my mind a thousand feet high / On the ace of songs' where 'we learn by the cables of orioles'. He continues: 'I am about to build my nest / In the misdirected and unpaid express / As I walk away from this poem / Hiding the ace of freedoms'.[2] The picture here is of the poet as the bird who ascends the tree, his home, his shelter, his nest, his ace, by myriad pathways, seemingly directionless, but in which are hidden his access to freedom.

The metaphor Merton chooses as the central conceit in *Cables to the Ace* is one of luxurious ambiguity and enormously tensile capabilities. The cables that tether the poet to his ace are like those by which the ship's anchor is raised and lowered and/or the bundles of cables designed to carry an electric current or to transmit messages across boundless time and space. They are like the cables of the bridge that allow its suspension in mid-air with assured security. They are analogous to the cables that fasten the tightrope on which the walker crosses ever so precariously,

[*] The research for this paper was partially funded by a grant from The Social Sciences and Humanities Research Council of Canada.
 1. Quoted by Bill Wyman (March 2001), *www.Salon.com/bobdylan*.
 2. Thomas Merton, *Cables to the Ace* in *idem*, *The Collected Poems of Thomas Merton* (New York: New Directions, 1977), pp. 393-454 (454). Unless otherwise noted all quotations will be taken from this volume.

but eventually, to the other side. In our new century, they are a more powerful scientific and social influence than we have ever known, captivating and capturing human society and offering seemingly infinite capabilities for communication and knowledge — the worldwide web of fiber-optic 'cables' known as the Internet. They are also, though, the cables that bring messages of death and destruction to their readers — the teletransmitters of news, horrific and inevitable. They are the means by which governments rule and advertisers proliferate, often creating an ethos of propaganda and misinformation that accompanies their arrival. Earlier, in *Conjectures of a Guilty Bystander*, Merton had written: 'The double-talk of totalism and propaganda is probably not intentionally ironic. But it is so systematically dedicated to an ambiguous concept of reality that no parody could equal the macabre horror of its humor. There is nothing left but to quote [its] own words'.[3] These words are a prescient perspective for a reading of *Cables to the Ace* in which Merton's poetic voice, as it has never done previously, creates all of these possibilities (and those he could not have imagined), in its ever-widening gyres of intelligence and iconoclasm.

At the time during which *Cables to the Ace* was written, Merton was focusing more fully on creative writing, particularly poetry. In his letter of 8 October 1966, to James Laughlin of New Directions, Merton's publisher and friend, he supposed that 'perhaps the most living way to approach theological and philosophical problems…[is] in the form of creative writing and literary criticism'.[4] In his Working Notebook no. 17 (which comprises personal notes from the end of 1965 to the beginning of 1966), he writes that 'this means regarding poetry as more essentially my work (instead of an accidental pastime)'.[5] When he makes a list of his aspirations on the following page of this journal, he says, 'Another conviction: great importance of poetry in my life now'.[6]

Such poems as 'Letters to Che', 'Picture of a Black Child with a White Doll', Secular Signs' and, later, *The Geography of Lograire*, reflect his profound concern with social issues along with the sense of freedom granted by his spending of much more time at, and eventual permanent relocation to, his hermitage, St Mary of Carmel. His wide-ranging readings

3. Thomas Merton, *Conjectures of a Guilty Bystander* (Garden City, NY: Doubleday, 1966), p. 241.
4. Letter to James Laughlin 8 October 1966, in David D. Cooper (ed.), *Thomas Merton and James Laughlin: Selected Letters* (New York: W.W. Norton, 1997), pp. 300-301.
5. Thomas Merton, Working Notebook no. 17, p. 64. All unpublished notations taken from these notebooks are used by permission of the Merton Legacy Trust. Some of the workbooks are paginated; others are not.
6. Merton, Working Notebook no. 17, p. 65.

include the writings of Gandhi, Bonhoeffer, Boris Pasternak (with whom he corresponded in the now famous Cold War Letters),[7] Thich Nhat Hanh, Gabriel Marcel, William Faulkner, Dorothy Day and Flannery O'Connor. Merton's notebooks and the marginalia in his personal copies of books he was reading are a fascinating study in his genius's ability to appropriate, synthesize and recreate his own imaginative vision about this complex period of history.[8] He read, for instance, Nietzsche's *The Birth of a Tragedy* while in St Anthony's Hospital for medical treatment in July 1965. A year later, he studied T.S. Eliot's *The Sacred Wood* at the hermitage, noting Eliot's 'objective correlative' as the strategy for expressing emotion in language—a concept that would influence his writing of *Cables* and *Lograire*.[9] Freud, Tillich, Heidigger and Berdyaev (whom he credits with 'a good critique on subjectivity')[10] are central to Merton's readings in philosophy and psychology. Added to these are his profound responses to the thought of Camus, Rilke, Sartre and Roland Barthes in the arena of literature and language. In his review of Barthes' *Writing Degree Zero*, Merton demonstrates his synthesis of Zen and structuralism, with its groundbreaking ideas about the 'language of philosophy that understands the "sign" to be "arbitrary"'.[11] On reading Camus, Merton offers his interpretation that the problem of *The Plague* is that it 'deprives the inhabitants of the plague-stricken town of the consolation of the past and hope in the future, forcing them to live in an impossible present'.[12] In February 1966, while reading Rilke, Merton notes that he clearly realizes that his preoccupation with Rilke is its enshrining of solitude. He was still deeply conflicted by his choice to be a solitary—a vocation that, more often than not, seemed to fly directly in the face of his profound concern for the world outside the monastery. In response to Rilke, he writes, 'it [solitude] is a central problem for me and for this age and I might as well cope with it as best I can, without illusions and without pretense—in other words humbly, doggedly, patiently, faithfully. This too is *Auftrag*'.[13] To these numerous seminal readings,

7. Thomas Merton, *Witness to Freedom: Letters in Times of Crisis* (ed. William H. Shannon; New York: Farrar, Straus & Giroux, 1994).

8. Fifty-two entries that later became cantos in *Cables to the Ace*, appear in Working Notebook no. 15 (August 1965).

9. Merton, Working Notebook no. 15 (August 1965–66).

10. George Woodcock, *Thomas Merton, Monk and Poet: A Critical Study* (Vancouver: Douglas and McIntrye, 1978), flyleaf.

11. Thomas Merton, 'Roland Barthes—Writing as Temperature', in Br. P. Hart (ed.), *The Literary Essays of Thomas Merton* (New York: New Directions, 1960), pp. 140-46.

12. Thomas Merton, Working Notebook no. 14 (June 1964).

13. Merton, Working Notebook no. 17, entry for Septuagesima Sunday, 6 Feb

Merton adds the influences of Sartre's treatise on literature and existentialist thought. He is struck by Sartre's idea that when the reader engages a text,

> meaning is no longer contained in the words, since it is [the reader]…who allows the signification of each of them to be understood; and the literary object, though realized through language, is never given in language. On the contrary, it [the literary object] is by nature silent and an opponent to the word.[14]

This idea is ultimately an instructive hermeneutical principle by which *Cables to the Ace* can be navigated. In the silent moment of ambiguity/ contemplation about possible 'meanings' in the text, Sartre 'appeals to the reader to lead into objective existence the revelation that the writer has undertaken by means of language'.[15] Merton calls on his readers to do just that. Significant here (and for fruitful readings of the entire corpus of Merton's poetry) is that Merton did not embrace, as have many of the postmodernist deconstructionists, the notion that there are, in essence, no ultimate meanings, no overarching metanarratives. (Bradford T. Stull, in his perspicacious discussion of the late poetry of Merton, contemplates Merton's relationship to postmodernism, on other grounds.)[16] Rather, for Merton, the multiplicities and complexities of literature and its human stories are radiant with fecundity in the ways in which they ultimately lead us back to the unity and oneness of God and humanity.

During this period, Merton was publishing poems in numerous journals and magazines — *Commonweal, Catholic World, Motive, Poetry* and *Sewanee Review,* to name only a few. Later, he would initiate his own literary journal, *Monks Pond* (1968) (perhaps with the encouragement of Wendell Berry and Denise Levertov).[17] He invited and received submissions from notables among his contemporaries — Jack Kerouac, Louis Zukofsky, Wendell Berry, Denise Levertov, and others. He was deeply involved with ideas and perspectives that would form the confluence of his enormous epic poem of social history, *The Geography of Lograire.*

Cables to the Ace presents the revolution/evolution of Merton's adoption of anti-poetry, resulting in large part from his contact with the

1966, p. 77. NB. *Auftrag* in the German refers to an assigned task, a commission bestowed on the one by the another.

14. J.P. Sartre, *Literature and Existentialism* (trans. Bernard Frechtman; New York: The Citadel Press, 1962), p. 44. (Underlined in Merton's copy of the text).

15. Sartre, *Literature and Existentialism*, p. 46.

16. Bradford T. Stull, *Religious Dialectics of Pain and Imagination* (Albany, NY: State University of New York Press, 1994), p. 175 n. 14.

17. Michael Mott, *The Seven Mountains of Thomas Merton* (Boston: Houghton Mifflin, 1984), p. 503.

poetry of the Chilean poet, Nicanor Parra, to whose writings he was introduced by James Laughlin, and some of whose antipoems Merton translated into English in 1967[18] (eight of which appear in *The Collected Poems of Thomas Merton*); to this, one should add the influence of Pablo Neruda, Octavio Paz and Pablo Antonio Cuadra (who had visited Merton at the monastery in May 1958, and some of whose poems Merton had translated in *The Jaguar and The New Moon* [1959]), as well as numerous other Latin American poets, including Michel Grinberg, to whom Merton was introduced by Ernesto Cardenal, a Nicaraguan poet and erstwhile novice under Merton at the Abbey of Gethsemani. He was particularly influenced by the Surrealist poets of South America. Thérèse Lentfoehr comments that in *Cables* this 'surrealist influence shows Merton's metaphors drift[ing] loose from their referents, with the result of a suspension of meaning'.[19] I would counter that this is, in fact, the strategy by which he creates parody and irony, thus giving genesis to multiple layers of meaning in this collage of prose and poetry. From his readings in Sartre, Merton noted that,

> the habit of anti-poetry...opens up the [s]ort of thing which a merely reasonable approach could not accept...Its style [is] a sequence of *non sequiturs*. An underground logic of association in conflict with the apparent demands of logical communication...–a Surrealist poem.[20]

He goes on to realize that 'after you have read it for awhile it haunts you in your next book...you find for yourself, curious resonances that aren't really there'.[21] This notation is valuable in that it very much describes the characteristics of the antipoetry which Merton adopted as he wrote *Cables*.

In conjunction with Merton's own literary activities during this period, he was occupied with such voices as Bob Dylan (whose recordings were sent to him by Ed Rice in the hopes of having Merton review them for *Jubilee* and to whom Merton referred, somewhat unconvincingly, as the American François Villon).[22] Merton was taken with Dylan's 'Rainy Day Woman' and in notebook no. 15 (August 1965–66), he writes that 'Dylan sees life as a mosaic of unrelated [and] superficial images – clashing in a ludicrous entertainment that has its own special significance'; Merton

18. Ross Labrie, *The Art of Thomas Merton* (Fort Worth, TX: Texas Christian University Press, 1979), p. 136.

19. Sister Therese Lentfoehr, *Words and Silence: On the Poetry of Thomas Merton* (New York: New Directions, 1979), p. 74.

20. Thomas Merton, Working Notebook no. 18 (1966–67).

21. Merton, Working Notebook no. 18.

22. Mott, *The Seven Mountains*, p. 461.

goes on to claim that Dylan's music mimes 'the psychopathology of everyday life'.[23] This recognition appears in Merton's allusions to the poetics of Dylan's music, which mirrors the frenetic and fractured images which Merton picks up on:

> I am an entire sensate parcel
> Of registered earth.
> Working my way through adolescence
> To swim dashing storms
> Of amusement and attend
> The copyrighted tornado
> Of sheer sound
>
> Though metal strings
> Complain of my mind's eye
> Nine fond harmonies
> Never leave me alone...
>
> Plate glass music
> And oracular houses
> Of earth spent calm
> Long comas of the propitious time...[24]

Other voices of the times also captured Merton's attention. Their diversity included Canadian media theorist Marshall McLuhan, along with numerous 1960s poets such as Gary Snyder, Robert Lowell and Edwin Muir; to these, one must add his important correspondence with Czeslaw Milosz, as well as his extensive reading in social commentary and philosophy. Probably as a response to their influences, in a letter to Cid Corman, Merton describes *Cables* as imprecise, noisy, crude, full of vulgarity and parody, making faces and criticizing and so on...[25] His contact with the world outside the monastery is constant and increasing. In Working Notebook no. 16 (August 1965–November 1965), he notes that the monks are now getting newspaper pictures of space flights on the monastery bulletin board (he goes on to connect the human desire for flight with the ascension of Christ) although in the same notebook he acerbically adds that he feels trapped in the monastery because 'the abbot keeps [him] in to salve his own conscious for being out'.[26] But thanks to the beneficence of friends who send along numerous contemporary magazines and journals, Merton is not isolated from what he

23. Merton, Working Notebook no. 15.

24. Merton, *Collected Poems*, p. 447.

25. Thomas Merton, 5 September, 1966, in *idem, Courage for Truth: Letters to Writers* (ed. Christine M. Bochen; New York: Farrar, Straus & Giroux, 1993), p. 249.

26. Thomas Merton, Working Notebook no. 16, p. 53.

wishes to read. His notes include the circulation copies of *Life* and *Playboy* (although he specifically asked Ping Ferry not to send *Playboy* to him, wryly commenting that he was not 'strong enough').[27] More seriously, Merton writes,

> I have not faced technological society and the crises of maladjusted man in a culture which develops too fast for him… My task is to come to terms completely with the world which I love and of which I am a part, because this is the world redeemed by Christ… That is why I am here [at Gethsemani] and must stay here.[28]

In the June 1964 issue of *Realités*, he read, with amazement, that computers could read 12000 words a minute; that theologians at the Vatican had asked a computer if God existed and it had replied, 'Now He does'.[29] Later, in the delectably satiric *Cables* 8, Merton's speaker relates his attempt to engage a computer in spiritual dialogue:

> Write a prayer to a computer? But first of all you have to find out how It thinks. Does It dig prayer? More important still, does It dig me?… How does one begin: 'O Thou great unalarmed and humorless electric sense…'?[30]

In the antipoetry that ultimately forms the 88 Cantos of *Cables to the Ace*, Merton's poetic voice synthesizes the forces of his multi-faceted consciousness — ranging from the quiet romanticism and piety of the earlier poems to the eclecticism of *Emblems of a Season of Fury* (1963), which had integrated his longtime concern with social unrest and his experience of Zen. Merton's burning world 'consumes prophets and dilettantes alike'.[31] He passionately claims that 'all the ascesis of [his] life as a hermit centers on…real awakeness'.[32] During this period, when Merton is conflicted about the amount he is writing in comparison with the solitude he says he desires, he chastises himself for his 'verbalizing' and, in frustration, remarks that '[p]erhaps the Zen way is better — (silence until the whole thing breaks and then there is one enigmatic word for all of it)'.[33] But, of course, his relation with Zen went much deeper than this. He had been mentored by John C.H. Wu in the sayings of Chuang Tzu (which he paraphrased in English and referred to as one

27. Mott, *The Seven Mountains*, p. 460.
28. Merton, Working Notebook no. 16, p. 53.
29. Merton, Working Notebook no. 14.
30. Merton, *Collected Poems*, pp. 399-400.
31. Labrie, *The Art of Thomas Merton*, p. 133.
32. Merton, Working Notebook no. 17, p. 78.
33. Merton, Working Notebook no. 16, p. 13.

of his 'necessary' books, in the Rilkean sense).[34] And interestingly, Daisetz Suzuki (Japanese Zen Master) eventually assigned to Merton the somewhat dubious claim of being the one Westerner who understood Zen better than any other.[35] Suzuki and Merton had found substantial commonality in their interreligious dialogue. Merton had engaged some of the East's connections with his own understanding of Western mysticism and wrote of Suzuki that he had 'transposed Zen into the authentic terms of Western mystical traditions that were most akin to it'.[36] Although Merton had been experimenting with concrete poetry in his diaries as far back as 1949, when he wrote *Cables* he seems, as Thérèse Lentfoehr claims, to have 'pulled all its focus into a Zen mystical dimension...'[37]

The innovative modes of antipoetry that Merton adopts often dissuade his readers from venturing further but, in fact, there is a myriad of *Cables* which can support such a venture. Indeed, the poetic voice in *Cables to the Ace* deploys a tonality beyond satire and parody that results in expression which is often terse and subversive. It is anticipated by the poet's announcement in the 'Prologue' that 'the poet...has changed his address and his poetics are on vacation'.[38] This was, Merton explained in a letter to Robert Lax, his plan 'to create an atmosphere in which the parts of the poem were suspended in 'midair' between true and false... an everlasting *pons asinorum* (bridge of access)'.[39] But Merton's rebellion against, even defiance of, lyrical tones and forms was not experimental or experiential in the same way as the beat or antipoets of his age, even though Merton was influenced and fascinated by them. His purposes, as usual, framed in the context of his spiritual journey, were iconclastic and prophetic. He attacks cherished beliefs and the icons of a material culture but he does so in order to open them into the wholeness of the Hidden Ground of Love.[40] Ross Labrie explains it well when he says that Merton created possibilities for 'fresh...experience' and 'original idiom' with his antipoetry, which was 'a campaign against the debasement of language'.[41]

34. Merton, Working Notebook no. 16, p. 59.
35. Mott, *The Seven Mountains*, p. 309.
36. Merton, *Zen and the Birds of Appetite* (New York: New Directions, 1968), p. 63.
37. Lentfoehr, *Words and Silence*, p. 63.
38. Merton, *Collected Poems*, p. 395.
39. Letter to Robert Lax, 4 November 1966, quoted in Labrie, *The Art of Thomas Merton*, p. 138.
40. Thomas Merton, letter to Amiya Chakravarty, 13 April 1967, in *idem*, *The Hidden Ground of Love* (ed. William H. Shannon; New York: Harcourt, Brace & Jovanovitch, 1985), p.115.
41. Labrie, *The Art of Thomas Merton*, p. 136.

In *Cables to the Ace*, Merton's alternatives to poetic conventions and subversions of cultural norms offer us rich allusions that convey his consciousness of a Ground of Being in which human beings can share their experience rather than devolving into the folly and pessimism of 'the imago, the absurd spectro, the mask over their own emptiness'.[42]

This assumption of folly and pessimism is the almost inevitable result of the abuses and debasements which attend the fracturing of language from intention and context. Monica Weis concludes that Merton's writings in this period are a form of cartography 'pointing to the core virtues, or habits of being, that we need in order to discover our true identity and set the direction of our lives'; she further explains that these habits are characterized by a sense of place (which for Merton had become the hermitage), religious wisdom (now affirmed in Merton's renewed monasticism, post-romantic friendship with M.), and innocence (which Weiss defines as 'reassurance that one is *in* the right'),[43] (not necessarily *right*) (emphasis mine).

This is further demonstrated by Merton's ecumenism and openness to traditions of mysticism and monasticism in other religions. George Kilcourse Jr, reminds us that Merton's final years demonstrate the convergence of his efforts at Western monastic renewal and dialogue with Asian spiritual traditions.[44] In *Cables to the Ace*, this convergence is melded with pre- and non-Christian mythology and allusion. Among the many references and entrances given to Catholic liturgy, saints and mystics, Merton includes quotations from and allusions to Greek mythology, Plato, Shakespeare's Caliban and Dogen, and so on. In addition, the working notebooks that supported Merton's writing of *Cables* contain numerous quotations gathered from his eclectic readings in Chuang Tzu, the myths of Atlas, Blake, Joyce's *Finnegun's Wake* and its Ulysses' myth, T.S. Eliot, and the New Testament, along with American Pop culture, technological exposés and nuclear physics.

In order to clarify further the context of Merton's writing of *Cables to the Ace*, it is crucial to situate it in some of his other experiences — intellectual, social and spiritual. The 1960s had spawned social unrest of phenomenal proportions in America, resulting in the assassinations of Martin Luther King, Malcolm X and the Kennedys. At this time Merton became active in the Catholic Peace Fellowship and was in regular

42. Merton, *Witness to Freedom*, p. 292.
43. Monica Weis, 'Ishi Means Man: Book Reviews that Critique Society', *The Merton Seasonal* 24.4 (1999), pp. 9-13. (11, 13).
44. George Kilcourse, Jr, *Ace of Freedoms: Thomas Merton's Christ* (Notre Dame, IN: Notre Dame University Press, 1993), p. 10.

contact with the Berrigan brothers; he received visits at the hermitage from Joan Baez (who, with her husband Ira Perl, had founded the Institute for Non-Violence); he was conducting an intense correspondence with Rosemary Radford Reuther regarding feminism and his positions on theological and social issues; meanwhile, Chuang Tzu's teachings had taught Merton how to fast and how to hear with his whole being, in the Eastern way. (He concludes that the West has technology without wisdom while the East has wisdom without technology[45] — a theme central to his writing of *The Geography of Lograire*.) Merton registers his commonality with Tao. He has a profound encounter with Thich Nhat Hanh, who comes to Gethsemani to see Merton in May of 1966 — a visit which results in the famous ecumenical essay, 'Nhat Hanh Is my Brother'. To these experiences Merton responds with a series of essays and reviews on social and cultural issues, particularly focused on marginalized and oppressed peoples, caught in the violence of the decline of modern Western culture.[46]

His passionate focus on the debasement of language as a corollary of this decline forms the platform for his antipoetry. He will not allow his use of poetic form and structure to be sucked into the vortex of spiritual and cultural degradation, as he observes it. His response is to explode poetic conventions into a language which finds its intentionality in non-violent solutions to exploitations of every kind. He asserts in his incisive essay, 'Ghandi and the One-Eyed Giant', that 'violence is essentially wordless', falling into the chasm between thought and communication (the abyss between one's 'true self' and one's 'false self').[47] In this chasm foments the chaos of history, language and culture, which are in decline; their realities are subsumed by technocracy and commerce with their attendant colonizing and totalizing forces of consumerism and aggrandizement. These forces evacuate human autonomy and freedom from the societies that they invade. The incumbent dilemma is satirized throughout the images and tones in *Cables*, particularly impressively in Cable 50:

> Give me a cunning dollar that tells me no lie
> Better informed
> Truth-telling twenties
> And fifties that understand

45. Thomas Merton, 'Gandhi and the One-eyed Giant', in *idem, Gandhi on Non-Violence* (New York: New Directions, 1965), p. 1.

46. Thomas Merton, *Raids on the Unspeakable* (New York: New Directions, 1964); *idem, Conjectures of a Guilty Bystander* (Notre Dame, IN: University of Notre Dame Press, 1968).

47. Merton, 'Gandhi and the One-eyed Giant', p. 6.

I want to carry
Cracking new money
That knows and loves me
And is my intimate all-looking doctor
Old costly whiteheaded
Family friend
I want my money
To know me like whiskey
I want it to forgive
Past present and future
Make me numb
And advertise
My buzzing feedbacking
Business-making mind

O give me a cunning dollar
That tells me the right time
It will make me president and sport...

And I want my money
To write my business letters
Early every day.

He goes on, in a sardonic anthropomorphism, to characterize human life in a technocracy:

Each ant has his appointed task
One to study strategy
And one to teach it
One to cool the frigidaire
And one to heat it.

Each ant has his appointed round
In the technical circuit
All the way to high
One to make it and the other to break it...

Each ant has his appointed strategy to heat
To fuse and to fire at the enemy
And cool it down again to ninety-nine
In the right order—
But sometimes with the wrong apparatus.[48]

Cable 48 (subtitled 'Newscast') gives us an iconic illumination of the text of *Cables* which can assist our attempts to locate the convergence of Merton's poetics with his subversion of the language of poetry—his manifesto against the distortions of language in culture and the media. It

48. Merton, *Collected Poems*, pp. 429-31.

is here where Merton seems to turn language in on itself, seemingly obfuscating its intentions. These nine stanzas of reportage present the reader with a stunning disjunction of form and content, creating a vacuum of disquieting silence in the intellectual and emotional resonance of the words. This silent disjunction is subsumed by satire and, at times, sardonic wit:

> ...All-important Washington drolls
> Continue today the burning of forbidden customs
> Printed joys are rapidly un-deciphered
> As from the final page remain
> No more than the perfumes
> And military shadows
> President says the affair must now warn
> All the star-secret homespuns and undecided face-makers
>
> Today's top announcement is a frozen society
> Publicizing a new sherbet of matrimonial midways
> And free family lore all over the front pages...[49]

One must trek far beyond the words themselves and their conventional uses in order to locate their intention. Indeed, the complexities of meaning in the antipoetic statements Merton adopts are present in the self-reflexive ironies present in the intentions, not the disguises of the utterances. The disturbance and anxiety that result from this seemingly meaningless juxtaposition of phrases and images subverts the expectation of the reader/listener, leaving behind a seemingly unrequited desire for interpretation. The disjunction of form and content is complex and frustrating, requiring its audience to enter this silencing of meaning and humbly, if unwillingly, accept its incumbent disorientation. From such reconnaissance ensues the recognition of the debasements of language by the dominant powers in the culture with their all too often sinister motivations—for Merton, the perpetrators are government and the mass media in their drive to commerce. But here, the ephemeral but real silences in cognition and emotion engendered in the poem's audience demand a fresh commitment from the reader with every new approach, bidding us to contemplation. The difficulty, of course, is that our modern lives are

> so cluttered with words that we no longer know how to handle silence...
> Our life is poured out in useless words, we...never hear anything...never
> become anything, and in the end, because we have said everything before
> we had anything to say, we [are] speechless.[50]

49. Merton, *Collected Poems*, pp. 427-28.
50. Thomas Merton, letter to Amiya Chakravarty, 13 April 1967, in *idem, The Hidden Ground of Love*, p. 115.

As the reader recoils from the disorienting moment, this 'newscast' purveys the witty and sarcastic humour that its speaker employs. The poem's imagery takes on the warped effects of a hall of mirrors in which one knows that there is a reality but cannot detect it anywhere in the distortions that the mirrors reflect. There is, at once, the grotesque and the humoresque:

> Children of large nervous furs
> Will grow more pale this morning
> In king populations
> Where today drug leaders
> Will promote an ever increasing traffic
> Of irritant colors
> Signs of this evident group
> Are said to be almost local...
>
> Today a small general open space
> Was found lodged in the immediate shadow
> Of the heavenly pole. It was occupied
> Early in the week by Russian force teams...[51]

The reader's response motivates a desire for understanding, a return to the language of meaning, but the seeming vacuity of the text has now subverted that possibility. In this canto, Merton's speaker demands reflection about a culture and society that are in peril when language is no longer associated with authenticity and reality.

In an incisive study of a culture's loss of myth (or in postmodern terms, the deconstruction of the metanarrative), Mircea Eliade offers observations that Merton read and studied and which very well might have helped to impel his writing of *Cables*: 'that it is of the greatest importance to rediscover a whole[ness]...which is concealed in the most ordinary, everyday life of contemporary man; it will depend upon himself whether he can work his way back to the source and rediscover the profound meanings of all these faded images and damaged myths'.[52] In her early thesis on *Cables to the Ace*, Gail Ramshaw gives entrance to some of the complexities of the work with the premise that 'the chaos of amnesia is challenged by the power of the voice of myth'.[53] In the silent, even contemplative pause elicited by the poet's words and images, is rendered the longing for wholeness and integrity that, for Merton, is the

51. Thomas Merton, *Collected Poems*, p. 427.
52. Mircea Eliade, *Images and Symbols in Religious Symbolism* (New York: Sheed & Ward, 1961), p. 128. Merton underlined this passage in his reading of the text.
53. Gail Ramshaw, 'The Pattern in Thomas Merton's *Cables to the Ace*', *The Merton Annual* 10 (1968), pp. 235-46.

call to humanity and unity. It is the moment to recognize one's Ground of Being as at one with peace and compassion. In *Cables*, one can see demonstrated the irony which shocks its audience into the recognition of its peril, in the manner of Jesus' parables.[54] In the instinct that follows, one engages the poet's intentions which decry the violence which erupts when language and its speakers' intentions devolve into misunderstanding and fragmentation, propaganda and war.

Merton resonated profound dismay with what he was reading about the disintegration, decentering of the relationship between 'sign' and 'signifier' in the culture's use of language. Although he did not employ the term, we recognize Merton's understanding of what would become the 'postmodern' bent in literary theory, when he noted the words of Karl Jaspers:

> In the cultural chaos that now exists, anything can be said, but only in such a way that it signifies nothing. The vagueness of the meaning of words... the renunciation of that true significance which first enables mind to enter into touch with mind, has made an essential mutual understanding impossible. When language is used without true significance, it loses its purpose as a means of communication and becomes an end in itself.[55]

As readers engage *Cables to the Ace*, they instinctively proffer the mind substitutes for words and images in order to bring 'sense' to what seems to be 'nonsense'; in this process, the contravention of meaning in these verses becomes clear. Merton is at play with words in this vivid expression of the vulnerability of language, but not in the manner of the postmodern game of deconstruction. Rather, his pose is grounded in the certainty that language, like all aspects of being, is fundamentally incarnational; though it often takes on the limitations and vulnerability of its forms. In the end, it is its speakers and hearers who manipulate language without regard for its relationship to truth and reality, creating the suspicious hermeneutic common to postmodernity and concluding that irony is the only outcome for language. If we fail the moments of meaning, Merton would claim that 'we will not find our 'true selves' because the play of the images that make up the sign systems that constitute our culture evolves from [this] disassociation of ourselves from others'.[56] Merton paid special attention to Karl Jaspers' theory that 'when we misuse language, we generate a myriad of significances that constitute the sound and fury of our lives. But in such, there is no Being. No God.

54. Kilcourse, Jr, *Ace of Freedoms*, p. 158.
55. Karl Jaspers, *Man in the Modern Age* (New York: Doubleday, 1957), pp. 127-28.
56. Robert Inchausti, *Thomas Merton's American Prophecy* (New York: State University Press, 1998), p. 133.

No silence. [No possibility for *satori, dharma, prajna*.] Only dissonance, tropes, and complex systems of irony'.[57] In the silent reprise that accompanies this recognition, cable 48 summons its audience to respond with intention and commitment to heal the wounds by which words, in their debased form, betray humanity and truth. The awakening moment of contemplation that results in the attentive reader of *Cables to the Ace* produces a Zen-like recognition of Merton's poetic purposes. One seeks not to understand the words but to recognize their profound misuse.

Only in the intuitive understanding, beyond the words one reads and hears, can meanings be deployed. At such moments, in the luxuries of the absence of sound and noise, intuitions become clearheadedness, awakeness, knowingness and beingness. In these precious, hidden and fragmented intuitions of wisdom lie transcendence and wholeness—the 'non-violent alternative' in which language is emptied of the violence which explodes between thought and communication. In this desert devoid of easy answers to its riddles, in this solitude, space and emptiness, seemingly unavailable to decoding, is the way of peace.

It is fitting that in Cable 86, near the end of the *Cables* (which were to be continued/'pourrait être continue'), Merton calls on the fourteenth-century apophatic mystics Eckhart and Ruysbroeck whose perspectives and experience inform Merton's engagement of a kind of *via negativa*. In his *Cables*, there is much of darkness and negativity, illuminant only when misunderstanding and false promises are radiated by 'the true word of Eternity'[58] and the 'shadow of God which enlightens our inward wilderness'.[59] Even in the ethos created by the distortions and implosions of the dichotomy of language and intentionality, the light and shadows are reversed and light shines from the luminiferous images to which the poet's language alludes. In retrospection, one sees that it is the later cable 80 that provides a glossarial context for the panoramic and dramatic force of *Cables to the Ace* (indeed, Merton himself claimed that the *Cables* could be read backwards or forwards with similar effect);[60] this being so, they demonstrate their elasticity and reflexivity in relation to time and space, giving them, as a whole, an attribute of transcendence:

> Slowly slowly
> Comes Christ through the garden
> Speaking to the sacred trees
> Their branches bear his light without harm

57. Jaspers, *Man in the Modern Age*, p. 128.
58. Meister Eckhart, quoted in Merton, *Collected Poems*, p. 453.
59. Ruysbroeck, quoted in Merton, *Collected Poems*, p. 453.
60. Merton, letter to James Laughlin, 4 June 1967 in Cooper (ed.), *Thomas Merton and James Laughlin*, pp. 321-22.

Slowly slowly
Comes Christ through the ruins
Seeking the lost disciple
A timid one
Too literate
To believe words...

The disciple will awaken
When he knows history
But slowly slowly
The Lord of History
Weeps into the fire.[61]

In this prayerful lyric, human history becomes the realm of God's king-dom. The weeping Christ brings salvation in the wake of his tears, ready to extinguish the fires of our ruin. The repetitions and falling trochées of the lines serve to harmonize the theme and tone, reflecting the ongoing work of God in Christ. Slowly but certainly, they reiterate and recover the paradox of life in death, refracting images of peace, recasting the power of language and *logos*, 'seeking the lost disciple.../ Too literate / To believe words'. In this conflation of language and history, the poem's speaker confidently asserts that with Christ as the Lord of our History, we are '[n]ot to be without words in a season of effort. Not to be without a vow in the summer of harvest'. He continues with the contextualizing question: 'What have the signs promised on the lonely hill?' and then patiently points us to the illuminating admonition: 'Word and work have their measure, and so does pain. Look in your own life and see if you find it'.[62] This is no mean or facile triumphalism. It is a knowledge born of loss, ruination, the void, the desert. From the:

> [t]otal poverty of the Creator...springs everything. The waste is inexhausti-ble. Infinite Zero. Everything comes from this desert Nothing. But for each of us there is...a point of nothingness in the midst of being: the incompara-ble point not to be discovered by insight. If you seek it, you are lost. If you stop seeking, it is there. But you must not turn to it. Once you become aware of yourself as a seeker, you are lost. But if you are content to be lost you will be found without knowing it, precisely because you are lost, for you are, at last Nowhere.[63]

In this Zen-like 'nowhereness', Merton's poetic voice captures the essence of the moment of creation before the unconscious mind can usurp

61. Merton, *Collected Poems*, p. 449.
62. Merton, *Collected Poems*, p. 450.
63. Merton, *Collected Poems*, p. 452.

expression. In such a timeless moment, Being takes on the manner of childlike simplicity and purity, as does the assumption of peace. The ace remains anchored, a refuge at the heart of all the noise, subterfusion and chaos. The poet 'walk[s] away from this poem / Hiding the ace of freedoms' to which are fixed all the 'cables', negative or goodly, and by which all of us may be led back to the hidden wholeness resident in God and all his created beings.

Ultimately, there is a synchronous parallel between the process that takes place in the interior/exterior life of Merton and the epiphanous temperament of his poetic voice, entirely appropriate to the monk who sought unity, integration, and most of all, transcendence of the self. This journey has intensified in the mystic's silence and solitude which engenders his embrace of active non-violence by his social conscience. In the decade prior to his death, Merton had reached far into and beyond his own humanity and spirituality to renew his explorations and his commitment to unity with humanity and God. The now famous Fourth and Walnut passage, experienced and recorded well before his antipoetic voice had matured, points us directly to such unifying, integrating moments:

> In Louisville, on the corner of Fourth and Walnut, in the center of the shopping district, I was suddenly overwhelmed with the realization that I loved all these people, that they were mine and I was theirs, that we could not be alien to one another even though we were total strangers… I have the immense joy of being human, a member of the race in which God himself became incarnate. As if the sorrows and stupidities of the human condition could overwhelm me, now that I realize what we all are. If only everybody could realize this! But it cannot be explained. There is no way of telling people that they are all walking around shining like the sun.[64]

This iconic epiphany provides the legend by which to decode the *Cables* which lead us to the 'freedom' hidden in their irony and paradox, belying the unity and incarnate truth in which language is grounded.

Merton's journey was characterized by his passion for both silence and peace — his 'non-violent alternative'. *Cables to the Ace* chronicles the iconoclasm and subversion of language, idea and mystic ideal which accompanied his embracing of non-violence. Ultimately, the complexity and mystery that threaten to confound the reader of Merton's penultimate epic antipoem are the same means by which he indentures his paradigm for the mystic's experience of transcendent peace. In the concluding cables, the poetic voice points us to the Christian's hope for salvation from the abyss of violence into which we are at every moment threaten-

64. Merton, *Conjectures of a Guilty Bystander*, p.140.

ing to fall. From *Cables to the Ace*, Merton's dramatic and poetic icon, radiates the power of the Incarnational Word, wherein history, language, conscience and intentionality are fused and integrated, rendering wholeness and salvation.

[TMA 15 (2002) 121-135]
ISSN 0894 4857

The Influence of 'Beat' Generation Poetry on the Work of Thomas Merton

Claire Hoertz Badaracco

Thomas Merton balanced a public voice with a strong interior emotional life in the Cistercian contemplative tradition. Yet in his later poetry, Merton's writing reflected the technical experiments of his contemporaries who embedded political and social concerns within literature. In Merton's *Cables to the Ace*, he sought to balance the political weight of a symbol against the emotion of a visual image. *Cables* is a lamentation, a liturgy framed in secular language directed to an audience that included the Beat poets who argued about the death of the best minds of a generation of Americans, a decade before the media argued about the death of God. The public identities of Beat generation poets rested on the pose of being angry, misunderstood and rebellious. The movement included Lawrence Ferlinghetti, Robert Kelly, Robert Duncan, Robert Creeley, Gregory Corso, Jack Kerouac and Ken Kesey. Though Merton felt a spiritual kinship with the Beats, his journal entries and correspondence with Robert Lax show an impatience with any poet trying to preach, to play the guru; as the decade waned he became less eager to jump on the City Lights bandwagon. Nonetheless, by the 1960s, his literary reputation established, Merton had looked for heaven in a grain of sand, and in an epic poem. Less religious men had. Merton admired his contemporaries who had written large, epic-length poems like Ginsberg's *Howl* or William Carlos Williams's *Paterson*. This admiration included the Objectivist poet Louis Zukofsky, whose poem *A*, a 800+ page libretto, composed over a 50-year period, spanned generations. Though not very well known to the American public, the attempt set Zukofsky as a poet's poet, in Merton's view, an exceptional writer, who could tell a story, write an autobiography, if you will, through poetry.

Unlike the hippies of the 1960s of whom Merton disapproved, the Beat generation of the 1950s defined itself as being about poetry. Despite the profanity of their language, Merton saw the movement as essentially religious. The Beats' philosophy was counter-cultural; resistant to the materialism lambasted in Allen Ginsberg's poem, 'Supermarket in California'. Merton saw advertising as a source of spiritual corruption not so much because it inspired greed, but because it led souls into a profound confusion about the nature of creativity. As advertising homogenized the aesthetic of cultural production, it accentuated the tendency to regard 'genius' as an expression of individualism, that situated the artist as a hero, 'the high priest in a cult of art that tends to substitute itself for religion'. As true creativity could be mistaken for godliness by the unchurched, Merton argued, religiosity among Christians could be confused with salesmanship, and simply mirror the wrongs of creative advertising. In his journal entry of 5 May 1967 (Ascension Day), Merton condemned the whole business of public culture that 'fabricates' importance so everyone knows the same names. Neither knowing the headliners of the day nor not knowing them matters, he argued, because 'One needs a whole new language' in order to speak truth plainly. That quality of brash, even brazen protest against the bourgeois life of capitalist materialism, a trademark of the Beat generation and of the Objectivist school of poets, including Zukofsky and Charles Olsen, is incorporated along with the detritus of advertising, commercial language and business in Thomas Merton's *Cables*.

Merton valued classic form in religion and in art, that which endured beyond the limits of the time and place of its composition. He believed a poet had to search within for meaning and reach out, technically, to the level of a Homer, Dante or Milton. The classic vernacular was a language of inner experience rendered through metaphor. It did not have the 'quality of necessity', egotism or urgency that Merton said characterized more prosaic poetry, but was concerned purely with the aesthetic, the transcendent, and yet each word or rhyme established its own necessity within the context of the sentence or line.

The 1960s found clerics, students and poets engaged in constructing poetry of protest emerging from the absorption in the cultural moment. American poetry written by Louis Zukofsky and the Objectivists, William Carlos Williams and the Imagists, and by the Beat generation changed the craft of poetry by popularizing the vernacular. Merton's personal journals, letters and poetry are imbued with a clear sense of his audience's values as contemporary. He admired poets who remained 'free', who were not driven to be prophets, and who realized ' that one life

does not exhaust the possibilities of one man', as Merton wrote in his review of Zukofsky.[1]

As he explained to Zukofsky, Merton had grown up in a world full of myth and symbol, and sought to 'reconcile' the poetic technique that completely stripped the symbol of that, using only visual images for impact. He tried to find a middle ground where he could integrate a 'direct and continuous relation with the visible' and yet allow for a symbolic power. [2] Merton called this balance the 'Paradise' mentality, found in Milton's *Paradise Lost*, William Carlos Williams's poetry and essays, and according to Merton, in Louis Zukofsky's poetry. Just as he admired Milton's sense of space, the distance between heaven and hell—'Nine times the Space that measures Day and Night'—so he admired Williams's use of concrete images that sounded like a Haiku or Koan: 'so much depends on a red wheel barrow glazed with rain water beside the white chickens'. Similarly, he admired Zukofsky's childlike sense of rhythm and rhyme: 'I'm a mosquito/May I Bite your big toe? Here's ten dollars/Use it/as you know'.[3] The paradise mentality enabled the poet to structure ideas 'musically instead of logically', to accept the ways in which 'life's silences are mined with love' and for the reader to 'hear with a paradise ear' the cosmology of love, the Franciscan and Ignatian acceptance of finding God in all things, and incorporating all into the creative fecundity of the poetic, the transformative experience, even things mundane or commercial. [4]

The poets of the Beat generation, Merton wrote, got into trouble when they substituted social activism for religion and confused freedom and dignity with perpetual motion. In 'Prophetic Ambiguities: Milton and Camus', an essay written in October 1966 first published in the *Saturday Review* of 1967, Merton described the link between Satan as the prototype for the modern guru or protest poet that he later damned in *Cables*, the paradigm of the motivated mover and shaker, who like Milton's Satan could tolerate Hell because he was seldom home.[5] In his journal

1. Thomas Merton, *Literary Essays* (New York: New Directions, 1966), pp. 128-33 (129). See also George Kilcourse, Jr, *Ace of Freedoms: Thomas Merton's Christ* (Notre Dame: Notre Dame University Press, 1993), pp. 173-98; Thomas Merton, *The Hidden Ground of Love: The Letters of Thomas Merton on Religious Experience and Social Concerns* (ed. William H. Shannon; New York: Farrar, Straus & Giroux, 1985), pp 382-83.

2. Merton, *Literary Essays*, p. 129.

3. John Milton, *Paradise Lost*, Book I, l. 50; William Carlos Williams, *Selected Poems* (New York: New Directions, 1969), p. 30; Merton, *Literary Essays*, p. 131.

4. Merton, *Literary Essays*, p. 131.

5. 'Prophetic Ambiguities: Milton and Camus', in *idem, Literary Essays,* pp. 252-60 (p. 253).

for the months during which he composed *Cables*, Merton wrote that he began reading *Paradise Lost* seriously 'for the first time in my life' and he noted the 'metaphysical restlessness' in Milton that would have been 'unthinkable' in Dante: 'Yet Dante builds a Cathedral. And we are no longer in the age of Cathedrals. Milton's movie is more like us', Merton wrote.[6]

Without undermining Milton's great achievement in the epic, Merton astutely observed the correspondence between Milton's Satan and Batman, and the sense that the celestial epic is 'structured' like a comic strip or movie. The same must be said of Merton's *Cables to the Ace*. The constant motion, frame succeeding frame, that makes up the *Cables* poem is structurally iconoclastic. By contrast, Merton's contemplative archetype, the 'Paradise Mentality', is peace, stillness: 'Not a loss of self in mystical absorption but self-transcendence in the dynamic stillness which, as the Zen Masters said, is found not in rest but in truly spontaneous movement'.[7] The modern reader who still prefers the psalms to Burma Shave jingles yet who wants something snappy is meant to confront the poem, to break through the code of intimacy, as must the reader of *Paradise Lost*, in all its 'fruitful ambiguity', to see the 'tensions' between the charismatic, the urbane rebel, Satan and the classicist.[8]

For any American poet, managing a public persona historically has been important to achieving popular success. As early as 1912 in America, Ezra Pound and Harriet Monroe, and four or five other individuals without enough poems for a book of their own, published in journals and in anthologies as an Imagiste 'movement'.[9] Their work fueled the growth of poetic principles perfected by William Carlos Williams in the late 1930s and early 1940s, and in the 1950s by Louis Zukofsky and Charles Oslon, in what the poets themselves called Objectivism (also Objectism) or 'projective' or 'open' verse, a term not entirely understood by critics and even some poetry scholars today. But Merton understood what Zukofsky and Olson were about, meditating on the object in Zen-like concentration, finding the presence of the Creator in the things created, matching the music of paradise through poetry, the song of praise

6. Thomas Merton, *Learning to Love: Exploring Solitude and Freedom* (Journals, 6; 1966–1967; ed. Christine M. Bochen; San Francisco: HarperSanFrancisco, 1997), pp. 144-45.

7. Merton, *Literary Essays*, p. 254.

8. Merton, *Literary Essays*, pp. 255, 252, 238. See also Arthur W. Biddle (ed.), *When Prophecy Still Had a Voice: The Letters of Thomas Merton and Robert Lax* (Lexington: University of Kentucky Press, 2001).

9. Claire Badaracco, *Trading Words: Poetry, Typography and Illustrated Books in the Modern Literary Economy* (Baltimore: The Johns Hopkins University Press, 1995).

not about perfection but about the construction of the ordinary and the beauty to be discovered there, if only people were not too busy to look.

As an aesthetic shadow culture, Protest and Confessional poets like the Beat generation used self-referential political and autobiographical image frameworks. For example, Allen Ginsberg owed as much to William Carlos Williams as the Patterson physician did to Walt Whitman. Ginsberg's ability to publicize himself, to carve a public self that bridged the hippies and rock generations, made political poetry synonymous with the Beats. Louis Zukofsky represents another kind of poet, devoted to his inner vision, not widely recognized despite a lifetime of craft. One wonders if Merton might not have envied just a bit Zukofsky's anonymity, along with his epic poem *A* and his musical lyrics.

In Merton's Beat poem *Cables to the Ace*, composed during 1966–67, the classic saints of literature break out of their reliquaries to converse with the contemporary culture through the commentator, Merton. With an eye on the length and poetic techniques of his contemporaries, Merton incorporated phrases from the literary classics, the poetry of T.S. Eliot, William Blake, James Joyce, Dylan Thomas, Whitman, Shakespeare and Milton. The poem incorporates the prophetic and social protest dimensions of Ginsberg's 'Supermarket in California', 'Howl' and 'Kaddish' and Zukofsky's 'All', 'Poem Beginning "The"', and *A*. As early as 1961 Merton wrote to Williams about his hope that, 'I can some time send you a long poem I think you may like'. Six years later, Merton wrote to Zukofsky that he had 'fallen head first into a long poem of my own, swimming in its craziness and trying other work and just walking in the sun'.[10]

10. Verse 69 of *Cables* imitates Louis Zukofsky's 330-line poem, 'Poem beginning The', and in Merton's list of 26 nonsequitors, where each line is numbered separately and all begin with verbs, Merton promises in the first line to 'Move that system'. The reader has already learned from Cable 55 that the 'hero does not trust the evidence of verbs'. But here the poet provides evidence, as he predicted in Cable 12, that all the symbols have moved: they have become images. Nor is the list more nonsense than that offered in the daily 'telefake' dramas of the evening, the pseudo-heroics of the cinema and sitcom. In the tabloid dream starring, in no particular order, Oliver Twist, the Maltese Falcon, the Trojan War, Little Red Riding Hood ('in chains...learns love-secrets of best looking fugitives') there are startling headlines: 'Animated clergy storms conceptual void in theo-drama while Deity groans'. The network is thus taken over, the health-buffs destroy the owls, and the 'sardonic asides' of the poet and presumably the audience bring down the whole season to crashing ruin (Merton, *The Collected Poems of Thomas Merton* [New York: New Directions, 1977], p. 442). Thomas Merton, *The Courage for Truth: The Letters of Thomas Merton to Writers* (ed. Christine M. Bochen; New York: Farar, Straus & Giroux, 1993), p. 292.

Merton's aesthetic affinity with both Williams and Zukofsky led him to overlook the secular, profane yet prophetic vernacular of Ginsberg. He did not object so much on moral grounds as a priest, but because profanity was commonplace in the advertising culture:

> Not that I am mad at dirty words, they are perfectly good honest words as far as I am concerned, and they form part of my own interior mumblings a lot of the time, why not. I just wonder if this isn't another kind of jargon which is a bit more respectable than the jargon of the slick magazines, but not very much more. And I wonder how much is actually said by it.[11]

Merton saw advertising as a source of spiritual corruption not so much because it inspired greed, but because it led souls into a profound confusion about the nature of creativity. As advertising homogenized the aesthetic of cultural production, it accentuated the tendency to regard 'genius' as an expression of individualism, that situated the artist as a hero, 'the high priest in a cult of art that tends to substitute itself for religion'.[12] True creativity could be mistaken for godliness by the unchurched, Merton argued, just as religiosity among Christians could be confused with salesmanship, a mimetic mode of creative advertising. In that same journal entry on Ascension Day (5 May 1967), Merton argued for the fresh, plain language one needed in order to speak authentically as an artist.[13]

Not unlike the ascetic, the poets of the Beat generation, even the quiet and meticulous Objectivists Zukofsky and Olson, dealt in philosophical absolutes. The poetic impulse led these men, along with Merton, to want to redeem America from its habit of soul-numbing materialism and militarism. To do so, Ginsberg and his City Lights confrères assembled a public persona for the media: they had to assert themselves as a movement, and their pamphlets, books about bohemian life and their poems drew public attention. Protest, resistance and profanity were the means to what they saw as a peaceful end. Merton wrote to Williams that the Beat movement was 'certainly religious in its concerns… [W]ho are more concerned with ultimates than the beats? Why do you think that just because I am a monk I should be likely to shrink from beats?… I am a monk, therefore by definition, as I understand it, the chief friend of beats…'[14] In the summer of 1961, following publication of Merton's poem 'Chant' in the first issue of *Journal for the Protection of All Living Beings*, Merton wrote to Ferlinghetti what it meant to him to be countercultural,

11. Merton, *The Courage for Truth*, p. 271.
12. 'Theology of Creativity', in *idem, The Literary Essays*, pp. 355-70 (360).
13. Merton , *Learning to Love*, p. 227.
14. Merton, *The Courage for Truth*, p. 290.

resistant. 'I think we have to examine the question of genuine and deep spiritual non-cooperation, non-participation, and resistance... Have you by any chance read the Old Testament prophets lately? They knew how to hit hard in the right places, and the chief reason was that they were not speaking for themselves'.[15]

Cables is written in open, projective verse using the Imagists' and Objectivists' techniques, and adapting the Beat generation poets' tone of protest. In short, Merton is appealing to an audience of his contemporaries, including those bearded coffee drinkers in the cafes of fog-bound San Francisco. As Merton's journal entries recount for the months during which he composed *Cables*, when he vascillated between the emotional peaks and valleys caused by his love affair, he read Milton, and the Beat poets who were still new to him. *Cables'* lack of narrative coherence reflects Merton's compositional pace, the poetic models that were in the air in contemporary culture, and also his state of mind during the time — ambivalent, distracted, seeking the love of a woman while reluctant to let go of the monastery. Six months before composing *Cables*, Merton recorded drafting some of the 'very wild free poetry — very irrational and absurd', which he found at once 'satisfying', 'banal' and 'incoherent'.[16] On his occasional trips into Louisville for medical attention, Merton read poetry in the Bingham room of the University of Louisville Library: John Berryman's 'Homage to Mistress Bradstreet', and the Beats: '...and some [Gregory] Corso, R[obert] Creeley and others not so good (I still can't read Charles Olson)'.[17] Objecting to the self-promotion of the Beats, Merton 'doubted whether or not he should have anything further to do with their poetry'; at the same time, he sought out their work to read. His critical attitude probably reflects the influence of two visitors, Dan Berrigan and Jacques Maritain, to whom he had read 'bits' of the new *Cables* composition.[18]

Merton recorded that he was still unsatisfied because *Cables* seemed 'hollow', though he thought better of his work later after reading Milton. At the end of October he recorded finishing *Cables*, without liking or understanding what he had written. 'It is disturbing and false in many ways. It is not myself and I don't know who it is. A glib worldly spirit. Empty voices'.[19] He continued to agonize about its 'agit-prop' style melodrama, and while calling the poem 'mechanical' and an 'imitation

15. Merton, *The Courage for Truth*, p. 268.
16. Merton, *Learning to Love*, p. 120.
17. Merton, *Learning to Love*, p. 148.
18. Merton, *Learning to Love*, p. 148.
19. Merton, *Learning to Love*, pp. 144, 150.

of his former vitality', he wondered in the next breath if the poem might not be 'really good'.[20] He added the French verses in late November.[21] In December, Merton continued to rework the poem, reading bits to friends in January.

In July 1966, Cid Corman suggested Merton 'Must read all of Zukofsky', but Merton wondered how to obtain the books.[22] No doubt the obscure work of Zukofsky was unavailable in the University of Louisville library. By October, Merton tired of Corman, calling him 'pontifical', and turned to Zukofsky himself in order to obtain the books.[23] It was Zukofsky who sent Merton copies of his work to read. In his November 1966 review of W.W. Norton's edition of Zukofsky's collected short poems, Merton wrote that he thought Zukofsky 'one of the best poets writing in America today — has perhaps been the best for many years... Zukofsky has probably done more for the language of poetry than any other American writer'.[24] In Zukofsky's identification of the enduring poetic principles, the Objectivist's perspective on the meditative text, the word itself as a focus of contemplative attention, Merton would have found a kindred spirit. Zukofsky wrote, 'And it is possible in imagination to divorce speech of all graphic elements, to let it become a movement of sounds'.[25]

In March, Merton received letters from Zukofsky, who had read revisions of *Cables*, and he sent the books. Of Zukofsky's poem *A* Merton wrote that it was 'more moving than any other modern poetry I have read'.[26] Merton especially admired the musicality of Zukofsky's words, without any pretense or artificial poetic flourish. The image Merton records in his journal from *A* (#6) illustrates his comprehension of the typical Objectivist use of image, where the idea of the image is embedded in an animated landscape, and objects wrapped in haiku-style metaphors, move by an unseen power, usually electronic, the type of movement one reads often in Merton's *Cables*.

> The fir trees grew around the nunnery,
> The grille gate almost as high as the firs,

20. Merton, *Learning to Love*, p. 152.
21. Merton, *Learning to Love*, pp. 155-56.
22. Merton, *Learning to Love*, p. 163.
23. Merton, *Learning to Love*, p. 98.
24. Merton *Learning to Love*, p. 148.
25. Thomas Merton, review of Zukovsky in *idem, Literary Essays*, p. 128. The review was written in November 1966 and first published in *The Critic* 25 (Feb–March 1967) under the title 'Paradise Bugged', pp. 69-71.
26. Louis Zukofsky, *A* (Berkeley: University of California Press, 1978), pp. 566-69.

> Two nuns by day passed in black, like
> Hooded cameras, as if photographing the world'.[27]

Though he found Olson's poetry less appealing, Merton read Zukofsky's prose remarks on Objectivist poetic thought, and wrote: ' This I think must contain a lot of important directions and suggestions'.[28]

Symbols in poetry can create a wall between the poet and reader. At this point in Merton's reading, the appeal of the autobiographical voice, the plain speech, punctuated by the concentrated, meditative gaze on an objectified, unsentimental image is great enough, as one reads Merton's journals for this period, to assert the claim for the influence of these poets on Merton's own poetry. As Olson wrote, 'a thing, any thing, impinges on us by a more important fact, its self-existence, without reference to any other thing, in short…its particularity'.[29] In *Cables*, Merton incorprated the Objectivists' attitude, which was intensely observant of the details of the image without the emotional or psychological freight of the past. He wrote to Zukofsky in the Spring of 1967:

> I have naturally grown up all full of myth and symbol and sound and explanation and elaboration… In the long run I think one can have both the direct and continuous relation with the visible and also see it as a symbol but not as containing a symbol that is something else and of something else. Hence what I really would like to do with Olson is reconcile his direct way with also a traditional symbol way that is properly understood.[30]

Cables to the Ace is a poem about the loss of symbols in a world of fragmented images, and it occurs on several levels: emotional, verbal, visual. Merton declared 'mass psychosis' the result for his age, when cosmic symbolism was submerged by a 'tidal wave of trademarks, political party buttons, advertising and propaganda slogans', and poets were driven through the 'cultural garbage' to seek vital symbols among the 'moonlit cemeteries of surrealism'.[31] Composed during the turbulent year when his relational life threatened his vows as a monastic, the poet's anxiety about that contradiction informs the technical level of the poem. Interwoven within that nonverbal paradox of emotion, fragments of mass media language, while perfectly good for public poets like the Beats, threaten the interior life, the serenity of the poet's prayer, as an incandescent, material world creates continual losses of rhythm in the poem. Visually, the poem is frameless. Though refrains and themes

27. Merton, *The Courage for Truth*, p. 206.
28. Merton, *The Courage for Truth*, p. 206.
29. Merton, *The Courage for Truth*, p. 206.
30. Merton, *The Courage for Truth*, p. 293.
31. Merton, *Literary Essays*, p. 333.

make the whole hang together and work as a poem, each verse sustains its own visual metaphors, and they are more often realistic than symbolic; that is to say they are flattened, more journalistic than literary. But that may be the poet's point, to illustrate the tension between the language of the world, advertising and doxology. True and false worlds wage a battle of words in *Cables* as fierce as in Milton's epic, pre-lapsarian world.

As in Zukofsky's poems, in *Cables* several voices sing at one time. The lack of coherent narrative framework accentuates the projective style of Merton's objective technique. In the sense that Olson used the terms, projective verse was intended to reach across the footlights, so to speak, and grab the reader by the ear. The difference between the theories of objectivism and Zukofsky's poetry is music, the fundamental classic principle of poetry. In his review-essay on Zukofsky's poetry, Merton praised the poetry as combining the Zen-like attention to ordinary life in all its details, and structuring the ideas 'musically rather than logically'.[32]

Finally, there is a loss of ego in *Cables*: the poet himself disappears beneath his verses, as Olson, the Objectivists, or the desert fathers would prescribe. Behind the poetic formlessness of the *Cables* poem and the absence of steady metre, the TV glares, jazz and rock music grind, the computer screen glows, the news machine blaring headlines paid for by advertising shouts and grins. Now and again, the poet intrudes, talking about life in the monastery, then he slips into the wings, the bystander-observer.

Olson called 'objectism' a combination of prayer and Zen meditation. The underlying metaphysical structure was to rid the poem of the 'interference of the individual as ego, of the "subject" and his soul, as being a particularly Western point of view that subordinated the objects to himself. 'For a man is himself an object, whatever he may take to be his advantages, the more likely to recognize himself as such the greater his advantages, particularly at that moment that he achieves an *humilitas* sufficient to make him of use', Olson wrote.[33]

Olson's literary critique derived from a pure aestheticism, but his description of this style of writing poetry might have been written by Merton or one of his Zen masters. Olson wrote:

> It comes to this: the use of a man, by himself and thus by others, lies in how he conceives his relation to nature, that force to which he owes his

32. Merton, *Literary Essays*, p. 132.
33. Charles Olson, *Selected Writings* (ed. Robert Creeley; New York: New Directions, 1966), pp. 24-25.

somewhat small existence. If he sprawl, he shall find little to sing but himself… [I]f he stays inside himself, if he is contained within his nature as he is participant in the larger force, he will be able to listen, and his hearing through himself will give him secret objects to share. And by an inverse law his shapes will make their own way. It is in this sense that the projective act, which is the artist's act in the larger field of objects, leads to dimensions larger than the man.[34]

Cables represents a curious balance between the interior and exterior values that infused poetry during the 1950–70 period. The poet's advertisement of *Cables* begins in the subtitle, that it is about 'liturgies of misunderstanding', but the poet writes in a confessional voice so 'familiar' to the popular reader, and to the popular Beat writers, that he cannot help but be understood. The poem appears to be about the death of literature, the supremacy of the material and commercial language, yet the denouement of the poem has its own secrets, written in French, and seems more love poem than prayer. *Cables* are of course the poet's own numbered lines, for this is a poem about the writing of poetry, dedicated to his close friend and fellow poet Bob Lax with whom he corresponded in code-like punning and who leapt for joy upon receiving *Cables*: 'each message wrapped in its own numbered cookie is each more terrifying than the next. Reader is thrown in a parox of frightened delight…'[35]

What makes the Prologue striking, and more like the Beats than like Whitman, is the contemptuous gaze it directs toward the reader. Rather than the traditional role of the prologue, which is apology, sympathy and invitation, Merton jibes: 'You, Reader, need no prologue. Do you think these Horatian Odes are all about you…? Go advertise yourself… What more do you want, Rabble? Go write your own prologue'.[36] This tone is adapted from the Beat poets, especially Ginsberg: I submit Merton is really talking *to* the Beats rather than *about* his subject. It is about as far from the humility he admires in Zukofsky and praised by Olson as pure 'objectism' as it is far from the Fourth and Walnut vision. Yet the overall spirit of the poem, to see and use evil to touch and describe the good, is as much Milton as it is Franciscan.

Merton struggled in *Cables* to restrain emotion and yet employ it in the service of the image, as did Williams and Zukofsky. For example, one with which Merton would have been familiar, is the posture of the poet as the wisdom figure, and the reader as congregant in Williams's poem 'Tract' (1927), directed to mourners who misunderstand grief. Williams,

34. Olson, *Selected Writings*, p. 25.
35. Olson, *Selected Writings*, pp. 23-25; see also Merton, *The Courage for Truth*, p. 293.
36. Merton, *Collected Poems*, p. 452.

a physician, of course encountered death frequently, and he tried to demystify the poetics of death by emphasizing its realism through mundane images. The poet urges his 'townspeople' to 'knock the glass out' of the hearse that separates the bereaved from the dead. Williams wrote that people possessed the 'ground sense necessary' to understand the metaphysics of death and that they 'have it over' a 'troop or artists' who try to mask its realities. The image Williams urges on the townspeople who are using a polished black hearse is a weathered farm wagon—he doesn't damn one thing without offering a solution within an alternative vision of reality. Williams's preaching in 'Tract' escalates when it comes to the driver's top hat, when the poet's voice really becomes strident, a pitch found more often in Ginsberg or in Merton's Prologue.[37]

A further illustration of the expression of inevitability in the relationship between Imagist and Objectivist poetic techniques in Merton's *Cables*, can be found in a close reading of two verses, nos. 13 and 30, each offering important examples of significant images well controlled. Verse 13 is a vision of Louisville's workaday world, stasis in the midst of hubub. The subtitle, 'The Planet over Eastern Parkway', refers to the major tree-lined boulevard in Louisville leading to the Medical Arts Building and St Joseph's Infirmary, where Merton often went for medical care and to either call or meet the student nurse, and Lourdes Hall, where she lived. The verse portrays an 8 a.m. rush hour, where executives gather like horses at the starting gate and drive like crazy at the sound of the 'smart pistol', their alarm clocks. By evening, after the workday ends, the 'cart wheel planet' sets, and people go home to their evening pursuits illuminated by 'electric stars'.[38] By centering the motion in the images, Merton evokes tranquility or stillness in the midst of metropolis. In this time-lapse photographic image that sustains the verse, lights streak across the static black background of the natural night. But absence of light in Merton is not absence of meaning, it is the beginning of not knowing, of contemplation.

The resemblance between this verse and Williams's 'Yachts' and 'The Term' is in the expression of inevitability, of eternity in motion, whatever the fate or plight of humans. There is silence behind the motion, surely, but it is a silence of the deaf, and of the dead. In both Williams's poems, the contemplative poet observes the inevitable motion surrounding the focus of his gaze, the object of his contemplation. In both poems, the rhythms of the ordinary drown out the cries of human suffering:

37. Merton, *Collected Poems*, p. 395; William Carlos Williams, *Selected Poems*, pp. 12-14, 71-72, 91-92.
38. Merton, *Collected Poems*, p. 403.

callous indifference to human suffering is the basis of the realities both poets face. In 'Yachts', a boat race turns ugly: as the cries of men overboard are met by 'skillful yachts' passing over their drowning bodies in the sea in order to get to the finish line. In 'The Term', the poet's gaze is on a rumpled sheet of paper, 'the length and bulk of a man' rolled down the street by the wind as a car drives over it, then is picked up again 'to be as it was before'.[39] In *Cables* awe is engulfed by the mundane, by business, habit triumphs over inspiration, and both condition a type of blindness to human suffering. Embedded within the poem dedicated to listening is a Zen-like meditation on seeing.

Merton's verse 30 of *Cables* also works on images of objective indifference and emotional paradox within a metaphor or automated motion: 'An electric goat's head/Turns and smiles/Turns and smiles/Ten stories high/Emerald and gold'. This advertisement or neon billboard, an image from New York's Times Square, is juxtaposed to a placard-wielding clergyman standing on the street corner, silently revolving, perhaps circling by walking in place, offering a homiletic encouragement by sloganeering, 'You can still win'. Significantly, there is no exclamation point at the end of this slogan, but like the wounded football hero in verse 28, this 'nominee to share the human condition' declares 'straight fact'. The clergyman's message also reads like an advertisement, a motivational sign for the profiteer's rat race described in verse 13 on Eastern Parkway's rush hour. A comparable example, one Merton would have known, is found in Williams's 'The Term', a crumpled test paper rolls down the street in the wind and is crushed by a car: 'Unlike/ a man it rose/again rolling/ with the wind over/and over to be as/it was before'.[40] In both Merton's poem and in that by Williams, the image is centered in the mind's eye while the electronic, objective thing around it rolls over and over, indifferent to human beings. Emotional indifference to other humans is sinful in Williams's and Merton's worldview — a philosophy shared by the Beats, though the word 'sin' was not in their vocabulary.

The 'killer', Merton argues in *Cables*, is not merely the electricity of the city, the media or the 'solemn twittering of news', but, more gravely, the 'image in the magic', the emotional 'chloroform' that 'slowly consumes the energy of motors', that keeps 'the dimly lighted bottles' 'full of flowers' in the 'night sanctuaries', the restaurants and bars of the lonely that sustain the chattering, in an otherwise emotionally soundless universe,

39. Merton, *Collected Poems*, p. 44.
40. Williams, *Selected Poems* (New York: New Directions, 1969), pp. 91-92.

punctuated only by the human cry, 'NOW', in the next apartment, and the sound of the flush toilet that closes verse 30.

Beyond the explicit level of the images Merton employs throughout *Cables*, where the city is a circus, there is the image of the war-machine, the Nazi holocaust about which so many good people, even in the church, remained aloof. The poet's philosophical response to indifference is that it's a matter of existentialist 'roots' and 'moss', deep-seated and the habits or routines that grow slowly on the surface and mask reality. From the poet whose epiphany about the spiritual unity of the mass culture was manifest on Fourth and Walnut in Louisville, seeing the 'anxiety of cities' as skulls or as pearls was a spiritual choice. Merton could be a harsh social critic, acerbic and contemptuous in tone, leaving this reader to ponder if he struggled, and to what extent, to pull himself out of his own darkness. Or was the harsh critical tone something he used because he had read it in the contemporary poetry of the Beats?

Both Merton and the imagist poets worked in stark contrasts, chaos and peace, hubub and stillness, racket and silence, despair and joy. In Williams's world of the 'Yachts', 'Tract' and 'The Term', the silent movie, the reeling automaton is a metaphor for indifference in which muffled cries of the lost go unheard. The haiku-style image, the snapshot of the wheelbarrow is meant to concentrate the reader's mind. There is something youthful in that simple concentration, and a different level of complexity is required adequately to render the architecture of the modern mind. In Merton (*Cables* 77), the poet writes that he is 'Working his way through adolescence', growing toward full sound, metal strings, and the nine fond harmonies that never leave his thoughts, meaning something closer to Zukofsky's libretto, one assumes. Merton is content, though, to be a 'messenger', living out of the shadow of town. To an extent, the poet in *Cables* functions as a reporter, and the stanzas are news stories. Yet the poet-monk shares openly with the reader the pretense of objectivity: this is not a story or narrative about reality, the poet sings, it is meant to involve the reader in the poem's reality through alarm, humor, recognizable people. Of all the available masks exhibited throughout *Cables*, many are less opaque than the poet-monk. Never 'familiar', 'it is often the most naked', nor is sending disturbing messages 'without risk', but his comfort is in his freedom: 'Nothing that is chosen is unbearable'.[41]

One can conclude that as *Cables* incorporated many varied types of language, media, news, advertising—even those things Merton thought a corrosive force—the poem also can be said to reflect the impression

41. Merton, *Collected Poems*, p. 448.

other poets made on Merton. At the time he composed *Cables*, Merton was reading widely in the poetry of the Beats, as well as in Milton.

Merton believed that real poetry, like valid prayer, is pure communication, in the childlike, faithful sense of saying emotionally direct and uncomplicated things in simple words — trusting someone is there to catch the words as they fall. Analysis of his method of composition demonstrates he admired contemporary models of poetic techniques he wanted to try, and that he did so, within the disciplined restraints imposed by his love for paradise.

[TMA 15 (2002) 136-154]
ISSN 0894 4857

A Woodshed Full of French Angels:
Multilingual Merton

Virginia Bear

Lovely poem on Chagall by Raïssa Maritain in P. Van der Meer's *Ren-contres*. Like to translate it in *Jubilee* with a note on her and perhaps some Chagall picture.

In any case the woodshed [the 'hermitage', St Anne's][1] is again full of French angels the way it was the summer I read Julien Green's *Journals*. And coming back again, by the willows (going with the empty shadow of the path, after bright sun), all the angels of Montauban and of Chartres...[2]

July 27, 1961

If there were French angels in the woodshed with Thomas Merton that summer day, they were only momentarily displacing the other linguistically gifted angels that joined him on other days. Merton reading Raïssa Maritain in French, recalling other French authors, and thinking about France, was not unusual, for despite being a native English speaker living in a monastery in an English-speaking country, Merton's daily life involved the use of an unusually large number of languages; in the Latin of public and private prayer, in his study of writings in Latin, French, Greek, German, Spanish (and more), and in his interactions with non-English-speaking people, both correspondents and visitors.

This pattern had been set from childhood. From the earliest words of his parents in a mixed French and English, to the presentations he

1. Michael Mott, *The Seven Mountains of Thomas Merton* (Boston: Houghton Mifflin, 1984), p. 71.
2. Thomas Merton, *Turning toward the World: The Pivotal Years* (Journals, 4; 1960–1963; ed. Victor A. Kramer, San Francisco: HarperSanFrancisco, 1996), p. 146 (27 July 1961).

translated from and into French in the last days of his life in Bangkok,[3] Merton's world was never defined by a single language.

Merton lived for 27 years in a cloistered monastery in the Kentucky countryside. Though he expected to end his fledgling literary career when he entered the monastery, it was the beginning of the production of a remarkable volume of works, including poems, articles, lectures, and books published during his lifetime and still appearing more than 30 years later. Merton's writing had connections with foreign languages, including translations and books based on scholarship in other languages. Moreover, no one who has read more than a few Merton books would fail to note the ease with which Merton included foreign languages in his writing, not always translated — assuming, it would seem, others felt the same 'comfort of foreign languages'.[4]

Many authors have written of Merton's fluency in various languages. To a student of languages, however, 'fluent' is an imprecise term, covering a wide range of proficiency, dependent on the speaker as well as the context. Having studied several languages (Spanish and Japanese extensively), the present author was left only with questions when Merton's 'fluency' at a language was stated. It is the goal of this study, then, to clarify — to the extent possible 30 years after Merton's death — Merton's level of fluency or proficiency in all the languages he used (or mentioned), including a selection of passages by Merton or others which either assisted in the evaluation, or served to illustrate Merton's multilingual world.

The evaluation is based on the ILR scale (Interagency Language Roundtable, originally developed by the United States Foreign Service Institute).[5] This scale, shown in the following table, includes the four major areas of language competence: the active skills of speaking and writing, and the passive skills of reading and listening. The resulting numbers, of course, do not result from actually testing Thomas Merton, but are intended to provide a relative framework for information gathered from books, articles, letters shown in the following table, interviews and surveys conducted with people who knew Merton.

3. Video recording of Merton speaking at Bangkok, Thailand (archived at the Thomas Merton Center, Louisville, KY).
4. Thomas Merton, *Dancing in the Water of Life: Seeking Peace in the Hermitage* (Journals, 5; 1963–1965; ed. Robert E. Daggy; San Francisco: HarperSanFrancisco, 1997), p. 124. Merton was recalling hearing many languages spoken on the streets of New York, where he had travelled to meet Zen teacher Daisetz Suzuki (10 July 1964).
5. Alice C. Omaggio, *Teaching Language in Context: Proficiency-Oriented Instruction* (Boston: Heinle & Heinle Publishers, Inc., 1986), pp. 11-19.

Table 1. *Language Proficiency Levels*

Proficiency Level	Definition
0 (No Proficiency)	Unable to use the language, or at best knows a few memorized words and phrases.
1 Elementary proficiency	Able to satisfy most survival needs and some limited courtesy/social demands.
2 Limited working proficiency	Able to satisfy most routine social demands, work requirements, and shows some ability to communicate on concrete topics.
3 Professional working proficiency	Able to use the language with sufficient structural accuracy and vocabulary to participate in most formal and informal conversations.
4 Full professional proficiency	Able to use and understand the language with a great deal of fluency, grammatical accuracy, and precision of vocabulary and idioms.
5 Native or bilingual proficiency	Able to use the language like an educated native speaker.

Moving from one level of proficiency to the next takes relatively little time at the earlier stages, but movement to each successive level requires progressively increasing amounts of time. Few attain Level 5 and, informally, most people would consider a person at Level 4, or even Level 3, as 'fluent'. Merton's proficiency in several languages will fall in these three levels, but the scale will permit a more nuanced comparison.

There are some languages that Merton could read very well, but the other skills (i.e. writing, speaking) were much less well developed. In these cases, the rating was based on the most advanced skill, noting the limitation. Where a more definite rating was difficult, an intermediate rating was given (such as German, rating 2–3).

After beginning with English, the rest of the languages are listed by Merton's proficiency, from least to greatest. Where several languages have the same rating, they are in alphabetical order. Following the language listing are a few observations on Merton and languages. Note that 'macaronic language' is mentioned but not rated, as it is not a language, but a literary device.[6]

6. Macaronic language is a deliberate mixture of languages. Merton used it playfully in letters to friends, in his early novel *My Argument with the Gestapo: A Macaronic Journal* (New York: New Directions, 1975), and in the poem *Mens Sana in Corpore Sano: Macaronic Lyric* (1941), published in Patrick F. O'Connell, "And Called it Macaronic':

English

Rating: 5

English was Merton's mother tongue, so the '5' rating does not come as a surprise, but Merton's facility at learning foreign languages also was evidenced in his facility with English dialects and accents. At the age of 18, he had an early awareness of accents in a self-description; 'Accent: varies with the company he is with and the area he is in'.[7] Much later he recalled his childhood in several countries, having 'had my own very small share of being beyond the pale in various societies — foreigner in French and English schools and so on... I was always able to develop the right accent and the right protective feathers in a few months'.[8] When he moved from England to New York, his British accent faded in short order.[9] His acquired American accent was authentic enough that Bob Gibney told the story of their conversation with a British sailor in which Merton quickly revived an English accent, moreover a Cockney accent, at that.[10]

Arabic, Persian, Sanskrit

Rating: 0

In 1961, not long after his first contact with Sufi correspondent Abdul Aziz, Merton told James Laughlin he had an '...awful urge to study Sanskrit and then Persian... Yah, it is probably crazy. I will never have the time'.[11] Four years later, Merton told Laughlin that now Aziz was trying to persuade him to learn Arabic, but that without an instructor in the picture, it would probably be as unsuccessful as his attempt to learn Russian.[12] There are several other times he mentions the desire to learn other 'Oriental' languages, knowing it would probably never happen.[13]

An Unpublished Early Poem of Thomas Merton', *Merton Seasonal* 21.1 (Spring 1996), pp. 7-8.

7. Mott, *The Seven Mountains*, p. 71.

8. In a letter to Gloria Sylvester Bennett dated 19 January 1967 (*The Road to Joy: The Letters of Thomas Merton to New and Old Friends* [ed. Robert E. Daggy; New York: Farrar, Straus & Giroux, 1989], p. 345).

9. Paul Wilkes (ed.), *Merton by Those Who Knew Him Best* (San Francisco: Harper & Row, 1984), p. 16.

10. Mott, *The Seven Mountains*, p. 146.

11. David D. Cooper (ed.), *Thomas Merton and James Laughlin: Selected Letters* (New York: W.W. Norton, 1997), p. 164.

12. Cooper (ed.), *Thomas Merton and James Laughlin*, p. 258.

13. R.D. Baker and Gray Henry (eds.), *Merton and Sufism, The Untold Story: A Complete Compendium* (Louisville, KY: Fons Vitae, 1999), p. 127.

The translations from the Persian which are included in *Collected Poems* were, like his Chinese translations, not done directly from the original language, but using one or more French and or English translations, combined with Merton's own poetic intuition.[14]

Chinese

Rating: 0

Merton began to study Chinese in 1962, and was introduced to the structure of the Chinese dictionary. He learned a few characters, which he was able to use in teaching Chinese philosophy to the novices.[15] A sample of Merton's Chinese has been reproduced in *Turning toward the World*; a respectable and readable beginner's effort.[16] There is also a recording of Merton teaching his novices Chinese philosophy. The sound of chalk on blackboard can be heard, and from his spoken description, it is clear he has written Chinese characters for them.[17]

However well begun the effort, Merton did not continue his Chinese studies, and remarked in a letter, 'Someone tried to tell me you could learn Chinese in six weeks. Ha...'[18]

Merton described *The Way of Chuang Tzu* not as a translation, but as a 'rendering', based on his comparison of other translations, in consultation with John C.H. Wu.[19] Although it was a translation, he felt this was one of his best efforts, as reflected in a chart he made later to rate the relative quality of his own books. *The Way of Chuang Tzu* earned a 'better' rating, high praise given that he rated nothing at the highest level, 'best'.[20]

Esperanto

Rating: 0

Merton's acquaintance with the invented language Esperanto[21] seems to have been brief. In a review of *My Argument with the Gestapo* for any

14. Baker and Henry (eds.), *Merton and Sufism*, pp. 119, 287.

15. Thomas Merton, audiotape, *The Fully Human Being* (Kansas City: Credence Cassettes, 1995).

16. Merton, *Turning toward the World*, p. 19.

17. Merton, *The Fully Human Being*.

18. In a letter to Patrick Hart, 19 June 1966 (Patrick Hart [ed.], *The School of Charity: The Letters of Thomas Merton on Religious Renewal and Spiritual Direction* [New York: Farrar, Straus & Giroux, 1990], p. 306).

19. In a letter to Aunt Kit (*The Road to Joy*, p. 70).

· 20. James H. Forest, *Thomas Merton: A Pictorial Biography* (New York: Paulist Press, 1980), p. 65.

21. Esperanto was invented in 1887 by Polish oculist Ludwig Lazarus Zamenhof,

evidence that Merton knew Esperanto, extended passages containing multiple languages (including, in addition to English, Latin, French, Spanish, Portuguese, German, and possibly Esperanto) do exist. The word *'esperanto'* (or *'esperantu'*) itself appears about as frequently as the words which are possibly Esperanto, and it appears that Merton wanted to give the impression that Esperanto was part of the macaronic language assemblage, rather than actually knowing it.

Here, Madame Gongora, 'well known to almost everybody in London', discusses what the author is up to, in Spanish, French, English, Italian, and the mention, at least, of Esperanto: *'Y escript quoi che placer tu mismo, hey, garzoni? Escript dialectico personal, sin umbrages di folor realist? Escript su proprio esperantu. Bono. Bono. Je vous aime, artisto'.*[22]

Hebrew

Rating: 0

Merton never studied Hebrew, although fairly early in his monastic career (1949) he ruefully quoted a theologian who recommended a daily practice of an hour of the Greek New Testament in the morning, and the Hebrew Old Testament in the evening, 'This makes me hang my head considerably'.[23]

Japanese

Rating: 0

In 1966, Merton told a correspondent that if he were 'young enough to tackle a new language' it would probably be Japanese,[24] and he did report purchasing a book of Japanese phrases to take to Asia, but there is no further mention of Merton studying Japanese.[25]

using the pseudonym Doktoro Esperanto ('Doctor Hopeful'), intended to be an international language. (David Crystal [ed.], *An Encyclopedic Dictionary of Language and Languages* [Cambridge, MA: Basil Blackwell, 1992], p. 125).

22. Thomas Merton, *My Argument with the Gestapo*, p. 48. Roughly translated, 'And do you like what I am writing, hey, young lady? I write in a personal dialect, without being hindered by realism. I write in your own Esperanto. Good. Good. I love you, artist'.

23. Thomas Merton, *The Sign of Jonas* (San Diego: Harcourt, Brace & Company, 1953), p. 213.

24. Hart (*The School of Charity*, p. 306, 19 June 1966).

25. Thomas Merton, *The Other Side of the Mountain: The End of the Journey* (Journals, 7; 1967–1968; ed. Patrick Hart; San Francisco: HarperSanFrancisco, 1998), p. 143.

Russian

Rating: 0
Although their correspondence was in English,[26] Merton told Boris
Pasternak that he wanted to learn Russian, in order to read Russian liter-
ature in the original.[27] He was optimistic at first, writing to James Laugh-
lin, 'I am still at the stage where Ivan Ivanovitch works without rest all
day in the factory. And other such things—'At our club we have a real
fine radio'. Have you any simple Russian reading? ... I'll be in a position
to read simple prose in a week or two, I think'.[28] However, his early
enthusiasm could not compete with other demands on his time, and the
effort was not long pursued.[29] Future Merton scholars might regret this
as well, as Merton reported that writing in Cyrillic was improving his
handwriting.[30]

Catalan

Rating: 2 (Reading Only)
Although Merton was born in French Catalonia, and even identified him-
self as a Catalan of sorts to a publisher seeking permission for a Catalan
translation,[31] he never actually studied Catalan. However, Catalan is
closely related to both French and Spanish, Merton's two strongest mod-
ern languages. Thus it is not surprising that he reported he was enjoying
reading Catalan in a letter to a correspondent in 1967,[32] and in the same
year asked to be lent a Catalan dictionary.[33]

26. Naomi Burton Stone and Lydia Pasternak Slater (eds.), *Pasternak/Merton: Six
Letters* (Lexington: King Library Press, 1973), p. v.
27. In a letter to Boris Pasternak, 22 August 1958 (in *idem*, *The Courage for Truth,
Letters to Writers* [ed. Christine M. Bochen; New York: Farrar, Straus & Giroux, 1993],
p. 87).
28. Cooper (ed.), *Thomas Merton and James Laughlin*, p. 138.
29. In an interview with Fr Chrysogonous Waddell, 18 February 2000.
30. Thomas Merton, *A Search for Solitude: Pursuing the Monk's True Vocation*
(Journals, 3; 1952–1960; ed. Lawrence Cunningham; San Francisco: HarperSanFrancisco,
1996), p. 248 (17 January 1959).
31. Thomas Merton, *'Honorable Reader: Reflections on my Work'* (ed. Robert E.
Daggy; New York: Crossroad, 1981), p. 33.
32. In a letter to Louis Zukofsky, 18 July 1967 (Thomas Merton Center).
33. Ralph Eugene Meatyard, *Father Louie: Photographs of Thomas Merton* (New
York: Timken Publishers, 1991), p. 27.

Greek

Rating: 2

Merton had no knowledge of contemporary Greek,[34] and was never confident with classical Greek. Although he studied classical Greek at Oakham (prior to college), Merton later regretted his lack of zeal then. 'I could use some Greek now. I would like to read the Greek Fathers in the original. The best I can do is find my way in the New Testament'.[35] His translation from the Greek, *Clement of Alexandria: Selections from the Protreptikos*, was done with 'much help from the new French version'.[36]

Despite this lack of confidence in his own proficiency, Merton did not abandon Greek. In 1965, he described being re-energized to read the Greek New Testament, inspired by the arrival of a 'lovely Byzantine ikon'.[37] The final evidence of Merton's valuation of Greek was a card among the personal possessions returned to the Abbey after his death, with a passage from the *Philokalia* in Merton's own distinctive handwriting, in Greek.[38]

Provençal

Rating: 2 (Reading Only)

Merton never formally studied Provençal, and one might be justified in reading a little surprise into these lines from a letter to his old friend Bob Lax: 'I can read Provençal fairly easily, and have been finding out Provençal poetry is just as fine as they all say! ... The sound of the language itself is wonderful — adjectives and particles ending in -etz and -atz ... I found out I could read more Provençal than just those lines in Dante, because I got a big Provençal book with convenient French translations

34. Thomas Merton, audiotape, *Mary: Light and Temple* (Kansas City: Credence Cassettes, n.d.).

35. William H. Shannon, *Silent Lamp: The Thomas Merton Story* (New York: Crossroad, 1992) p. 61.

36. Thomas Merton, *Conjectures of a Guilty Bystander* (Garden City, NY: Doubleday, 1965), p. 190.

37. Merton, *Dancing in the Water of Life*, p. 321 (3 December 1965).

38. Lawrence S. Cunningham, *Thomas Merton and the Monastic Vision* (Grand Rapids: Eerdmans, 1999), p. 181. The passage is from John Carpathios, 'If we wish to please the true God and to be friends with the most blessed of friendships, let us present our spirit naked to God. Let us not draw into anything of this present world — no art, no thought, no reasoning, no self-justification — even though we should possess all the wisdom of the world'.

handy and it was okay easy that way, and well, I didn't need a transla-
tion for EVERY line'.[39]

German

Rating: 2–3

Merton's German was stronger than he generally admitted. Surprisingly,
he began his German studies in France at Montauban,[40] and continued
with it in England and the United States. Perhaps because of the ease
with which he learned the Romance languages (French, Spanish, etc.),
the additional work required for German did not seem to him to be
equally rewarded. Father Chrysogonus Waddell commented in an inter-
view conducted by Victor Kramer that, 'He knew German, but it just
wasn't his language. He felt impatient with it because it just didn't come
that spontaneously'.[41]

From two recordings of Merton's conferences to his novices where he
read from Rilke's poetry in the original language, a native speaker of
German evaluated Merton's spoken German as understandable, but
with a strong American accent.[42] Although the recording is not dated, it
would have been at least 20–25 years since Merton had studied German.

There are numerous self-deprecating comments in his letters about
his difficulties with German, but Merton occasionally exceeded his own
expectations. 'I am beginning to be glad I learned (barely) to read
German in school… The perfect language for an existential theology…
Things can be *discovered* in German, that can be perhaps reproduced
afterwards in other languages'.[43] To those who know Merton's love for
Rilke, it will come as no surprise that it is while reading Rilke that he
came to realize, 'I really know more German than I think, maybe… My
own guesses will be better for me than the translation'.[44]

39. Merton, *The Road to Joy*, p. 147 (21 August 1939).

40. Thomas Merton, 'Monsieur Delmas', in Morris L. Ernst (ed.), *The Teacher*
(Englewood Cliffs, NJ: Prentice-Hall, 1967), p. 49.

41. Victor A. Kramer, 'Truly Seeking God…in Christ', *The Merton Annual* 11, pp.
148-73 (151).

42. Thomas Merton, audiotapes, *Poetry and Imagination* (n.d.), and *Natural Contem-
plation* (1988), (Kansas City: Credence Cassettes). Evaluated by Hermann Goeppele of
Seattle, Washington, born near Nuremburg, and still frequently returning to Germany.

43. Merton, *Dancing in the Water of Life*, p. 91 (19 March 1964).

44. Thomas Merton, *Learning to Love: Exploring Solitude and Freedom* (Journals, 6;
1966–1967; ed. Christine M. Bochen; San Francisco: HarperSanFrancisco, 1997), p. 7 (16
January 1966).

Italian

Rating: 3–4

Merton's characteristic modesty concerning his language abilities is well illustrated in a letter to Roberto Gri, a young Italian student, which begins with Merton modestly claiming he has forgotten all the Italian he ever knew — yet the disclaimer is in Italian![45] However little confidence Merton had in his written Italian, his spoken Italian approached some degree of fluency. When Msgr Larraona, then secretary of the Sacred Congregation of the Religious, came to Gethsemani, Merton interpreted a talk. He later wrote that his visitor to the monastery 'said some wonderful things. But I especially liked the way in which he said them. Italian is a wonderful language to preach in'.[46] To Merton's contemporary Brother Patrick Hart, Merton seemed to translate easily from Italian, but it is well to note his further comment, 'Some monks said his translations were more interesting than the original!'[47] Merton may have been more interested in communicating ideas than making literal translations.

Merton's Italian education was solid. Italian was not yet offered at Oakham, but arrangements were made for Merton to study it independently (along with French and German).[48] It began with the purchase of a copy of *Hugo's Italian Self-Taught*. He brought it to the hospital where his father lay gravely ill, opening it in the waiting-room to teach himself a few verbs while waiting to visit his father.[49] Merton soon moved beyond verbs, and advanced to 'Italian novels, if I could get them, and going through the *Oxford Book of Italian Verse*'.[50] Merton's strength in Italian helped him win a scholarship to Cambridge's Clare College, and although the memory of his misbehavior outside of class haunted him for

45. Merton, *The Road to Joy*, p. 334. '… *ho completamente dimenticato tutto che sapeva'*. (10 December 1964).

46. Merton, *A Search for Solitude*, p. 10. The passage goes on to mention Merton had two conferences with Msgr Larraona in Spanish, Larraona's native language (23 August 1952).

47. In an interview with Brother Patrick Hart (16 December 2000).

48. Mott, *The Seven Mountains*, p. 56.

49. Thomas Merton, *The Seven Storey Mountain* (Fiftieth Anniversary edn; New York: Harcourt, Brace & Company, 1998), p. 90. Nine years later, again in a hospital, he reports reading all of Dante's *Paradisio*, in Italian, while recovering from an appendectomy (p. 303).

50. Thomas Merton, *Fitzgerald File*, unpublished manuscript, Thomas Merton Center, n.p.

the rest of his life, he wrote that reading Dante 'was the one great benefit I got out of Cambridge'.[51]

Merton's journals mention books that he is reading in Italian, never accompanied by any complaints about their difficulty. His Lenten reading in 1963 was *The History of Italian Monasticism*, 'in Italian, pleasantly illustrated',[52] and as late as December 24, 1967, Merton recorded reading an 'appalling' article in Italian on 'The Monk in the Church'.[53]

Portuguese

Rating: 3-4 (Primarily Reading)
According to his Portuguese friend and translator Sr Maria Emmanuel de Souza e Silva, Merton was able to read 'very complex poetry in Portuguese'.[54] She additionally confirmed that their correspondence, while conducted in English, occasionally included untranslated Portuguese, with Merton writing occasional words and phrases, Sr Emmanuel writing longer passages. Merton's own evaluation of his Portuguese reading ability appeared in a letter, interestingly enough in French, '*Si vous voulez m'ecrire en portuguais, je le lis facilement*'.[55] ('If you want to write to me in Portuguese, I read it easily.') Also, to Alceu Amoroso Lima he wrote, 'Do not apologize for writing to me in Portuguese … I enjoy very much reading it'.[56] This however did not equate to an easy proficiency, for to another correspondent Merton wrote about a Portuguese book, 'which I have not yet read, I am ashamed to say—and I fear it would take too long in Portuguese'.[57]

Merton commented on his own Portuguese writing ability, 'It would probably be impossible for me to write it very coherently',[58] and he apparently spoke even less; Alceu Amoroso Lima Filho (son of Alceu Amoroso Lima), who visited Merton in 1960, did not hear Merton speak any Portuguese during the visit.[59]

51. Merton, *The Seven Storey Mountain*, p. 135.
52. Merton, *Turning toward the World*, p. 301.
53. Merton, *The Other Side of the Mountain*, p. 30.
54. In a survey returned from Sr Maria Emmanuel de Souza e Silva to the author, 31 July 2000.
55. In a letter to an unnamed Sister, Thomas Merton Center (14 November 1966).
56. In a letter to Alceu Amoroso Lima (*The Courage for Truth*, p. 164, November 1961).
57. In a letter to Sr Emmanuel de Sousa e Silva, 30 October 1967 (Thomas Merton Center).
58. Lima (*The Courage for Truth*, p. 164, November 1961).
59. Alceu Amoroso Lima Filho, letter to the author, 3 July 2000.

Although Merton did not study Portuguese until nearly 20 years after his visit to the 1939 World's Fair, he had sufficient consciousness of the language to report his surprise at its pronunciation, when listening to a Portuguese lesson at the Linguaphone booth. '[I] found out things I didn't believe...they pride themselves on pronouncing everything the way it is spelt, and so do the Hungarians; [yet] in neither language can I find that the pronunciation has anything to do with the spelling... Amusing dipped effects in Portuguese where the 'e' is dropped out'.[60]

At Gethsemani, Merton learned Portuguese from Fr Bede Kok (a fellow multilinguist originally from Denmark via Brazil[61]) in 1958[62] and for a while reserved an hour a week on Portuguese for the sake of the translations of Brazilian poets.[63]

With characteristic enthusiasm, Merton writes of his affection for Portuguese in 1961, 'It is a language I delight in, and it is really the one I like best. It is a warm and glowing language, one of the most human of tongues, richly expressive and in its own way innocent... it seems to me that Portuguese has never yet been used for such barbarities as German, English, French, or Spanish...'[64]

Spanish

Rating: 4–5

Merton's competence in Spanish was second only to his fluency in French. Merton did not begin his study of Spanish until the summer term of his first year at Columbia,[65] but this late start proved to be no handicap. When he visited Cuba almost five years later, he seemed to revel in using his Spanish: 'I made friends with about fifty-one people of all ages. The evening ended up with me making a big speech in broken Spanish... all about faith and morals... I heard someone say, '¿Es católico, ese Americano?' 'Man', said the other, 'he is a catholic and a very good catholic', and the tone in which he said this made me so happy that I could not sleep'.[66] Merton's religious experience mediated by the Spanish language coincided again at Our Lady of Cobre, where the

60. Thomas Merton, *Run to the Mountain: The Story of a Vocation* (Journals, 1; 1939–1945; ed. Patrick Hart; San Francisco: HarperSanFrancisco, 1995) p. 57.

61. Hart interview (16 December 2000).

62. Merton, *A Search for Solitude*, p. 213 (17 August 1958).

63. Mott, *The Seven Mountains*, p. 324.

64. Lima, November 1961 (*The Courage for Truth*, p. 164).

65. Transcript of Thomas Merton, Columbia University, in the Abbey of Gethsemani. The class was in 1935.

66. Merton, *The Seven Storey Mountain*, p. 307.

words sung by a choir of children, *'Creo en Diós'*[67] (I believe in God), evoked a vision of God's presence in the Eucharist, so vivid as to seem to 'lift me clean up off the earth'.[68]

While in Cuba, Merton would sometimes attend Mass at more than one church, and wrote characteristically of the excellence of Spanish:

> I would listen to the harmonious sermons of the Spanish priests, their very grammar of which was full of dignity and mysticism and courtesy. After Latin, it seems to me there is no language so fitted for prayer and for talk about God as Spanish: for it is a language at once strong and supple, it has its sharpness, it has the quality of steel in it, which gives it the accuracy that true mysticism needs, and yet it is soft, too, and gentle and pliant, which devotion needs, and it is courteous and suppliant and courtly, and it lends itself surprisingly little to sentimentality. It has some of the intellectuality of French but not the coldness that intellectuality gets in French: and it never overflows into the feminine melodies of Italian. Spanish is never a weak language, never sloppy...[69]

Traveling alone, as he had in his earlier European travels to France, Germany, and Italy, Merton immersed himself in the language and culture of Cuba, and observed his own progress in Spanish. Listening to a flamenco singer, he reported, 'For the first time I was able to understand the words of the song all the way through, and what poems! Baby...'[70] The few weeks (no more than six)[71] in Cuba marked Merton's Spanish, years later. Fr Chrysogonous Waddell recounted hearing Merton being asked where he got his Spanish accent, and Merton replied, almost as though he were embarrassed, *'En Cuba'* (in Cuba).[72] Perhaps it was the intensity of his experiences there that marked his accent after such a short time.

While not as closely associated with Cistercian history as French and Latin, Merton's own interest in Spanish and Latin American literature — starting with St John of the Cross — ensured that Spanish became a major language in his monastic life. While studying St John, he referred to both English and Spanish texts, making corrections to the Spanish text where needed. He edited Spanish translations of his own works, and wrote to a

67. Merton, *The Seven Storey Mountain*, p. 310, but *'Yo Creo'* (I believe) in Mott, *The Seven Mountains*, p. 151, and Merton, *Run to the Mountain*, p. 217.

68. Merton, *Run to the Mountain*, p. 218 (29 April 1940).

69. Merton, *The Seven Storey Mountain*, p. 306. The passage ends in a phrase not generally considered offensive when written half a century ago, '...even on the lips of a woman'.

70. In a letter to Bob Lax (*The Road to Joy*, p. 155, April 1940).

71. Merton, *The Seven Storey Mountain*, pp. 149, 152.

72. Waddell interview (18 February 2000).

correspondent, 'I often like my stuff better when it comes out in Spanish'.[73]

Merton spoke Spanish, even including spiritual direction, with Ernesto Cardenal, and other Spanish-speaking novices at Gethsemani.[74] Merton was also called to interpret for Spanish-speaking visitors to the monastery ranging from church dignitaries to prospective monks.

There are at least a dozen letters in the archives of the Merton Center at Bellarmine University that Merton wrote in Spanish, all or in part, testifying to his proficiency. While often lacking the accents which are part of Spanish (for the reasons described in the section below on French), Merton's Spanish correspondents do not complain about his orthography or his grammar. Still, he modestly writes, 'It always takes a little effort to get wound up to write in Spanish'.[75] He advised another correspondent, 'It would be easier to write in English if you could read it', but apparently she could not, and subsequent letters continue in Spanish.[76]

French

Rating: 5

Although there were several other languages at which Merton achieved a level of fluency, his French was superb and approached native fluency. He could speak standard French, but also with the accent of Toulouse, including making jokes in that dialect.[77] A native speaker of French who spoke on the telephone with Merton would not have heard a foreign accent, according to Sr Myriam Dardenne.[78]

Merton's formal studies in French began at the age of ten, where he suffered the indignity of being placed with much younger boys in an ordinary French school, and was accordingly well motivated to improve his French quickly. This was a success; a teacher at St Antonin reported that Merton was 'the best student he ever had in French. He got the best grades'.[79] By the time he transferred to the Lycée Ingres in Montauban

73. In a letter to Mery-Lu Sananes and Jaime Lopes-Sanz (*The Road to Joy*, p. 338, 7 March 1966).
74. In a letter to Sr Therese Lentfoehr (*The Road to Joy*, p. 222, 21 February 1956).
75. Cooper (ed.), *Thomas Merton and James Laughlin*, p. 331.
76. In a letter to Sr Victorias, 18 July 1965 (Thomas Merton Center).
77. Waddell interview (18 February 2000).
78. In an interview with Sr Myriam Dardenne (9 June 2001). Sr Myriam was superior at the Trappistine monastery in California when Merton visited. She and several other sisters had come from Belgium to found the new monastery.
79. Wilkes (ed.), *Merton by Those Who Knew Him Best*, p. 78.

(near Toulouse), Merton had already begun writing his first novels; profusely illustrated adventure stories in French.[80] Three years later he left France forever, although he continued his French studies in England and the United States.

Merton was known for his French language ability, and was referred to as the 'French monk' on at least one occasion.[81] From early in his monastic career, he was called to provide interpretation for French (and other) guests,[82] as well as translations of French (and Latin) language materials.[83]

Merton also used French as a bridge to other languages and cultures, reading translations from Chinese, Persian, Arabic, and so on, sometimes more accessible in French translations than English. Later, he used French as a bridge in the opposite direction, from those languages into English, most often for poetry. It was in French that he began his studies of Asia, as early as the winter of 1937–1938, when he 'sat for hours, with the big quarto volumes of the Jesuit Father Wieger's French translations of hundreds of Oriental texts'.[84]

Merton routinely corrected the printer's proofs of the French translations of his works.[85] He also wrote poetry and prose in French, including articles which were published in French magazines and journals.[86] It took some effort: 'Did a little work on the book about Abbé Monchanin — which I am supposed to review (have been dragging my feet because this review is supposed to be in French)'.[87] Nevertheless, Fr Charles Dumont, editor of *Collecteana Cisterciana*, wrote to Merton in 1964, 'Apart from one or two mistakes, your French is still very good, even from a literary point of view. Please do send more of this excellent stuff'.[88]

Written French and Spanish both require diacritics (accents, tildes, etc.), and Merton's handwritten letters in these languages were properly written. However, for three reasons, typewritten letters in both languages

80. Merton, *The Seven Storey Mountain*, p. 58.

81. Mott, *The Seven Mountains*, p. 331. This was when Merton was asking for permission to transfer to Cuernavaca.

82. Mott, *The Seven Mountains*, p. 233.

83. Cunningham, *Thomas Merton and the Monastic Vision*, p. 30.

84. Merton, *The Seven Storey Mountain*, p. 205.

85. After working on the French translation of his autobiography, he mused, 'It seemed completely alien, the work of a man I never even heard of' (Merton, *The Sign of Jonas*, p. 328).

86. Baker and Henry (eds.), *Merton and Sufism*, p. 239.

87. Merton, *Learning to Love*, p. 4.

88. In a letter from Charles Dumont, 13 November 1964 (Thomas Merton Center). Capitalization of 'French' is corrected in the quotation.

rarely exhibit these marks. First was the element of time. Several who knew Merton and were interviewed in the *Thomas Merton Oral History* remarked on the speed at which he worked, seldom going back to make corrections of any kind.[89] Second, none of the typists knew French very well.[90] Third, only rarely did he or his typists have access to a proper typewriter. Once, at the arrival of a properly equipped machine, he wrote to James Laughlin (publisher and friend), 'I picked the keys myself to get some French accents in case I should some day order a ton of *pâte de foie gras*, or *boeuf rôti* or even a dozen bottles of *kümmel*. Really it is for letters to foreign brass, of course'.[91] Merton knew these missing accents and marks were a problem; he referred to letters without them as 'very poor copy' in a letter to Dumont.[92]

Even in his final trip, the journey to Asia, Merton used French. Most interestingly, there is videotape in the Thomas Merton Center recording him speaking both English and French at the Bangkok conference. Merton switches easily between languages, although in French there are more pauses between phrases. Merton had not been an official translator at the conference, but served when requested, and one participant recalled, 'Father Merton translated with so natural a skill that one was hardly aware of his brilliance in reproducing from memory long passages of Dom de Floriss' remarks'.[93] So, at the end of his life as at the first, Merton's world was multilingual.[94]

Latin

Rating: 5 (given the dearth of native speakers)
Merton used Latin on a daily basis for prayer and study, and his monastic brothers characterized his proficiency highly, 'He really knew Latin',[95] and 'He seemed to move easily through the language of St Augustine, John Cassian, St Bernard, and St Thomas'.[96]

89. *Thomas Merton Oral History* (ed. Victor Kramer; Decatur, GA: Deweylands Press, 1985), pp. 5, 8, 246.
90. In a letter from Dumont, Holy Saturday, 1964 (Thomas Merton Center).
91. Cooper (ed.), *Thomas Merton and James Laughlin*, p. 153.
92. In a letter from Dumont, 27 May 1966 (Thomas Merton Center).
93. *The Catholic World* 209 (July 1969), pp. 160-63.
94. And although the last person he spoke to was Belgian Fr François de Grunne, a French speaker, that conversation was not in French. When they first met, Thomas Merton 'presented himself under the name, Frère Louis, with the kindest of smiles. If not, we always spoke English, and it was a delight to listen to his musical voice'. Fr François de Grunne, OSB, letter to the author, December 2000.
95. Waddell interview, (18 February 2000).
96. In a letter from Fr Felix Donohoe to the author (26 June 2000).

His first studies were classical Latin in England, starting at Ripley Court at a remedial level with younger boys, continuing at Oakham School. Available transcripts show no Latin college classes, although by the time he was at Columbia University, he earned pocket money as a Latin tutor.[97] After he completed his Master's degree at Columbia and began teaching English literature at St Bonaventure University, Merton began to read Latin again, consulting with Fr Philotheus Boehner[98] as needed.[99] On Merton's first visit to Gethsemani Abbey, he astonished the guestmaster by asking for a copy of the letters of St Bernard in Latin from the library — it was the guestmaster's first request for a book from a retreatant, much less one in Latin.[100]

It is important to note that the Latin which Merton began to study independently after Columbia and subsequently used at Gethsemani was not classical Latin, but medieval Latin. Most students of medieval Latin, like Merton, start with a firm classical Latin foundation, subsequently learning additional vocabulary and syntax, which vary through time and region.

Latin permeated Merton's life in the monastery, both privately and publicly. For most of his monastic life, the Mass and community prayers were in Latin. Merton loved the Latin liturgy, and he was not pleased with the change to English. However, living in the hermitage allowed him to continue to say his prayers in Latin. 'Down in the monastery they now have English vigils. I cling to the Latin. I need the continuity!'[101] He celebrated the Eucharist in Latin whenever possible, and had a deep personal relation to the Vulgate, even though it was considered technically inferior to more recent translations.[102]

Although there is no evidence of extended Latin texts written by Merton, there is at least one poem in Latin which he wrote for Victor Hammer.[103] Merton also followed the example of St John of the Cross, writing short phrases in Latin, giving them to the young monks as texts

97. Merton, *The Seven Storey Mountain*, p. 235.

98. Thomas T. Spencer, "'Tom's Guardian Angels': Merton's Franciscan Mentors', *Merton Seasonal* 26.2 (Summer 2001), p. 17.

99. Shannon, *Silent Lamp*, p. 113.

100. *Thomas Merton Oral History*, p. 259. The guestmaster was Fr Joachim Tierney.

101. Merton, *The Other Side of the Mountain*, p. 60 (29 February 1968).

102. *The Legacy of Thomas Merton* (ed. Patrick Hart; Kalamazoo: Cistercian Publications, 1986), p. 221.

103. Thomas Merton, *The Collected Poems of Thomas Merton* (New York: New Directions, 1977), p. 1005.

for meditation.[104] His translations from Latin include *The Wisdom of the Desert*.[105]

Here ends the listing of individual languages. One might have noticed that all the languages listed in which he made any real progress are all Western languages, and those at which he excelled were Romance languages — Latin and languages descended from Latin. Having first learned French, Merton benefited not only from his own affinity for language learning but also the affinities among the other Romance languages he encountered. While modern Romance languages in general have a high level of lexical overlap, about 40 per cent cognancy for a standard 100-word list, some languages are even closer. For French and Spanish, cognancy is 65%, and for Spanish and Portuguese, 90 per cent.[106]

It is not necessary here to discuss how Merton's linguistic gifts affected his life; all his biographers have noted this to varying degrees. He occasionally discussed this as well, and there is a revealing passage in his private journal which gives yet another motivation for his passion for languages as well as knowledge in general: 'I realize I have pushed too far…reading too widely about everything, trying to write too much again, trying to set myself up as an authority on everything in my own imagination'.[107] However, Merton's face to the world about his language skills was typically humble. There are passages in his letters in French (and others in Spanish) where he apologized, *'Cette lettre n'est pas un chef d'oeuvre de francais, mais vous me comprenez'*[108] ('This letter is no masterpiece of French, but you will understand').

Even some of Merton's deepest spiritual experiences were multilingual, including the *'Creo en Diós!'* experience in Cuba mentioned above; the realization at Polonnaruwa in then Ceylon, 'The rock, all matter, all life, is charged with *dharmakaya* — everything is emptiness and everything is compassion';[109] and the famous 'Fourth and Walnut' experience

104. Cunningham, *Thomas Merton and the Monastic Vision*, p. 40.

105. Thomas Merton, *The Wisdom of the Desert* (New York: New Directions, 1960).

106. Bernard Comrie (ed.), *The World's Major Languages* (New York: Oxford University Press, 1990), p. 206.

107. Merton, *Turning toward the World*, p. 22 (19 July 1960). The passage continues, 'Slow down! Don't expect to learn Chinese all of a sudden! Still, I think I will write that article on Chinese thought'. In the space of a few sentences he develops a self-criticism, processes it and decides to keep on doing it anyway!

108. In a letter to Dumont, 18 June 1965 (Thomas Merton Center). The original typed letter lacks diacritics (*francais* vs. *français*) and must have been typed on a typewriter without French accents and symbols.

109. Merton, *The Other Side of the Mountain*, p. 323 (4 December 1968).

where the wall between the world and the monastery vanishes, and Merton sees at the center of the hearts of the human race '*le point vierge* (I cannot translate it)...the pure glory of God in us'.[110]

Merton spent most of his life in a multilingual world, from his birth in a Catalan-speaking area of France to his death in Thailand at an international monastic conference. Early successes in French, Italian, and German first led him to consider a career in the English diplomatic service,[111] or perhaps to life as a journalist, working up to what seemed to be the prestigious position of foreign correspondent.[112] Yet, though his adult life was ultimately spent within the confines of a monastery, Merton's life journey, facilitated by his multilingual abilities, was paradoxically most far-reaching when he stayed in one place. Ironically, when he finally achieved his dream of world travel, his life suddenly ended.

From his virtuosity in French, Latin and Spanish, to his competence in German, Greek, Italian and Portuguese and his acquaintance with Catalan, Chinese, Provençal, Russian and other languages; it would be impossible to strip the influence and actual appearance of foreign languages from Merton's thinking and his writing. And yet while multilingual ability is not a requirement for a writer and spiritual teacher, this ability was surely one of Merton's great gifts.

110. Merton, *Conjectures of a Guilty Bystander*, p. 158.
111. Shannon, *Silent Lamp*, p. 53.
112. Merton, *The Seven Storey Mountain*, p. 69.

[TMA 15 (2002) 155-165]
ISSN 0894 4857

Language Mixture in a Macaronic Poem of Thomas Merton

Johan Seynnaeve

A common assumption, with which a reader approaches a literary text, is the expectation that the work is written in one and the same language.[1] This corresponds to the everyday experience of two or more people communicating with each other in spoken language. When we address someone we speak to him[2] in a language we suppose he knows[3], and if this assumption turns out to be right we continue the conversation using the same means of expression. It is in this very situation anyone who sits down to write a literary work finds herself: she addresses a reader who she assumes is capable of understanding what she is about to tell him in a language she has chosen. It would seem strange if a writer who knows several languages decides to use them in the same work as she likes it or even arbitrarily.

However, there are literary works in which more than one language is used as the means of expression, even though language mixture in literature remains the exception. This phenomenon, therefore, requires an explanation. Because of its marginal status it has received little attention either from linguists or from literary critics. The reason for this neglect seems to be the general opinion that a literary text can only be a real work of art if it is written in the native tongue of the author. This explains

1. The term 'language' is used here is to refer to any kind of system that two or more people use for communication.
2. This essay adopts a solution to the problem of sexism in the use of English pronouns first proposed by Ralph Fasold: switching between feminine (*she/her*) and masculine pronouns (*he/him/his*) whenever a singular generic pronoun is needed. See Ralph Fasold, *The Sociolinguistics of Society* (Oxford: Basil Blackwell, 1984), p. 264.
3. Imagine a person who speaks two or more languages and has to choose which one to use.

the surprise of many students of European literature of the Middle Ages, for example, when they are confronted with the multilingualism of that period. It is easy to forget that there were entire periods during which it was not natural to express oneself in one's native tongue, and that this situation still exists among speakers of minority languages.[4] At the same time we need to take into account those situations, even in everyday circumstances, where the person we address might be fluent in two or more languages and, in case we are equally fluent in the languages he knows, we have the option of switching from one language to the other in the course of the conversation or use words from language A while speaking language B. In a multilingual society a writer has the same option when composing a literary work.

These preliminary remarks lead us to an important distinction. The term language mixture in literature can refer, on the one hand, to the use of more than one language in a text where passages in one language alternate with passages in another language and the choice of language is determined by the content matter (e.g. philosophy, theology, literature proper) or by literary genre (poetry, drama, prose). On the other hand, the term can also be used for texts which are written mainly in one language with frequent switches to words, phrases or sentences in another language or other languages. In this essay I will consider language mixture in this second sense and illustrate some of its mechanisms in the poem 'Mens sana in corpore sano', written by Merton when he was teaching English at Saint Bonaventure and appropriately subtitled 'Macaronic Lyric'. It is indeed customary to designate as macaronic[5] any text that includes words from one or more languages other than the basic language used as constituents of a text that is fundamentally in the basic language. Thus, notwithstanding its Latin title the basic language of the poem is English and material of variable length (a single word, a phrase, a clause) from Latin, French, Spanish, German and Italian is mixed in with the English of the poem. Why did Merton alternate these languages in this fashion? Why did he sometimes integrate them a word, a phrase or a clause at a time into his English? Why are some of these integrated phrases simply borrowed and other complexly realized within the con-

4. A case in point is that of the Tiwa Indian community of Taos, New Mexico. A pueblo-dwelling community of about 2000 speakers, its members grow up speaking Tiwa. For purposes of writing they resort to Spanish or English.

5. For a recent and thorough discussion of the origin and the use of the term 'macaronic' see the introductory chapter of Siegfried Wenzel, *Macaronic Sermons: Bilingualism and Preaching in Late-Medieval England* (Ann Arbor, MI: University of Michigan Press, 1994).

straints of English grammar?[6] Why is the foreign language material in the poem 'readily translatable with minimal knowledge of the languages'?[7] These are some of the questions this contribution will attempt to answer.

Below Merton's macaronic poem as it appears in O'Connell, ' "And called it macaronic": an unpublished early poem of Thomas Merton' is reproduced.

Mens Sana in Corpore Sano: *Macaronic Lyric*[8]

Mens sana (nerfs de cafe)
Corpore sano (defense de fumer!)
'What are ces mots of advice you have sung us!
Mens feeble in corpore fungus?'

Mens grandma in corpore grandpa
Comes never to lovers of rhumba and samba:
La vie carries on plus heureuse, also longer
With mens sana in corpore conga!

These are palabras far besser to teach:
'Mens happy in corpo felice!'

No! Joys of the sense
Ruin corpus and mens!
Your corpus is drunk and your reason is dense!
So please to pensare some thoughts of demain:
Mente di coucou in corpo migraine!

Merton may have been familiar with some of the early examples of literary texts that mixed languages in one form or another, especially those of the author this poetic form is preeminently associated with, the Benedictine monk Teofilo Folengo, who mixed his Latin hexameters with Italian words and phrases.[9] Unfortunately, no references to the

6. It is, of course, impossible to determine to what extent Merton was conscious of the structural aspects which will be suggested in an attempt to answer these questions. Poets deal intuitively with words and do not consciously plot every resonance of the symbols and themes they play with. They know, either by a great inborn talent, or by a period of apprenticeship, what sounds good. In trying to determine patterns in a poem we should allow for the possibility that a poet can structure a poem far beyond explicit intent or knowledge.

7. Patrick F. O'Connell, ' "And called it macaronic": An Unpublished Early Poem of Thomas Merton', *The Merton Seasonal* 21 (1996), pp. 7-8 (7).

8. O'Connell, ' "And called it macaronic" ', pp. 7-8.

9. Also known by his pseudonym Merlin Cocai, this Italian poet was born in Mantua in 1491 and died at the monastery of Santa Croce in Campese in 1544. His

Italian monk survive in Merton's published journals and letters. His 1939–41 journal, by contrast, is full of notes and comments on the most famous macaronic writer of the twentieth century, James Joyce. In fact, Merton's interest in writing in a mixture of languages is closely connected with his enthusiasm for Joyce in general and for Joyce's last and most problematic work, the macaronic masterpiece *Finnegans Wake*, in particular, the publication of which Merton lists as one of the three important things that happened in 1939.[10] The impact this work had on his writing Merton acknowledged in a journal passage from 25 January, 1941: 'Joyce language; that's what I like writing. I'd like to write that all the time'.[11]

In its simplest description, the language of *Finnegans Wake* is a combination of prose and poetry characterized by the inclusion of multitudinous fragments of foreign languages. This work undoubtedly provided the impetus for Merton to experiment with this literary form in his letters, journals, and poetry. On 5 May, 1941 Merton wrote: 'What is one recreation I am happy about, and the only one? Writing — not this, but a letter in a crazy new language to Gibney yesterday, and a macaronic poem'.[12]

The following day, 6 May, Merton also started working on a book-length macaronic project entitled *Journal of my Escape from the Nazis*.[13] Nearly a decade after his entrance in the monastery, on 3 March 1951, he would reflect on his macaronic journal and its language as '[a]n invented language which I still like'.[14] And when preparing the manuscript for publication in February 1968 he commented:

> [T]his *Journal of Escape* [...] I have always thought of as one of my best. Not that it holds together perfectly as a book, but there is good writing and it comes from the center where I have really experienced myself and my self.

main macaronic work, *Baldus*, appeared in 1517. For an enlightening discussion of Folengo and his poetic language see: Bruno Migliorini, 'Sul linguaggio maccheronico del Folengo' *Avsonia* 23 (1968), pp. 7-26.

10. Thomas Merton, *Run to the Mountain: The Story of a Vocation* (Journals, 1; 1939–41; ed. Patrick Hart; San Francisco: HarperSanFrancisco, 1996), p. 88.

11. Merton, *Run to the Mountain*, p. 301.

12. Merton, *Run to the Mountain* (rev. edn), p. 361.

13. The manuscript would be revised several times and Merton periodically considered publishing it. It finally appeared, posthumously, in 1969 as *My Argument with the Gestapo* with the subtitle *A Macaronic Journal* (Garden City, NY: Doubleday).

14. Thomas Merton, *Entering the Silence: Becoming a Monk and a Writer* (Journals, 2; 1941–1952; ed. Jonathan Montaldo; San Francisco: HarperSanFrancisco, 1995), p. 450.

It represents a very vital and crucial — and fruitful — moment of my existence.[15]

A typical passage in the book that serves to illustrate how profound the impact of Joyce was can be found in ch. 19 in the final section of the letter to Madame Gongora:[16]

Refleji en su cor de tecnico
Su tipo de poema favoritt
Et es el tipo macaronico
Lo mas hermoso jamais que se vitt!

If his favorite type of poem was one of the macaronic type the reader of *The Collected Poems* ends up empty-handed after a search for a poem that would merit this description. O'Connell, however, has pointed out that:

There is a genuinely macaronic poem earlier in the journal itself [i.e. the journal Merton kept while at Saint Bonaventure's], the lovely lyric 'Silet mons/Silent arva' which concludes the description of a projected short story about a hermit in the December 19, 1939 entry (*Run*, pp. 114-117).[17]

He goes on to argue that the poem Merton referred to in the 5 May 1941 entry quoted earlier is not 'Silet mons / Silent arva' but almost certainly an unpublished and uncollected poem '[i]ncluded in the collection of material which Merton had given seminarian Richard Fitzgerald just before leaving for Gethsemani in December, 1941',[18] a poem entitled 'Mens sana in corpore sano'.[19]

The poem is essentially a set of variations on the theme stated in the title. That theme, of course, is a well-known Latin epigram, a cleverly worded statement that is most commonly translated in English as 'a sound mind in a sound body'. It is one of the many pointed observations that can be found in the work of the classical Roman satirical poet Juvenal[20]. It figures among the many the pieces of advice Juvenal gives his readers as to what they should pray for. Indeed the entire verse

15. Thomas Merton, *The Other Side of the Mountain: The End of the Journey* (Journals, 7; 1967–1968; ed. Patrick Hart; San Francisco: HarperSanFrancisco, 1998), p. 51.

16. Merton, *My Argument with the Gestapo*, p. 190. This is the second stanza of a three-stanza macaronic poem the narrator includes in a letter he is writing to Madame Gongora from the Hotel Rocamadour in Paris. Madame Gongora, herself, is a sibyl who prophesies in macaronic language.

17. O'Connell, '"And called it macaronic"', p. 7.

18. O'Connell, '"And called it macaronic"', p. 7.

19. I want to thank Paul Pearson for providing me with a xerox of the typewritten autograph of the poem.

20. Full name: Decimus Junius Juvenalis (c. 65–c. 128 CE)

reads: 'Orandum est, ut sit mens sana in corpore sano'[21] (One should pray for a healthy mind in a healthy body).

For a good understanding of this verse one needs to know that it is preceded by a section in which the poet gently mocks the whole process of prayer. The background against which this recommendation is given, in other words, detracts somewhat from the seriousness of the advice. This is entirely in line with a particularly striking feature of satirical writing, namely its tendency to inspire a reaction of ambivalence. Should we approve of the satirist or disapprove? Should we identify with him (and it generally is a 'him') or dissociate ourselves? The answer varies from audience to audience, from reader to reader. What is certain is that this ambivalence renders satire a challenging type of literature.

From a broad-brush structural point of view, the poem is almost wholly built on the repeated restatement of the title, which is varied in diverse ways and occurs in the last line of each stanza. In other words, Merton takes as his point of departure the familiar epigram stated in the title and then stanza by stanza goes through a playful distortion of that familiar theme:

> Mens Sana in Corpore Sano
>
> Mens feeble in corpore fungus?'
>
> With mens sana in corpore conga!
>
> 'Mens happy in corpo felice!'
>
> Mente di coucou in corpo migraine!

The first line of the second stanza breaks this pattern: 'Mens grandma in corpore grandpa', a restatement of the theme at the beginning of a stanza. I take it not to be by coincidence that the exception occurs at exactly this juncture in the poem. This line occupies an obviously transitional position and serves as a linking device between the first and second stanzas to highlight the close parallelism between them. The similar formal makeup of these two stanzas further underscores this parallelism: they are the only stanzas that consists of four lines; their rhyme scheme is of the same form (aabb, ccdd); and the language mixture index[22] in both is three (English, French and Latin).[23] Jointly with these

21. Verse 356 of the tenth *Satura*.

22. I use the term 'language mixture index' as an indicator of the number of languages used in a stanza.

23. The third stanza combines material from English, Spanish, German, Latin and

features, therefore, the stanza-initial restatement serves as a device that emphasizes the conspicuous symmetrical design in the first half of the poem. There is, however, another point to make in connection with this design. The title of the poem contains two noun phrases, 'mens sana' and 'corpore sano', each of which consists of a noun followed by an adjective. This twofold structure is projected in the first two lines by a simple repetition of the same noun phrases. In their similar formal make-up the first two stanzas can be seen as a further development of this structure.

The pattern that has been set up by the title and reinforced first by the first two lines and then by the first two stanzas is interrupted by the third stanza. With just two lines it is the shortest stanza of the poem. In addition, it also has the highest language mixture index. This is a very common compositional technique. In musical terms it is the bridge of the composition: whereas the first and second stanzas have the same melodic and harmonic structure, the third stanza presents a different structure. The fact that the second stanza repeats the music of the first sets up a pattern, which is 'disappointed' by the newness of the bridge, leaving a sort of unresolved situation, which is given resolution in the fourth stanza.

When we return to the questions raised earlier in this essay we find that subtle differences in language mixture help articulating the basic structural features of the poem outlined in the preceding paragraph. In the remainder of this essay I will suggest that the ways in which foreign language material is integrated in the English text can be correlated to the poem's overall pattern. Some of this material represents strict borrowing, a process by which a linguistic item from one language (the source language) is adopted in another (the recipient language) with varying degrees of adaptation but within the grammatical system of the recipient language, not that of the source language. Thus, a word like French 'vogue' can be borrowed into English with or without retention of the vowel (ɔ),[24] but in order to be classified as a borrowing it must conform to English syntactic patterns. In a sentence like 'Bell-bottoms were once in vogue', consequently, the French word represents borrowing since it conforms to the rules of English syntax. But in a sentence like 'Bell-bottoms were once *en vogue*', because the French word is realized in accordance with French syntax, it represents not borrowing but code-switching. Unlike borrowing, code-switching involves the alternation of

Italian and consequently has an index of five. The fourth stanza has an index of four (English, Latin, French and Italian).

24. The French pronunciation is [vɔg]; in English it is pronounced [vog].

two or more grammatical systems: rather than adopting a word from another language, in other words a speaker switches languages entirely. In addition, while the switch may involve a single word, it is more likely to involve a phrase or clause. In the main, however, an instance of code-switching, in contradistinction to one of borrowing, is realized in accordance with the grammatical system of the source language. Thus the reason 'corpus' and 'mens' in the second line of the last stanza represent borrowing and not code-switching is the fact that its nominative inflectional ending would be ungrammatical in Latin, which would require the accusative 'corporem' and 'mentem'. Other examples of borrowing are the Spanish word 'palabras' and the German word 'besser' in the first line of stanza three.

We move on to more complex forms of language mixture, where the foreign language material is longer than a word. Among the easiest of these cases, since they in effect do not need to be syntactically integrated, are those that involve the noun phrases in the first two verses. The switches from the Latin noun phrase 'mens sana' to the French 'nerfs de café', and from Latin 'corpore sano' to French 'defense de fumer' are simple juxtapositions, where Latin syntax does not affect French syntax or vice versa.[25] On the other hand switches between subject noun phrase and the verb phrase do involve syntactical accommodations, as in the third line of the first and the second stanzas:

> "What are ces mots of advice
>
> La vie carries on plus heureuse

In the first case a French noun phrase, 'ces mots' ('these words'), is integrated in a sentence according to English syntax and in the second an English verb phrase, 'carries on', is part of a grammatical French sentence ('Life carries on happier'). Syntactic accommodation also occurs in phrases where the grammatical category of an item changes. In the last line of the fourth stanza, for example, what originates as a noun ('migraine') is recuperated as an adjective following 'corpo'. By a different kind of syntactic accommodation an infinitive ('pensare') in line three of the same stanza is borrowed as an imperative.

One final instance of language mixture is illustrated in the rhyming pairs 'teach' / 'felice' and 'demain' / 'migraine'. In both cases a foreign word is phonologically accommodated to facilitate the correspondence with

25. Note that the lack of syntactic integration is reflected in the punctuation (the use of parentheses).

the sounds of the English words they are paired with. The Italian pronunciation of the adjective 'felice', (feliče), is adapted to (felič) and the French word 'demain' (dǝmẽ), is changed to (dǝmejn).

Let us now look at the way these different instances of language mixture can be motivated in terms of the overall structure of the poem. We have seen how there are a number of respects in which, on the one hand, the first and second stanzas are structurally similar and, on the other hand, the third stanza is clearly marked off. When we chart the occurrences of borrowing and switches through the poem, an interest pattern emerges.[26] In the first two lines of stanzas one and two we find either simple borrowings or switches that do not involve syntactic accommodation. The third line in each of these stanzas, however, involve the two instances of code-switching with syntactic accommodations mentioned earlier. It is not by chance that we find such a pattern—that this pattern points up an essential aspect of the parallelism that exists between the first and the second stanza. In the third stanza, however, we find only instances of borrowing, even though this is the stanza with the highest language mixture index. This is entirely in line with the structural position of the clearly demarcated third stanza. What we find in the last stanza, interestingly, are instances of every type of language mixture mentioned: a borrowing in 'Your corpus is drunk', code-switching without syntactic accommodation in 'Ruin corpus and mens', code-switching with syntactic accommodation, as in 'to pensare' and 'migraine', and phonological adaption in 'demain'. This is the stanza that gives closure to the unresolved situation created by the third stanza.

It is thus evident that the language mixture in this poem is not arbitrary and that the switches do not occur randomly, but are motivated by the overall structure and parallelisms created. Ultimately, switches motivated in this way, like any number of other rhetorical strategies, demonstrate and foreground Merton's linguistics competence. Borrowing alone might have sustained this kind of stylistic motivation and would have been considerably easier for Merton. The fact that he uses the whole range of language mixture mechanisms ranging from simple borrowing to complex code-switching clearly demonstrates his interest in languages and also reveals him to be the most fluent kind of polyglot.

In 'Mens sana in corpore sano' Merton seems to tells us 'Life should be taken as I take languages, with a blend of seriousness, attention, irony

26. As pointed out earlier the last line in each stanza is the restatement of the theme stated in the title. These lines can be viewed as the frame around which the structure of the poem is developed.

and freedom'. The poem is, in a sense, and in the same spirit, a development of a sentence from *Finnegans Wake*: 'They lived and loved ant laughed end left'.[27]

It is worth mentioning, finally, that, while the existence of macaronic writing in poetry can be explained in terms of its function, a prose text like *My Argument with the Gestapo* is less amenable to such an analysis. This is not the place to attempt a detailed analysis of the novel. It is sufficient to draw attention to the following fragment from the novel to show how radically different it is from Merton's macaronic poem not only in its linguistic structure but even more in its rhetorical function:

> Yherezt nopitty ont dzhe steirs.
> Dzhere eitz nobbudy onz dhe stoirs.
> [...]
> Jzhere ids nyubbodi omn dlhe shtairs.
> Tzere its noobodo uan we stairs, nope.
> [...]
> Dear has nopretty in the stars?
> [...]
> Dzhere ess know's doddy on these stairs, nope.[28]

In fact, it is doubtful whether the quoted passage really qualifies as macaronic language. It is certainly not a case of language mixture in any of the senses discussed earlier in this essay, but rather a seriously modified form of the writer's own language. The reader is presented with variations of the simple phrase 'There is nobody on the stairs' in an invented language that has more in common with the linguistic experiments of the Dada movement of the late 1910s and early 1920s than with the clearly identifiable cases of borrowing and code-switching of 'Mens sana in corpore sano'. One wonders if the linguistic technique Merton chooses here attempts to achieve an effect comparable to the multiple imagery of a dream and if the purpose of the passage is to penetrate beneath even the most inclusive recordings of a flow of consciousness, and to express in literary medium the flow of subconscious imagery in a dream state. That this appears to be the case becomes clear when the narrator subsequently declares that 'it was only a dream. [...] I stand at the top of the stairs, and there is, indeed, nobody in the stairs'.[29] This and other such passages, easily found throughout the novel, are not exam-

27. James Joyce, *Finnegans Wake* (New York, NY: The Viking Press, 1982; centennial edn), p. 18.
28. Merton, *My Argument with the Gestapo*, pp. 197-98.
29. Merton, *My Argument with the Gestapo*, pp. 200-201.

ples of macaronic language but rather of Merton's own invented language, his Esperanto, despite the novel's subtitle, *A Macaronic Journal.*[30]

30. It should also be pointed out that the bulk of the novel is written in English and that the passages containing instances of invented language are clearly marked and do not occur in every chapter of the novel. It is significant that in what has been identified as one of the strongest episodes in the novel (Ross Labrie, *The Art of Thomas Merton* [Fort Worth, TX: The Texas Christian University Press, 1979], p. 30), the penultimate chapter, which focuses on the war-inflicted schizophrenia of a French soldier, not a single instance of Merton's Esperanto is to be found.

[TMA 15 (2002) 166-193]
ISSN 0894 4857

Thomas Merton and Walker Percy: A Connection through Intersections

John P. Collins

In his essay, 'The Street is for Celebration', Thomas Merton describes the city street as a habitat for the alienated who become transformed through the power of love which 'will set our lives on fire and turn the rubble back onto gold'. Speaking of the street as a space, Merton states *'[an] alienated space, an uninhabited space, is a space where you submit'*. Further, 'The alienated city isolates men from one another in despair, lovelessness, defeat'. The transforming power of love will enable the people to have joy and inhabit the street 'when it becomes a space for celebration'.[1] Walker Percy's novel, *The Moviegoer*, has a number of street scenes. Binx, the protagonist of the novel reflects:

> The street looks tremendous. People on the far side seem tiny and archaic, dwarfed by the great sky and windy clouds like pedestrians in old prints. Am I mistaken or has A fog of uneasiness, a thin gas of malaise, settled on the street. The businessmen hurry back to their offices, the shoppers to their cars, the tourists to their hotels.[2]

Although Binx has a difficult time articulating the nature of his search, he clearly recognizes that 'the malaise of everydayness' is an obstacle to the search. Later in this essay, Merton's epiphany or transformation on a street corner in Louisville is juxtaposed with a street corner scene in New Orleans, where Binx experiences an epiphany and his transformation is the culmination of the search.

In late January 1964, Thomas Merton wrote in a letter to Walker Percy:

1. In Thomas Merton, *Love and Living* (ed. Naomi Burton Stone and Brother Patrick Hart; New York: Farrar, Straus & Giroux, 1979), pp. 46-53.
2. Walker Percy, *The Moviegoer* (New York: Vintage Books, 1998), p. 18.

> There is no easy way to thank you for your book. Not only are the good words about books all used up and ruined, but the honesty of *The Moviegoer* makes one more sensitive than usual about the usual nonsense. With reticence and malaise, then, I think your book is right on the target.[3]

So begins the brief and intermittent correspondence (1964–67) between Walker Percy and Thomas Merton. In between the letter exchange was a meeting that the correspondents had at Merton's hermitage along with other members of the editorial board of the publication *Katallagete*. From the above excerpt of this first letter one can gain a flavor of the obvious enthusiasm that Thomas Merton had for Walker Percy's first book, *The Moviegoer*. In subsequent correspondence to other literary personages Merton conveyed equal enthusiasm for this book and Percy's subsequent works. Although an admirer of Percy, Merton did not leave a critique through essays as he did with other literary luminaries such as Albert Camus, William Faulkner, Flannery O'Connor and Boris Pasternak. If Merton had lived longer perhaps he would have written a literary critique or if Percy pre-deceased him Merton might have written an 'Elegy', as he did at O'Connor's death. The one advantage that we have with Percy, however, is that we have copies of the letter-exchange with Merton and even a record of a meeting at the hermitage which is not the case with Faulkner, Camus and O'Connor.

This essay analyzes the relationship between Thomas Merton and Walker Percy as documented through interviews, letters, journal entries and commentaries by scholars. Further, delineating the similarities of both men provides the necessary backdrop to an understanding of their interest in the novel as a genre for uncovering what Percy calls the 'malaise' in contemporary society. A brief review of selected works of both writers will show the affinity between Merton and Percy. Finally, the aforementioned novel, *The Moviegoer*, will provide the context for Percy's glimpse of an epiphanic event, an occasion of grace on the corner of 'Elysian Fields and Bon Enfants'. This fictional event will be juxtaposed with an historic event, the occasion of grace for Thomas Merton at the corner of Fourth and Walnut, 18 March 1958.

I. Early Influences

Walker Percy was born in Birmingham, Alabama in 1916, at the age of 13 he lost his father through suicide and at the age of 15 his mother died in an accident. Percy subsequently took up residence with his second

3. In Thomas Merton, *The Courage for Truth: The Letters of Thomas Merton to Writers* (ed. Christine M. Bochen; New York: Farrar, Straus & Giroux, 1990), p. 281.

cousin, William Alexander Percy, who was a literary luminary in his own right.[4] While residing in Greenville, Mississippi, Percy became friends with future historian and writer, Shelby Foote. This friendship lasted over a lifetime and their correspondence mainly about literary matters was published in 1997.[5] Percy graduated from the University of North Carolina in 1937 and he subsequently entered medical school at Columbia University, underwent three years of psychoanalysis and graduated with an MD in 1941. He and his wife, Mary Bernice (or 'Bunt') converted to Catholicism while residing in New Orleans. Percy published essays on language, philosophy, religion, psychiatry, morality and Southern literary culture. His first novel, *The Moviegoer*, won the National Book Award in 1962. Other novels included: *The Last Gentleman* (1966), *Love in the Ruins* (1971), *Lancelot* (1977), *The Second Coming* (1980) and *The Thanatos Syndrome* (1987).

Students of Merton, of course, can readily grasp the more obvious similarities between the two men. Merton was born in 1915 and he, too, experienced the early death of his parents as he lost his mother when he was 6 and when he was 15 his father died. Both men attended Columbia University and, in fact, were there simultaneously. Percy received an MD in 1941; Merton received his BA in 1938 and his MA in Literature in 1939. Both were converts to Catholicism; they read St Thomas Aquinas and were caught up in the 'tremendous spiritual awakening in the late forties and fifties'. This was the age of Monsignor Fulton Sheen, a radio and television priest, who referred frequently to the writings of St Thomas. Etienne Gilson's book, *The Spirit of Medieval Philosophy*, provided a solid neo-Thomistic foundation for Merton and Percy.[6] Although both Merton and Percy were influenced by the neo-Thomistic constructs of the period, their attraction to Catholicism and ultimate conversion, was expressed in varied ways according to their experiences.

In a 1987 interview with Robert Cubbage, Percy was asked what motivated him in regards to his conversion to Catholicism. His response was that he traced the historical roots of the Church and even found that St Peter was buried 'in the basement of a Cathedral in Rome. Other churches can't produce evidence like that'. Percy admits that his conversion is hard to explain: 'Because in the end, faith is a gift. It's grace, an extraordinary

4. See William Alexander Percy, *Lanterns on the Levy: A Recollections of a Planter's Son* (New York: Alfred A. Knopf, 1941).

5. See *The Correspondence of Shelby Foote and Walker Percy* (ed. Jay Tolson; New York: W.W. Norton, 1997).

6. See Kieran Quinlan, *Walker Percy: The Last Catholic Novelist* (Baton Rouge: Louisiana State University Press, 1996), pp. 36-41.

COLLINS Thomas Merton and Walker Percy 169

gift'.[7] During an interview with Bradley R. Dewey in 1974, Percy states that he reached the decision to become a Catholic by reading Kierkegaard's essay, 'The Difference between a Genius and an Apostle'.[8] From his reading of Kierkegaard, Percy concurred that apostles were 'authorized to tell others what constituted the good life and that these people derived their authority not from themselves, not from their genius or wisdom or power, but from the authority of God'. However, 'to fully receive the message of Christ and his apostles something else was needed—the mystery and gift of grace'.[9]

It is instructive to note that Robert Inchausti describes Thomas Merton in Kierkegaardian terms 'as an apostle not a genius. He did not write great poetry or masterpieces of theology'. Merton wrote about or admired people who in their day 'brought them into conflict with the prevailing pieties of their age'. By examining his own solitude, he was able, through his candor, to speak directly to people's own solitude.[10]

As to what drew Merton to Catholicism, William H. Shannon conjectures that there are a number of factors to consider. Respecting the Catholic culture and suspecting the ecclesial structure of the Church, Merton was influenced by William Blake, Bramachari, and the spiritual classic, The Imitation of Christ. Jacques Maritain's Art and Scholasticism helped Merton 'untie the knots' of his Masters' thesis entitled, 'Nature and Art in William Blake: An Essay in Interpretation'.[11]

Gilson's book, The Spirit of Medieval Philosophy, revolutionized Merton's life up to that point. He came across 'the word, aseitas'. Now the Catholic beliefs took on new meaning. The Aseity of God means that 'God is Being Itself', or 'He is the pure act of existing'. After making more notations from the book, Merton asserts that these statements about God 'lay deep in my own soul'. His former idea about God, a 'fatuous, emotional thing', is transformed into the knowledge 'that no idea of ours, let alone any image could adequately represent God, but also that we should not allow ourselves to be satisfied with any such knowledge of Him', Merton con-

7. Lewis A. Lawson and Victor A. Kramer (eds.), More Conversations with Walker Percy (Jackson: University Press of Mississippi, 1993), p. 185.
8. Lewis A. Lawson and Victor A. Kramer (eds.), Conversations with Walker Percy (Jackson: University Press of Mississippi, 1985), p. 110.
9. Jay Tolson, Pilgrim in the Ruins: A Life of Walker Percy (Chapel Hill: The University of North Carolina Press, 1992), p. 200.
10. Robert Inchausti, Thomas Merton's American Prophecy (Albany: State University of New York Press, 1998), pp. 1-3.
11. William H. Shannon, Silent Lamp: The Thomas Merton Story (New York: Crossroad, 1992), p. 91.

© The Continuum Publishing Group Ltd 2002.

tinues. 'The result was that I at once acquired an immense respect for Catholic philosophy and for the Catholic faith'.[12]

While Walker Percy read Etienne Gilson and Jacques Maritain as well, his attraction to Catholicism was considerably influenced by reading St Thomas Aquinas. The system building, logic, propositions and Aquinas's dialectical style appealed to Percy's penchant for logic and system building.[13] Percy's conversion was 'the result of an intellectual process as well as grace'. Percy still held to his convictions that science can help solve some of humanity's problems and that science can work in tandem with faith. 'But while science could generalize about the human creature, it could not put its finger on the creature's unique endowment, his individuality'. Implied in this individuality is not only humankind's existence but the soul. As Percy pondered his own individuality — his existence, his soul — he came to Christianity out of feelings of self-disgust and his own unworthiness because the recognition of man's inadequacy and corruption 'was the first step in hearing the Christian message'.[14]

Remember Merton had his own feelings of unworthiness and disgust prior to his conversion. Reflecting upon his dissolute life, Merton writes:

> If my nature had been more stubborn in clinging to the pleasures that disgusted me: if I had refused to admit I was beaten by this futile search for satisfaction where it could not be found, and if my moral and nervous constitution had not caved in under the weight of my own emptiness, who can tell what would have eventually have happened to me? Who could tell where I would have ended?[15]

Merton reflecting upon the natural human condition through his own sordid condition likens the soul to a 'lucid crystal left in the dark'. Through the gift of sanctifying grace, humanity's selfish nature 'becomes transfigured and transformed when the Love of God shines in it'. This new transfigured and transformed state allows a person to lose 'himself completely in the Divine Life within him' and, thus, become a saint.[16]

During an interview with Dorothy H. Kitchings in 1979, Percy was questioned about the Catholic Church and the authenticity of the Pope and the possible impact on his work. Percy responded:

> ...I feel like Flannery O'Connor when Flannery said that far from finding the Catholic Church confining or in any way oppressive, she found it liberating.

12. Thomas Merton, *The Seven Storey Mountain* (New York: Harcourt, Brace & Company, 1994), pp. 172-75.

13. Tolson, *Pilgrim in the Ruins*, p. 174.

14. Tolson, *Pilgrim in the Ruins*, pp. 198-200.

15. Merton, *The Seven Storey Mountain*, pp. 164-65.

16. Merton, *The Seven Storey Mountain*, pp. 169-70.

It puts you in touch with, first with the mystery, and that, in truth, religion has to do with mysteries. It addresses the nature of man. And secondly, the whole Catholic view of man is man as a pilgrim, or on a search or on a pilgrimage—man as a wayfarer, which is what a novel is about, you know; which is probably why Buddhists don't write good novels, or Freudians don't write good novels, or Marxists don't write good novels. They don't see man that way. So the idea of a bishop or a priest, or even a pope looking over my shoulder bothering me is absurd.[17]

During the same period when Percy remains somewhat conservative regarding Catholicism, Thomas Merton began to emerge as a constructive critic. Merton writes to Mark Van Doren, on 28 January 1941, 'I am finding out all sorts of good things about scholastic philosophy, and, incidentally learning to be critical of St Thomas, which is a good thing for a Catholic to be, I find—and a rare one'.[18] Reflecting upon this masterful Columbia professor, Merton claims that Van Doren has Thomistic attributes which influence his teaching. '[T]he scholastic temperament that Merton ascribes to Van Doren in his characterization is easily traced to Merton's Thomistic studies under the self-effacing tutelage of Dan Walsh at Columbia'.[19] When asked by M.R. Chandler for books that influenced him, Merton responded in a letter dated 19 July 1963 listing the *Summa Theologica* as one of nine works.[20] In his journal entry dated 26 June 1941 Merton writes that he is 'reading a lot of St Thomas Aquinas'.[21] Zynda assesses that Thomas Aquinas had a major impact on Merton's mysticism:

> Thomas Aquinas had a major theological influence on Merton, for it was through Aquinas that Merton came to know and understand mysticism. Aquinas placed an emphasis on the necessity of developing the intellect. It was the intellect that would serve to safeguard the authentic mystical experience from false mysticism of emotionalism, fanaticism, and occultism.[22]

17. Lawson and Kramer (eds.), *More Conversations*, pp. 5-6.
18. Thomas Merton, *The Road to Joy: The Letters of Thomas Merton to New and Old Friends* (ed. Robert E. Daggy, New York: Farrar, Straus & Giroux, 1989), p. 9.
19. Thomas Del Prete, 'Thomas Merton on Mark Van Doren: A Portrait of Teaching and Spiritual Growth', *The Merton Seasonal* 16.1 (Winter 1991), pp. 16-18 (17).
20. William H. Shannon (ed.), *Witness to Freedom, Letters of Thomas Merton in Times of Crisis* (New York: Farrar, Straus & Giroux, 1994), p. 166.
21. Thomas Merton, *Run to the Mountain: The Story of a Vocation* (Journals, 1; 1939–1941; ed. Patrick Hart; San Francisco: HarperSanFrancisco, 1995), p. 377.
22. Mary Damian Zynda, CSSF, 'Contemporary Mystic Study: Thomas Merton as Supported by Evelyn Underhill's Stages of Mystical Development', *The Merton Annual* 4 (1992), pp. 173-202 (185).

In regard to Merton's respect for the dignity of human beings, Zynda states: 'Finally, within Aquinas' thought we perceive the dignity which he attributes to humans. He is open to the world, respects the integrity of the human person and maintains that union with God is the highest state to which one can attain'.[23] The impact of Aquinas is evident two and a half decades later, when one appraises Merton's experience or epiphany on the corner of Fourth and Walnut. 'I was suddenly overwhelmed with the realization that I loved all those people, that they were mine and I theirs, that we could not be alien to one another even though we were total strangers'.[24]

Merton, however, was becoming increasingly wary of the rigid framework of scholasticism in his writing and explains that the difficulty is with the Thomists and not with St Thomas himself. 'They have unconsciously sealed off' St Thomas who 'was open to the world'. This isolation or containment has forced those who embrace Thomism 'to renounce everything else' and to reject the non-Thomist arguments.[25]

As the lines of scholasticism blurred for Thomas Merton, conservative or classical Catholicism was the mainstay for Walker Percy. Linda Whitney Hobson states, 'Percy's Catholicism is the classical type defined by Thomas Aquinas'. Faith is a partial form of knowing and therefore 'has important cognitive effects on the believer' who has a choice of believing or not. Thus, the believer who has control of his spiritual life can choose to perceive the abundant grace of God in his daily life.[26]

II. Correspondence and a Meeting

The correspondence between Thomas Merton and Walker Percy has been aptly described through the biographies of Percy written by Patrick Samway and Jay Tolson.[27] The published letters of Thomas Merton[28] and the letters of Walker Percy to Thomas Merton are additional source material.[29] As stated previously, Merton was enthusiastic about Percy's

23. Zynda, 'Contemporary Mystic Study', p. 185.
24. Thomas Merton, *Conjectures of a Guilty Bystander* (Garden City, NY: Doubleday, 1966), p. 140.
25. Merton, *Conjectures*, p. 186.
26. Linda Whitney Hobson, *Understanding Walker Percy* (Columbia: University of South Carolina Press, 1988), p. 6.
27. Patrick Samway SJ, *Walker Percy: A Life* (Chicago: Loyala Press, 1997); and Jay Tolson, *Pilgrim in the Ruins*.
28. Merton, *The Courage for Truth*, pp. 281-84.
29. *Letters to Thomas Merton from Walker Percy* (The Thomas Merton Center Archives, Bellarmine University Brown Library).

first novel and sent him the letter dated January, 1964.[30] Merton had also written in his journal entry of 18 January 1964 the following note:

> The great impact of Walker Percy's novel, *The Moviegoer*, is that the whole book says in reality what the hero *is not*, and expresses his awareness of what he is not. His sense of alienation, his comparative refusal to be alienated as everybody else is (not successful), his comparative acceptance of the ambiguity and failure. Book full of emblems and patterns of life. (The misty place where they fish, or rather his brother fishes, like a vague movie too.)[31]

Not long after his journal entry, Merton wrote Mark Van Doren a letter dated 11 February 1964 in which he conveys his enthusiasm for *The Moviegoer*. In the letter, Merton describes the main character, Binx, who in the beginning seems like 'a supreme dope of some sort for going to so many movies, but in the end it turns out that he is the only smart one, in a wild existentialist kind of way'. Further, Merton explains that 'the best thing about the book is that in the end nobody says who is supposed to be right anyway'. He is pleased, evidently, that 'there is no justification for consoling religions. I mean the kind that think they can console by saying everything is all right'.[32]

According to Tolson, Merton admired both Percy's 'philosophical convictions' and his method of discovering 'what he had to say as he said it'. Moreover, Merton 'liked the fact that the characters were free from authorial control' and he 'was one of the first readers to appreciate the dialogic character of Percy's fiction'. Merton's view of the stoic Aunt Emily in *The Moviegoer* was somewhat disconcerting to Percy but he seemed to appreciate a different point of view of the character as previous commentary about her by southern reactionaries was favorable. Tolson observes that because 'Merton was a more doctrinaire liberal' than Percy and because Merton was the 'product of a bohemian background', he would have had no knowledge of the 'occasional Stoics who stood firmly by what they purported to believe'. Percy's uncle, William Alexander Percy, was a Stoic and therefore Percy 'knew there was far more substance to the Aunt Emilys than Merton could see'.[33]

In the first letter to Percy (January 1964), Merton offered to contact a French publishing firm, Le Seuil, to assist with the publication of the

30. See Appendix below, p. 192.
31. Thomas Merton, *Dancing in the Water of Life: Seeking Peace in the Hermitage* (Journals, 5; 1963–1966; ed. Robert E. Daggy; San Francisco: Harper SanFrancisco, 1997), p. 64.
32. Merton, *The Road to Joy*, p. 47.
33. Tolson, *Pilgrim in the Ruins*, pp. 315-16.

novel in France and he also sent Percy a copy of his poems, *Emblems of a Season of Fury*.[34] Percy responded to Merton in a letter dated 14 February 1964: 'I am a slow writer, easily discouraged, and depend on luck, grace, and a good word from others'.[35]

As a result of the correspondence Percy accepted one of Merton's calligraphies. 'The calligraphy, when it arrived, was hung on the wall above Percy's desk next to the motto from Kafka, 'Warte!' ('Wait!'), an injunction in whose wisdom Percy profoundly believed. Work, to him, was vigilant waiting'.[36] When Percy's novel, *The Last Gentleman*, was published in 1966, Merton again was very supportive of his work. In a letter to Bob Giroux, Merton writes:

> Walker Percy is one of the few novelists whose books I am able to finish. This is in fact a haunting, disturbing, funny and fantastic anti-novel structured like a long dream and relentlessly insisting that most of reality is unconscious. It ends up by being one of the most intelligent and sophisticated statements about the South and about America, but one which too many people will probably find so baffling that they will not know what to make of it. Even then, if they persist in reading it, they cannot help being affected by this profoundly wacky wisdom of the book. Precisely because of the wackiness I would call it one of the sanest books I have read in a long time.[37]

Evidently learning of the letter Percy responded to Merton, 'Am most grateful for your response to that novel (the writing of which is a poor thing for a grown man to spend his time doing, I am thinking most of the time)'.[38] During an interview with Victor A. Kramer and Dewey W. Kramer on 1 May 1983 Walker Percy stated that he only had met Thomas Merton on one occasion (first Saturday in July, 1967).[39] Percy had been appointed to the advisory board of the magazine *Katallagete* (Merton was also a member) and there was a scheduled meeting of the board at Merton's hermitage located at Gethsemani. Percy stated that he was curious about Merton because he had heard some strange stories about him, for example, Merton was schizophrenic and that he left the Church as well as living with a couple of women. In fact, Percy was surprised at the

34. Merton, *The Courage for Truth*, p. 282.

35. *Letters to Thomas Merton from Walker Percy* (The Thomas Merton Center Archives).

36. Tolson, *Pilgrim in the Ruins*, p. 316.

37. Samway, *Walker Percy*, pp. 251-52.

38. *Letters to Thomas Merton from Walker Percy* (The Thomas Merton Center Archives).

39. Tolson, *Pilgrim in the Ruins*, p. 341.

number of intellectuals who admired Merton but could not come to grips with the fact he was keeping his vows as a Trappist.[40]

Upon meeting and observing Merton, Percy noted that he looked healthy and not sickly as presented by Monica Furlong in her biography of Thomas Merton. Percy states:

> But he was very husky, and I think he was dressed in — he had jeans and I don't know whether it was a T-shirt. I have a recollection of something like a Marine skivy-shirt, something like that and a wide belt. And as I say very, very healthy looking. A pretty tough-looking guy. And very open, outgoing, nice, nice and hospitable.[41]

Following some light conversation which included 'bantering, kidding around', Percy and Merton were left alone for a while, perhaps half an hour. Much to Percy's later disappointment, serious conversation about writing did not take place. There were many questions which Percy recollected he wanted to ask but did not. Percy recalled that it was amazing how little they 'found to talk about'. The questions that Percy wanted to ask but did not included his relationship with the Abbot; his own reaction to *The Seven Storey Mountain*, since Percy felt that Merton grew to dislike the book in later years, realizing that a monastic vocation has an initial romantic glow which is not sustained over time; his views about Far Eastern or Asian monasticism; and what about all the books he had written for the abbots over the years — was he forced to write them or did he really enjoy doing it.[42]

Percy remembered two surmises by Merton at the meeting. One was the possible diminution of the large monasteries and the creation of small urban units. But Percy felt that was a standard reply reflective perhaps of the 'small is beautiful' sayings of the 1960s. Merton also referred to the cheese industry at Gethesemani as being commercial exploitation of the monks. This comment was in the context of non-violence and he said 'even the Trappists violate this principle'. Regarding Merton as a writer, Percy said that he read most of his prose work but not particularly his poetry. Percy read *The Seven Storey Mountain* at about the same time he converted to Catholicism and he recalled 'it had a good deal of influence on me'. Percy evidently could identify with it because Merton was at Columbia and also a convert to Catholicism. The timing of the book was good coming about the same time as the post-World War II generation in which there was a 'feeling of uprootedness and dislocation'. Percy was fascinated by Merton 'striking out for the

40. Lawson and Kramer (eds.), *Conversations*, p. 310.
41. Lawson and Kramer (eds.), *Conversations*, p. 311.
42. Lawson and Kramer (eds.), *Conversations*, pp. 311-17.

wilds of Kentucky' which apparently partially stimulated him to read *The Seven Storey Mountain* with great enthusiasm and interest.[43]

According to Percy, Merton had a political period and his 1941 novel, *My Argument with the Gestapo*, was written 'from a left wing point of view, about Nazi bombers flying over the waterfronts of Hoboken or something'. Percy went on to say that 'it astounded like a very bad novel'. Percy mentioned that Merton was on his own spiritual quest. In response to a question about why Merton was such a popular writer, Percy commented:

> Well, it had to do more with his talent. He was a very skillful writer and a very appealing writer and a very prolific writer. And also, the times — in the late forties and fifties there was a tremendous spiritual awakening or hunger in this country and in the postwar generation.[44]

Percy states that he is not a critic of poetry but it strikes him that much of Merton's poetry is really not first rate. Victor A. Kramer conjectured that Merton would not have re-published much of his poetry which was placed in the large volume entitled *The Collected Poems*. However, Percy believed that Merton's tapes of his talks at the Abbey — much of it for the novices — was excellent. When Percy made a retreat at a Jesuit Retreat House near New Orleans, he listened to a series of tapes of Merton's 'Talks to Novices'. Percy states that the tapes are really impressive. He really had a gift for that.[45]

Percy was impressed with Merton's humor as well; 'Well, what was admirable about it was the spontaneity and the humor. It's funny. I would think he would have been an excellent Novice Master'.[46] After the meeting at the hermitage, Percy wrote a letter to Merton dated July 13, 1967, explaining that the reason why they were left alone for a while was the hope that their conversation would create many new ecumenical ideas for the publication *Katallagete*.[47] When Percy requested a book on Bantu metaphysics, Merton recommended 'an essential reference book, *Bantu Prophets in South Africa* by Bengt Sundkler, which he was using for the 'South' section of *The Geography of Lograire*'. Percy described his new novel and the setting at the 'Paradise Country Club'. Merton reacted well to the novel in progress that was finally to be entitled *Love in the Ruins*. Since 'country clubs had always been a target for Merton's satire',

43. Lawson and Kramer (eds.), *Conversations*, pp. 311-19.
44. Lawson and Kramer (eds.), *Conversations*, p. 316.
45. Lawson and Kramer (eds.), *Conversations*, p. 318.
46. Lawson and Kramer (eds.), *Conversations*, p. 318.
47. *Letters to Thomas Merton from Walker Percy* (The Thomas Merton Center Archives).

it is possible that he 'may even have made a contribution' to the novel.[48] After reading Merton's essay, 'The Long Hot Summer of Sixty-Seven', Percy resisted the attempt to combine the race question and the Vietnam War 'under the same rubric, since [he said] I regard one as the clearest kind of moral issue and the other as murderously complex and baffling. At least it baffles me'.[49]

III Alienation and Malaise

Merton and Percy had some comparable experiences and influences and similar concerns about contemporary society although they expressed these concerns through different literary genres. Victor A. Kramer co-gently remarks that Thomas Merton found *The Moviegoer* 'a key to our contemporary moment's distress'. Through Binx Bolling, the hero of the novel, 'Merton realized that all persons in this culture are displaced, yet in continuing to question, they find glimmers of the sacred'. According to Kramer, part of Merton's legacy was an examination of the 'culture's fundamental questions about how to live and love in an age which seems so radically different from earlier ages'.[50] In his book, *Thomas Merton: Monk and Artist*, Kramer notes that collective society and institutions endangered the soul and Merton joined other Christian writers of the times to highlight 'the dilemma of the individual in a mass society — Caroline Gordon, James Agee, Flannery O'Connor, and Walker Percy'.[51] Amid our collective society alienated man begins the search and as Thomas Merton withdrew from the world many people of the world were 'fleeing to him. Why?' Lawrence Cunningham suggests that Walker Percy 'sums up middle American malaise' in the essay entitled, 'Bourbon' which may be one answer to the question, 'Why?'[52] In this essay Percy writes:

> But, as between these evils and the aesthetic of Bourbon drinking, that is, the use of Bourbon to warm the heart, to reduce the anomie of the late twentieth century, to cut the cold phlegm of Wednesday afternoons, I

48. Michael Mott, *The Seven Mountains of Thomas Merton* (Boston: Houghton Mifflin, 1984), p. 491.

49. *Letters to Thomas Merton from Walker Percy* (The Thomas Merton Center Archives).

50. Victor A. Kramer, 'The Fragmentation and the Quest for the Spiritual in the Late Twentieth Century', *The Merton Annual* 10 (1998), pp. ix-xiv (x).

51. Victor A. Kramer, *Thomas Merton: Monk and Artist* (Kalamazoo, MI: Cistercian Publications, 1984), pp. 109-10.

52. Lawrence S. Cunningham, 'The Monk as a Critic of Culture', *The Merton Annual* 3 (1990), pp. 187-99 (192).

choose the aesthetic. What, after all, is the use of not having cancer, cirrhosis, and such, if man comes home from work every day at five-thirty to the exurbs of Montclair or Memphis and there is the grass growing and the little family looking not quite at him but just past the side of his head, and there's Cronkite on the tube and the smell of pot roast in the living room, and inside the house and outside in the pretty exurb has settled the noxious particles and the sadness of the old dying Western world, and him thinking; 'Jesus, is this it? Listening to Cronkite and the grass growing?'[53]

Walker Percy's novel *The Moviegoer* is in some ways a fictional counterpart to Thomas Merton's alienation theme evident in his works. A brief examination of selected passages from two of Merton's works, *My Argument with the Gestapo* and a 1968 essay entitled, 'Why Alienation is for Everybody', will underscore the nexus between Merton's writings about alienation and Percy's malaise of everydayness which is the theme of *The Moviegoer*.[54]

Since Merton was enthusiastic about *The Moviegoer*, we can conjecture that the novel became yet another link between the spiritual and literary imaginations that enhanced his vision for the contemplative life.[55] We have referred earlier to Merton's conceptions about the literary informing the spiritual through his letter to James Laughlin. Through the 'sapiential' approach Merton 'promotes an appreciation of the literary artist's mimetic ability to communicate a unique knowledge ('depth of awareness') through a work which recreates and interprets human experience'.[56]

It is appropriate that references to the cinema be selected as a construct to examine two passages that provide a link between Merton and Percy. In Merton's novel there is a movie scene in which the narrator, a young man, like 'all contemporary men' are 'seeking in the luminous illusions of the motion picture a respite from inconsolable loneliness and alienation'.[57] The following is a cinematic scene from *My Argument with the Gestapo*:

53. Walker Percy, *Signposts in a Strange Land* (ed. Patrick Samway, SJ; New York: Farrar, Straus & Giroux, 1991), pp. 102-103.

54. Lewis A. Lawson, *Following Percy* (Troy, NY: The Whitston Publishing Company, 1988), p. 123.

55. George Kilcourse, Jr, *Ace of Freedoms: Thomas Merton's Christ* (Notre Dame: University of Notre Dame Press, 1993), p. 128.

56. Kilcourse, Jr, *Ace of Freedoms*, p. 134. For an analysis of the 'sapiential method' as defined by Thomas Merton see Kilcourse, Jr, *Ace of Freedoms*, ch. 4, 'Son of the Widowed God'.

57. Ross Labrie, *The Art of Thomas Merton* (Fort Worth, TX: The Texas Christian University Press, 1979), p. 37.

And all of a sudden, I was overwhelmed with sadness, sitting at the end of the row, because I suddenly remembered all the times I had sat in movie houses at the beginning of the afternoon, waiting for the picture to start. It was like remembering my whole life. I had spent all the days of my childhood with my legs hanging from the hard seat of a movie, in a big hall full of the sound of children's voices… 'I really hope it will be a good picture'. Nobody understood why I said that… The film, however, was so bad that none of us could stand it… We left in the middle of the picture and came out into the rainy street, blinking and confused, like sick people, horrified at the pallor of one another's faces, at our unnatural expressions of weariness and dismay — as if the movie had been so awful that it had destroyed our health.[58]

Labrie explains that 'The futility of this form of escapism is silhouetted by the garish decorations in the dimly lit theaters'.[59] Through the character Binx in *The Moviegoer* Percy describes the futility of the movies as a means of escaping the malaise:

What is the nature of the search?… The search is what anyone would undertake if he were not sunk in the everydayness of his own life… To become aware of the possibility of the search is to be onto something. Not to be onto something is to be in despair. The movies are onto the search, but they screw it up. The search always ends in despair. They like to show a fellow coming to himself in a strange place — but what does he do? He takes up with the local librarian, sets about proving to the local children what a nice fellow he is, and settles down with a vengeance. In two weeks time he is so sunk in everydayness that he might just as well be dead.[60]

The connection between Merton's alienation theme and Percy's malaise can be further illustrated by these passages. First, from Merton's essay:

Alienation begins when culture divides me against myself, puts a mask on me, gives me a role I may or may not want to play. Alienation is complete when I become completely identified with my mask, totally satisfied with my role, and convince myself that any other identity or role is inconceivable.[61]

Merton describes the pain of trying to be 'fifty different people' and we finally end up hating our false self and alienated from our true self. Like Percy's not knowing that you are in a state of despair Merton states:

58. Thomas Merton, *My Argument with the Gestapo* (New York: New Directions, 1969), pp. 81-82.
59. Labrie, *The Art of Thomas Merton*, p. 37.
60. Percy, *The Moviegoer*, p. 13.
61. Thomas Merton, *The Literary Essays of Thomas Merton* (ed. Patrick Hart; New York: New Directions, 1981), p. 381.

'To live in constant awareness of this bind is a kind of living death. But to live without any awareness of it at all is death pure and simple — even though one may still be walking around and smelling perfect.'[62]

This statement resonates with Percy's epigraph in *The Moviegoer*: 'The specific character of despair is precisely this: it is unaware of being despair. Søren Kierkegaard, *The Sickness Unto Death*.'[63]

Binx in *The Moviegoer* describes the malaise 'as the pain of loss' from the people in the world: 'What is the malaise? …The malaise is the pain of loss. The world is lost to you, the world and the people in it, and there remains only you and the world and you no more able to be in the world than Banquo's ghost.'[64]

As a happy consumer residing in the aesthetic stage, Binx says, 'The car itself is all-important'. But as he rides merrily along to the Gulf Coast he finds a false happiness with the car and he is soon enveloped in the malaise of despair. He describes himself and his friend Sharon as 'a little vortex of despair moving through the world like the still eye of a hurricane'.[65]

Binx is the epitome of Merton's definition of the false self — trying to be someone he is not — those 50 different people and finally realizing his self hate has driven him to despair. As we will see later in this essay, Binx finally is on to the search when he experiences an epiphany.

Walker Percy had been asked about the nature of the 'search', the central metaphor, in his novels. He responded as he did on this occasion when queried during an interview with John Griffin Jones in 1983:

> I think the normal state for a man to find himself in is in a state of confusion, spiritual disorientation, drawn in a sense to Christendom, but also repelled by the cultural nature of Christendom. To answer your question, the common thread that runs through all of my novels is of a man, or a woman, who finds himself/herself outside of society, maybe even in a state of neurosis, psychosis, or derangement… Maybe I try to design it so that it will cross the reader's mind to question the, quote, 'normal culture', and to value his own state of disorientation. You say the search. I think the search is the normal condition. I think that's the one thread which unites all of my characters, that they're at various stages of disorder, and are aware of it, and not necessarily unhappy about it, not altogether unhappy about it.[66]

62. Merton, *Literary Essays*, p. 382.
63. Percy, *The Moviegoer*, epigraph.
64. Percy, *The Moviegoer*, p. 120.
65. Percy, *The Moviegoer*, p. 121.
66. Lawson and Kramer (eds.), *Conversations*, p. 281.

Merton, like Percy, was concerned with the cultural nature of Christendom as he stated in August 1963: 'If there is a 'problem' for Christianity today, it is the problem of the identification of 'Christendom' with certain forms of culture and society, certain political and social structures which for fifteen-hundred years have dominated Europe and the West'.[67] Percy at different times defines symptoms of the malaise. In one interview with Robert Cubbage dated November 1987, Percy referred to the 'age of thanatos', perhaps, beginning with the Battle of Somme and Verdun during World War I in which two million men were killed within a two-month period. He lamented abortion when the Supreme Court legalized the 'murder of 30 million unborn human beings'. 'The role of chemicals to relieve depression has been overdone rather than employing some "old-fashioned psychotherapy",' he complained. 'It reminds one of Aldous Huxley in *Brave New World* where everyone was taking pills and feeling fine'.[68] Still in another interview with Timothy Dwyer in 1987, Percy suggests part of the malaise may be students in the high school not interested in reading because they are 'watching the tube eight hours a day'. Perhaps kids are 'hanging out in cars' too much.[69]

Lewis Lawson explains that the 'malaise of everydayness' is a masquerading of happiness and not being aware that such persons are in a state of despair. 'These people are desperately alienated from themselves'.[70] Everydayness, according to Martin Luschei is a 'generalized loss of awareness that walls a person off from his surroundings and diminishes his vitality'. Numbness and anxiety result from one's anonymity and routine existence.[71] In trying to find one's way out of the malaise the term 'wayfarer' is employed by Luschei. 'The term wayfarer comes from Marcel' and by definition a wayfarer 'is a man who is not at home but on the road'. Being on the road is the conception of salvation as man moves towards God, a transcendence which is the one distinguishing mark of human existence.[72]

Thomas Merton describes the journey in another way through contemplation, a transcendence:

67. Thomas Merton, *Honorable Reader: Reflections on my Work* (ed. Robert E. Daggy; New York: Crossroads, 1989), p. 66.
68. Lawson and Kramer (eds.), *More Conversations*, pp. 183-87.
69. Lawson and Kramer (eds.), *More Conversations*, p. 182.
70. Lawson, *Following Percy*, p. 9.
71. Martin Luschei, *The Sovereign Wayfarer* (Baton Rouge: Louisiana State University Press, 1972), p. 21.
72. Luschei, *The Sovereign Wayfarer*, p. 37-38.

> Contemplative wisdom is then not simply an aesthetic extrapolation of
> certain intellectual or dogmatic principles, but a living contact with the
> Infinite Source of all being, a contact not only of minds and hearts, not only
> of 'I and Thou', but a transcendent union of consciousness in which man
> and God become, according to the expression of St. Paul 'one spirit'.[73]

The mission of the contemplative can be viewed from two levels. The lowest level is 'the recognition of this splendor of being and unity — a splendor in which he [the contemplative] is one with all that is'. The higher level, according to Merton, is 'the transcendent ground and source of being, the not-being and the emptiness that is so called because it is absolutely beyond all definitions and limitation'.[74]

When Percy accepted The National Book Award he described *The Moviegoer* as an attempt to make 'a modest restatement of the Judeo-Christian notion that man is more than an organism in an environment, more than an integrated personality, more even than a mature and creative individual, as the phrase goes. He is a wayfarer and a pilgrim'.[75] The castaway in Percy's essay, 'The Message in the Bottle,'is an image of a 'wayfarer', a man searching for the news. Percy delineates the different categories of news as information, island survival, and scientific knowledge which can 'be arrived at independently on any island'. It is the news from across the sea that the castaway seeks, a metaphor of the Christian faith. But to receive the news, the castaway must have the proper disposition — one who knows something is missing in his life and heeds the call to 'Come!' For Percy, the worst kind of despair was not to recognize that you were in a state of despair as one 'who lives the most meaningless sort of life, a trivial routine of meals, work, gossip, television, and sleep, he nevertheless feels quite content with himself and is at home in the world'. The newsbearer is essential and must be one who 'has the authority to deliver the message'. The genius, in Kierkegaardian terms, generates knowledge and may be, in fact, ahead of his time but his knowledge is not transcendent. The transcendence of the apostle is recognized by the gravity of the message as one who is called by God and 'I make you eternally responsible for what you do against me'.[76]

Alienated man in contemporary society was a theme throughout Merton's writings that parallels Percy's castaway. Douglas V. Steere states in the foreword to Merton's *The Climate of Monastic Prayer* that 'Thomas

73. Merton, *Honorable Reader*, p. 90.
74. Merton, *Honorable Reader*, p. 89.
75. Percy, *Signposts*, p. 246.
76. Walker Percy, *The Message in the Bottle* (New York: Farrar, Straus & Giroux, 1987), pp. 119-49.

Merton was passionately aware of the inward crises of our age and its acute need of the dimension of contemplation'.[77] Further:

> In an age of science and technology, in which man finds himself bewildered and disoriented by the fabulous versatility of the machines he has created, we live precipitated outside ourselves at every moment, interiorly empty, spiritually lost, seeking at all costs to forget our emptiness, and ready to alienate ourselves completely in the name of any 'cause' that comes along... Contemplation is related to art, to worship, to charity: all these reach out by intuition and self-dedication into the realms that transcend the material conduct of everyday life. Or rather, in the midst of ordinary life itself they seek and find new and transcendent meaning.[78]

IV. The Novel

With limited success in creating a readership with his essays, Walker Percy finally turned to the novel as a vehicle for dramatizing his philosophic and religious experience in a non-didactic and indirect way. According to Percy in a 1980 interview with Henry Kisor, the role of the novelist is '[t]o question the values of society' just as canaries in a mine 'would swoon' if there was bad air.[79] The idea of the philosophical novel was alien to American writers at the time but customary to French writers. Percy states in an interview with Malcolm Jones in 1987 after two failed earlier novels, *The Charterhouse* (1951) and *The Gramercy Winner* (1954):

> And it crossed my mind, what if I did something that American writers never do, which seems to be the custom in France: Namely, that when someone writes about ideas, they can translate the same ideas to fiction and plays, like Mauriac, Malraux, Sartre. So it just occurred to me, why not take these ideas I'd been trying to write about, in psychiatry and philosophy, and translate them into a fictional setting in New Orleans, where I was living. So I was just sitting out there (back porch), and I started writing.[80]

According to Robert Coles, Percy was determined by 1959 'to tie his philosophical ideas firmly down; give them the life that a novel can offer'.[81] Indeed he found his voice in the French tradition of the

77. Thomas Merton, *The Climate of Monastic Prayer* (Kalamazoo, MI: Cisterican Publications, 1969), p. 17.

78. Merton, *The Climate*, p. 17. Douglas V. Steere quotes from a short essay appended to a 1959 edition of *Thomas Merton's Selected Poems*, pp. 109-11.

79. Lawson and Kramer (eds.), *Conversations*, pp. 197-98.

80. Lawson and Kramer (eds.), *More Conversations*, p. 175.

81. Robert Coles, *Walker Percy: An American Search* (Boston: Little, Brown & Co., 1978), p. 144.

philosophic novel, as the voice in *The Moviegoer*, although a 'distinctive Percyan tone' is indebted to Albert Camus.[82] During a 1977 interview with Herbert Mitgang, Percy expressed his admiration for the French novelists because they combine philosophical conviction with novelistic art which is 'usually fatal, but the French seem to achieve it. Sartre solved the problem of joining art and philosophy in his best work, *Nausea*, and Camus did so in several of his books'.[83] Although Percy was indebted to the French novelists for content he owed his debts elsewhere for the stylistic devices. The phrase 'everydayness' appearing in *The Moviegoer* is a term borrowed from Heidegger. Luschei describes it: 'This condition can be defined as a generalized loss of awareness that walls a person off from his surroundings and diminishes his vitality. It is connected with routine and the anonymity of people in the mass, and it results in numbness and anxiety'.[84] Binx Bolling in *The Moviegoer* encounters inauthenticity – another concept borrowed from Heidegger and further explained by Sartre as bad faith or '[t]o be aware of playing a false role and go on deceiving oneself'.[85] Percy's concern about inauthenticity has a parallel in Merton's description of 'the true self and false self'. In a review of Merton's tapes Victor A. Kramer has commented: '[I]f we are to locate our true self, we must strip away what is false forever. The self we project, to and for others, is sometimes not us. One is reminded of Walker Percy's *Lost in the Cosmos*. Man is lost precisely because he has become too concerned about others and has lost sight of his truest inner self'.[86]

Although Percy was indebted to Søren Kierkegaard, he experienced frustration understanding Kierkegaard over the years. He notes in an interview with Bradley R. Dewey in 1974: 'So reading Kierkegaard is like growing up; it takes a long time, many years, a lot of work. And I still can't say that I have read him thoroughly or even completely'.[87] Merton enjoyed the same reading as Percy and remarked in his journal entry dated 26 November 1940: 'A week ago today, I bought Kierkegaard's *Fear and Trembling* at the Oxford University Press, and have since talked about it so much I feel as if I had been reading Kierkegaard all my life'.[88]

In an interview with Jo Gulledge in 1984, Percy further explains that

82. Luschei, *The Sovereign Wayfarer*, p. 15.

83. Lawson and Kramer (eds.), *Conversations*, p. 146.

84. Luschei, *The Sovereign Wayfarer*, p. 21.

85. Luschei, *The Sovereign Wayfarer*, p. 26.

86. Thomas Merton, *The Merton Tapes*, reviewed by Victor A. Kramer, *The Merton Annual* 5 (1997), pp. 362-68 (365). The tape was AA2267, 'The True Self and the False Self'.

87. Lawson and Kramer (eds.), *Conversations*, 107-108.

88. Merton, *Run to the Mountain*, p. 259.

'the whole of *The Moviegoer* is about Binx's malaise, and everybody picked up on the *malaise* because that was something that hadn't been written about, at least not by most American novelists during that period'.[89] Percy defines two different kinds of searches; the search for scientific truth is explained through reading Binx's *The Chemistry of Life* which is a vertical search for truth. Conversely the search for the existential is the horizontal search and 'addressed to the concrete realities of existence' as opposed to the abstractions of the vertical search.[90] In other words science can take one only so far in explaining humankind—one needs to ask the question 'who am I' which is the horizontal search.

During an interview with Bradley R. Dewey in 1974, Percy asserted that in the essay, 'The Difference Between a Genius and an Apostle', Kierkegaard describes a genius as one who 'arrives at truth like a scientist or a philosopher or a thinker'. Whereas the apostle 'has heard the news of something that has happened, and he has the authority to tell somebody who hasn't heard the news what the news is'. Percy explains that Binx embarks on the horizontal search and 'he certainly did not mean looking for God, although he talks about that... Everybody believes in God, so how can you search for something everybody believes in?' Therefore, Binx 'embarked on kind of an antic search which was still in the esthetic mode...walking out to the lake at night...going to the movies'.[91]

Judylyne Lilly and Claude Richard moderated in an interview with Walker Percy on World Net, 3 December 1986. Percy states that Binx does not go to the movies as a form of entertainment but rather as 'exercises in repetition and rotation so that this is all part of the search'.[92] Rotation and repetition are the means for transcending the three spheres of existence, the aesthetic, the ethical and the religious. Both rotation and repetition are methods of avoiding alienation. Rotation is the search for the new and looking around the bend for new hope. Binx experienced rotation as he had new experiences with a revolving door of different secretaries. Repetition is the return or recreation of past events and people. One looks to the past for the lost thread of his life; and if it is an authentic repetition he compares 'what he was and what he is' and either despairs or experiences 'a religious conversion' like Binx who '"leaps" from the aesthetic sphere clear over to the religious'. The aesthetic sphere can be best described as 'the happy consumer' who does all the right things; has the right clothes, hairstyle and car—all designed to make a statement. The ethical sphere is

89. Lawson and Kramer (eds.), *Conversations*, pp. 301-302.
90. Luschei, *The Sovereign Wayfarer*, p. 88.
91. Lawson and Kramer (eds.), *Conversations*, pp. 113-14.
92. Lawson and Kramer (eds.), *More Conversations*, p. 160.

represented by Aunt Emily in *The Moviegoer* who personifies the Stoic philosophy which 'includes charity, compassion and reason'. The religious sphere is where one realizes a faith in God but cannot or will not express this faith because 'he would commit the blunder of being what Percy calls 'edifying', so he acts humorously in regarding himself and the world'. Also since faith is inward — 'to talk about it is to lose it and threaten to become that supreme boor, the proselytizer'.[93]

Thomas Merton had his own experience using the novel as a medium for expressing his ideas but was unsuccessful in his attempts. In fact, his 1941 novel *My Argument with the Gestapo* (formerly entitled *Journal of my Escape from the Nazis*) was published only posthumously in 1969. Naomi Burton tried placing it before Merton entered the monastery but was vetoed by her senior editors. She mentions two other novels that Merton sent her, *The Labyrinth* and *The Man in the Sycamore Tree*, which were also not accepted for publication.[94] Mott mentions yet another novel, *The Straits of Dover*, which came back with a rejection slip on 14 October 1939.[95] Naomi Burton refers to 'three finished novels that he [Merton] himself destroyed before entering the Abbey of Gethsemani'.[96] However, Mott states that, 'One copy of one draft of *The Labyrinth*' remains.[97]

In Merton's published novel, *My Argument with the Gestapo*, the young traveler, Thomas Merton, reports through the voice of a poet. 'There is a pervading sense of dreamworld or hallucination heightened by the device of passages written in a macaronic language, invented from multilingual roots, to satirize and parody political propaganda speeches dealing with the war'.[98] In the novel Merton records his own sense of the malaise and the search. Anthony T. Padovano notes: 'The novel is a novel of fancy but everywhere there is the smell and taste of decay. The fictional Merton conducts an endless search by means of questions that receive no answers and by journeys that have no motive other than movement'.[99]

93. Hobson, *Understanding Walter Percy*, pp. 15-22.

94. See Naomi Burton's 'A Note on the Author and this Book' (dated St Valentine's Day, 1969 from York, Maine) following the preface of Thomas Merton, *My Argument with the Gestapo*.

95. Mott, *The Seven Mountains*, p. 137.

96. Thomas Merton, *My Argument with the Gestapo*. Note by Naomi Burton. Also see Paul Peterson, 'Thomas Merton in Search of his Heart: The Autobiographical Impulse of Merton's Bonaventure Novels', *The Merton Annual* 9 (1997), pp. 74-89. This is an excellent description of Merton's early novel attempts. He draws upon the fragments of the remaining manuscripts.

97. Mott, *The Seven Mountains*, p. 127.

98. Merton, *My Argument with the Gestapo* (backcover).

99. Anthony T. Padovano, *The Human Journey* (Garden City, NY: Doubleday, 1982), p. 13.

Robert Lax attempted to be a constructive critic for Merton's novel-writing but Mott reports, 'No one in the next two years [1939–1941] was able to convince Merton he was not a novelist'. Mott adds that Merton's self-assessment as to his failure as a novelist was 'because he was unable to create a fictional character, and because he made the mistake of thinking that anti-plot means plotless'.[100] As we all know Merton successfully developed the theme of the search and the journey in his memorable spiritual autobiography, *The Seven Storey Mountain*. Padovano observes, 'Merton's appeal for Americans is premised on the narrative character of his work [*The Seven Storey Mountain*] organized under the symbols of journey and the self'.[101]

Though failed as a novelist, after entering the monastery, 'Merton embarked on what would become the most fruitful career of any priest-poet in the history of American letters'. In fact, 'his whole life and writing career built toward a combination that would finally rival the career of all priest-poets!'[102] Merton enjoyed literary acclaim as a prose-writer and poet. Maritain called the closing of *The Sign of Jonas*, a prose-poem, 'one of the finest passages in modern literature'.[103]

In spite of his success, 'There was still something of a frustrated novelist in Merton' and as late as 1964 he claims to still have an idea for a novel in mind. If he cannot write the successful novel, Merton realizes the value of the genre as a vehicle or medium for expressing the 'truth'. Mott judged that through 'careful reading of the works of Camus and Faulkner, Merton was coming to a new sense of the power of the novel of certain writers to reach a hidden level of truth through fictional models'. Merton also had an interest in Flannery O'Connor and Walker Percy as well.[104] In a letter to James Laughlin dated 8 October 1966 Merton remarks, 'Jacques Maritain and I both agreed that we thought perhaps the most living way to approach theological and philosophical problems now (that theology and philosophy are in such chaos) would be in the form of creative writing and lit. criticism. I am pleased with the idea and it seems to make sense'.[105]

In an essay on William Faulkner, Merton questions whether there is 'such a thing as religious literature at all'. He continues to explain within the Faulkner critique that there should be no confusion between 'literary'

100. Mott, *The Seven Mountains*, p. 137.
101. Padovano, *The Human Journey*, p. 4.
102. Kramer, *Monk and Artist*, p. 10.
103. Patrick Hart (ed.), *Thomas Merton: Monk* (New York: Sheed & Ward, 1974), p. 47.
104. Mott, *The Seven Mountains*, p. 477.
105. David D. Cooper (ed.), *Thomas Merton and James Laughlin: Selected Letters* (New York: W.W. Norton, 1997), p. 301.

and 'religious' values. 'Obviously, religious orthodoxy or sincerity is no guarantee that a work is artistically valid... If, on the other hand, an understanding of the work implies some awareness of religious values, then one must be able to identify oneself to some extent with the author in holding these values to be "real".' William Faulkner is one of those 'sapiential' authors 'who possess this power to *evoke* in us an experience of meaning and of direction or a catharsis of pity and terror which can be called 'religious' in the same sense as Greek tragedy was religious'. The sapiental or 'The 'wisdom' approach to man seeks to apprehend man's value and destiny in their global and even ultimate significance'.[106]

How to get a sense of a spiritual union of God and man across to his readership was a constant concern of Walker Percy, who was one of those aforementioned novelists that Merton felt could 'reach a hidden level of truth through fictional models'.[107] Percy's indirect style was his method of conveying the Christian message. Percy states in an interview with Brent Short in 1990, 'If you get caught writing a "religious novel" — about God, Judaism, Christianity — you are dead... As one of my characters, Binx Bolling in *The Moviegoer* says, "Whenever anyone says God to me, a curtain goes down in my head"'.[108] Underscoring the indirect method, Percy states in a 1971 interview with Charles T. Bunting:

> The main difficulty is that of language. Of course the deeper themes of my novels are religious. When you speak of religion, it's almost impossible for a novelist because you have to use the standard words like 'God' and 'salvation' and 'baptism', 'faith', and the words are pretty well used up... [T]he so-called Catholic or Christian novelist nowadays has to be very indirect, if not downright deceitful, because all he has to do is say one word about salvation or redemption and the jig is up, you know.[109]

V. Epiphanies

An epiphany has been defined in *A Handbook to Literature*:

> *Epiphany* has been given wide currency as a critical term by James Joyce, who used it to designate an event in which the essential nature of something — a person, a situation, an object — was suddenly perceived. It is thus an intuitive grasp of reality achieved in a quick flash of recognition in which something, usually simple and commonplace, is seen in a new light,

106. Merton, *Literary Essays*, pp. 94-100.
107. Mott, *The Seven Mountains*, p. 477.
108. Lawson and Kramer (eds.), *More Conversations*, p. 239.
109. Lawson and Kramer (eds.), *Conversations*, p. 41.

and, as Joyce says, 'its soul, its whatness leaps to us from the vestment of its appearance'. This sudden insight is the *epiphany*.[110]

In *The Moviegoer* we come to the climax of the novel when Binx affirms his love for Kate after seeing a black man emerge from a church in New Orleans on Ash Wednesday:

> The Negro has already come outside. His forehead is an ambiguous sienna color and pied; it is impossible to be sure that he received ashes. When he gets in his Mercury, he does not leave immediately but sits looking down at something on the seat beside him. A sample case? An insurance manual? I watch him closely in the rear-view mirror. It is impossible to say why he is here. Is it part and parcel of the complex business of coming up in the world? Or is it because he believes that God himself is present here at the corner of Elysian Fields and Bon Enfants? Or is he here for both reasons: through some dim dazzling trick of grace, coming for the one and receiving the other as God's importunate bonus? It is impossible to say.[111]

Percy speaks about the phenomenon of grace: 'I have to be careful when I speak about grace. I have to be extremely allusive. I think Caroline Gordon said, "The novelist is entitled to use every trick of deceit and underhandedness at his or her control".'[112]

Lawson says of Binx, 'Such is the restoration of his spirit that he sees a sign of God's grace—a black man emerging from a Catholic church with his forehead marked with ashes—and converts, achieves an existential repetition'.[113] Percy explains that an aesthetic repetition is the 'savoring of the past as experience' but 'without surrendering the self as a locus of experience and possibility'. Conversely, the existential repetition is 'the passionate quest in which the incident serves as a thread in the labyrinth to be followed at any cost'.[114] Or as Luschei explains, the aesthetic repetition is 'a mere sampling of emotion, a breaking out of everydayness', whereas an existential repetition is 'a moment of serious insight contributing to the search'.[115] In another essay Lawson says of this event in the novel, 'Much of that meditation is sufficiently vague to apply to anyone, but only someone who has experienced grace and knows the richness of its workings could be capable of such a brilliant description of it'.[116]

110. C. Hugh Holman, *A Handbook to Literature* (New York: The Odyssey Press, 1960), p. 198.

111. Percy, *The Moviegoer*, pp. 234-35.

112. Lawson and Kramer (eds.), *More Conversations*, p. 239.

113. Lewis A. Lawson, *Still Following Percy* (Jackson: University Press of Mississippi, 1996), p. 54.

114. Percy, *The Message in the Bottle*, pp. 95-96.

115. Luschei, *The Sovereign Wayfarer*, pp. 51-52.

116. Luschei, *The Sovereign Wayfarer*, p. 110. The word 'grace' is used loosely in lit-

Hobson explains, 'If the reader is, like Binx, in need of God, he will see in Percy's writing the signs of grace. If the reader is a scientific humanist, he probably will not, but he may appreciate the good story'.[117] According to Quinlan, 'Binx can look at a prosperous Negro who has just emerged from a church and wonder whether or not the indistinct mark on his forehead represents the action of God's grace'.[118] Desmond observes that, 'However, at the novel's end, Binx remains open to his search and to the possibility of the presence of God in the ordinary world'.[119] In an interview with W. Kenneth Holditch, Percy makes this observation about the scene at the corner of Elysian Fields and Bons Enfants:

> [T]he strange thing is that he [the Negro] will receive the sacraments; that the sacraments work nevertheless. You have this strange admixture of the inauthentic living by social status; and yet who are we to say that the sacraments are not operative? That he's not receiving grace along with it? That's the mystery.[120]

Percy responds to a question about 'the infinite mystery' in an interview with Jan Nordby Gretlund in 1985:

> So it bothers you that the solution to the search turns out to be a mystery? All right, Faith consists of two or three mysteries: the Incarnation is a mystery, the Trinity is a mystery, and the real Presence in the Eucharist is a mystery. But that is the end of the search, that is the end of the quest, you don't go beyond that. Either you believe that, or you don't.[121]

Although Binx's 'epiphany' on the corner of Elysian Fields and Bon Enfants was fictional, Thomas Merton's 'epiphany' on 18 March 1958 was 'very real'. This event occurring on the corner of Fourth and Walnut Streets in Louisville, Kentucky (the home of the Early Times Distillery—

erature. We have seen Walker Percy not really defining the word but being 'extremely allusive' when speaking of it. Perhaps we can infer that Percy, being the good Scholastic, may have grasped a meaning through reading St Thomas in his treatise on Sacramental Grace as it relates to virtues and gifts. In a reply to an objection, St Thomas states the grace of the virtues and gifts perfects the essence and powers of the soul sufficiently as regards ordinary conduct. St Thomas proceeds to demonstrate the value and need of sacramental grace. In the context of *The Moviegoer* one might assume that Percy is referring to grace as it perfects the soul through virtues and gifts. St Thomas, *Summa Theologica*, Volume Two, Part IIIQ. 62 Art.3., p. 2357.

117. Hobson, *Understanding Walker Percy*, pp. 42-43.

118. Quinlan, *Walker Percy: The Last Catholic Novelist*, p. 97.

119. John F. Desmond, 'Walker Percy's Eucharistic Vision', *Renascence* 52.3 (Spring 2000), pp. 219-31 (221).

120. Lawson and Kramer (eds.), *More Conversations*, pp. 11-12.

121. Lawson and Kramer (eds.), *More Conversations*, p. 106.

a favorite whiskey of Walker Percy) was recorded in Merton's book, *Conjectures of a Guilty Bystander*.[122]

The above recorded epiphany was one of Merton's three epiphanies, as described by Gary Cummins. The first occurred in Havana, Cuba in 1940; Louisville, of course, was the second in 1958, and Polonnaruwa, Sri Lanka in 1968 was the third. 'Each epiphany revealed to Merton something of reality, Christ, his relationship with God, the human race, and creation. As he struggled to verbalize things too Other for amorphous words or theological precision, Merton unconsciously linked the three with the classical vocabulary of mysticism and his own spiritual lexicon'.[123]

Whether it is the fictional epiphany on the corner of Elysian Fields and Bons Enfants, or Merton's personal epiphany on the corner of Fourth and Walnut, 'it is the soul, the whatness leaping from the vestment of its appearance'[124] — a moment of grace. This moment of grace is a transformation of the person in 'God's living presence' but Charles R. Meyer makes a distinction between the one who is permanently disposed to grace and the person who is not fully committed and therefore, the transformation is transitory and related to an individual act of the person.[125] But as William Reiser, SJ, explains, 'No single moment stands in isolation unsupported by all things that have made us who and what we are. It is unhelpful to think of the will of God as coming from outside or beyond what we already are. There is, we might say, a biography of grace. The will of God in our lives has a history'.[126] So it was, perhaps, with Merton and with Percy's fictional character, Binx, on their respective corners — a biography of grace.

VI. The Last Letter and a Homily

It is somewhat ironic that both Walker Percy and Thomas Merton, converts to Catholicism, would be buried on the grounds of an abbey — their search finally ended. Walker Percy had become a member of the Bene-

122. William H. Shannon, *Something of a Rebel: Thomas Merton, his Life and Works. An Introduction* (Cincinnati, Ohio: St Anthony Messenger Press, 1997), p. 160.

123. Gary Cummins, 'Thomas Merton's Three Epiphanies', *Theology Today* 56.1 (April 1999), pp. 59-72 (59).

124. Holman, *A Handbook to Literature*, p. 198.

125. Charles R. Meyer, *A Contemporary Theology of Grace* (New York: Division of the Society of St Paul, 1970), p. 174. It is appropriate that grace as transforming be used in this context.

126. William Reiser, SJ, *Jesus in Solidarity with his People: A Theologian Looks at Mark* (Collegeville, MN: The Liturgical Press, 2000), p. 90 n. 1.

dictine lay confraternity shortly before his death and was buried in the grounds of St Joseph's Abbey (Louisiana), 12 May 1990 amid a gray, ominous sky with threatening clouds.[127] Thomas Merton, a member of the Cistercian Order of the Strict Observance was buried in the grounds of the Monastery of Our Lady of Gethsemani, 17 December 1968, while 'rain, turning to snow, fell on the crowd'.[128]

In a later commemoration service for Walker Percy at St Ignatius Church in New York City on 24 October 1990 Shelby Foote 'delivered what he considered his "last letter" to his best and oldest friend':

> I would state my hope that Walker Percy will be seen in time for what he was in simple and solemn fact — a novelist, not merely an explicator of various philosophers and divines, existentialist or otherwise… Their subject [other writers], his and Faulkner's — and all the rest of ours, for that matter — was the same 'the human heart in conflict with itself.[129]

In his funeral homily, Dom Flavian Burns, Abbot of Gethsemani, said of Thomas Merton, 'The world knew him from his books: we knew him from his spoken word. Few, if any, knew him in his secret prayer. Still, he had a secret prayer, and this is what gave the inner life to all he said and wrote'.[130]

'The human heart in conflict with itself' expressed through Percy's novels and Merton's secret prayer revealing his 'inner life' through his voluminous writings have given us, for our time, twin prophets connected, yet distinct, guiding all of us in 'our search'.

Appendix

Letter from Thomas Merton to Walker Percy [January 1964].[131]

There is no easy way to thank you for your book. Not only are the good words about books all used up and ruined, but the honesty of *The Moviegoer* makes one more sensitive than usual about the usual nonsense. With reticence and malaise, then, I think your book is right on the target.

For a while I was going around saying it was too bad guys like Hemingway were dead, as if I really thought it.

127. Tolson, *Pilgrim in the Ruins*, p. 489.
128. Mott, *The Seven Mountains*, p. 570.
129. *The Correspondence of Shelby Foote and Walker Percy*, pp. 303-304.
130. James Forest, *Thomas Merton: A Pictorial Biography* (New York: Paulist Press, 1980), p. 215.
131. *The Courage for Truth*, pp. 281-82.

You are right all the time, not just sometimes. You are right all the time. You know just when to change and look at something else. Never too much of anyone. Just enough of Sharon. The reason the book is true is that you always stop at the point where more talk would have been false, untrue, confusing, irrelevant. It is not that what you say is true. It is neither true or false, it points in the right direction, where there is something that has not been said and you know enough not to try to say it.

Hence you are one of the most hopeful existentialists I know of. I suppose it was inevitable that an American existentialist should have a merry kind of nausea after all, and no one reproaches you for this or anything else. It is truer than the viscous kind.

I think you startled with the idea that Bolling would be a dope but he refused to be, and that is one of the best things about the book. Nice creative ambiguities in which the author and the character dialogue silently and wrestle for a kind of autonomy.

As for Southern aunts, if they are like that you can keep them. (But I praise the Southern aunt's last speech too. Insufferable, the last gasp.)

All this says nothing about how I was stirred up by the book. It should be read by the monks for a first lesson in humility. But I guess they would be bowled over by Sharon, so I better not hand it around to the novices.

I am glad Fr. Charles [Jack English, a Trappist monk from Holy Spirit Monastery in Conyers, Georgia] came by here and got sick and told you to send the book.

Now send me all your other books or things you write, please. Do you want anything of mine? I do artworks very abstract, maybe you would like one. Let me know if you like abstract brush and ink calligraphies.

Did this book get published in France yet? If not tell me and I will get the guys at Le Seuil busy on it at once.

I will send you my new book of poems (*Emblems of a Season of Fury*).

[TMA 15 (2002) 194-209]
ISSN 0894 4857

Seven Lessons for Inter-faith Dialogue and Thomas Merton

Allan M. McMillan

Between 1962 and 1965 the Second Vatican Council of the Roman Catholic Church expanded the parameters of interfaith dialogue in ways that few could have anticipated. The sealed enclosures of sectarian certitude gave way to cautious encounters, then curious interest and finally open dialogue. It was a defining moment in the life of the Church. While others searched for connections between the various Christian communities, Thomas Merton also looked deeper and found ways to dialogue with great world religions other than Christianity. To accomplish this task, Merton drew upon lessons learned at various stages of his life. An examination of Merton's autobiographical writings provides the path for the discovery of seven lessons learned in his own life and suggests a pattern for our own.

This essay demonstrates that Merton had insights not typical to the times in which they occurred and that his learning had an experiential base. Merton learned that a meaningful dialogue between different religions would not be well served by theological debate alone or by merely comparing religious practices. He found that such dialogue would necessarily draw people together and therefore it would be impossible to accept a person while denigrating their faith expression. Merton discovered that a meeting-ground for dialogue is possible in the 'Mystical' response to events and relationships and that these responses can stir in the soul of any person. By reflecting on his own conversion to Catholicism, he came to an appreciation of the need to go beyond an exchange of concepts to an experiential dialogue. He also shows an appreciation for moving away from proselytizing during interfaith dialogue to an encounter between faith-filled persons from differing traditions. Perhaps Merton's greatest contributions to interfaith dialogue come in his will-

ingness to seek personal conversions and to see these changes as gifts given for the betterment of all.

When Merton was born in January 1915, his parents were living in Prades, a village in southern France. Owen Merton was an Anglican from New Zealand. Ruth Jenkins was a Quaker from the United States of America. They were art students living in Paris when they met and married. The Great War forced them to seek their fortunes in the south of France and it was there that Tom (as his mother insisted he be named) was born. They moved back and forth between France and America until Ruth died of stomach cancer when Tom was only six years old. Ten years later, Owen died of a brain tumour. In Tom's autobiography, *The Seven Storey Mountain*, we learn of his early faith development, insights, questions and eventual conversion to Roman Catholicism. But it is through the lenticle of his monastic vocation that we see the church of his youth, even as his own life began to shape and change the church in which he was to become a priest and a monk.

There is a passage in his autobiography where Thomas Merton describes an encounter that would set a pattern for later dialogue. His love of a family by the name of Privat challenged his own beliefs and his way of looking at others. The Privats lived in Murat, in the Catholic province of Auvergne, and the time was the winter of 1926. Tom was 11 years old. His description of this peasant couple is not unlike the portraits found in Gaugin's paintings. Short, stolid and Catholic to the core, their diet was rich in butter, milk and daily devotions. Tom was sent to the Privat's farm to put meat on his bones and get over his inclination to suffer frequent bouts of influenza while attending school in Montauban. During a quiet moment one evening, the conversation switched to religion. The Privats questioned the seeming lack of faith in his young life and Tom responded with an attempt to justify pluralism within Protestantism. He was not successful. The Privats were not to be taught by the boy with the big ideas. On the other hand, the boy would never forget what they taught him. He says, 'They did not answer me with any argument. They simply looked at one another and shrugged and Monsieur Privat said quietly and sadly: "*Mais c'est impossible*" ...I wanted them to argue, and they despised argument'.[1] Such was the environment and the stance of the church in the time of Tom's youth. It was provincial, peasant, missionary, dismissive and solidly sure of itself. There was no argument. There never would be. This first lesson from the days of his youth

1. Thomas Merton, *The Seven Storey Mountain* (New York: Harcourt, Brace and Co., 1948), pp. 57-58.

was retained by Tom until his death: that *faith is not for wars and debates but dialogue.*

The second lesson is similar to the first: *one cannot ignore the person and attack their faith expression.* It is obvious from his description of the event that Tom loved the Privats and that they loved him. Who they were and the context in which they live mattered greatly in the process of understanding their faith. Who we are is as important as what we believe. *Dialogue is relational.*

Tom was not always amenable to the faith expressions of other people. He could be rebellious and he wore his obstinacy like a badge of independence. He wrote:

> I remember that in that year, when we stood in chapel and recited the Apostle's Creed, I used to keep my lips tight shut, with full deliberation and of set purpose, by way of declaring my own creed which was: 'I believe in nothing'. Or at least I thought I believed in nothing.[2]

While attending school in Oakham, England, he opposed Buggy Jerwood's translation of 1 Cor. 13 when he interpreted *charity* as *gentlemanliness, fair play and sportsmanship.*[3] He found Plato and Socrates to be intolerable and Descarte's *Cogito ergo sum* to be illusory.[4] He wrote, 'There can hardly have been any serious intellectual reason for my dislike of these philosophers, although I do have a kind of congenital distaste for philosophical idealism'.[5] His *'congenital distaste'* must have been inherited from Pop, his mother's father, who lived a life of American pragmatism and self-determination and who threw money at problems in the hope that they would disappear. But there was more than this distaste at work in Tom's heart. He buried himself in the jazz of Duke Ellington, Louis Armstrong and the Old King Olivers.[6] He found himself divided in sentiment like the black jazz singer Josephine Baker whom he had once heard sing *'J'ai deux amours, mon pays et Paris'.*[7] He wanted to be free of the beliefs of others but this was not always easy. In the days just prior to the death of his father, Owen Merton painted 'irate byzantine saints with beards and great halos'.[8] It seems that this both challenged Tom Merton and confused him. How could he love his father and argue with Owen's need to express his faith in religious art? How could he make sense of

2. Merton, *The Seven Storey Mountain*, p. 98.
3. Merton, *The Seven Storey Mountain*, p. 73.
4. Merton, *The Seven Storey Mountain*, p. 75.
5. Merton, *The Seven Storey Mountain*, p. 75.
6. Merton, *The Seven Storey Mountain*, p. 78.
7. Merton, *The Seven Storey Mountain*, p. 84.
8. Merton, *The Seven Storey Mountain*, p. 83.

these actions? Was it the disease of his brain tumour or was something else happening in the final days of his father's life? The impact was profound and the experience led him to a new realization, a third lesson, *that beyond philosophy, beyond institutional religion, 'mystical' responses to events and relationships stir in the soul of every man.* Later he would write:

> After all, from my very childhood, I had understood that the artistic experience, at its highest, was actually a natural analogue of mystical experience. It produced a kind of intuitive perception of reality through a sort of affective identification with the object contemplated — a kind of perception that the Thomists call 'connatural'[9]

At the very time when Tom Merton needed his father to be a partner in the experience of becoming a man; at the time when he needed someone to counsel him on the practical aspects of relationship with God and others; at that moment, Owen died. The legacy of the father lived on in the son. Memories of the few precious years with Owen punctuate the opening chapters of *The Seven Storey Mountain*. Whenever Owen is mentioned, there is great longing and deep loss in the words of Thomas Merton. Had Owen lived, things could have been different. The father who had worked barefoot in his vegetable garden would have appreciated the agricultural part of the monastic work of his son and the rhythm of the seasons in the liturgy. They would have been able to discuss so many things; things like pacifism and Gandhi. Instead, Gandhi came to England a few months after Owen died. Did Tom see a connection between struggles of the father of the new India and his own father's struggle to live? Gandhi marched to the sea to gather salt. Owen painted pictures of angry saints. Both actions seemed futile considering the size and empire of their opponents. Both were eventually overtaken but in the end both were victorious. We cannot be sure of the full connection between the two men, but when describing Owen some years later, Tom is not afraid to described his father as a 'great soul' (a *mahatma*[10]). On that occasion he wrote: 'Of us all, Father was the only one who really had any kind of faith'.[11]

9. Merton, *The Seven Storey Mountain*, p. 202.

10. When Merton was still a student in Oakham, he wrote a controversial paper on the life and works of Gandhi and argued with the football captain about the fact that Gandhi was right (cf. Thomas Merton, 'A Tribute to Gandhi', in *idem, Seeds of Destruction* [New York: Farrar, Straus & Giroux, 1964], p. 222). His use of the term *great soul* or *Mahatma* is not a term Merton would have used lightly. It was a poetically loaded term. Obviously he saw his father and Gandhi in some synchronous way that joined fatherhood to justice and rightness, and goodness and the other values usually attributed to a faith or creed.

11. Merton, *The Seven Storey Mountain*, p. 83.

How could he dismiss these ideas without dismissing the person who held the beliefs? *Mais, c'est impossible.* By holding on to his father's memory Tom would have something to believe in. He might not have realized it in the beginning but it would prove to be the mustard seed of his own faith. To hold onto the person he remembered and believed in, he would have to allow himself to be challenged by the beliefs no matter how minuscule their observable reality. Moral values and belief systems are not culturally dictated. The serious practitioner of any faith will always be one who has examined faith seriously and then chosen to live by it. In the beginning Tom was more curious than committed.

For a time he busied himself by avoiding the question of what Owen believed. Then, while in Rome on his 'grand tour' during the summer vacation following his eighteenth birthday, something happened which changed him at a very deep level. If Tom was anything at this time, he was a Protestant; a bright, reflective, intelligent, but unpracticed Protestant. Had he been a Catholic, he would have been caught up in feelings of pride and triumph as he visited the ancient churches with their mosaics and statues. But because he was a Protestant and a sometime agnostic, Catholic culture of this magnitude would have hit him with great force. Rome was not a homecoming. It was a faith experience, and his father and art were connected to it. The sense of having been visited by his dead father lead him to a deep moral conversion and a desire for prayer.[12] He needed to pray and to do so as publically as he could. The next day, no longer tight-lipped, he went to the Dominican church of Santa Sabina and prayed the Lord's Prayer with all the faith he had in him. In his autobiography he tells of this event and then adds a very interesting comment which has a sense of compassion and understanding for the feelings of others. 'Another thing which Catholics do not realize about converts is the tremendous, agonizing embarrassment and self-consciousness which they feel about praying publicly in a Catholic Church'.[13] Here, the reader can recognize a fourth lesson learned by the young Merton: *that one cannot understand the depth of feelings and faith experiences of another person unless one has experienced and wrestled with them in his or her own life.* This compassion, this willingness to *'suffer with'* the other opens us to the appreciation of the greatness of how other people respond to the Divine call.

After a disastrous year at Cambridge, Merton enrolled at Columbia University in the heart of New York City. Because of his literary interests and abilities, he spent time as editor of the year book, the *Columbian* and

12. Merton, *The Seven Storey Mountain*, p. 111.
13. Merton, *The Seven Storey Mountain*, p. 113.

was art editor for *Jester*, the school journal. His circle of friends at Columbia introduced him to the next phase of his interfaith odyssey. Tom Merton and Ad Reinhardt, the artist, mingled with a group who were either dabbling in communism or in mysticism. For most of the students, this quest for the 'mystical' was merely innovative, curious, and contemporary. For Merton, it was more. He seized every opportunity available to understand his own life, to reflect and observe the inner processes and workings of his own troubled spirit. He sensed that his direction as an artist, author and poet was within. He needed to understand, and the best way to explore this labyrinth was through dialogue and appreciation of what was happening in the lives of those around him. Merton gave up on Communism after a few meetings, but his search for the mystical lead him to a Hindu monk called Dr Bramachari, a devotee of Lord Jagad-Bondu. Bramachari was wise in his approach to the young student for he was willing to explain the externals of his own Hindu practices but not the faith level at which he lived.[14] Here was a fifth lesson: *the goal of interfaith dialogue is not conversion or ecclesial cloning but the honest, authentic, informed meeting of two persons who stand in integrated traditional paths which are tested and true.* If one person has had full formation in their path, and the other is of a lesser level of formation, then the dialogue cannot reach its full potential until some measure of equity has been established. We cannot borrow the faith experiences of another. By understanding ourselves; by being willing to take the steps on our own path and by struggling to own that which is God-given; then we can meet others on their journey. The fact that Bramachari stayed at the level of practices indicates that this is where Tom and his friends were on their own journeys and Bramachari chose to meet them there. Rather than discuss dogma and philosophy they talked about the segregation employed by missionaries working in India and their comfortable manner of living which gave a negative witness to Christian teachings.[15]

Bramachari recognized Tom's needs and his abilities and suggested that he read up on the mysticism of Christianity, books such as *The Confessions of St Augustine*, *The Imitation of Christ*, and *The Ignatian Spiritual Exercises*.[16] This posed a problem for Merton in that he had already read Augustine and Thomas à Kempis. He had some fear of the institutional church that caused him to panic whenever he was surrounded by it. On one occasion, his first visit to St Bonaventure's College in Olean, New

14. Merton, *The Seven Storey Mountain*, p. 195.
15. Merton, *The Seven Storey Mountain*, p. 196.
16. Edward Rice, *The Man in the Sycamore Tree: The Good Times and Hard Life of Thomas Merton* (New York: Doubleday, 1972), p. 33.

York, he refused to get out of the car despite the urging of his very close friend Bob Lax. He wasn't sure why he felt the way he did but Merton finally decided that there were too many crosses and too many holy statues. 'It made me very uncomfortable. I had to flee'.[17]

On another occasion, he bought a book at Scribner's in New York. It was *The Spirit of Medieval Philosophy* by Etienne Gilson. While returning to his home on Long Island, he discovered the *nihil obstat* and *imprimatur* on the inside of the cover. 'The feeling of disgust and deception struck me like a knife in the pit of the stomach. I felt as if I had been cheated! They should have warned me that it was a Catholic book! Then I would never have bought it'.[18] It took some time before he read the book. Only then did he realize his own prejudgments and biased thinking. He not only looked at the message of the book but he examined his own process of change. Here was a sixth lesson to be learned: *the more we meet others in their faith, and the deeper the encounter, the more we are invited to change in our own lives, to challenge our own prejudices, to root out the darkness and blindness of our own quest, and to experience fully the power of the lights given by God.* He later commented 'For as far as the light of God is concerned we are owls. It blinds us and as soon as it strikes us we are in darkness'.[19]

During this same period he had become interested in the study of Buddhism through a reading of Aldous Huxley's *Ends and Means* and a series of Buddhist texts which had been edited by the French Jesuit, Father Léon Weiger.[20] There was something in the Oriental thought that fascinated him, drew him, and compelled him to keep reading even though he found the aphorism difficult to comprehend. He had encountered some Oriental mannerisms in the reading of the Bible, especially in the book of Job, which had a connection to the study of William Blake on whose art and poetry he did his Master's thesis. Within the circle of his closest friends were Bob Lax, Bob Gerdy and Seymour Freedgood. All of them were Jews. Merton could have found God by going toward Judaism or Buddhism. But in the end, on 16 November 1938 after much soul-searching, maturing and responding to the call of God, he was baptized a Catholic, with Ed Rice as his sponsor and Bob Lax, Bob Gerdy and Seymour Freedgood in attendance.[21]

Over the next few years, Tom Merton continued to write. He taught briefly at St Bonaventure's College in Olean, New York, volunteered at

17. Merton, *The Seven Storey Mountain*, p. 201.
18. Merton, *The Seven Storey Mountain*, p. 171.
19. Merton, *The Seven Storey Mountain*, p. 170.
20. Rice, *The Man in the Sycamore Tree*, p. 13.
21. Rice, *The Man in the Sycamore Tree*, p. 32.

Friendship House[22] in Harlem, and took decidedly Catholic holidays to Bermuda and Cuba. On occasions and always to his own surprise, he was caught up in moments of 'mystical' insight. These experiences broke through his normal levels of awareness much like what had happened in Rome when his dead father's presence penetrated his inner darkness. When he attended Mass in the Church of St Francis in Havanna, he witnessed children singing *'Creo en Dios'* at the time of the Consecration. The experience, which began with human listening and delight, was suddenly elevated to the level of profound insight and divine awareness. This was a transforming moment for the newly baptized Merton. It happened suddenly without any anticipation. What was humanly brilliant became divinely brilliant. He then adds the following comment: 'And yet the thing that struck me most of all was that this light was in a certain sense "ordinary" — it was a light (and this most of all was what took my breath away) that was offered to all, to everybody, and there was nothing fancy or strange about it.'[23]

These moments of great insight were always personal lessons to Thomas Merton. *The seventh lesson is that these moments of insight were not his alone. They were offered to everyone. What surprised him most was that these insights seemed so ordinary after the fact.*

Then to the surprise of his friends and the draft board (three days after the Japanese attacked Pearl Harbor), he disappeared into the cloistered life of one of the strictest Catholic monastic orders in America. For all intents and purposes, his departure from the world on 10 December 1941 should have been the end of all interfaith endeavours.

When his autobiography appeared in print eight years later, it was his conversion to Catholicism that made the headlines. Few readers would know that almost one-third of the original text had not passed the scrutiny of the monastic editors and that this portion of the book was never published.[24] Of what remained, the references to Gandhi, Communism and the other religions were regarded as aberrations or detours en route

22. Friendship House was founded by Catherine De Hueck Doherty as an outreach for the poor, she is also affectionately referred to as *the baroness* because she was first married to a member of the nobility in her native Russia. She authored a number of books on this apostolate and later located the training of her associates in Combermere Ontario.

23. Merton, *The Seven Storey Mountain*, pp. 284-85.

24. The fact that one-third of the autobiography of Thomas Merton was never published is a comment made by Robert Giroux. Robert had been a classmate of Merton's at Columbia University and was the one who was instrumental in having the work published. His comment was made during the filming of *Merton: A Film Biography* by Paul Wilkes and Audrey L. Glynn (First Run Features Home Videos).

to the heart of the Church Triumphant. Then came other books: books of poetry, books of theology, books on prayer and the lives of a few saints. These were all quite acceptable, if not predictable for a Trappist monk. But suddenly, like weeds among the wheat, Merton surprised everyone with *The Wisdom of the Desert* (1960), *Gandhi on Non-Violence* (1965), *The Way of Chuang Tzu* (1965), *Mystics and Zen Masters* (1967) and *Zen and the Birds of Appetite* (1968). In *Catholic World,* he published an article entitled 'Christian Culture Needs Oriental Wisdom'. In his book *Conjectures of a Guilty Bystander* (1965) there were references to D.T. Suzuki who wrote extensively on Zen Buddhism and to Louis Massignon who spent the better part of his life in dialogue with Islam and Sufism. Merton spoke of Taoism, Tibetan Monasteries and the Shakers in the chapter entitled 'The Madman runs to the East'. Where did all this come from? What was this monk trying to do? Was he still Catholic? Was he still a monk? Conservative Catholics had enough on their plate at this time. They were living through the shock of the Second Vatican Council (It would be years before many even knew there were documents on Ecumenism and non-Christian Religions, to say nothing of reading them.) They had the war in Vietnam; priests like the Berrigans pouring blood on draft records; Martin Luther King, race riots and non-violent marches for integration; folk singers like Joan Baez protesting the war along with Thich Nhat Hanh, an itinerant Buddhist monk from North Vietnam preaching peace here in America and now there was an all-too-vocal Trappist who was friend to them all and writing books that some might suggest no Catholic should read.

Merton's interest in other world religions was not an aberration or a bizarre monastic hobby. It was the result of his prayer life, his self-examination, and desire to continue growing through the shared experiences of others who were on a similar quest. As a contemplative monk he explored contemplative traditions wherever he found them, especially those which combined poetry and art with the mystical expression. His writings had opened to the general public an understanding of contemplative prayer. For many, this was a major shift in their spirituality and prayer life. The popularity of his books proved there was a hunger for God that was not being addressed by the conventional forms of spirituality. In some cases, his teachings helped us to understand the attainability of certain forms of prayer previously thought to be the prerogative of saints and mystics. Without denying the worth and value of prayer forms learned from parents and teachers, he invited contemporaries to go deeper and to see the roots of traditions.

Merton's words also rang bells of recognition in the hearts and minds of those who read him in translation. Around the world, people asked

'Who was this monk of the West who speaks to the heart of people in the East?' Merton helped them see that there was depth and profound spiritual life in the centre of the seemingly baroque or renaissance institution of the Roman Catholic Church. Suddenly, not only was dialogue possible, but there was also something to talk about.

There are many examples of how perceptive and sensitive Merton was in the act of dialogue. He showed that he could go quickly to the heart of the matter by poetically writing on several levels at the same time. One example of this is found in the preface to the Japanese edition of *The New Man* (1961). It had been translated by Yasuwo Kikama, and Merton was delighted to be able to communicate with the people who had been through the pain of war and nuclear holocaust. He began with Christ's words to Nicodemus in John 3: 'You must be born again'. Not only was the dialogue between Nicodemus and Christ appropriate for the book but Merton showed a great sympathy with Japanese culture. By commenting on this one passage, Merton was able to call the reader to a higher level of personal reflection as a preparation for reading his book. He did this in several ways. Merton knew *haiku* poems and the cha-no-yu (tea ceremonies) with their magnificent gardens and how these aspects of Japanese culture ritualized the seasonal flow of Japanese life. He knew the contrast between the *samurai* who willingly gives his life for his lord as opposed to the *ronin* who is without a lord to serve. Merton would also have known that the word *kamikaze* meant 'divine wind'. In this preface we see Merton threading his way between traditions of Shinto, Zen Buddhism and the Christian gospel:

> These 'higher religions' answer a deeper need in man: a need that cannot be satisfied merely by the ritual celebration of man's oneness with nature — his joy in the return of spring! Man seeks to be liberated from mere natural necessity, from servitude to fertility and seasons, from the round of birth, growth and death. Man is not content with slavery to need: making his living, raising his family, and leaving a good name to his posterity. There is in the depths of man's heart a voice which says 'You must be born again'.[25]

Then Merton presented the image employed by Jesus when he spoke of the wind blowing where it will. This is the Spirit of God, this Divine Wind, this Kamikazi. In sentiment at least, and never with a direct statement, he has introduced a feeling so close to the Japanese psyche, that this alone compels them to be interested and to feel invited into Merton's

25. Thomas Merton, 'Preface to the Japanese Edition of *The New Man* October 1967'. in Robert E. Daggy (ed.), *Introductions East and West: The Foreign Prefaces of Thomas Merton* (Oakville, Ontario: Mosaic Press, 1981), pp. 107-16 (110).

world and reflections. Having made this connection, he shows them his heart:

> To be born again is to be born beyond egoism, beyond selfishness, beyond individuality, in Christ. To be born of flesh is to be born into the human race with its fighting, its hatreds, its loves, its passions, its struggles, its appetites. To be born of spirit is to be born into God (or the Kingdom of God) beyond hatred, beyond struggle, in peace, love, joy, self-effacement, service, gentleness, humility, strength.[26]

It is as if Merton has declared his own culture (with its bomb} to be *ronin* while showing what the culture could be if it wanted to be truly *samurai*. These are concepts and ideas with which the Japanese reader could identify. The translation was presented compassionately and with a poetry that had all the clarity of the shout of a Zen master.

Within the Catholic Church, Merton was not alone in dialogue with the East. At the beginning of this century, Charles de Foucauld lived as a hermit in the midst of the Muslim Tuareg of the Sahara. His was a witness of the gospel of presence in prayer and sacrifice. Bede Griffiths, a Benedictine monk of Prinknash Abbey, left England when invited to join a Shantivanam, a Christian monastic community which had embraced the customs and style of the ashram. There he became a leader in the Christian-Hindu dialogue. Mother Teresa of Calcutta is perhaps the best known for she left the security of her community of Loretto to go out into the streets, armed only with trust in providence and a heart full of compassion. 'I've always said we should help a Hindu become a better Hindu, a Muslim become a better Muslim, a Catholic become a better Catholic'.[27] When she died some years later, her witness was praised by Sikh, Muslim, Hindu, Buddhist, Jain and Christian.

Merton's approach to other religions was different. For the most part he stayed at Gethsemani. He chose to dialogue with religions that had a mystical tradition and an expression in art and poetry that parallelled the mystical traditions of Christianity. Rather than seek syncretisms of signs and symbols he sought to meet others at the level of the heart. Using his considerable linguistic sensitivity and voluminous knowledge of his own traditions, Merton sought out those who had experiences like his own and walked in ways that made them his brothers and sisters before God. Merton was all too aware of how easily we can dismiss the writings and the teachings of other traditions simply by labelling one as *pantheism* and another *quietism*. He felt that the study of religions merely

26. Merton, 'Preface', p. 113.
27. Paul McKenna, 'Mother Teresa, Interfaith Ambassador', *Scarboro Missions* 79.2 (February 1998), p. 8.

by comparing rituals was not adequate or effective. His quest was for the shared spiritual or aesthetic experience. '[T]he 'universality' and 'catholicity' which are essential to the Church necessarily imply an ability and a readiness to enter into dialogue with all that is pure, wise, profound, and humane in every kind of culture. In this one sense at least a dialogue with Oriental wisdom becomes necessary. A Christian culture that is not capable of such a dialogue would show, by that very fact, that it lacked catholicity'.[28]

During the time that Merton was Master of Novices, he dedicated a lot of time to the exploration of other faith traditions: the Sufi, Lao Tzu, Zen Buddhism and the Shakers. He was aided on his journey by a host of friends and associates, some of whom he got to meet and dialogue with in person. He felt that it was important for not only the monks of his monastery, but for all Christians. In *Conjectures of a Guilty Bystander,* in the chapter entitled, 'The Night Spirit and the Dawn Air' he writes: 'I will be a better Catholic, not if I can *refute* every shade of Protestantism, but if I can affirm the truth in it and still go further... If I affirm myself as a Catholic merely by denying all that is Muslim, Jewish, Protestant, Hindu, Buddhist, etc., in the end I will find that there is not much left for me to affirm as Catholic: and certainly no breath of the Spirit with which to affirm it.'[29]

One of those who aided Merton in this process of self-discovery was Louis Massignon, a man who had spent a lifetime in dialogue with Islam. The reading of Massignon's work was a turning-point for Merton, an awakening, and, as we shall see, a springboard for one of his moments of profound 'mystical' insight. If we are going to experience, to feel with every fiber of our skin, the reality of the truth before which we stand, we will need to learn the language that owns these experiences. Only when they have become part of our being can we say that we truly know them and begin to live them. Merton writes, 'Massignon has some deeply moving pages in the *Mardis de Dar-es Salam:* about the desert, the tears of Agar, the Muslims, the *"point vierge"* of the spirit, the center of our nothingness where, in apparent despair, one meets God—and is found completely in His mercy.'[30] Empowered with such a concept, Merton begins a process of self-reflection that culminates in his famous moment of truth of 19 March 1958 in Louisville, at the corner of Fourth and Walnut.

28. Thomas Merton, 'Christian Culture Needs Oriental Wisdom', in Thomas P. McDonnell (ed.), *A Thomas Merton Reader* (New York: Harcourt, Brace & World, 1966), pp. 319-26 (326).

29. Thomas Merton. *Conjectures of a Guilty Bystander* (Garden City, NY: Doubleday, 1966), p. 129.

30. Merton, *Conjectures,* pp. 135-36.

> At the center of our being is a point of nothingness which is untouched by sin and by illusion, a point of pure truth, a point or spark which belongs entirely to God…which is never at our disposal, from which God disposes of our lives, which is inaccessible to the fantasies of our own mind or the brutalities of our own will. This little point of nothingness and of *absolute poverty* is the pure glory of God in us… I have no program for this seeing. It is only given. But the gate of heaven is everywhere.[31]

Not wanting to remain only with concepts and ideas discovered in books authored by strangers, Merton also corresponded with some people in the hope that their friendship would lead them deeper into personal dialogue and experience. One of these was Abdul Aziz. He was an Algerian psychoanalyst and a specialist on Sufism.[32] In one of his letters he writes:

> I have a Moslem friend who feels himself urged to pray for me, and I pray for him: but when he gets the urge to pray for me on the *night of destiny* (a key point in the fast of Ramadan) I usually get a whacking cross of some sort. I don't know usually when Ramadan is, or the night of destiny (it varies), but I can generally tell if I get knocked on the head some time in March that Abdul Aziz is praying for me. I send him books about St John of the Cross and he sends me some about the Sufis. Great people.[33]

It was statements like these, so full of his own inner conviction, his joy and his enthusiasm, that caught the imagination of those who read Merton. What is this seeing, this insight? What was this Wisdom that comes to us on street corners and crowds into our dreams?[34] We began to realize that this man was leading us to an appreciation of the powerful presence of God in other traditions and we wanted to experience them as well. Suddenly the enigmatic story-telling of the Zen masters found a new place in our hearts. Each new piece of the puzzle added new color and definition to what we already knew. It was so fascinating and surprisingly easy; almost entertaining.

> Another Zen master, when asked if a monk should read the sutras, replied in characteristic Zen style: 'There are no byroads and no crossroads here;

31. Merton, *Conjectures*, pp. 141-42.

32. Thomas Merton, *The School of Charity* (ed. Patrick Hart, New York: Farrar Straus & Giroux, 1990), p. 265.

33. Thomas Merton, *The School of Charity* (ed. Patrick Hart; New York: Farrar, Straus & Giroux, 1990), p. 172.

34. Thomas Merton, *A Search for Solitude: Pursuing the Monk's True Vocation* (Journals, 3; 1953–60; ed. Lawrence S. Cunningham; San Francisco: HarperSanFrancisco, 1995), p. 176. Merton had a dream about Wisdom. She came to him as a young Jewish girl and identified herself as someone called Proverb. Several days later he wrote her a letter.

the mountains are all the year round fresh and green; east or west, in whichever direction you may have a fine walk'. The monk asked for more explicit instructions. The master replied: 'It is not the sun's fault if the blind cannot see their way.'[35]

Having brought us to an appreciation of insights by others, Merton shows us how to find similar forms in our own culture and how this can have importance for us. He crosses borders with his bounding connectedness. He not only draws disparate ideas into the same neighborhood but then makes it possible for us to live and to learn from the connections. Once, when discussing the moment in the bullfight when the bull is killed, he refers to this as the *moment of truth*. In short order, he also sees the *moment of truth* in the resolution of a koan by the Zen practitioner. But before he explores the connections to an illogical conclusion, he resolves the problem with a truism. 'Zen sees life itself as a spiritual Bullfight. Spaniards simply externalize it'.[36]

Merton enjoyed Zen. It gave him a whole new way to understand his life of contemplation especially in the hermitage years. He confessed that his writing of *The Way of Chuang Tzu* was something he enjoyed more than any other he could remember. When he got to meet Thich Nhat Hanh it was like meeting Chuang Tzu in the flesh. Merton calls Nhat Hanh 'my brother...' 'He is more my brother than many who are nearer to me in race and nationality, because he and I see things exactly the same way'.[37] Both were monks; both had lost brothers in the midst of war, and both wrote poems to their dead brothers. They met in their opposition to what was happening in the war in Vietnam. Thich Nhat Hann was from North Vietnam. Merton was from America. As the world would have it, they should have been enemies. They met and embraced as brothers.

For one so committed to dialogue with the Eastern Masters, it is not surprising that Merton's final moment of awakening happened in Sri Lanka at the temple of Polonnaruwa. He went alone, and barefoot in the wet grass. He was a Catholic monk at a Buddhist shrine with a Muslim aesthetic.[38] In this, his moment of truth, Merton found that everything connects. When he wrote about the event four days later, he worried that

35. Thomas Merton, *Mystics and Zen Masters* (New York: Dell Publishing, 1969), p. 220.

36. Merton *A Search for Solitude*, p. 174.

37. Thomas Merton, *Thomas Merton on Peace* (London: Mowbrays, 1976), pp. 152-53.

38. 'The absence of shadow in Persian miniatures reveals that they spring from the world of Archetypes which reflects the Light from the Divine'. Is this what Merton meant by going beyond the shadow and the disguise? Cf. Laleh Bakhtiar, *Sufi: Expressions of the Mystic Quest* (New York: Thames & Hudson, 1976), pp. 14-15.

he had diminished the experience by sharing it with others in a conversation at table. In reading his journal entry, one gets the feeling that the event was more than he thought possible to describe and yet he writes paradoxically, 'The thing about all this is that there is no puzzle, no problem, and no "mystery". All problems are resolved and everything is clear, simply because what matters is clear'.[39] The resolution of his own personal quest has become the conundrum of those who wonder what Merton meant when he described the event as going beyond the shadow and the disguise. A koan? A parable? A window or a gate? What matters is clear. What is not clear does not matter.

Did Thomas Merton attain true enlightenment? Did his years of studying Zen prepare him for a moment of *satori* (Zen enlightenment)? He was never able to tell us. Merton died of accidental electrocution little more than one week later. In *The Man in the Sycamore Tree* by Ed Rice, we are told that in some Buddhist traditions, the reincarnation of a Buddha is not recognized until his death and then alligators will come and eat a dog. Apparently this happened 12 December 1968, on the grounds of the conference Merton attended at the time of his death and that this was witnessed by the abbots and monks.[40] The Dalai Lama called Merton a 'Catholic *geshe*' (a learned monk)[41]. Perhaps he did achieve enlightenment.

Somewhere, and somehow, the lessons Merton learned in his own life found their way into his writings in spite of the fact that he was a monk living in silence in the midst of the Kentucky Knobs. Merton teaches us seven lessons: (1) that dialogue is relational; not debate; (2) that persons are more important than faith expressions; (3) that contemplation and mystical prayer are a meeting ground for dialogue and are available to us and to all; (4) that we come to understand by experience, not by concept; (5) that interfaith dialogue can be an 'honest encounter' without seeking the 'ecclesial conversion' of the other; (6) that interfaith dialogue challenges us to entertain change in our own hearts and (7) that such change is not personal gain, but God-given through us to others. What Merton experienced, he owned. What he owned, he shared. What he shared, changed his community, his church and his world. It continues. He invites us to see what he has seen. These lights require an awakening

39. Thomas Merton, *The Other Side of the Mountain: The End of the Journey* (Journals, 7; 1967–1968; ed. Patrick Hart, San Francisco: HarperSanFrancisco, 1998), p. 323.

40. Rice, *The Man in the Sycamore Tree*, p. 10.

41. Pierre-François de Béthune, OSB, 'Preface', in Donald W. Mitchell and James A. Wiseman, OSB (eds.), *The Gethsemani Encounter: A Dialogue on the Spiritual Life by Buddhist and Christian Monastics* (New York: Continuum, 1999), pp. xi-xvi (xi).

that is not easy. 'Here is an unspeakable secret: paradise is all around us and we do not understand…' Wisdom', cries the dawn deacon, but we do not attend'.[42]

42. Merton, *Conjectures*, p. 118.

[TMA 15 (2002) 210-231]
ISSN 0894 4857

'Aware and Awake and Alive': An Interview about Thomas Merton with Brother Paul Quenon

Conducted and edited by George A. Kilcourse, Jr
Transcribed by Susan Merryweather

Brother Paul Quenon

Paul Quenon, a native of Fairmont, West Virginia, entered the Abbey of Gethsemani in 1958 shortly after graduating from high school. His two-year novitiate was under Thomas Merton as Novice Master, Fr James Connor as Undermaster, and Abbot James Fox. He studied philosophy with Dan Walsh for three years; Fr Flavian Burns and later Fr John Eudes Bamberger were his Junior Masters at the monastery.

Brother Paul received a Masters Degree in Systematic Theology at Catholic Theological Union in Chicago, and spent three years in Nigeria teaching and helping at Awhum Monastery. He served ten years as Junior Master, and currently is Director of Education at the Abbey of Gethsemani.

He has published two books of poetry: Terrors of Paradise *(1995) and* Laughter, my Purgatory *(2002). His anthology of poetry,* Smaller than God *(2001) was co-edited with John B. Lee, and his collection of stories,* Holy Folly *(1998), was co-authored with Fr Timothy Kelly and Brother Guerric Plante. All of these are published by Black Moss Press in Windsor, Ontario. He is co-editing an annual literary volume called* Monkscript *(2002) published by Fons Vitae in Louisville, KY. He photographs in 35-mm format and has exhibited his work in universities and galleries in Chicago, Milwaukee, Cincinnati, Columbus OH, Louisville and Lexington KY.*

Brother Paul is past and present member of the board of the International Thomas Merton Society and of the Thomas Merton Foundation. He is facilitator for the Merton Chapter at Gethsemani, and for the Cistercian Lay Contemplatives. In May 2002 he was one of the facilitators at the Merton Pilgrimage to Prades, France, sponsored by Simon Fraser University, Vancouver, British Columbia. His daily jobs in the monastery include cooking, telephone installation, gardening, teaching and singing as Cantor.

Kilcourse: Brother Paul, even before you came to the Abbey, it's possible that you might have known some of Thomas Merton's work. Had you read any of Merton's writings before you entered the Abbey of Gethsemani?

Quenon: The only book by Thomas Merton I'd read before entering Gethsemani was *The Seven Storey Mountain,*[1] and it was a book that led me to Gethsemani. Other books had led me to monasticism but *The Seven Storey Mountain* led me to Gethsemani. First of all, it made me aware that there was a monastery in the United States, and it was a book which showed me that a person can be a modern man and at the same time be a monk. So that got me over a hump. Even though I was very young, I was wondering if this was something that could still be done without seeming like you were in a bygone age and a foreign country. When I talked to Fr Louis about reading *The Seven Storey Mountain,* he said, 'How did you like it?' And I said, 'Well, it was a bit long in the middle'. He gave a look and was a bit amused, but he might have been a little bit put off by that.

1. Thomas Merton, *The Seven Storey Mountain* (New York: Harcourt Brace Jovanovich, 1948).

(Left to right) Thomas Merton; Carolyn, Josephine, Eileen and Paul Quenon at Abbey of Gethsemani; tobacco barn – Summer 1959.

Kilcourse: Describe for us your first meeting with Merton.

Quenon: My first meeting was in the retreat house. I was told that the Novice Master would come to meet me, and this rather heavy-set man, who seemed pretty old to me, came in. I figured he must be 65, although actually he was only about 43 at the time. He didn't ask too many questions. He didn't seem to be probing much. He seemed to be more interested in getting me into the flow of things. And he said, 'Tomorrow we'll be going out in the woods and cutting down some trees'. That visual way of talking was characteristic of him, and it should have been a clue right away that he was Thomas Merton, but I didn't recognize him. He was just the Novice Master to me.

Things went on for about a month, and I had no idea that the Novice Master was Thomas Merton until somebody told me. I was very happy it happened that way because by then I had established a relationship based on the fact that he was my Novice Master and not a famous writer, whom I had read already. That continued to be the nature of the relationship, and it was always in the forefront. Occasionally we might talk about something he'd written and maybe sometimes he would share something he had written. But it was very much a secondary thing.

Kilcourse: So, you knew him as Fr Louis?

Quenon: As Fr Louis.

Kilcourse: And 'Thomas Merton' was the public dimension.

Quenon: And his public dimension was really a different part of his personality, a different part of his life. His style of writing is quite different from his style of speaking when he's giving a conference, and then, again, from his style of conversation.

Kilcourse: Merton was your Novice Master, and Novice Masters in those days had more than one task with the novices. I know it included teaching, but could you just say something about how you experienced him as Novice Master.

Quenon: The Novice Master was the most important thing about the relationship. Teacher was really secondary. He was good at teaching, but the primary thing was that you related to somebody who was really your spiritual director. It was more a disciple relationship — as a disciple rather than a relationship as a student — and there was a certain level of trust that you had to have and a kind of intimacy. You disclosed something of your own spiritual struggles, an opening of the heart, where you talked about how you think God is working in your life. Or what God wants for you, what is my vocation, do I really belong here? What has been my experience in growing up? These are all things that you have to discuss. Things a teacher does not know except accidentally. But this is the essential part of being a Novice Master.

Kilcourse: So, the word 'Master' really describes master-disciple?

Quenon: Yes, the vocabulary now is tending toward Novice 'Director', but that really guts it of its spiritual element. I know the domination paradigm is to be avoided. Nevertheless there is something about the figure of a spiritual master in a sense that he has mastered his art, like a master craftsman. A spiritual master is somebody who has spiritual maturity, experience and wisdom, and can communicate that to you. Or at least can bring it to bear on guidance for your soul in your vocation.
Kilcourse: You mentioned Merton being your spiritual director. Without prying into any of the confidential sessions, could you tell us something about his style or manner of direction, his special gifts in spiritual direction?

Quenon: His manner was casual and practical. He would ask you how you were doing at work, what's it like in choir, how do you like choir, what'd you think of that talk in chapter the other day. Just incidental things, what's going on in the monastery and what's going on in your life. You would go from there into deeper things.

The superficial conversation could go on for quite a while sometimes, and often it wasn't until near the end, when the bell was going to ring for Compline, that I would bring up something important. Then we would have to stay and miss Compline. I don't think he minded that too much. He said I would 'bring the rabbit out of the hat at the very end', so that became a habit. I found a lot of times that he could read my heart, and this is 'discernment of spirit', which the Desert Fathers talk about. He could read me in a way I couldn't read myself. He understood me better than I understood myself sometimes, and that was a bit unsettling. I certainly couldn't understand *him*. I often found myself trying to understand what he's telling me, and it wasn't until maybe after a year that I could really begin to understand.

Kilcourse: He seemed to have a lot of contact by mail that was 'virtual' spiritual direction. Any particularly memorable people in that category?

Quenon: I didn't know what was going on with the other novices, except incidentally. Sometimes he didn't find it too easy to relate to some of the other novices, and I might hear a crack or two about that. There were people who were writing to him. I got very little exposure to that, except one time there was this buzz going around in the monastery about something that had happened. I walked by the Undermaster's room, and the word 'miracle' was mentioned. I began to make connections of what was actually going on, and here's the story as I can remember it: one morning at the end of the Novices' Mass I saw Fr Louis open the tabernacle and place an envelope, letter size, inside. He held it between his index finger and second finger and with his left hand placed it vertically inside the curtain. Then closed the door and finished Mass. I wasn't sure if that was a strange thing for a priest to do or not. Maybe there was some sort of blessing he wanted on this letter before he sent it.

Later that afternoon, or the day after, I went to the chapel for a visit. When I entered there was a flapping of wings as a bird flew from the altar out the front window on the left. I went to Fr Tarcissius, the Undermaster, and told him a bird got into the chapel, and screens should be put on the windows. He said there are screens. I said, but not on the front two windows. When I went back, I saw they were sealed shut and never *were* opened.

At a conference following, Fr Louis asked if anyone knew what became of the letter he had put in the tabernacle. No one answered. It didn't seem right to me that anyone, at least not a novice, should be fooling around with the tabernacle unless he was sacristan. And the sacristan, Fr David, had nothing to say.

A week or so later I passed the Undermaster's office and overheard something the two or three novices there were saying about 'a miracle'. I wasn't inclined to give attention to talk about miracles. I was grateful I hadn't heard much talk like that here yet. I supposed there was a lot of that sort of talk among the Brother Novices, and I was a little concerned it might be creeping over into the Choir Novitiate. So I walked past the door without giving pause.

Then at the next conference Fr Louis said a woman he knew had been in a crisis. He read a letter from her that started out by saying: 'I don't know how your letter, which was not postmarked, got here. I found it on the table when I walked into the house...' Then she expressed how it came at just the right time when she was in such darkness, etc. Fr Louis didn't say how it got there either. Later, in spiritual direction, when I tentatively brought up the letter in the tabernacle, Fr Louis said we don't need to think about that too much. Christ can take care of these things.

Accordingly, I more or less forgot about these things. But now that so much else has been written about Fr Louis, I consider this too ought to be included.

Kilcourse: It's been said that Merton had a profound influence on a generation of novices at Gethsemani. Many of those went on themselves to become abbots in the various communities. He certainly exercised an important office as Novice Master and earlier as Master of Scholastics at the Abbey. Paul, you've developed into a fine poet and photographer. These were two artistic expressions that Merton cultivated so fruitfully. I doubt that Merton could sing as well as you. You are a fine cantor at the monastery, but how has his influence stimulated your gifts as poet and photographer.

Quenon: He stimulated me more by example than by direct effort. There was only one time I remember when we did something artistic together. Somebody had brought a can of beer into his office and left it there. He invited me in and we split the beer and drew pictures. After that he posted them up on the bulletin board and said, 'There were two Russian artists here last night, Popov and Chekov'. I did write a poem when I was a novice and he liked it. He put it up on the board, and nothing

much happened after that. I didn't do a whole lot of writing until after he died.

A person has to die before you inherit something of that spirit which moves them. I sometimes made an effort to develop my imagination in the context of my spiritual life. That's one of Merton's chief qualities as a person, that he was a man of the imagination as well as the spirit. He was aware and awake and alive in his imagination and considered that to be an important part of his spiritual life. So I've emulated that example. I would go around seeing things, angles, just the quality of light at certain times of the day, and how a certain configuration of space and objects can be very beautiful. But I didn't try to capture any of this until I started using a camera 30 years later.

Kilcourse: So, it wasn't imitation in a non-flattering way. You weren't trying to become a latter-day Thomas Merton poet-photographer, but it was the fact that you lived life with that kind of intensity. You wanted to live as intensely as he had.

Quenon: Yes, I would say that. He almost had to be out of the way before I could do it. I couldn't feel my own space, I didn't feel I was somehow out from under his critical gaze until after he was gone. Then I was working from within, so to speak.

Kilcourse: Do you remember anything vivid about your relationship with Merton and your friendship and communication?

Quenon: He would be more perceptive about me than I was about myself, and that would cause some tension. I never felt totally comfortable with him. He was a man with a gift of words and could use words quite pointedly, but he was also a man who was non-verbal in his ways of communication. He could penetrate through a smokescreen of words and leave you on the spot and knock you to another level of experience, where you had to cope with things without controlling them and rationalizing.

I remember one morning, within the first three months of my novitiate, when I went outside to the wall behind the novitiate, overlooking the valley. The sky was incredibly blue, and everything exquisitely fresh. My senses were cleansed by the rigor of our life and intensified by my budding manhood. Everything in that quiet moment was more vivid than I ever knew before.

I strolled around the corner and Fr Louis came by. He saw immediately into my soul and looked pleased. But when I saw that he saw, I was made self-conscious. He immediately saw that change come on and his

look turned dark. This must have been a moment of what the Desert Fathers called 'discernment of spirit'. For me it was too much a moment of being obvious. So much happening without exchange of words was unsettling.

Later he complained to me of my being too self-conscious. I wasn't sure which phase of that meeting he was talking about — the before or the after. And shortly, he made complaint that I used words to control the situation. I felt, in fact, small confidence embarking on a sea of non-verbal communication in unfamiliar relationships. It was struggle enough just to get the verbal part right.

At home, Mother could read my mind, and I would read hers without even knowing it. And having a twin sister involved much the same.

Another time, he was at work with the novices in the woods. I was standing a while worried over private things a young man is likely to be worried about. He saw me, squeezed his eyes shut and burst out: 'I'm never going to do that ever again' — as if reading my own thoughts. I was astonished. It startled me and broke the spell of the moment, but it didn't resolve my worry. Maybe I was becoming addicted to worry. And, moreover, I wasn't sure I wanted to be that easy to read.

I resist speaking about the following episode; perhaps it should be left alone and there is no business my putting it into words. But if I speak about Merton as I knew him I might as well go all the way. The blocks against the non-verbal busted soon enough. I had a dream, or something of the sort, since it started out with what seemed like a real shout from Fr Louis' side room adjacent to the dormitory. I got up and ran to the socket in the wall and pulled out a plug. In reality there was no socket and no plug in that wall. I told Fr Louis that dream the next day. He said, 'You saved my life'. Then he told me he'd had a dream that he was electro-cuted, he was lying on the floor in a room surrounded by monks and nuns and some big-wigs, and the Primate of the Benedictines was there. The coincidence of our dreams annoyed me and seemed pretty special. It never happened again.

The recollection of this incident in 1958 after his death in 1968 dis-turbed me. I was inclined to disbelieve it. I was uncertain whether I was remembering something, or just making it up in my imagination — a way of filling in the gaps of what was a sudden and shocking end. His death was terribly significant in many ways, for me a joyful experience, and I felt his presence in a new and closer way. But the dream episode seemed too much like a way of fitting together pieces of a puzzle.

Now after years of distance from the death I feel free to revisit the novitiate days on their own terms. And there I find this memory recog-nizable on its own terms as a memory. And with it some subsequent

effects it had on Fr Louis. He took this incident or coincidence as something needing attention. Perhaps it was a confirmation of his own dream he suspected was significant. I am not sure how much attention he paid it. He must have prayed over it. And it might also have given him pause about why I was in the monastery at all.

He asked me, 'Are you staying here for my sake?'

I said, 'No, I want to be a monk'.

Later, he read to me an answer to a letter he wrote to 'a prophet', some friend who he said had that kind of grace. The tone of the letter was garrulous and lengthy. Fr Louis read it with laughter, especially at the point where he warned Fr Louis that his prophet there at the monastery is immoral and 'he should not be trusted for what he does when he goes out into the woods'—or something to that effect. I was not sure how I fitted into that picture at all, but I was not as willing to dismiss the suggestion as ludicrous as Fr Louis seemed to be. After that, there was no more mention of the subject, and we just took it for what it was or might be, and left it at that—*he*, I presume, out of faith, *me*, out of a desire to avoid a false faith.

It was at this time, either before or after, maybe both, when Fr Louis spoke about the complaints that individuals make about our sermons in Chapter being so dull and windy. He said that the sermon a priest gives should be like a shout that a man standing outside a burning house makes to the people inside to get out. I was reluctant to pursue the thought of how he might apply that. Was it a shout to get out of the monastery which was as good as doomed? I was focused on trying to get in. Or did it speak to my own thought to get out of the Catholic church, which sometimes seemed fatally constricted. Either interpretation was too narrow. His explanation used words such as 'eschatological', 'a different kind of world' and so forth. A shout to escape this world based upon illusion.

There was one more time when I heard a shout in the night. It was a day or two before 10 December 1968, when Fr Louis died in Bangkok. I was awakened by the voice, which I identified as the same voice who spoke to us in Chapter. I thought of running down to see him, but as I came to my senses I realized that was impossible. Fr Louis still had to be in Bangkok. The shout awakened me to a world that seemed vital and full. Coming to my senses seemed a turn toward a world that was dull, gray, half alive. All was quiet in the dormitory. I did not rouse myself. But I could not get back to sleep. Eventually the Tower bell struck two o'clock. Next day no one seemed to have heard the noise. Brother Benedict suggested I might have heard Brother Nivard. But it didn't sound like Nirvard to me.

When reports of Fr Louis' death came in, they told of how someone heard a shout. A couple of monks came to his door. They knocked but there was no answer. The door was locked. Over the door was a louvre. They climbed, pushed it open and looked in. He was lying under the fan electrocuted. The fan was still plugged into the wall. Before long the room was full of monks and nuns, dignitaries and the Abbot Primate of the Benedictines, Rembert (later Archbishop) Weakland.

There was another shout: the body was returned to Gethsemani a week later. According to ritual practice, the community gathers in the cloister to receive the body and accompany it into church. I had set up a loud speaker and microphone for the prayers. The wires were looped through a window into the chapter room, where the amplifier was located. When the hearse arrived I hurried into the chapter room to turn it on and adjust the volume. The moment the coffin was brought into the cloister I carelessly stepped on the microphone wire and it let out a great yelp. The rapture of silence, at such a grave moment, seemed raw, absolutely crude. But its significance was immediately evident to me. It announced his arrival, an echo of his cry of departure. When Christ gave up his spirit on the cross, he cried with a loud voice. It was a jolt to awareness.

The coffin was moved down the cloister, a smooth, gray form and came to rest below the sanctuary, a small beached whale. The lid was never opened and the funeral began immediately. Fr Flavian, who presided as Abbot, had seen it opened for identification at the morgue. The sight must have still been with him. He had turned a color I had never seen him before or afterward. He turned pink. The moment was pivotal in his whole career. The Cellar, Brother Clement, who was also there, said the decay was so advanced he would not have been able to recognize Fr Louis. Fr John Eudes, our house physician, confirmed the identification by looking at his teeth.

The day was misty and there was a slight drizzle falling on the cemetery. The moment before the coffin was lowered Fr Eudes kissed his fingertips and lay it on the head of the coffin. After it was lowered, and time came for the first shovels of dirt to be thrown in, Fr Flavian turned to Fr Raymond to begin it. Fr Raymond stood still and would not move. Fr Flavian motioned him again to begin. Reluctantly, he took a shovel, and the dirt and stones landed with a loud clunk on the metal coffin.

Afterwards, I climbed the red cedar by the grove to remove the loud speaker. I had to put my arms around the tree to untie it and the fragrance close to my face was sweet.

Kilcourse: You spent time in Africa, Paul, teaching there. Could you tell us something about that experience? Would it be accurate to say that Merton's global consciousness might have played a role in that?

Quenon: I went to Africa primarily to teach. I went to Africa to help at another monastery. I was at a place in my life where I needed to help and be of help. I had personal reasons, too. I wanted to have an experience of monasticism in another context, away from the middle-class, bourgeois American standard of living and its culture, the affluence and the materialism, which Merton had criticized so pointedly. I thought it would be a wholesome thing to be able to work from the ground up and go back to the elemental things about struggle for existence and living in a foreign country and trying to start a new monastery.

This monastery I went to was just in its beginning phases. It had been in existence five years by then. That's Awhum in Anambra state, Nigeria. When I got there, of course, they were quite aware of Gethsemani. They had read Thomas Merton, and they saw him as a man of truth who would speak directly. I suppose part of it was his civil rights position which might have won their hearts. But what really won their hearts was that he spoke the truth and that he was talking about things of God and things of the spirit. They didn't find him hard to understand. He's an intellectual and many people find him hard to understand. For some reason these Nigerians who were not well educated (they only had six years of schooling) didn't seem to have that problem.

Kilcourse: Were they reading him in translation?

Quenon: They were reading him in English. It had been a British colony so in one degree or another they knew English. Merton was very interested, of course, in Third World countries and had done some writing with regard to cargo cults[2] in New Guinea. He wrote primarily to show what the impact of modern culture has on these primitive societies. I think that's still a neglected area of Merton's studies — how he perceived these archaic cultures (I wouldn't want to call them primitive, but they are ancient cultures). What effect are we having on them, and what they can give to us? Merton's *Ishi Means Man*,[3] for instance, is another essay about this topic.

2. Thomas Merton, 'Cargo Theology', in *idem, Love and Living* (New York: Farrar, Straus & Giroux, 1979), pp. 80-94.
3. Thomas Merton, *Ishi Means Man* (Greensboro, NC: Unicorn, 1976).

I think that monasticism is a universal phenomenon, and it can be new wherever it is. The real growth in the order now is in the Third World countries. Monasticism is not dying. It's actually growing, but growing in different parts of the world than we're familiar with: not Europe, not America, not Japan, not any of the affluent countries, but in Africa, in Southeast Asia and South America.

Kilcourse: Are they going to come and evangelize us?

Quenon: I hope they will. They are at a place in their cultural develop-ment where monasticism has a function of transition. These archaic cultures are very much community-oriented. People think and work together. They feel things together. Monasticism has a very strong com-munal character to it, and yet it's oriented not just to the life of the com-munity but to higher consciousness: prayer, meditation, and so forth. It has a very strong appeal to people in these Third World countries, who are still struggling for survival and still know how to bond together, to try to work together on things. It's not always easy to strive towards spiritual goals.

Kilcourse: We would be lucky if we could retrieve that in the West. We may do it through their example.

Quenon: I'm not sure what's going to happen in the West. I think there might be a return to a need for community. We've become disillusioned with mass culture. We're aware now that we need to break down into local communities, have more local responsibilities for things. It's very much a struggle to do that. Monasticism is a model of how that can be successfully done.

As we develop electronic media — the computer and so forth — you don't need to go to a mall to shop anymore. You can stay up in your mountain chalet, take care of business, shopping, and just about every-thing else. Why not have small communities living in these 'hollers', valleys, self-contained units, yet not really self-contained because they are connected through electronic media to everything else in the world? There can be a very strong local community of responsibility, of experi-ence of joy and celebration.

Kilcourse: You've just given us a new definition of a global village.

Quenon: The global village will look more fragmented, but at the same time there will be this kind of virtual web, which ties it all together. We

222 *The Merton Annual 15 (2002)*

have to respect the local communities, and that's where we're still lacking. Monasticism can be a model of that. Arnold Toynbee said that in the future society will be patterned after the example of monasteries. That still remains to be seen, but it's a nice aspiration, I think.

Kilcourse: Talking about the Third World and monasteries, one of the links that you can give to our readers is the person of Ernesto Cardenal, who came to Gethsemani while you also were a novice there and certainly had an influence on Merton. He was a conduit for some of his reading of the Latin American and Central American poets. What can you say about Cardenal as a person and his importance in Merton's life? I know that you've included some of Cardenal's work in the most recent collection, *Smaller than God.*[4]

Quenon: Yes, he was very gracious to let us use a poem, several poems from the *Trappist, Ky.*[5] collection which he had written at the monastery. Merton describes them like Chinese paintings or Zen calligraphies. They were short and allusive. Of course, Ernesto Cardenal was just Frater Lawrence to me. He was ornery, he was this middle-aged man who was short and walked with a long stride and had a big nose and couldn't speak English very well. We didn't think of him as anything special except that he was different. He used to tease the novices, particularly one or two who were most teaseable. He would set them up, and then they would get back at him.

His background history only came through gradually in the sense that Fr Louis would say something about a friend of Frater Lawrence's being tortured in Nicaragua. 'Pray for him'. They'd make him drink a lot of water, tied off his penis, and then beat his bladder. That sort of thing. When that was happening, I remember going out to the garden after Mass one day. Half a dozen novices were making their thanksgiving in silence, as we regularly did, and Frater Lawrence was sitting there on the bench. The whole garden just seemed to be filled with this agony. I noticed everybody else started leaving. I stayed there, not too far away, and had this sense of this pain just hanging in the air. I guess the pain was eventually getting to Lawrence because he had to leave. He also had an ulcer problem, a sign that maybe he wasn't really made for a life at Gethsemani, too much tension. I'm sure it was his concern about the situation in Nicaragua.

 4. *Smaller than God: Words of Spiritual Longing* (ed. Br Paul Quenon and John B. Lee; Windsor, ONT: Black Moss Press, 2001).
 5. Ernesto Cardenal, *Trappist, Ky.* (Bloomington, IN: Iron Bird, 2002).

© The Continuum Publishing Group Ltd 2002.

I did get a sense that Fr Louis very much respected him and admired him as a poet. I asked if there ever would be any classes on poetry, and he said, 'Well, if we're going to have any classes on poetry, it would be Frater Lawrence who ought to give it and I would attend it. I myself would like to hear a class he would give on poetry'.

Kilcourse: He also did some plaster art.

Quenon: Oh, yes, he was working on these concrete pourings. He would use sand and scoop out a figure in the sand and then pour concrete into it. That's how he did a couple of crosses, and he did some plaster castings, one of St Thérèse and one of Mary and one corpus for a wooden cross.

Kilcourse: Merton was quite fond, wasn't he, of the crucifix that Ernesto created?

Quenon: Yes, yes, he did a crucifix. He did a crucifix for each cell in the dormitory. That was a ceramic pouring, with a very thin, worm-like corpus on it.

Kilcourse: There's been considerable writing about Merton's poetry, but much of that so-called scholarly writing shies away from evaluating Merton's poetry. A lot of it examines sources or influences on Merton or maybe a textual criticism of the poem, but not an analysis of it as poetry. Would you venture to say something about the quality of Merton's poetry as poetry?

Quenon: You would expect somebody in a monastery would be writing a very spare kind of poetry, haiku things, and expressing simplicity and poverty and clarity and the minimalist kind of form that you would associate with monastic culture. But Merton was just the opposite. He had a rather prolix poetic style, almost leaning toward the congested, a plenitude of imagery, and ways of using words which would be surprising. His vocabulary sometimes would send you to the dictionary. You don't know quite where 'this word' came from. I suppose that too is part of the conditioning of a monastery. When you're living in a very simplified environment then you compensate by having a florid interior life. Your imagination makes up for what's lacking exteriorly.

Maybe Merton's poetry is not evaluated because it eludes evaluation, it's not the kind of poetry that you can go 'ooh!' and 'ahh!' over. On the other hand you have to respect it because it's beyond you. At least, that's

my feeling, it was always somewhat beyond me. Here's something I can't take as trite or too facile. It can be difficult at times. To be difficult is not necessarily to be a good poet. Sometimes that's as much of a fault as an asset. He did get into simpler style in his middle period, that is, in the late 1950s and early 1960s.

Kilcourse: It becomes really obvious in *Emblems of a Season of Fury*.[6] The poetry is lean. It's even angular.

Quenon: And that part I find most accessible. People like his early poetry the best, but I don't think it's necessarily the best poetry. It's too predictable, in a sense. For that time it wasn't predictable, it probably sounded very fresh. His later poetry again moves into a different mode.

Kilcourse: Are you talking about *Cables*[7] and *The Geography of Lograire*?[8]

Quenon: Yes, *Cables* and *The Geography of Lograire*.

Kilcourse: How do you see those two ambitious poems? Certainly *Lograire* is the most ambitious he ever attempted.

Quenon: Yes, they are ambitious and they are experimental as they are exploring new frontiers, reflecting new influences. He didn't feel constrained by being a representative of the monastic world, and he could cut loose and follow his instincts.

Kilcourse: They are perhaps yet to really be evaluated.

Quenon: I think that could very well be true.

Kilcourse: You notice Jay Laughlin said that he thought that 50 years after Merton's death he might be remembered more for *The Geography of Lograire* than other things that he had written.
Quenon: Or maybe forgotten. It's hard to say at this point. People tend to remember the earlier poetry. Even sophisticated people who can understand things. I'm not sure later things will be remembered. The obscure 'prophetic' poetry of William Blake is largely unknown, but his simpler 'Songs of Innocence' and 'Songs of Experience' are remembered.

6. Thomas Merton, *Emblems of a Season of Fury* (New York: New Directions, 196).
7. Thomas Merton, *Cables to the Ace: Or, Familiar Liturgies of Misunderstanding* (New York: New Directions, 1969).
8. Thomas Merton, *The Geography of Lograire* (New York: New Directions, 1966).

Kilcourse: Do you see Merton's enduring influence on the traditions of monastic life as it's lived at the Abbey of Gethsemani?

Quenon: I think Merton certainly remains a presence in the monastery in ways that are more vast and profound than the new generations are aware of; things they take for granted now are really things for which he had to break the ground. He didn't leave his name labeled on these things. They're there, but people who have lived through that history know that his signature is hidden down in there somewhere.

Kilcourse: Give an example.

Quenon: For instance, the appreciation of contemplation in the monastic life. Earlier on, contemplation was not necessarily the center of focus. As a matter of fact, it was not at all the center of focus in the early phase at the Abbey of Gethsemani. Penance, keeping the rule, attending church, and singing the Psalms was the focus. Meditation was doing your devotions, reading a devotional book of meditation and then saying a prayer. Merton put everything on a deeper level and insisted that the goal of the monastic life is something beyond the observances. That then became the real focus for the renovation of the constitutions in the 1960s, 1970s and 1980s. I would say that's been one of Merton's chief influences.

In other ways, he now has less influence. The eremetical life is no longer an enthusiasm among monks, even the younger monks. There's not this dream to go out and live in a hermitage someday. There are fewer hermits now, at least in this country. That has crested. That's subsiding. There's more talk about community life now and avoiding individualism. Merton criticized the monastery as being too much like a corporation and a well-oiled factory, where everything's humming well. We're still pretty much into that mode. Work is very important for us. Having the system working well. That is all right if it is done with the right intentions—to free us to live the contemplative life. Merton has helped us to clarify our intentions. There's where Merton has been a plus. On the other hand, I think, there is an awful lot of focus on keeping the system running, and Merton was somewhat diffident about such things. He would just as well let them fall into shambles. Of course we can't let that happen.

Kilcourse: So he would have an anti-poem about the cell-phone at the monastery, right?

Quenon: Oh, absolutely. And about the computer. He wrote this essay about 'The Angel and the Machine',[9] which was prophetic in showing what kind of mentality people who live with computers get into, and how it has taken the place of the angel in people's minds.

Kilcourse: The late 1960s were a remarkable time of transition in Catholicism, liturgy, ecumenism. Did any of this seem to affect the monastery in Merton's time in a way that engaged him?

Quenon: I think the liturgical renewal was already fermenting at Gethsemani before Vatican II. We had this serious interest in doing Gregorian chant. We were making recordings back in the 1950s, and there were whisperings, backroom talk, about doing liturgies in English someday. That was taken for granted, it would happen eventually. Some people wouldn't talk about it, but other people were talking about it. Fr Louis himself liked the Latin liturgy, and he retained Latin as his chosen language when he went up to the hermitage and would say the Divine Office in Latin. But he respected what we were doing. He saw it as what the younger generation wanted and what they ought to get.

Kilcourse: How did Merton react to the transitional period of liturgical change at the Abbey?

Quenon: He had a kind of no-nonsense attitude about liturgy and would express himself overtly in one way or another. I remember the Paschal fire-rite in 1968. The location of the fire was behind the church, and the procession was around the cemetery to the west. The procession was halted at the door because some lights inside were left on, and the liturgists wanted a perfectly dark church to enter with our candles.

 I was in line beside Fr Louis. As the delay was prolonged he began losing patience. He began getting restless, turned, put his elbows up on the cemetery wall and looked off into the distance to the hills, disconnecting conspicuously from the slagging liturgy.

 Again, the first year we used English for the Good Friday Passion, the long narration was not sung as it always had been. The only authorized translation was the New American, and it was flat and prosaic. As the three readers droned on Fr Louis grew more and more discontented. He shook his head, made a bow, turned and walked out of the church.

 9. Thomas Merton, 'The Angel and the Machine', *The Merton Seasonal* 22.1 (Spring 1997), pp. 3-6.

These things were the converse side of his strong love of the liturgy, a liturgy that is well done. Well done, without becoming a performance. He prayed sometimes with uplifted spirits, most of the time with spirit collected and his feet on the ground. Such it seemed to me from brief passing glances. When things went wrong, however, he would flip over and become the liturgical bad boy.

The choir was lit by fluorescent lights – effective but not too attractive. The bulb was a yellow tint, which made it easy on the eyes. Someone complained it was too hard to read, so the bulbs were changed to white. The glare that resulted was, I thought, insupportable when they were first installed. Fr Louis arrived at Vigils, and after a psalm or two left church and returned wearing a pair of sunglasses. He continued using them unless there was daylight. A couple of days later a compromise was found. Every other light was white and every other yellow. So did it thereafter remain.

There was another incident. In the Novitiate chapel, the 'sacristy' consisted in a dresser at the rear. I was waiting there as server when he arrived for morning Mass. There was a new vestment set out for him, with an image of a burning candle. He took one look, gruffly looked at the burning candles on the altar, and made some vague gesture of discontent. Later he was to write about this as the redundancy of symbols in the liturgy.[10] Why have an image of a candle on a vestment when there are already real candles on the altar?

Such questions never occurred to us who thought any pleasing image would do.

Kilcourse: What's your favorite work of Merton's?

Quenon: My favorite work of Merton's is *Raids on the Unspeakable*.[11] I think those are really imaginative essays. He's not promoting any particular monastic agenda – he doesn't do that in anything except as he has

10. Thomas Merton, 'Absurdity in Sacred Decoration', in *idem, Disputed Questions* (New York: Farrar, Straus & Cudaky, 1960), pp. 264-73. See especially pp. 271-72: 'A vestment fulfills its function by being a garment. It does not have to become, at the same time, a holy picture, before it can be regarded as spiritual. Its shape, its texture, its color, all contribute far more to its 'spiritual quality' than any adventitious pictorial accretions our fancy may see fit to tack on to it. What is the source of this obsession with 'illustration' and mere pictorial decoration in sacred art? I think in part it comes from an unconscious assimilation of the commercial mentality. It comes from the fact that our minds have been corrupted by the spirit of advertising. We think in terms of trade-marks, not of symbols'. – *Editor.*
11. Thomas Merton, *Raids on the Unspeakable* (New York: New Directions, 1966).

filtered it through his own perception of things. Especially in *Raids on the Unspeakable* he's exploring new frontiers. I guess next to that would be *Conjectures of a Guilty Bystander,*[12] especially the section on the dawn and the third part, where he talks…

Kilcourse: 'Dawn and the Night Spirit?'

Quenon: 'Dawn and the Night Spirit', where he gets into *pointe vierge.* There's a kind of a breadth and diversity, an ecumenism to that book, which is refreshing.

Kilcourse: I too have told people that if there's a fire, I'm going to grab *Raids* first. Small as it is, it's so wonderfully exploratory. I think that's what you're talking about, too. It is broadening.

In his Bangkok address on the day of his death, Merton spoke on the kind of ferment of monastic life that since then has led to a diminishing number of monks. But he almost spoke optimistically, saying monasticism is an instinct of the human heart, it is imperishable. Do you discern signs of this ferment or any tell-tale signs of future Cistercian monastic life?

Quenon: I see a ferment going on in the Third World. In the First World, the more advanced cultures, there is a ferment going on, but it's of a different nature. I think today's challenge is working out what it is to be a monastery in a modern world, what it is to be in a symbiotic relationship with contemporary culture, economically and culturally, and yet retain monastic values, the monastic tradition and live it from day to day. That's really a challenge, and that's something we're working at very hard.

The Tibetan Buddhists are looking toward us to give them some sort of clue on how to do that because they are beginning to face it themselves, having been evicted from Tibet and living in India. There the young generation is going off to other things besides joining monasteries. So they come to Gethsemani, for instance, wanting to know about our industry. The Dalai Lama wanted to tour all our different departments—the fudge, the cheese, the fruitcake, the bakery—because they realize they're going to have to learn how to make their own living. And we've already established that. Merton was pretty sarcastic about our industries, but that's just the thing now that's a value to other traditions.

12. Thomas Merton, *Conjectures of a Guilty Bystander* (Garden City, NY: Doubleday, 1966).

It's some groundwork that we have done. All the monasteries in the United States and to a great extent in Europe have become independent and yet live monastic life with its liturgy, quiet and reading and meditation.

Kilcourse: So, this may ironically be the future for the autonomy of monks East and West, having their own industry, which would have been a surprise 40 years ago?

Quenon: And our autonomy is the thing that should assure our integrity because in past ages, as long as we were dependent on the nobles and the kings, we were compromised. They wanted to have their finger in how the monastery was run. And they would put their own sons in the Abbot's chair. That was the corrupt system of abbots '*in commendam*'.

Another example: when we were dependent upon the goodwill donations of the faithful there was too much of an emphasis on saying Masses, getting stipends, being super-liturgical. That created something of an imbalance in the monastic triangle of work, reading and prayer. The liturgical prayer assumed too much importance. When you're independent then you're able to get a better balance. But then the balance swings over to work. I think that's the struggle we're having now. Reading seems to be very much at risk. Although we have bigger libraries and more to read, there's less time to read.

Kilcourse: And without leisure there is no culture.

Quenon: Yes, quite so. Then we have the question what to do with computers and e-mail and Internet. Is it going to be a new form of *lectio divina*, of reading, or is it eating into it, and diluting it? So, all these things are the present ferment, and it's a very important ferment, but it's very much a test-tube process. It's not taking place on a vast scale. It's taking place in small communities. All the communities are relatively small compared to the past. And, I think, once that all gets worked out we'll be in a secure, solid position to draw in a lot of people who are looking for a balanced life and will come to us for it.

Kilcourse: Do you detect some neglected areas in Merton's studies?

Quenon: There's been so much writing on Merton. Let's start with the question, Is there a Merton cult? I think a Merton cult comes from people who don't read Merton. They just hear about him and don't really know what he stands for. He's just a figure, and a cult figure is somebody by

whom you identify yourself, rather than somebody who helps you move into your own deeper perception of things. Merton is really a gate-keeper. He should be there to move you into vaster spaces of spirit and of tradition and of other cultures of spirituality. But if you're not using him that way then he becomes a cult figure, an end in himself.

Being a cult figure is inevitable, I think, if somebody's written that much. He's like Walt Whitman. Whitman stands for a certain kind of American spirit, and people may have read very little of him, or may have read a little bit about him. Still he's kind of a touchstone, a refer-ence point. Merton is becoming a reference point, and that's inevitable. Hopefully people will go beyond that. But it's like Dorothy Day, too, she's becoming a reference point.

Kilcourse: She's even being spoken of as a candidate for becoming a saint.

Quenon: Well, she said that would be…what's her statement? She said, 'Don't diminish me that way'.

Kilcourse: Which is the perfect comeback.

Quenon: We can diminish Merton in the same way, but I don't think he'll be canonized. There's no movement afoot to do that. He's been Merton, and simply that in itself is enough.

Kilcourse: Neglected areas in Merton's studies?

Quenon: I'm not sure there are any. All this mass of secondary literature is a result of people who read Merton and really are inspired to write. Just going to his hermitage provokes writing. People go in there and all of a sudden it starts flowing. Merton writes in such a way that things start flowing in your own mind, so we've got this great flood of secon-dary literature. Almost everything's been covered. What is there left to do? And yet people keep doing it in new ways. Now the challenge is to find little pockets of things that haven't been done. Maybe, as I said, what was his take on Third World cultures, the primitive cultures? That still has to be explored a bit, I think.

Kilcourse: I have a final question, Paul. As one who has learned under Merton and has lived with him, how do you think Merton should best be remembered?

Quenon: I think Merton should be remembered as a joyful person and somebody who was very much aware and awake and alive to other people's concerns. He was that way because he was so immersed in God. He realized you cannot really be immersed in God without also at the same time being self-giving towards other people. He could be very self-protective, but he was self-protective precisely in order not to trivialize his relationship with other people or let that relationship be reduced to just chatting, useless exchanges of conversations.

Fr Louis had a place in the library Grand Parlor where we hung our work clothes and boots. His name was on a block, like everyone else's in Latin: *Ludovicus.* Above that someone placed a painting after he left on the Asian trip. It was a sign in blotchy pink with the words *Deo Gratias.* It had a look of young hippy art about it, even though it was in Latin. Maybe someone meant it to be a greeting for when he returned. They are the two last words at the ending of the sacrifice of the Mass. So it remained on the wall after he died, a celebration of the Mass now ended of a priest for our time. No one removed it, or the name block, or the clothes, for a long, long time. I think a good expression of how Merton should be remembered is *Deo Gratias.*

[TMA 15 (2002) 232-262]
ISSN 0894 4857

Bibliographic Survey
'Contemplation's Shadow and Merton's Act: Becoming a Saint Through Words'

Victor A. Kramer

I. Primary Work

Thomas Merton's journals, as we suspected, are now generating many new projects by other people. His influence continues out into widening circles. Through his journals which he revised for publication and the others which he knew full well would be posthumously published, through his correspondence (because he was keeping carbons at the request of Bellarmine College from 1963 on), as well as through drawings and his tape-recorded words which are becoming available, Merton continues to influence large groups of people. Much of what draws so many to the work of Thomas Merton is his ability to communicate the mystery of the nearness of God and his own journey toward holiness. His life's work, we now begin to see, was to draw others nearer to his insights about God's presence. Slowly, it is becoming clearer that all the voluminous writing (and lecturing, photography and drawing) is reaching a significant and growing audience. The shadow of earlier contemplative traditions absorbed by him, just as Ralph Ellison in *Shadow and Act* argues about the crucial interaction of Black and White cultures in America, draws others into the seeking of God. Merton did take Bob Lax's advice to become a saint and that then affects many other seekers.

Some of Merton's prayers and drawings have been skillfully compiled in the new *Dialogues with Silence: Prayers and Drawings*,[1] edited by Jonathan Montaldo. Beautifully printed, this selection of texts and art work

1. Jonathan Montaldo (ed.), *Dialogues with Silence: Prayers and Drawings* (San Francisco: HarperSanFrancisco, 2001), pp. 189. ISBN 0-06-065602-6.

will serve useful functions by making readers more aware of Merton's continuing prayerful and meditative stance throughout his sustained contemplative career. Derived from prose, poetry, journals and letters, the prayers—sometimes composed as formal works and sometimes 'found' within a much longer passage, such as a journal entry—work well in this new context along with the drawings.

This book provides full-page reproductions of selected drawings by Merton paired with appropriate prayers. The cumulative effect of being able to absorb approximately 100 drawings in this fresh context is stimulating, informative and, finally, potentially, contemplative. That familiar 'My Lord God, I have no idea where I am going...' is paired with an India ink drawing of a monk (is this a self-portrait?). Other drawings of monks set the tone of longing in the volume already in the opening pages.[2] Many wonderful, clear line drawings of women fill the book with mystery.[3] Still other sketches suggest tribute to St John of the Cross, saints, Mary, Christ, the Gethsemani landscape and simple images of nature. Some are the abstract work done toward the end of Merton's life. Together, all these drawings suggest Merton's movement toward simplicity.

Montaldo's editorial decisions are to be commended. Some critics will, of course, object to some of the selections of prose and poetry and this arbitrary arrangement. That is inevitable. Many other selections could have been made and we would then have had a totally different book. Some readers may object to the occasional editing which had to be done, but it was necessary. Sometimes, when the original source is consulted, it is quite clear that a much larger excerpt could well have been provided. Montaldo has also regularized syntax, omitted verbosity and sometimes added words (e.g., after 'brothers' he inserts 'and sisters') to make the prayers effective for a contemporary audience. On the whole, Montaldo's choices are successful on many levels, autobiographically and as formal work. Clearly as a meditative book, this works well. It is demonstrative of the fact that Merton's voluminous work can resonate with, and for, a wide audience. It is often as if he is saying 'I'm trying to catch in words the shadow, the reflection, of what I've sometimes felt'.

We should be thankful that *Dialogues with Silence* exists. One can imagine other similar books which could anthologize Merton (on social issues, on writers, on the liturgy; etc.). There will eventually be a companion book, I am sure, which will use the photography in a similar manner to make us ponder about the beauty of the natural and commonplace

2. Montaldo (ed.), *Dialogues with Silence*, pp. 2, 5, 8, 13.
3. Montaldo (ed.), *Dialogues with Silence*, pp. 10, 23, 26.

world—which Merton observed with care and precision through both word and photography, a world never fully explained.

Another example of Merton's definite entrance into the mainstream is his inclusion in a newly edited anthology called *Straight from the Heart*.[4] This proof of Merton's words resonating for a wide audience is seen within the context of a collection subtitled, 'Reflections from Twentieth-Century Mystics'. Here Merton appears in the company of Henri Nouwen, T.S. Eliot, Joyce Rupp, W.B. Yeats and Anselm Gruen (who all make the dustjacket) along with numerous other 'mystics' (Charles M. Shelton from *Achieving Moral Health*, C.S. Lewis, *The Joyful Christian*, etc.). Ryan's contents are arranged with quotations which go from 'charity' and 'commitment' to 'suffering' and 'vocation'. Merton appears 14 different times.

Such use of Merton (along with other 'mystics' who themselves may be surprised to be in such company—including Mitch Finley and Basil Pennington, for example) is probably inevitable, but a bit disappointing. One almost wishes that The Merton Legacy Trust has been able to say, 'Let's not collect the permission fees for this type of book'. William Shannon, Richard Rohr, Elizabeth Johnson—they are all here! Andrew Greeley also makes the grade. My count determined that Henri Nouwen is the leader and quoted 16 times beating out Merton who only appears 14 times. When one stops counting and making jokes about who is quoted frequently, however, it is clear that Merton's voluminous pondering about the spiritual life has produced much of great significance to, and for, today's reader.

In Ryan's opening 'chapter' about 'charity', a Merton sentence from *Life and Holiness*[5] is chosen: 'Charity is impossible without an interior poverty of spirit which identifies us with the unfortunate, the underprivileged, the dispossessed' (p. 6).[6] Merton's entire trajectory of striving to develop his 'interior poverty' has significance for anyone struggling to make sense of the isolation, separation and consequent loneliness which is so much a part of our contemporary culture and its need for charity. Merton's words do have an influence on the mainstream. His contemplative writing can lead others, therefore, to the possibility of mystical insight. This, then, brings to mind Merton's influence on so many persons both within his own monastery and now beyond. More of this 'shadow and act', the reflection of Merton's striving, will be discussed in successive sections of this essay.

4. Dick Ryan (ed.), *Straight from the Heart: Reflections from Twentieth-Century Mystics* (New York: Crossroad, 2001), pp. 189. ISBN 0-8245-1923-1.
5. Thomas Merton, *Life and Holiness* (New York: Herder & Herder, 19630).
6. Ryan (ed.), *Straight from the Heart*, p. 6.

In this regard it is interesting that in *The Best Spiritual Writing of 2001* the editor, Philip Zaleski, structures his opening 'Preface' around Merton's 1968 insights at Polonnaruwa. In Zaleski's view, Merton's record at that moment stands for a way of life which 'needs nothing'.[7] He then comments at length about Merton's frequent insights concerning the need to speak about what has been learned through silence or contemplation. He suggests that such need:

> explains not only Thomas Merton's vocation but also that all of who shoulder the great task of spiritual writing… The spiritual writer emerges from the silent world, the eternal spaces; for a while she plunges, pen in hand, into the noise and stench, heat and pain of creativity; and then she returns to silence. [8]

Such a need to go back into silence is increasingly clear through the insights gleaned from *Dialogues with Silence* and from this 'Preface' where Zaleski argues that all the best writers about spirituality have to be completely at home both in words and in the silence which generates words. The task which Merton has apparently taught to so many is passed on to other souls because of the momentary light he possessed. The 'writer-at-work and a saint-in-the-making…point beyond writing to the spirit'. [9] Such is Merton, the saint-in-the-making, able to direct others.

Wendell Berry, who knew Merton may (we suspect) have learned to some degree how to focus on particular contemplative moments by absorbing Merton's focus. In *The Best Spiritual Writings of 2001*, 'Sabbaths, 1999' are reprinted from *The Hudson Review*, all (12) poems of which show the need for careful observation of mystery. This too is Merton's dream; Berry writes:

> I dream of a quiet man
> who explains nothing and defends
> nothing, but only knows
> where the rarest wildflowers
> are blooming, and who goes
> where they are and stands still
> and finds that he is smiling
> and not by his own will.[10]

Merton's lectures to novices at Gethsemani (and to anyone else who cared to listen) are also having a widening influence because they reflect

7. Philip Zaleski (ed.), *The Best Spiritual Writing of 2001* (San Francisco: Harper-Collins, 2001), p. x. ISBN 0-06-251772-4.
8. Zaleski (ed.), *The Best*, pp. x-xi.
9. Zaleski (ed.), *The Best*, p. xiii.
10. Wendell Berry, 'Sabbaths 1999', in Zaleski, p. 16.

his own journey. These talks were carefully prepared and Merton's gifts as a natural teacher are in evidence whenever one listens to these released recordings. In previous reviews and review-essays, Dewey Kramer, David King, Steven Baumann, myself and Thomas Collins have surveyed Merton's vocal performances. [11] Now that approximately 100 hours of a large archive (500 hours?) have been released and analyzed we can now make a few generalizations and suggest still another project might be begun.

Scholars would profit from a project to transcribe all of the recorded talks given by Merton, and especially those which have been released for commercial consumption because there are many insights hidden there just as in the complete journals. Merton loves to teach and make connections between and among his historical and theological subjects which cover the board from particular historical and theological texts to modern poetry in relation to the contemplative aspects of life and modern events.

Several new releases of Merton's lectures have been issued by Credence Communications, Inc., including 'The Church Fathers' (AA3397) which discusses Tertullian and Cassian. Tertullian, Merton notes, 'is a great writer', in fact the greatest literary writer of his age. And because he so questions his culture, he is, therefore, very much like Nietzsche or Calvin, a great thinker (even though frequently quite wrong).

In Tertullian, because of his repulsion to Roman customs and paganism, his frequent answer was extreme, for example, in his defense of natural monotheism. Merton's comments successfully link Tertullian's culture and Christian persecution in with parallels to our own culture concerning abortion arguments: thus legalities in law allow perversions to be learned.

Tertullian's tract on 'Prayer' provides valuable materials about early Christian customs and the value of prayer today argues Merton, but he notes some odd ideas as well, where one logical thing can lead to another, as is the case with another tract by Tertullian about the absurdity of wearing of a laurel crown (and its complete unnaturalness).

11. Robert E. Daggy, Patrick Hart, OCSO, Dewey Weiss Kramer and Victor A. Kramer (eds.), Review by Victor A. Kramer in *The Merton Annual* 2 (1989) pp. 314-19; Review by Dewey Weiss Kramer in *The Merton Annual* 3 (1990) pp. 311-20; Review by Victor A. Kramer in *The Merton Annual* 5 (1992) pp. 362-67. Michael Downey, George A. Kilcourse and Victor A. Kramer (eds.), Review by Dewey Weiss Kramer in *The Merton Annual* 6 (1993), pp. 235-36; Review by Steven Baumann in *The Merton Annual* 7 (1994) pp. 176-78; Review by Thomas Collins in *The Merton Annual* 9 (1996), pp. 264-66. Kilcourse and Kramer, (eds.), Review by David Kim in *The Merton Annual* 12 (1999), pp. 236-39.

This lecture — witty, entertaining and valuable — is an excellent example of Merton's enjoyment of teaching and making cultural connections. He clearly relishes examining 'the extreme mind' of Tertullian whose book on 'Patience' is, Merton laughs, a wonderful example of Tertullian's getting quite carried away: all sins are rooted in lack of patience! Merton stresses that reading Tertullian provides many excellent examples of tight thinking (even though he's 'often off the beam'), and totally illogical in aspects of the development of his arguments.

Side 2 of this cassette begins with an analysis of 'The Lord's Prayer' in relation to Cassian and Tertullian with particular attention to the phrase 'Thy will be done'. Merton argues this reveals a whole concept which we have mostly lost today: love is the mover of all things, yet the will of God is love which includes our cooperation in the Divine plan. Comments about the Tower of Babel follow as an archetypal symbol of collective pride. The next phrase 'Give us...' is for Cassian logical and simple while for Tertullian there is an interpretation which leaps forward to make the immediate equation of 'bread' with 'eternal life'. Eucharistic communion as spiritual hunger satisfied is exceedingly important, argues Merton, and the beauty of reading Cassian and/or Tertullian is that they assist us to read closely and to understand that any text has enormous implications: we should hunger for spiritual truth, not just hunger for only material nourishment. Merton ties all this in with the fact that in a monastery (where we cultivate a longing for spiritual nourishment) monks should all remain 'famished'. He carefully draws his students into the idea that humankind seeks nourishment on different levels. By working carefully with just a few phrases, in fact what he is doing is showing his students how to read.

In still another lecture Merton outlines the myth of the holy grail, the Fisher King, and its relationship to the monastic life today. This tape is entitled 'The Quest: The Quest for the Grail and Conversion of Manners' (AA3403). The monastic community can be like the Fisher King. 'The community can be in a state of nothingness...as long as people are not answering the right questions: where is the Holy Grail?' The successful monastic life is built around questions; not only do we ask questions; the monastic life asks questions of us, 'What are you here for?' The spiritual life of the monastery has to be taken with great seriousness: especially in a 'tragic' time when the most important forgotten question is 'How should I be saved?' The monastic way of life is our way of salvation. (This particular lecture is brief.)

The second side begins with jokes, announcements, and so on. Then Merton comments about the conversion of manners by way of commentary about the Rule of St Benedict. He stresses that to be a monk is not to

assume that man is bad (Stalinism makes this assumption and thus produces conduct against the will of humankind). Such is a perverted notion! On the contrary, the monastic life is to be looked at in a different way: the real idea is that underlying such a daily life (with all its imperfections) is a good which can be brought out when we remove the obstacles. A conversion of external manners only is no conversion.

Merton's being attuned to his inmost self and willing to share insights, sometimes in a fragmented way as he speaks, serves as a kind of model for others who are tuned into a prayerful criticism of a culture often little concerned with listening. We recall that Merton's great friend and best influence is Bob Lax—and the prolific focused writing which flowed from Lax after he had voiced his own Mertonian awareness is examined in the next section of this review-essay as the fruit of someone who listened, removed obstacles from his own observations and art, and surely was as well a great source of encouragement to Merton who sometimes was a reflection of Lax. Similarly, Dan Berrigan, Thich Nhat Hanh, and John Dear listened to Merton and now speak in tones learned from him.

II. Lax's Relationship

Merton's life of energetic continuing conversion has, clearly, affected great numbers of people, including many of his closest friends (Bob Lax, Ed Rice, Robert Giroux) already when they were still undergraduates, and for decades following. Others, maybe when they met him only once, or had only minimal actual contact were nevertheless greatly influenced: Daniel Berrigan, Thich Nhat Hanh and John Dear are examples of writers who have been definitely changed by Merton's presence and in whose work the shadow of that presence is reflected. Merton has inspired us to 'be attentive' and to spend our lives reporting what is observed as praise: Lax, Berrigan, Thich Nhat Hanh and John Dear all have been shaped by Merton.

Merton's best work always seemed to be grounded in what he observes or sees made through art (his or that of others) which then points to what is beyond. Thus, words lead readers back to silence, to more acute observation, and to compassion with, and for, others. This is what Bob Lax learned best. Lax's whole career was one of celebration, observing the beauty of particular moments seen, caught, made as these suggest a particular point beyond seeing.

In the wonderful friendship of Merton with Bob Lax, and in their reciprocal relationship which they had as soulmates, writers, poets, artists and as commentators about the non-contemplative culture of the present we

observe how they learned from each other. We also receive constant hints of how we might learn from such love, discipline, humor, hope and care. Last year's edition of the correspondence of Merton and Robert Lax, lovingly and expertly edited by Arthur W. Biddle, was warmly received.[12] Carefully reviewed by Patrick O'Connell in *The Merton Annual* 14, that collection is a chronicle of these two lives expressed in the word as well as through limited and controlled images.[13] Much remains to be mined from those dense letters now carefully edited. They are the record of two friends sharing what they have slowly learned about looking, loving and especially being.

This volume of letters has stimulated me to review my own knowledge of Bob Lax's large body of writing. He often has given the impression that he has little to say in relation to his friend, Merton. That is in fact never the case. I myself first met Lax at a meeting of The Jacques Maritain Association in Louisville in 1980 (and asked Lax for an interview for the Thomas Merton Oral History which was minimally successful). Now with the two sides of their extended correspondence in print we are clearer about how these two writer/artist/soulmates had a continuing effect upon each other. I do not intend to theorize about the relationship, but of course my implication is that Merton learned from Lax, as did Lax learn from Merton, and ultimately these two careers will have to be studied together, like Pound and Eliot, or Hawthorne and Melville.

I have read 19 books by Lax in preparation for these brief comments.[14] All of his books are gems. All reflect his contemplative life, even more so his individually printed pamphlets — some would call them chap books — often with his own illustrations, which provide occasions for celebration,

12. Arthur W. Biddle (ed.), *When Prophecy Still Had a Voice: The Letters of Thomas Merton and Robert Lax* (Lexington: University of Kentucky Press, 2001).

13. Patrick O'Connell, *The Merton Annual* 14 (2001) pp. 244-51.

14. Robert Lax, *The Circus of the Sun* (New York: Journeyman Books, 1959); Thomas Kellein (ed.), *33 Poems* (New York: New Directions, 1942); Paul J. Spaeth (ed.), *Mogador's Book* (Zurich: Pendo, 1992); *Journal A* (Zurich: Pendo, 1986). The 14 subsequent books listed are also Pendo publications; *Journal B* (1988) [9-28-77 — 11-77][Spain]; *Journal C* (1990) [3-20-64 — 2-26-70][Kalymos]; *Journal D* (1993) [10-13-72 — 10-24-73][Kalymos]; *Journal E* (1996)[Hollywood Journal] Paul Spaeth (ed.), [6-18-41 (North Carolina, New York 4-18-45; 7-13-47 (Hollywood) 10-30-47; Virgin Islands 1-28-49 — 6-13-49)]; *Journal F* (1997)[Kalymos Journal] John Beer (ed.), [10-31-76 — 11-27-76]; Robert Butmann (ed.), *Episodes*(1983); *21 Pages* (1984); *The Light: The Shade* (1989); *Notes*(1995); *Dialogues*(1994); John Beer (ed.), *Moments* (2000); *Fables*(1983); *Psalm and Homage to Wittgenstein* (1991); Paul Spaeth (ed.), *Circus Days and Nights*, (New York: The Overlook Press, 2000); Paul Spaeth (ed.), *Robert Lax* (St Bonaventure University).

praise, enjoyment of the moment.[15] Lax is fascinated with the particulars of each sacred moment and with the responsibility of the artist/observer to catch (as best he can) some of that particularity. He made his job as artist to look continually at the events which immediately surrounded him and which were to be observed as mystery, but mystery which, of course, was never to be put fully into words. Lax indicates that with each observation of the 'source of each person's life'[16] he seemed to sense that the real source was in the union of the single moments with the entire universe.

His decades of writing, then, became an elaborate record of the good to be beheld in the rather ordinary and surprising events of his daily life. The 1995 book, *Notes*, on the surface appears to be a strange assembly of notes from a trip to Lucerne in 1981; poems; notes about observations at Patmos (1994); and three pages which date from February 1995, also written at Patmos. As artist-observer-mystic, what Lax demonstrates in this collection is the mystery of *both* observing and trying to get these observations into words which catch their essence and mystery. This, too, was Merton's continuing chore. There is no way to do a contemplative study about these two artists here, but I can draw out some of the evidence so that others might follow with a determined investigation.

One should also be aware that Lax's six volumes of *Journal* provide an overview of his life and observations from 1941 to the mid-1980s. Separate books cover spans of years, or in some cases just a few weeks. One should begin with *Journal E* (1996) 'Hollywood Journal' to trace Lax's first eight years (1941–49) (this is the fifth book published in the series).[17] A careful study of Lax's published journals as prayer or manuals of observation would yield valuable insights. In the books of poetry it is sometimes as if Lax imagines a challenge with himself, or with silence.

The book *Dialogues* (1994) is classic Lax, with Section 1 including five brief exchanges about the self. Here is wisdom which parallels Merton's *New Seeds of Contemplation*, yet distilled to the absolute minimum:

15. Robert Lax, *Above the Rock* (Vermont: Furthermore Press, 1985). All subsequent books in this note are from the same publisher. *ARC* (1984); *As Long As*; *Astrophysical Masterpieces*; *At the Top of the Night* (1983); *Cloud over Hill* (1984); *Dark Earth: Bright Sky* (1985); *Fat Ladies* (1984); *From the Top of the Ferris Wheel*; *Ghost* (1985); *I Can't See You*; *In and Out of Purdah* (1983); *In his Dreams* (1984); *Just Midnight*; *Said's* (1983); *Snow Flake* (1984); *Some Short Notes of Robert Lax* (1985); *The Love that Comes* (1984); *The Nights: The Days* (1985); *Other Notes*; *Water Sun Light Writes* (1984).

16. Robert Lax, *Notes*, p. 8.

17. See preceding footnote 14 for more specifics about how the journal episodes unfold.

A The
 way

 to
 be

 your
 self

 is
 to

 for
 get

 your
 self

B oh[18]

These groups of five interchanges ponder the mystery of being, doing, wishing — the simplest of our needs and desires. Lax pulls us into the need for simplicity through his own verbal simplicity. In these inter-related groups of stark poems the subjects of love, work, action, focusing on the moment, focusing on a particular moment, prayer, living well, compassion, health, the unity of all beings, are each pondered. Often in the form of aphorisms, these dialogues allow just the right combination of mystery and insight to suggest that if we keep asking the right questions we may move toward a kind of mysticism.

Fables (1983) presents us with more moments of insight about simplicity. Throughout Lax reminds his readers of the constant need to live in the moment — not to try to be like his 'man with the big general notions'.[19] Lax's *Fables* remind us that we must learn to do things because we enjoy doing them, and most of all he reminds us not to think about ourselves too much. Then goodness and wholeness presents itself.

Lax shows us over and over that simplicity (in intent, in action) will give us all we need, yet his fables often suggest we think ourselves out of simplicity and into much trouble. These fables are meditations while they also function as prayers. Lax in *Fables* reminds us that we should avoid too much thinking ('the man with his general notions') and concentrate on the particular. It is not surprising that Bob Lax's wonderful little book *Moments* (in German, the title is better: Hohe Punkte) exemplifies this distilled method. Most of these poems/notes/journal entries are only a few lines long and sometimes a particular item will be only two

18. Robert Lax, *Fables*, pp. 9, 19.
19. Lax, *Fables*, pp. 9-17.

lines. Yet in those few words, we often see Lax catching the essence of a moment observed by someone who has spent his lifetime observing.

In another book *21 Pages* (1984) Lax provides materials which must be autobiographical, but again cut to the minimum. The book deals with waiting, watching, darkness and readiness. Here we have narrative, prayer, meditation, glimpses of insight—a kind of journal which is foremost a record of waiting.

We move from waiting to watching, then to darkness and to readiness. Lax's point is that his narrator does not give up:

> Like a prisoner, waiting for a reprieve, counting the days, not counting not knowing what to count or why to count it, waiting for one thing, one moment, one event. I didn't feel like a prisoner, but I was waiting like one; doing nothing else but waiting.[20]

Episodes (1983) is, again, a collection of key insights—observed or enacted; something seen clearly 'pure & shining' (p. 1); life-defining (p. 2); obsessional (p. 3); desperate (p. 4); convincing (p. 5). Often in fewer than eight lines (sometimes five) Lax allows us to see how any one episode can be pivotal. Moments of insight which are more than one can easily absorb are caught in just a few words: Lax says, indirectly, of what all good artists or contemplatives do: 'the most important thing/was to know/where to set his easel'.[21]

The two pieces which make up *Psalm and Homage to Wittgenstein* pull together the two increasingly important themes in Lax: praise of God who speaks (often in silence) and simultaneously wonder about the mystery of language which cannot be fully explained.

Psalm is a speech to God and a record of apprehension of how God speaks so quietly back to the speaker. The speaker announces that a decision was made which involves silence:

> I made one choice, a long time ago, I don't
> remember what it was, but since then I've
> been falling.
>
> I don't think I mean I'm falling to the ground.
> I hope I don't mean I'm falling into hell. I'm
> falling toward you. I've been falling toward
> you since then.
>
> Whenever that was.[22]

20. Lax, *21 Pages*, p. 28.
21. Lax, *Episodes*, p. 37.
22. Lax, *Psalm and Homage to Wittgenstein*, p. 20.

The recent *Robert Lax: What Does a Stone Mean?*, edited by Paul J. Spaeth, provides still more insight into the enigma of Lax.[23] The late poems included there are demonstrations that everything carefully observed can provide meaning into everything else. This, too, was what Merton was learning.

III.Three Contemporary Admirers

Wisdom: The Feminine Face of God, by Daniel Berrigan, SJ, is a book which reflects his love of scripture and contemporary culture as well as his admiration for Thomas Merton whose imprint is frequently found throughout this strong commentary. Berrigan's book is an extended poetic commentary on the book of Wisdom. Sapientia, holy wisdom, love, informs the many levels of meaning in Berrigan's text which reads the Old Testament text and us via a poem by Merton. 'Hagia Sophia' provides a framework for this commentary and Berrigan acknowledges his debt immediately as he begins.

In Berrigan's 'Introduction' he explains how his reflections 'owe much' to Merton who in the 1950s had received a line drawing of a mother and child from an artist friend who said he was uncertain of the drawing's meaning. Merton announced that it had to be 'Hole [sic] Wisdom, and the child was of course Jesus'.[24] Berrigan's intense poetic reflections are 'guided by a theology that is at once radical and orthodox, and thus thoroughly compelling' says the writer of the Foreword to the book, Michael Baxter.[25] Berrigan's astounding line-by-line commentary allows the book of Wisdom to provide shocking insight into our contemporary situation which calls out so loudly for justice and love. He insists we must seek justice and God, and that 'God is found by those who do not put the Holy to the test'.[26]

Berrigan rails about capital punishment, greed for money, unnecessary hunger, displacement, loneliness, and 'imperial system of capitalism'. He quotes many contemporary figures and comments on our war to make his case. Clearly as a culture, he argues eloquently, we have forgotten about Wisdom. We have, in the meantime Wisdom 'turning

23. Paul J. Spaeth (ed.), *Robert Lax: What Does A Stone Mean?* (St Bonaventure University, 2001).

24. Daniel Berrigan, *Wisdom: The Feminine Face of God* (Franklin, Wisconsin: Sheed & Ward, 2001), p. 1. ISBN 1-58051-100-7.

25. Berrigan, *Wisdom*, p. xiv.

26. Berrigan, *Wisdom*, p. 7.

the world's wisdom on its head'.[27] He quotes Merton and provides his own radical commentary:

> Wisdom sends the infinitely
> rich and powerful One forth as poor and helpless...
>
> ...A vagrant, a destitute
> wanderer...
>
> A homeless God, lost in the mighty militant powers,
> without identification...

He then condemns aspects of our contemporary civilization:

> ...an image of the world emerges, a subhuman image,
> a bear pit, a bombing run, an abattoir. The powerful, intent on keeping
> or enhancing their status...

Relentlessly, for 197 pages, Berrigan allows the Wisdom of the Old Testament to testify about today's horrors. Ten times he uses Merton's 'Hagia Sophia' to focus his remarks on what we, as a culture, have forgotten. Berrigan's book is searing in its criticism of our culture's selfishness, while it is, as well, a loving tribute to the accomplishments of Merton who sang of seeing the beauty of God's love and our culture's need for the gentle embrace of nurture, kindness and, above all, compassion.

Thich Nhat Hanh also saw the wisdom of Merton as manifested in his openness and compassion for other like-minded seekers. These two monks were parallel characters cast into roles as spokesmen within cultures not concerned much with the truth in the midst of an evil war. Merton realized that Thich Nhat Hanh was his 'brother' who was seeking peace. Now we see both monks are prophets seeking peace for all humankind. The success of Robert H. King's book derives from the fact that it is based on the conviction that these two figures are prototypes of what all persons in today's culture aware of global connections should become.

Robert H. King's tightly packed *Thomas Merton and Thich Nhat Hanh: Engaged Spirituality in an Age of Globalization*, is an insightful example of how Merton's growing influence extends right down into the present moment of globalization. The subtitle of the book suggests its careful methodology: while Merton and Thich Nhat Hanh met only once, King successfully argues that they 'have become pioneers in the development

27. Berrigan, *Wisdom*, p. 54.

of what has come to be known as engaged spirituality'.[28] Each has built bridges of understanding to the other's tradition.

King's Prologue, subtitled 'A Personal Perspective', explains how this sometimes informal study has grown out of his own practice and his conviction about engaged spirituality as crucial for today. In successive chapters he describes the 'historic' meeting of Merton and Hanh; then he shows how quickly they learned from one another. He provides an overview of Merton as 'contemplative' and Hanh as 'engaged Buddhist'. He skillfully shows how the interest of culturally separated monks from different traditions converged to learn from one another in the heart of the raging Vietnam War.

Both men belonged to the Fellowship of Reconciliation and it was through that group that a meeting on 26 May 1966 was arranged. King correctly argues that this single meeting and the correspondence and writing that followed set the stage for one of the most significant developments in our contemporary world, 'real dialogue among the world's great religions'.[29] He is correct.

While there are some mistaken assumptions informing this study (see p. 26, '[M]onasticism has played a relatively minor role in Christianity') the general thrust of King's argument remains excellent because he understands that both Merton and Thich Nhat Hanh have become contributors to our current understanding of the globalization of culture. They each influenced one another and thereby our contemporary culture and its appreciation of how different traditions of faith often seek the same goals.

One could argue that there is little here which is new because Chapters 2, 3 and 4 basically only outline the lives and work of these two monks and demonstrate (in Chapter 4) the specifics of their 'Dialogue'. Yet in Chapter 5, 'Engaged Spirituality in an Age of Globalization', a new contribution is definitely provided by King. This is partly because he utilizes specifics from his own life experience and this is typical of what many others are experiencing, he argues.

Both Merton and Hanh have demonstrated that we must build on a spirituality which will allow us to develop a larger than merely limited faith perspective. The concluding section subtitled, 'The Globalization of Engaged Spirituality', demonstrates that the true contemplative in our culture could not avoid being 'affected by the problem of war, which

28. Robert H. King, *Thomas Merton and Thich Nhat Hanh: Engaged Spirituality in an Age of Globalization* (New York: Continuum, 2001), p. 38. ISBN 0-8264-1340-4.
29. King, *Engaged Spirituality*, p. 11.

[Merton] saw as having spiritual roots'.[30] King's use of Merton and Thich Nhat Hanh's parallel stories allows him to demonstrate that their thinking and recognition of each others' traditions and their concerns for all persons has become a model which works effectively today and will be needed in the future.

John Dear, author of the book *Jesus the Rebel: Bearer of God's Peace and Justice* (published in 2000) has provided still another book of meditations in 2001. The meditations about Jesus as 'bearer of God's peace' constantly reminds the reader of the relationship between the contemplative and the active person, and thus of Merton:

> As contemplatives who have dismissed anxiety and worry from our lives, we are free to dedicate ourselves to the most important task of life. 'Seek first God's reign and God's justice, and all these things will be given you besides'. The will of God, the essence of life, the culmination of wisdom, is found in the pursuit of the reign of God and the justice of God. There is nothing more important. Nothing else should hold our attention. Nothing else is worth our energy, time, or effort. Here we find our purpose and discover what it means to be human.[31]

John Dear's new book of meditations, *Living Peace: A Spirituality of Contemplation and Action*, is an even clearer example of Merton's positive influence. This is not a 'scholarly' book, but it is of value for several reasons. Dear has absorbed much from reading Merton, Dorothy Day, and other activists such as Berrigan. He has for 20 years been living a life of peacefulness and seeking peace through action and civil disobedience. There are many references to Merton's thought throughout this book yet it has no index.[32]

It is clear that Dear has been putting into action the lessons he has learned from Gandhi, Daniel Berrigan, Merton and others as he watches and witnesses in a society awash in violence. Dear's style is often informal while his concerns are urgent and clearly articulated. John Dear demonstrates both the necessity of action in relation to contemplation and the need, therefore, sometimes to put one's self on the line (literally) at the Pentagon, during the launching of nuclear submarines, at the School of the Americas, and so on. What is really interesting about this book is how it is simultaneously a book about Dear's need for *both* quiet and contemplative practice and engagement. It is a book about the need to speak out for a world where justice and mercy are frequently forgotten.

 30. King, *Engaged Spirituality*, p. 164.
 31. John Dear, *Jesus the Rebel: Bearer of God's Peace and Justice* (Franklin, Wisconsin: Sheed & Ward, 2000), p. 176 (47). ISBN 1-58051-073-6.
 32. John Dear, *Living Peace: A Spirituality of Contemplation and Action* (New York: Doubleday, 2001), pp. 227. ISBN 0-385-49827-6.

The litany of statistics provided by Dear about poverty and resources, weapons and distribution are shocking and Merton's prophetic awareness of our Western neo-colonial greed is echoed throughout this urgent text. Merton is a precursor to the compassion which Dear, as a symbol for the present generation, has taken up.

In still another book about global spiritualization Merton's thought provides a basic foundation. Throughout Wayne Teasdale's *The Mystic Heart* we perceive Merton's presence who Teasdale argues sought 'universal understanding'[33] in so much of his writing and personal seeking.

With a forward by the Dalai Lama and good tight concise writing about this encyclopedic topic Teasdale's study hardly ever misfires. Even his own autobiographical references work well because this author is able to incorporate these references (to his own teachers, his uncle, friends) in a useful manner which documents his personal journey from Catholic tradition to a new openness. He seeks to show that as a traditional Catholic he has been able to discover the many parallels which exist about so many different mystic paths.

By showing how Merton, Bede Griffiths, Krishnamurti and others were 'not content to settle down, but must press on to greater and greater discovery…[these holy thinkers suggest that] the fully formed mystic or contemplative is the new cultural hero who guides humankind to its maturity'.[34] Merton is at the heart of this continuing quest to uncover the mystic heart which informs all religious traditions.

IV. Echoes through Kelty

Merton's encouragement by Robert Lax to become a saint as reported in *The Seven Storey Mountain* has been transmuted to Merton's quest being a source of encouragement for myriads of fellow monks, friends, and listeners to his taped lectures. He also has influenced other writers who have absorbed his advice. Matthew Kelty's *Gethsemani Homilies* is another recent valuable collection of writings with strong, if indirect, echoes of Merton. Kelty is quite humble when quizzed about his own reading interests and possible influences by Merton, yet clearly this book of homilies is evidence that Kelty has ripened partly because Merton is in the background.

33. Wayne Teasdale, *The Mystic Heart: Discovering a Universal Spirituality in the World's Religions* (Novato, California: New World Library, 2001), p. 293. ISBN 1-57731-140-X.

34. Teasdale, *The Mystic Heart*, p. 232.

Kelty states in the interview which opens this collection that when Merton first talked to him about solitude he was not much interested in the subject. But with the passing of time Kelty reassessed what Merton had to say and then became much more open to the idea of solitude – all of which led him to an experimental small monastery in North Carolina and later to his life as a hermit in New Guinea. The quest, the understanding about solitude and silence, was helpful: 'I finally began to understand solitude, what it means. I wanted to do it full time. But I didn't want to do it out back of the monastery. You know, if you get married you don't live upstairs. You want to get a house of your own'.[35] This collection also includes Kelty's homily 'Love in Depth, On the Thirteenth Anniversary of the Death of Thomas Merton', which first appeared in *The Merton Seasonal* 24.1 (Spring 1999). Kelty reminds us that Merton's life was not one of suffering more. Rather, 'his engagement with God was more profound, his commitment more total, his abandonment more complete. In such a life the relation to God is superbly intimate, and no mortal living with such love can escape being burned.'[36]

We have a similar kind of affirmation expressed in many other books by writers about monasticism and the spiritual life for monks and lay people.

V. Merton's Continuing Presence

At a quiet level Merton's charm infects many writers of religious literature in simple homilies and in chapter talks as well as in 'self-help' books. Think for a moment of Dom Augustine Moore, OCSO. He entered Gethsemani in 1942 just six months after Merton's arrival there in December 1941. These men are about the same age – and each with a completely different priestly role to be played – yet we know to some degree they learned much from each other. In a newly edited book Dom Augustine writes in a chapter talk, for example, about 'compassion' and directly ties those remarks into Merton's approach: 'Thomas Merton wrote that the saints are what they are, not because their sanctity makes them admirable in the sight of others, but because the gift of sainthood makes it possible for them to admire everyone else'.[37] This seems to be a direct echo of *New*

35. Matthew Kelty, *Gethsemani Homilies* (Quincey: Francesca Press, Quincy University, 2001), pp. xvii-xviii. ISBN 0-8199-0998-X.

36. Kelty, *Gethsemani Homilies*, pp. 129-30.

37. Augustine Moore, *Within the Heart of Many: Homilies and Retreat Talks* (Conyers: Our Lady of the Holy Spirit Abbey, 2001).

Seeds of Contemplation[38] where Merton argues that we realize all are sinners and all need God's mercy.

Merton, as the progenitor of many Cistercians who today share their insights through their writings, clearly has served as a model for a significant group who now share their vision with others beyond monasteries. This is true of Basil Pennington and of James Stephen Behrens both of whom have lived the monastic life at the Conyers Monastery where Augustine Moore, Merton's contemporary, was Abbot.

Fr James Behrens notes that Walker Percy once remarked to him that he 'should always write with hope. He said that because I am a Christian and as a Catholic priest I am "stuck with a wondrous message and had little choice but to write about it" '.[39] Such hopefulness is at the root of all good Christian writing and is at the core of all Merton's best work of praise, a body of work designed to give hope.

We see this hope in Behrens, in Mother Gail Fitzpatrick, OCSO and in Thomas Keating, OCSO whose *Intimacy with God* (revised for a third printing in 2001)[40] absorbs insights from Merton (The glossary defines 'true self'). Keating explains in detail the relationships between modern psychology, finding one's self, and the interest in centering prayer. Through Keating's books and through his widely distributed tapes Keating teaches prayer and contemplation. And also through the organization 'Contemplative Outreach' thousands of persons have been drawn to a much closer 'intimacy with God'. In the first decades of this century explains Keating, the earlier 'Christian contemplative tradition [had been] believed to be locked up in cloisters. Even there, it often existed in a truncated form with an overemphasis on interior transformation...'[41] Keating's work, like Merton's, seeks to develop ways to share the Benedictine and Cistercian traditions.

Merton's 'influence' upon the thinking of monastics and spiritual writers is pervasive. References to him turn up in a wide range of contexts. Recently, I was struck by the section of Mother Gail Fitzpatrick's book *Seasons of Grace: Wisdom from the Cloister* where she frequently discusses how monastics are called to build communities and how the Merton talk 'Life and Community' defines community for her not as something easy but rather as 'being wherever you knock up against somebody in pursuit

38. Thomas Merton, *New Seeds of Contemplation* (New York: New Directions, 1962).
39. James Stephen Behrens, *Memories of Grace: Portraits from the Monastery* (Chicago: ACTA Publications, 2001), p. 156 (82). ISBN 0-87946-220-5.
40. Thomas Keating, *Intimacy with God* (New York: Crossroad, 3rd edn, 2001), ISBN 0-8245-1588-9.
41. Keating, *Intimacy*, pp. 112-113.

of doing something together, for only then do we decide to build community'.[42] What is striking about the commentary which follows by Mother Fitzpatrick is her insistence that God chooses 'whom we knock up against' and we then choose whether or not to be in community. It is Merton who provides the foundation for these insights. Merton built awareness of communities on many levels. Most especially he encouraged others to live in the present, thus to build a sense of community building and appreciation within the context(s) of their individual lives.

Dianne April's *Making a Heart for God: A Week inside a Catholic Monastery* is literally a book made possible by Merton's thought. There are references to his writing throughout and his words structure the book.[43] Thus, as she writes about Gethsemani's spirit, she is really writing, to some degree, about how Merton's spirit lives on there.

Similarly, the new book of 'conversations' with the monks of New Clairvaux in Vina, California is sprinkled with suggestive references to Merton's work—his writing and his personal influence.[44] Often in such remembrances, Merton is setting the tone. A further example would be Thomas Moore. In each of the books by Moore, author of *Care of the Soul*, some tribute is paid to Merton. Moore's 1997 book is an excellent example. Moore demonstrates that Merton teaches us how to be 'garden dwellers'.[45]

Moore's *The Re-enchantment of Everyday Life* is a 1997 text, but deserves fleeting mention in the present context because once again Merton so informs much of what is accomplished there. Merton needed decades to distill his wisdom (Moore explains he needed time also for such integration and distillation, see his introduction).

In this particular series of reflections about the absolute need for using one's imagination Moore shows readers why they must come back to re-enchantment of everyday life if they are going to heal their souls. As Moore writes, he incorporates fundamental contemplative lessons which he has learned from Merton, things evident in the 'diaries' says Moore: 'which are punctuated over years by single-sentence observations of

42. Gail Fitzpatrick, *Seasons of Grace: Wisdom from the Cloister* (Chicago: ACTA Publications, 2001), p. 209. ISBN 0-87946-216-7.

43. Dianne April, *Making a Heart for God: A Week inside a Catholic Monastery* (Woodstock, Vermont: Skylight Paths, 2000), ISBN 1-893361-14-4.

44. David D. Perata, *The Orchards of Perseverance: Conversations with Trappist Monks about God, their Lives, and the World* (Ruthven, Iowa: St Therese's Press, 2000), p. 201. ISBN 0-9672135-0-9.

45. Thomas Moore, *The Re-enchantment of Everyday Life* (New York: Harper, 1997), ISBN 0-06-092824-7.

nature that give a Zen-like contemplative counterpart to...personal thoughts and experiences'.[46]

The new book *A Pelican in the Wilderness: Hermits, Solitaries, and Recluses*, by Isabel Colegate, is also characteristic proof, again, that Merton has entered into the mainstream. Her book mentions him only twice, but both times in interesting ways: first, as a model of someone seeking knowledge about interfaith experience and therefore seeking connection with Dom Henri Le Saux, who became Swami Abhishiktanda and called himself a Hindu Christian monk. Second, Merton is discussed in relation to Rilke who Merton greatly admired. However Merton realized that Rilke's, or anyone's poetry, only provides a 'theological conception, or an image' and that more importantly for him such 'an image has to be sought and loved. "Union with God!" So mysterious that in the end man would do anything to evade it, once he realizes it means the end of his own ego — self-realization once and for all'.[47] Merton is here the model of a modern seeker, seeking to go beyond his own images, conceptions and writings.

Other recent successful books which testify to the presence of Merton in the minds of an extraordinarily wide range of writers include references to him in relation to 'Sacred Places' in New York City; his position as a Christian mystic in the developing Western tradition and his legacy; the use of writings as a valuable tool for discovering the mystic in 'all of us'; and, finally as references within a book about everyday simplicity.[48] He is being read.

VI. Academic Writing

The fact of Merton being recognized by everyday readers and by mainstream commentators about spirituality and contemplation is now a fact. His appreciation by the academy, his absence in secular anthologies is another fact. The latest book by Ross Labrie, ambitious and valuable, should assist 'sophisticated' audiences to place Merton as a contributor

46. Moore, *Re-enchantment*, p. 101.

47. Isabel Colegate, *A Pelican in the Wilderness: Hermits, Solitaries, and Recluses* (Washington, DC: Counterpoint, 2002), p. 284. ISBN 1-58243-121-3. (This quotation is from *The Intimate Merton*, no page number given.)

48. These books are Edward F. Bergman, *The Spiritual Traveler in New York City: The Guide to Sacred Places and Peaceful Places* (Mahwah, NJ: HiddenSpring). ISBN 1-58768-003-3; Ursula King, *Christian Mystics: Their Lives and Legacies throughout the Ages* (Mahwah, NJ: HiddenSpring, 2001). ISBN 1-58768-012-2; John Kirvan, *God Hunger: Discovering the Mystic in All of Us* (Notre Dame: Sorin Books, 1999), ISBN 1-893732-03-7; Robert J. Wicks, *Everyday Simplicity: A Practical Guide to Spiritual Growth* (Notre Dame: Sorin Books, 2000). ISBN 1-893732-12-6.

within the development of serious art and spirituality as well as the development of the history of ideas in the twentieth century. Ross Labrie's book, *Thomas Merton and the Inclusive Imagination*, is an excellent synthesis and explication of Merton's spiritual longing as it merged with and empowered his artistic and intellectual journey. This well-written study should serve to introduce Merton's accomplishments to a wider academic world unaware of Merton and his constantly developing 'inclusive' imagination.[49]

Labrie will not be able to 'prove' all of what he asserts, but the wholeness and clarity of patterns provided by this systematic analysis is a wholeness refracted from Merton's willingness to look at beauty and horror, love and hate, concern and disregard even when they appear so often side by side. In today's culture Labrie shows us that Merton's poetic imagination sees the unity of a world often fragmented (by economics, prejudice, anger, war, religious misunderstanding, selfishness, etc.). Labrie shows that it is through Merton's inclusive imagination that he remains hopeful, and in that hopefulness Merton remains able both to write and to bathe in the quiet of contemplation and ultimately in knowledge of the contemplative outside of predictable Catholic sources.

Early on Labrie clearly establishes some of the crucial connections he will then systematically examine:

> Although Coleridge used the term *meditation* in speaking of the poet's intuitive access to ultimate reality, it is clear that he meant by that term essentially what Merton meant by *contemplation* and furthermore that the contemplation Merton associated with the mystics was similar in kind to that which he perceived in the romantics. As Merton recognized, the bridge between romanticism and mysticism was Platonism. He explicitly noted Blake's indebtedness to Neoplatonism in his thesis on Blake, and even though he distinguished between the goals of art and those of mysticism in *The Ascent to Truth* (1951) as well as in two well-known essays on poetry and contemplation, written in 1947 and 1958 respectively, nevertheless the distinction seemed to lose its importance for him after the mid-1950s. Increasingly, following the mid-1950s and especially when he began to write more spontaneously and with not a great deal of effort given to revision, Merton used the writing of poetry as an opportunity for contemplation. Spontaneity itself, he recognized, was a feature of romantic composition, favored because it allowed the true self to respond to the subject at hand before the intervention of the rational self with its discourse of impersonal argumentation.[50]

49. Ross Labrie, *Thomas Merton and the Inclusive Imagination* (Columbia: University of Missouri Press, 2001), pp. 263. ISBN 0-8262-1382-0. See pp. 22-23, and the conclusion of ch. 1, p. 28, for Labrie's definitions.

50. Labrie, *Inclusive Imagination*, p. 7.

As this passage indicates, Ross Labrie's book is inclusive in that he has surveyed the published work and can then speculate about what holds the developing career together. This is a solid academic exercise, loaded with footnotes and documentation. It is also a pleasure to read. Labrie has investigated extensively and well. His systematic approach here is both new and valuable because he assiduously connects the many pieces of this enormous mosaic of Merton's intellectual and religious journey together. Labrie's scholarship preceding this book (*The Art of Thomas Merton* and *The Catholic Imagination in American Literature*[51] have provided ample ground work for this insightful piece of analytic scholarship.

Ross Labrie clearly loves literature, and especially poetry, as does Merton. He returns to the Romantics and specifically to William Blake, then to Hopkins and to Merton's love of these writers to construct his opening argument about the roots of Merton's inclusive imagination and method. Labrie successfully demonstrates that Merton's diverse production does have many connecting threads, most especially in Merton's continuing ability to make connections (mystical, liturgical, literary and ecclesiastical) from his own experiences (personal and through his voracious reading). Such enthusiasm then made it possible for Merton to see, sing and praise the bigger framework of God's creation, and our own responsibility to see that larger beauty and our apparent cultural deterioration in doing so in this historical era.

Labrie has systematically kept track of many streams in Merton's mind, manuscripts and publications. Often his dense footnotes reveal that in a single paragraph he has been able to make connections between and among what may even appear to be disparate references in Merton's writings, journals, correspondence, working notebooks and in little-known periodical publications.

This is an academic book and it is not easily read, yet it will prove to be a mine of information for other scholars as new projects of comparison unfold. This kind of synthesis is what we have been looking for in Merton studies — the beginnings of an overall explanation of Merton's immense productivity and seeking of religious and mystical unity. Labrie groups related themes to provide his investigative structure — Romanticism and Mysticism, Consciousness and Being, Solitude and Self, Nature and Time. He steps back from the forest of these 'inclusive' topics and proceeds often tree by tree to demonstrate what Merton has accom-

51. Ross Labrie, *The Art of Thomas Merton* (Fort Worth, TX: Texas Christian University Press, 1979); *idem, The Catholic Imagination in American Literature* (Columbia: University of Missouri Press, 1997).

plished. Each of his opening four chapters demonstrate what appears sometimes to be thematically disparate or unrelated ideas while there is always a connection built.

Labrie shows that Merton's work with Blake in 1939 as mystic is not unrelated, therefore, to Merton's groundbreaking thought of 1959–60 about ascetical and mystical theology. Labrie's subsequent critical examination demonstrates that there is no contradiction between the need for cultivation of solitude and a similarly important knowledge of the self which cannot be verbalized or explained:

> In the writings of the 1960s one can see the tension created by Merton's straddling of these two rather different ontological worlds in the long series of ruminations on the contemplative life titled 'The Inner Experience'. In this detailed examination of the contemplative life, Merton separated the evil done by the self from the 'good ground of the soul'. While such a distinction might appear to have driven a wedge between the quotidian and the ontological self, Merton's continued belief in the value of the organic, affective self was trenchantly expressed in his dramatization of the conflict between the self and technology in section 66 of *Cables to the Ace*:
>
> Science when the air is right says 'Yes'
> And all the bubbles in the head repeat 'Yes'
> Even the corpuscles romp 'Yes'.[52]

This is not to rest in the quiet of the 'true self'. Labrie also demonstrates by such careful tying together of materials that for Merton 'paradise' will only be a possibility for humankind when in some fundamental ways we are willing to cultivate a sense of childishness. As his book progresses Labrie continually demonstrates how, as Merton became increasingly interested in a wider and wider range of topics, he could see the commonalty in all:

> Thus, rather like Keats in the 'Ode to a Nightingale', he celebrated the self-forgetfulness that allowed him to unite with the whole of being. Incidental to this extension of himself into the whole of being was his growing awareness of the underlying unity of the spiritual and philosophical writers he was consulting. For this reason it seemed to him that the thought of Zen Buddhism unexpectedly resembled that of the Desert Fathers of the fourth century… The primordial ontology that underlay Merton's paradisal consciousness can be found in many corners of his writing. He admired, for example, Albert Camus's advocating what he called a 'primordial humanism, the seeds of which are implanted' in human nature. With a similar atavistic orientation, Merton, in an informal talk given in Calcutta in the fall of 1968, argued that what human beings had most to recover was their

52. Labrie, *Inclusive Imagination*, p. 21.

original unity and that that recovery was achievable in what they still retained of their original state as human beings.[53]

Finally, Labrie successfully argues that only through an understanding of the development of myth will we be able to understand our global culture:

> ...in notes for [his] projected talk in Calcutta, which were later published in the *Asian Journal* as an appendix entitled 'Monastic Experience and East-West Dialogue', he contrasted what he termed the Asian habit of 'non-hurrying and of patient waiting' with the Western passion for 'immediate visible results'. Through his encounter with Buddhism while traveling in the East, Merton was able to mount a challenge to the dominant rationalism, particularly in its disputatious aspects, of Western culture, as can be seen in his impressions of the great stone Buddhas in Polonnaruwa, Sri Lanka, in 1968, figures that struck him as quintessentially and ideally Asian.[54]

One cannot easily do justice to this dense study in a few pages of review. Suffice it to say that the connections are still being carefully provided between 'Romanticism and Mysticism' as the study concludes, and as we move to an examination of the last few years of Merton's literary production. Labrie argues it was

> ...distressing to Merton [to recognize that] knowledge...since the late Middle Ages Christianity had lost the power and desire to welcome non-Christian cultural values, turning away from them instead as potential sources of heresy. Resisting this cultural xenophobia, which he admitted had eased in the 1960s, he attempted to build within himself a cultural and spiritual edifice that included the voices of various religious and philosophical traditions. In this way, like Gandhi, he hoped to unite in himself the spiritual thought of the East and the West and so to prepare *in himself the* future reunion of divided traditions. He came to believe that he would be a better Catholic not by refuting 'every shade of Protestantism' but by affirming the truths of Protestantism: 'So too, with the Muslims, the Hindus, the Buddhists, etc'. It was at this point in his thinking he came to focus on what he came to regard as the most significant characteristic of unity – its inclusiveness. The extension of the self toward unity was generated by a perception of evil as disunity, a pulling into itself of the separated ego in the case both of individuals and of nations. In opposing such partisan perception, Merton focused on the history of culture as a history of amalgamation. From his earliest writings he had sought the high road of inclusiveness...[55]

53. Labrie, *Inclusive Imagination*, p. 125.
54. Labrie, *Inclusive Imagination*, p. 201.
55. Labrie, *Inclusive Imagination*, p. 226.

Labrie's book will allow other scholars to begin to understand the inclusiveness of Merton's vast imaginative project.

Another close reading of a challenging writer whom Merton greatly admired, Flannery O'Connor, is provided by George A. Kilcourse's careful work in his *Flannery O'Connor's Religious Imagination: A World with Everything off Balance.*[56] Kilcourse's framework about O'Connor's 'Christian Imagination'; the use of insights from Merton about belief and unbelief; and successful incorporation of theologians such as Romano Gaurdini and Karl Rahner give us a new way to understand the presentation and presence of grace in O'Connor. Similarly, his employment of William F. Lynch allows us to see that at the base of O'Connor's fictional imagination was her concern with choice and grace and freedom.

If we contrast Kilcourse's careful work with another new O'Connor study, Katherine Hemple Prown's *Revising Flannery O'Connor: Southern Literary Culture and the Problem of Female Authorship,*[57] it is perhaps understandable why Merton has not become a darling of the secular criticism which has developed into a true industry for O'Connor while seldom providing much attention to her religious imagination. Prown's book elegantly shows that O'Connor was very aware of technique, her indebtedness to other authors and that she was very much aware of the need to revise her manuscripts (especially early on) to minimize the appearance of a female voice. This limited study is of value. No doubt O'Connor's 'formulation of her literary identity' was significant.[58] Much more significant, I think, was her careful absorption of theology so that her characters make sense, not as oddities, but as creatures of God in an ordered universe which has been knocked out of kilter. Prown's book has a very narrow focus. Kilcourse's book, on the other hand, is well informed by insights from Merton and others and stresses Flannery O'Connor's Christian imagination. He does an excellent job of reading O'Connor's fiction and of using theological insights from Merton to focus on O'Connor's sometimes ironic twisted vision.

As we know from Robert Giroux who edited O'Connor and Merton, and wrote of their parallels in his introduction to O'Connor's short stories, these contemporary writers often observed contemporary culture through similar lenses. What Labrie and Kilcourse both succeed in doing for a widening of appreciation and understanding of Merton and O'Connor is to demonstrate that they learned never to write, imagine, and criticize within the vacuum of a writer's imagination, but within a

56. Mahwah, NJ: Paulist Press, 2001, pp. 328. ISBN 0-8091-4005-5.
57. Charlottesville: University Press of Virginia, 2001, pp. 201. ISBN 0-8139-2012-4.
58. Prown, *Reviving Flannery O'Connor*, p. 75.

universe of a 'Catholic theology of grace' and of 'men with free will',[59] even though sometimes unaware of Christianity at all.

VII. Periodicals

Some remarks about periodical publications and *The Merton Seasonal*, now in its twenty-seventh year of publication, are useful at this point. *The Seasonal* remains an excellent indicator of the pulse of Merton Studies. I will not survey all the contents of vol. 26, and here only indicate it stands as the reservoir of citations and ideas for Merton commentators and researchers: Look, for example, at vol. 26 no. 4: it includes three interesting articles (on a study-trip to Prades, Ed Rice, and about the value of *The Ascent to Truth*); two poems in the manner of Bob Lax; and an Ed Rice bibliography as well as a bilingual poem for Merton along with three good reviews including books which I also survey in this essay (*Dialogues*; King's *Thich Nhat Hanh*; and Kelty's *Gethsemani Homilies*) plus the most recent addition to the publications 'By and About' Merton which includes 75 items.[60]

For those who knew Bob Daggy and *The Seasonal* in its earlier years, we are both pleased that Daggy started this quarterly and that it has now grown to its present proportions under the skillful and dedicated guidance of the present editor, Patrick O'Connell. An evaluative word about each of the articles in the last number of vol. 26 allows us to be reminded of the kind of valuable and often 'speculative' work which frequently appears there.

The strongest article of this issue is David Joseph Belcastro's. His earlier work at ITMS meetings and in print has had to do with Czeslaw Miloszh and Albert Camus's relationships to Merton: here Belcastro goes back to Merton's first 'systematic' theological treatise about spirituality. Often the quotes within this article are extensive (too much so?) yet Belcastro makes his point well. He agrees with earlier commentators about the lack of focus in *The Ascent to Truth*, but he also finds 'seeds' of Merton's unfolding spiritual insights in this dense even daunting venture into St John of the Cross's world via the theology of St Thomas Aquinas.

Other articles in *The Seasonal* which concludes 2001 are helpful because they place Merton in relation to another important figure: his lifelong friend Edward Rice, and to Merton's place of residence as a child. The article about the study-trip to Merton's childhood village, Prades, is little

59. Kilcourse, *Flannery O'Connor's Religious Imagination*, p. 243.
60. *The Merton Seasonal* is published at The Thomas Merton Studies Center at Bellarmine University.

more than an item of journalism. Nevertheless, it contains bits of insight to be gleaned.

There are also several scholarly articles included in the bibliography included in vol. 26 no. 4 which do look promising. A group of articles appeared in *Franciscan Studies* 55 (1998).[61] There is also a new book called *Reading Thomas Merton: A Guide to his Life and Work* by John Laughlin published in 2000 which I have not yet seen. These citations must be examined. *The Merton Seasonal* remains, therefore, as the necessary clearing-house for new materials about Merton. Its short articles, sometimes not-before published materials, and bibliographic listings are useful and thus, finally, no scholar can do without this material as a primary source to be investigated.

Similarly, *The Merton Journal* (published by The Thomas Merton Society of Great Britain and Ireland) which appears twice a year provides basic insights about Merton and his influence. Often these pieces are useful for scholars as well as the general reader. This year I only examined the table of contents. In the *Merton Journal* for 2000 Arthur W. Biddle has written 'Robert Lax: An Appreciation' (Advent Issue, vol. 7 no. 2) and there are general articles entitled 'Models of Self-Emptying Love' (Alexander Webster) and 'Theravada Buddhist Monasticism in the West' (Kim Wolfe) which look promising. In vol. 8 no. 1, articles on 'Poetry and Contemplation' (Patrick O'Connell) and 'Thomas Merton's Antipoetry' (Sonia Petisco) appear. There are also poems, general articles and reviews. The Advent 2001 issue vol. 8 no. 2, includes articles about 'Merton and Nicannor Parra' (Paul Pearson), 'Merton and Pasternak' (David Scott) and about 'Merton and Alan Watts as Twentieth-Century Archetypes' (Peter King). Other pieces appear to be reflections and book reviews.[62]

Articles in other scholarly journals about Merton appear infrequently. George A. Kilcourse has published a carefully written article in the

61. The three articles in Vol. 55 (1998) of *Franciscan Studies* by Kathleen Deigman, CND, 'Road to Rapture: Thomas Merton's [Study at Bonaventure's] *Itinerarium Mentis in Deus*' (pp. 281-97); Michael Downey's 'Merton's Franciscan Heart' (pp. 299-309); and 'Where The Green Light Meets the Air': The Hermit as Pilgrim in the Franciscan Spirituality of Thomas Merton' by Sean Edward Kinsella constitute the beginning of what might eventually become a book-length investigation of Merton's absorption, informally and systematically, of Bonaventure's proposals about the journey to God; relationships between early Cistercian and Franciscan thinking; and the Franciscan eremitical life as a model for Merton's deepening understanding of the solitary life.

62. *The Merton Journal* is edited by Michael Woodward and information is available from 9 Croesonen Road, Abergavenny, Monmouthshire. NP7 6AE, UK, or by email at mertonjournal@p3p.org

American Benedictine Review entitled 'Unmasking an Illusion: Thomas Merton's Contemplative Grounds of Dialogue'. This survey provides basic information about Merton's foundational thinking concerning contemplative identity and the 'image of awakening' in his writings which suggest an 'implicit dialogue' with readers, thus an inchoate theology of dialogue.[63]

VIII. Conclusions

In conclusion, I will make some observations about the course of Merton scholarship during the past decade or more. No doubt Merton is now well known. What still remains is the question of whether he is being assiduously read by groups of critics who can understand his message and carry it into the wider world.

Scholarly research in periodical literature concerning Merton, even in journals which one might assume should generate such articles germane to Merton Studies, remain quite scarce. Look, for example, at the recently published issues of *Christianity and Literature*. Most of what appears about Merton is in the form of reviews or short items in the two journals just discussed. The bibliographic survey articles which were prepared for the first five volumes of *The Merton Annual* were inclusive, yet often disappointing in the quality of materials surveyed because at that time (1987–1991) our temptation seemed to be to include everything which appeared in print as items which should be evaluated. The fact of the matter is that 15 years ago much Merton commentary was, if not hagiographic, so admiring of Merton that one wonders of its objectivity. This easy acceptance is beginning now to change.

In the five years following (1992–97), as *The Merton Annual* changed its editorial focus—and began looking for scholarship beyond the so frequently admiring—the material surveyed became somewhat more analytical. Still often it stood as pleas for the recognition of Merton in the wider world of scholarship and as requests for more systematic scholarship.

In vols. 11–15, another trend has emerged. George Kilcourse and myself have alternated this yearly survey about scholarship concerning Merton. We both have regularly lamented the lack of interaction between and among scholars. We also have expressed disappointment that Merton scholarship does not yet seem to be being accomplished much within the academic world of the Humanities. Where are the seminars

63. George A. Kilcourse, 'Unmasking an Illusion: Thomas Merton's Contemplative Grounds of Dialogue', *American Benedictine Review* 52.1 (March 2001), pp. 35-59.

about Merton at the Modern Language Association, or at the regional meetings, and so on? Where are the Merton agenda items at *Christianity and Literature* meetings? They remain quite rare. Yet what we have also observed in these five years is another phenomenon in Merton recognition through his influence upon other important writers and commentators. He has now been 'accepted' in at least two new ways (1) people of influence (Daniel Berrigan, Thich Nhat Hanh) clearly have absorbed Merton and this is revealed in their writings and actions; (2) scholarly work is also beginning to be done with the wider academic community in mind which synthesizes Merton's work along with preceding scholarly inquiry. This is seen in two ways: (1) in the new book by Ross Labrie which is inclusive (not just as an acceptance of Merton, but in its own methodology); (2) also in scholarly work which has appeared in *The Merton Annual* itself.

The editors have carefully restrained themselves from making comments over the years about the good work which has appeared in our own pages. However, 15 years of such work and approximately 4700 pages of published material does allow me to make some judgments.

Best of all (and Merton might love this) he is now reaching a wide audience beyond the Catholic audience — and not just by reading, but by a combination of means: reading, retreats, workshops, and scholarly conferences which relate him to other traditions (Sufism, Buddhism, Judaism) beyond the Catholic. He has become somewhat of an icon in the literature of comparative spirituality. As demonstrated in section IV of this review-essay, Merton is included in popular anthologies about spirituality and is included in collections of essays and studies about world religions. He has become part of our wider cultural life like Thoreau or Wendell Berry. Scholars are beginning to read him with the care which he demands. Scholars are also looking carefully at his texts and his methodology, at his background built up in life and love, reading and action.

Merton has, in a sense, short-circuited the critical 'system'. He has certainly not yet been given a stamp of approval by academia, but thousands of readers keep his books in print. He also has continued to influence other significant religious thinkers and spiritual writers. I am reminded of the immensely successful genre of romance novels, scorned by the elite, virtually ignored by all scholars except those interested in popular culture, yet they sell in enormous numbers and do affect enormous numbers of lives.

To some degree Merton has been and will continue to be ignored by people looking for systematic theological treatises or formal philosophy, or by readers who only approve of what a secular culture chooses to

endorse. Despite his isolation, good and careful work of analysis and synthesis appears and Labrie's book is the best recent example. The many original investigations published in *The Merton Annual* itself are more strong evidence. Merton, I trust, will be examined by a wider reading community in the future. An excellent and prophetic book by a European scholar hints about Merton's future recognition.

In this just published translation of Dorothee Soelle's *Mystik und Widerstand: Du Stilles Geschrei* (1997), now in English, *The Silent Cry: Mysticism and Resistance*, Merton is integrated within the study, examined as part of the pattern of humankind's longing for God in Western thought as well as in this current age of fundamentalism and materialism.[64]

Soelle's major work which encyclopedically surveys the history and development of mysticism in the West examines the relationship between the recognition of suffering and the mystical impulse. She sees Merton as a mystic who could fight 'in the resistance against the Vietnam War' and as someone able to act in this manner precisely because he was in tune with nature and capable of praising all of nature. She quotes Merton's remembrance of listening to rain and sees this as 'the beginning of the mystical journey…in and with the other of nature'.[65] Soelle unites this survey of major mystical figures in European and American traditions with the continued demand to speak for the abused and forgotten. When one acts in harmony with the universe, she insists, then like Merton writing to Jim Forest in 1966, one must see the whole world with its mystical foundation:

'Do not depend on the hope of results. When you are doing the sort of work you have taken on, essentially an apostolic work, you may have to face the fact that your work will be apparently worthless and even achieve no result at all, if not perhaps results opposite to what you expect. As you get used to this idea, you start more and more to concentrate not on the results but on the value, the rightness, the truths of the work itself'. He advises the young pacifist to become free from the need to his own affirmation. For then 'you can be more open to the power that will work through you without your knowing it'. Living in mystical freedom one can say then with Eckhart, 'I act so that I may act'. Being at one with creation represents a conversion to the ground of being. And this conversion does not nourish itself from demonstrable success but from God.[66]

Soelle's work places Merton's life of solitude and action in the main-

64. Dorothee Soelle, *The Silent Cry: Mysticism and Resistance* (Minneapolis: Fortress Press, 2001), pp. 325. ISBN 0-8006-3266-4.
65. Soelle, *The Silent Cry*, p. 100.
66. Soelle, *The Silent Cry*, p. 232.

stream of Western thought. Her knowledge of literature, myth, folklore and the facts of contemporary economics, war and greed provide a fitting setting for investigating the life and work of Merton who saw beyond his enclosure to affirmation of a world in severe danger.

[TMA 15 (2002) 263-278]
ISSN 0894 4857

Reviews

LABRIE, Ross, *Thomas Merton and the Inclusive Imagination* (Columbia, MO: University of Missouri Press, 2001. pp. 263. ISBN 0-8262-1382-0 (hardcover). $34.95.

At least three reviews of Ross Labrie's *Thomas Merton and the Inclusive Imagination* (hereafter *Inclusive Imagination*) are possible. The first would be the easiest and most obvious. It would include a number features, among them these: a summary of the book's major claim, an analysis of the claim as it is developed, an evaluation that asks and answers this question: does the book successfully fulfill its own intent? The second review would be a bit more allusive, more playful, more subtle. It would detail, in short, the ways in which *Inclusive Imagination* shows that Merton is a master conversationalist in dialogue with myriad traditions, cultures, writers. The third review would be the most dangerous. It would discuss the subaltern tension present in the book, a tension central to Merton's own life as a child of his time: the tension between modernity and postmodernity.

The First Review

The book's major claim is this, quoted at length:

> Growing up against the background of two world wars, which were to be followed by other regional wars, Merton experienced society as synonymous with divisiveness and nationalism. For this reason in part, perhaps, in the 1930s he looked outside of twentieth-century culture for an alternative vision. In Blake, Wordsworth, Saint John of the Cross, and Meister Eckhart he encountered such an alternative discernment of human existence. Essentially, this involved the recovery of the self and its latent unifying, transsocial orientation toward being and the consciousness of being. The romantics and mystics suggested to Merton not the need to find worlds other than this one but rather the need to find other worlds *in* this one, worlds that one could not only think about but also live in (pp. 28-29).

In sum, *Inclusive Imagination* is devoted to demonstrating the three parts of this claim. First: Merton was informed by romanticism. Second: Merton was informed by mysticism. Third: together, romanticism and mysticism provided Merton a way into the world. Admirably, *Inclusive Imagination* teases out Merton's relationships to a host of romantics and mystics and the traditions that they represent.

Most compelling is *Inclusive Imagination's* claim that for Merton romanticism and mysticism were not discrete, separate movements, despite the limitations of grammar. By 'limitations of grammar' I mean this: the conjunction 'and' in the phrase 'the romantics and mystics suggested to Merton' implies that Merton was influenced by the romantics on one hand, by the mystics on the other. 'And' unifies and separates these two, making them co-equal, but distinct. However, *Inclusive Imagination* also holds that Merton blended these together. The first chapter, for instance, points to Merton's essay titled, 'Poetry and Contemplation: A Reappraisal' (p. 6).[1] In this essay Merton claims that "the poet was always akin to the mystic" (*Inclusive Imagination*, p. 6). In addition, *Inclusive Imagination* holds that Merton 'used the terms *imagination, intuition, contemplation*, and *mysticism*...as if they were interchangeable' (p. 6).

Yet, this interplay of romanticism/mysticism did not lead Merton into a severely interiorized life, a life of privatized fantasy and contemplation. In fact, *Inclusive Imagination* holds that this interplay led Merton in the opposite direction. It led him to embrace the world in its myriad forms.

The Second Review

Merton's embrace of the world certainly included other people and, even, what we call 'nature' (see, e.g., pp. 33-34). As *Inclusive Imagination* argues, Merton came to 'an inclusive view of society in which social relationships were perceived through an ontological lens' (p. 64). This means that Merton, infused by his blend of romanticism/mysticism, came to understand 'the spiritual reality that inhered in the object contemplated' (*Inclusive Imagination*, p. 6). The world, for Merton, was not 'merely material and hence meaningless', but, indeed, infused by God (*Inclusive Imagination*, p. 6). Or, to put it another way, as Merton matured he came to focus 'on the divine immanence in being' (*Inclusive Imagination*, p. 54). This focus allowed him to see God in the world, not apart from, allowed him to embrace the other as infused with the divine.

One might suggest that this second review would be, simply, a continuation of the first. After all, doesn't the second part of the book's title, 'the Inclusive Imagination', suggest that the act of Merton's embrace is, indeed, part Merton's romantic/mystic worldview? Of course.

However, paraphrasing the work of Lawrence Cunningham, *Inclusive Imagination* notes that 'Merton was distinctive as a major religious writer in entering the "larger world of cultural discourse"' while remaining rooted in a particular religious tradition' (*Inclusive Imagination*, p. 227). While this is not an explicit point of *Inclusive Imagination*, it is central to the work of the book nonetheless. Thus, it would form the center around which the second review would move. Merton was a conversationalist *par excellence*, a writer and reader whose habits of mind were extraordinary. Merton's most obvious conversation partners, in the explicit terms of *Inclusive Imagination*, are the romantics and the mystics: Blake, Wordsworth, Coleridge (e.g. pp. 1-18), and St Gregory of Nyssa, St John of the Cross, and Meister Eckhart (e.g. pp. 18-19) among them.

1. Thomas Merton, *The Literary Essays of Thomas Merton* (ed . Patrick Hart; New York: New Directions, 1981), p. 245.

However, while *Inclusive Imagination* is focused on romanticism and mysticism, it also shows the ways in which Merton, as a romantic and mystic, reaches out constantly in conversation to others. Perhaps the best known conversation partner is 'the distinguished Buddhist scholar Daisetz Suzuki' (e.g. p. 19). Neither a romantic or a mystic (at least in the Christian sense of the word), Suzuki provided Merton an entrée into the world of Zen Buddhism, a world increasingly important to Merton as he moved into the late 1950s and 1960s. Merton's interest in Buddhism is well known, and *Inclusive Imagination* discusses it throughout its eight chapters. Perhaps less well known is Merton's ongoing conversations with many other writers and traditions. Aldous Huxley? Yes (p. 25). The Bhagavad Gita? Yes (p. 25). Heidegger? Yes (p. 36). Protestant Theology? Yes (p. 50). Sartre? Yes (p. 42). Pyschoanalysis? Yes (p. 75). William Faulkner? Yes (p. 74). Taoism? Yes (pp. 234-35). Louis Zukofsky? Yes (p. 126).

Even as a book focused on Merton as romantic and mystic, *Inclusive Imagination* cannot help but move into an implicit study of Merton as a high-culture modernist, to borrow Lawrence Cunningham's terms. *Inclusive Imagination*, perhaps unconsciously, perhaps unknowingly, demonstrates the ways in which Merton, as romantic and mystic, was a modernist monk, a modernist writer, a modernist reader, open to the conversations of world.

The Third Review

But was he? That is to say, was he a modernist monk? A modernist writer? A modernist reader? The answers to these questions depend on the answers to two other questions: (1) About which Merton is one speaking? (2) Which definition of modernism does one use to discuss Merton?

To suggest that Merton, in his 'early' phase, can be classified as a modernist is to come dangerously close to the ridiculous. After all, as *Inclusive Imagination* notes, *The Seven Storey Mountain* offers a hint — and probably more than a hint — of Merton's attitude about the larger, non-monastic, non-Roman Catholic world when he joined the Trappists. According to Merton, the monastery at that point in his life offered 'a barrier and defense against the world' (*Inclusive Imagination*, p. 57).[2] While *Inclusive Imagination* downplays the anti-modernist, anti-world implications of this passage in favor of what it suggests about the solitude Merton sought (p. 58), *Inclusive Imagination* none-the-less admits that this passage 'may be taken as a sign of Merton's desire to retreat from the mainstream of American society' (p. 58). Later, *Inclusive Imagination* goes so far to suggest that the early Merton was indeed different from the later Merton.

Consider the book's discussion of Merton's idea of freedom. *Inclusive Imagination* notes that 'Merton's appreciation for such inner freedom had developed considerably by the mid-1960s from the rather rigid, religiously orthodox idea of freedom that one encounters in works such as *The Seven Storey Mountain* and the early books of poetry' (p. 120). The phrase 'rather rigid, religiously orthodox idea of freedom' hardly needs to be interpreted in detail. Rigid is not, however understood, a good quality. Whatever positive characteristics *Inclusive Imagination* finds in the early Merton (and it finds many, rightly), it also suggests (albeit implicitly) that the early Merton was not

2. Merton, *The Seven-Storey Mountain* (New York: Harcourt Brace, 1948), p. 320.

the world-embracing, extraordinarily inclusive Merton of later years. *Inclusive Imagination* implies that the early Merton and the later Merton are not radically discontinuous, but, still, they are different (e.g. pp. 238-39).

Was the early Merton a modernist? No. Was the later Merton? Yes and no. The third review would concentrate on this yes and no, play it out, implicit as it is. *Inclusive Imagination* opens to its readers a tension central to the later Merton, a tension central to post-World War II America: the tension between modernism and postmodernism.

Of course, this statement begs the question raised above. How does one understand modernism? *Inclusive Imagination* provides one way to answer this question in its allusion to Lawrence Cunningham's work on the high-modernist Merton. With this allusion, *Inclusive Imagination* seems to suggest that modernism includes a rapacious intellect willing to span multiple and diverse literary traditions in order to pursue answers to questions that vex the human. Fair enough. However, I would like to suggest another version, based on my own work in postmodern rhetoric and poetics.

As I have argued elsewhere,[3] postmodernism is best understood in the following way. It is a worldview that holds that languages are plural, histories ambiguous. Readers of the Roman Catholic theologian David Tracy will see my indebtedness to his work, to be sure. My point is this: the postmodern sensibility teaches us that no one language is necessarily superior to others and that one's own language can emancipatory and oppressive, heroic and tragic. It also teaches us that no one history is superior to others and that one's own history can be emancipatory and oppressive, heroic and tragic. By contrast then, modernism would miss these dialectics present in language and history. A modernist understanding of history might suggest that American history is totally emancipatory and thus superior to other histories. A postmodernist understanding would suggest that, indeed, American history is emancipatory, but it is also filled with oppression. Thus, Americans might want to consider humility as a strength when engaged in cross-cultural discussions about the value of competing histories.

Without fully defining the terms, *Inclusive Imagination* suggests that the late Merton, child of romanticism and mysticism, sometimes was modernist, sometimes postmodernist. *Inclusive Imagination* maintains, for example, that Merton's long poem *Cables to the Ace* works in a 'postmodernist fashion' in order to deconstruct 'institutional and collective discourse' so that such discourse might be reduced 'to silence' (p. 175). As *Inclusive Imagination* holds, the late Merton 'was disillusioned by the saturation of Western culture by institutional language' (p. 172), a language that often was 'self-serving', and 'propaganda' (p. 173). *Inclusive Imagination* argues that *Cables to Ace* worked to undo this institutional language, to promote a better understanding of human language in history. In contrast, *Inclusive Imagination* suggests that *The Geography of Lograire*, Merton's book-length poem, is a 'modernist, structuralist poem' that works to create a 'common mythdream in which human beings wanted to be valued by one another' (p. 182). In its discussions of both *Cables to the Ace* and *The Geography of Lograire, Inclusive Imagination* shows how Merton was intensely concerned about the question of language and the question of history, both central to modernism and, especially, postmodernism.

3. Bradford T. Stull, *Religious Dialectics of Pain and Imagination* (Albany: State University of New York Press, 1994).

In all honesty, I must admit that my own reading of *The Geography of Lograire* contradicts the one presented in *Inclusive Imagination*. I have argued that *The Geography of Lograire* is a postmodern poem in the best sense of the term.[4] Confessions of scholarly disagreement aside, it is in this tension between modernism and postmodernism that *Inclusive Imagination* is at its most provocative, its most powerful and, necessarily, its most incomplete. I say 'necessarily, its most incomplete' because *Inclusive Imagination* was not meant to be a study of the ways in which Merton is in conversation with, is informed by, modernity and postmodernity.

Yet, *Inclusive Imagination* is led to this juncture, this pivotal tension, not out of happenstance. Rather, I suggest that the book cannot help but head into this tension. Because Merton is a romantic/mystic who reaches out to the world, who is in conversation with multiple and diverse traditions and writers, Merton's work is marked by the dialectic of modernism and postmodernism. Romanticism as a language and history is important to Merton, but it is not enough. Mysticism as a language and history is important to Merton, but it is not enough. *Inclusive Imagination* demonstrates that he is informed by both, and is thus led to many other worlds, many other traditions, guided by these two languages and histories, but not contained by them.

All three reviews would suggest that *Inclusive Imagination* provides its readers a great service. With graceful prose it traces the ways in which Merton is informed by romanticism/mysticism and thus moves deeply into the world, deeply into conversation with global communities. *Inclusive Imagination* also suggests what might be the next important path in Merton studies. Following its subaltern lead, scholars and writers would do well to consider Merton in light of modernity and postmodernity. After all, consider that Merton, Trappist monk and Roman Catholic priest, came to 'encounter the divine by staring at a bowl of carnations in a monastery chapel or in looking at the statues of two reclining Buddhas in a part of the world far away from his monastic home' (*Inclusive Imagination*, p. 246). To make sense of this sublime image is, I suggest, the postmodern challenge.

Bradford T. Stull

KING, Robert H., *Thomas Merton and Thich Nhat Hanh: Engaged Spirituality in an Age of Globalization* (New York: Continuum, 2001), pp. i-x + 202. ISBN 0-8264-1340-4 (hardcover). $24.95.

This is a fine and worthwhile book. While not exactly groundbreaking, especially in regard to Merton scholarship, its juxtaposition of Merton and Nhat Hanh on the themes of an engaged spirituality and interreligious dialogue is insightful and well crafted. King tells the story of the development of these themes in the life and thought of his two subjects in a way that elicits reflection on contemplation and action in the reader. This is a book, then, that leads not only to knowledge but also potentially to self-knowledge.

Contemplation (or meditation, in Buddhist terms) is central to this book as it is to the lives of Merton and Nhat Hanh. King contends that both men, though immersed in different religious traditions and starting from very different places, arrive at what can be called an 'engaged spirituality'. Thus they found a way to resolve one of life's fundamental problems — the tension between contemplation and action — and forged a

4. Stull, *Religious Dialectics of Pain and Imagination*, pp. 61-94.

spirituality relevant to an age of globalization. 'Contemplation, if it is genuine, must express itself in action on behalf of others, while social action unaccompanied by contemplation invariably grows sterile and unproductive. Contemplation *and* action are required for a fully integrated spirituality. This is the central message of both men and the over-arching theme of this book' (p. 6). King develops another theme as well: these two monks are models for interreligious dialogue. Thus King's thesis seems to be the following: contemplation or meditation is a sound foundation for the spiritual life. Genuine contemplation leads to action, to engagement with the suffering of the world. Contemplation or spiritual practice is also a constructive basis for interreligious dialogue. The life and thought of Merton and Nhat Hanh produce and demonstrate these points.

Thomas Merton and Thich Nhat Hanh met only once, for about two hours of conversation, at the Abbey of Gethsemani in Kentucky, on 26 May 1966. Nhat Hanh was on a speaking tour calling for peace in Vietnam, his native land. The two monks quickly established a deep spiritual bond. As a result, Merton wrote a brief essay, 'Nhat Hanh Is My Brother',[5] which helped to get Nhat Hanh a wider hearing in the United States. King uses this 'historic meeting' to introduce the stories of Merton and Nhat Hanh and the book's themes, which he then develops in the following chapters.

King traces the development of Merton's understanding of contemplation through a comparison of his *Seeds of Contemplation* (1949) and his revised and expanded edition, *New Seeds of Contemplation* (1962). As Merton's practice of contemplation leads him to a deeper understanding of self in relation to God, he 'turns toward the world' and begins to speak prophetically about the pressing social issues of the time and in particular about nuclear war and peace. As Merton experiences the unity of all in love through contemplation, he embraces his solidarity with others and takes responsibility for the world. Merton's contemplation results in action, and it colors his engagement with the world.

Thich Nhat Hanh was drawn to contemplation early in life and became a Buddhist monk as a youth. He soon joined a reform movement that was aimed at making Buddhism more attractive to young people through engagement with the suffering of the world. In Vietnam, suffering was tied to the experience of war, first with the French colonial regime after World War II, then increasingly with the United States. Nhat Hanh's 'engaged Buddhism' led to his alienation from the Buddhist establishment and from the governments of both the South and the North. In the early 1960s Nhat Hanh left Vietnam to come to the United States to work for peace where he found the root cause of the war. His exile from his native land continues to this day. He and his followers have established a Buddhist community in southern France called Plum Village, which sponsors spiritual training and Nhat Hanh's world travels giving retreats and teaching about Buddhism. Both the Christian contemplative and the engaged Buddhist teach an engaged spirituality.

In an age of globalization, interreligious dialogue is becoming increasingly important. Neither Merton nor Nhat Hanh recognized this early in their vocations. Merton is rather disparaging toward Zen in *Seeds of Contemplation*, and Nhat Hanh first encounters Christianity in its connection with French colonialism. Their experience of contemplation/meditation and their life experiences, however, draw both monks into the

5. Thomas Merton, *Faith and Violence* (Notre Dame, IN: Notre Dame Press, 1968), pp. 106-108.

Buddhist–Christian conversation, and both emerge as models and exemplars of inter-religious dialogue. Both use spiritual practice — the experience of contemplation/medi-tation — as the ground for interreligious dialogue, and both demonstrate that such conversation transforms the participants while deepening their commitment to their respective religious traditions.

In the final chapter, King reflects on the concept of engaged spirituality. Here he includes Mahatma Gandhi and Martin Luther King, Jr, as two other conversation partners and models. What I find missing from this discussion is a deeper notion of action. As an academic — a teacher and writer — I find the 'action' that flowed from Merton's and Nhat Hanh's contemplation encouraging, but it is a step removed from the practice of the corporal works of mercy as exemplified by a Mother Teresa or a Dorothy Day. Is the action of teaching and writing an adequate response to the experi-ence of genuine contemplation? Can service and social action draw a spiritual seeker into contemplation, or is the movement usually from contemplation to action? These are the questions I hope Robert King will address in his next book on engaged spirituality.

<div style="text-align: right">J. Milburn Thompson</div>

MONTALDO, Jonathan (ed.), *Dialogues with Silence: Prayers and Drawings* (San Francisco: HarperSanFrancisco, 2001), pp. i-xviii + 189. ISBN 0-06-065602-6 (hardcover). $25.

Merton's practice as a visual artist has never been fully studied. This is not altogether surprising, given the voluminous weight of his legacy in writing. But Merton did leave over 800 drawings and more than 1300 photographs. What is to be made of them? It first should be said that not all are great works of art. Merton had a facility that only occasionally rose to the level of real quality. Jonathan Montaldo makes the case in his new book that the drawings are 'relics' of Merton's contemplation, like the commentaries to God that he composed. Certainly that seems to be the case. Drawing, especially the late works inspired by Zen calligraphy and abstract expressionism appear to be a way the monk used to seize 'the grip of the present' in his imaginative and reflective life. As such, they seem to be by-products of his life of spiritual practice, not works of art designed in every instance to stand fully on their own.

In looking at Merton drawings now housed at Bellarmine University, it is these late drawings, mostly *not* included in the book, which are most compelling. These abstract drawings from the 1960s are on a variety of papers, some designed for art making, others scraps that happened to come to hand. Characteristically they are brush draw-ings in black ink, usually on a white sheet. The best of these calligraphic sketches show Merton playing with mark making, fully aware of the weight of ink on the paper, experimenting with degrees of absorbency ranging from translucency to the black sheen of more heavily applied pigment. Merton experimented with hand-printing and occasionally was sufficiently proud of what he had done to give an example to one of his correspondents. Some sheets show the barest of scratches: others are more fully worked out pictographs reminiscent of Southwest Indian designs.

The 1960s abstract works often come in series. For example, a series of circular designs run through a wide variety of kinds of ovals in bold strokes that look like Japanese or Chinese ink-brush inscriptions. In the elaboration of ideas that Merton explores in these drawings, issues of wholeness and disintegration, open and closed

forms, motion and stasis are endlessly worked out. He goes back and forth between pure abstraction and figural variations: crucifixes, fish, kneeling figures, and what appears to be a jazz musician alternate with triangular planes, shapes like tree branches and faint indications of verticals and diagonals suggesting generalized images of wind-blown grasses. These drawings are strongly related to the automatist practices of the 'Action Painters', those abstract expressionists who believed that the deepest recesses of the subconscious could be tapped through free pictorial improvization.

It is in the endless repetition of certain shapes in the abstract drawings that we come closest to Merton as the mystic contemplative. In these drawings he is using a means readily available to center his thoughts on God. These are not symbols that stand for a given iconographic meaning. To paraphrase Coomaraswamy, these are symbols that search for meaning, rather than stand for a given meaning.

As for us as viewers, Merton did not make it easy. He signed very few of the drawings and was seldom instructive as to which way was up. Occasionally he offered titles, but mostly on works which had a clever but superficial relationship to traditional themes in Asian art: hence 'War Horse' and 'Lucky Dragon'. Merton did not have the exquisite sensibilities of a Franz Kline or a Robert Motherwell regarding the relationship of image to the surface it is made on. Merton seldom covered the whole sheet of paper. It is difficult to understand how Merton would visualize his work matted and framed, presented to the public. Although at times he achieved a wonderful poetic interchange of positive and negative spaces in his drawings, he seems to have been more interested simply in the making of signs and symbols, not the placement on the page or the relationship of the image to the edges of the paper. The difficulties accentuate the essentially private nature of this material.

Ultimately, Merton's art does deserve a carefully selected exhibition, and a good first show has already been done at the Museum of Fine Art in Owensboro, Kentucky, Ideally the drawings would be shown with a selection of the photographs. In contrast to the drawings that give intimate clues to Merton's inner world, the photographs show Merton exploring with joy the confines of Gethsemani. There too, the curator will face difficult problems. Should one use Merton's frequently blurry prints, or have new prints made from the surviving negatives, utilizing all the darkroom magic of burning and dodging to accentuate lights and darks? Is it a falsification to give the work the full benefit of the doubt, calling attention to the Trappist's powers of visualization rather than the inadequacies of his technical proficiency?

An additional challenge for a full-scale Merton exhibition is the state of some of the work. His drawings and photographs need to be better preserved with proper mounting and matting. The Thomas Merton Center has them in glassine envelopes in accordion folders but better protection is needed. Some are bent or crimped and require the full attention of a paper conservator.

Parallel to the monk/artist's own work, there is much research to be done on Merton's relationship to the visual arts at large. His parents were both painters and his father was associated briefly with Alfred Steiglitz's Gallery 291, where fellow exhibitors included such giants of American art as Marsden Hartley, Arthur Dove and Georgia O'Keeffe. (An Owen Merton retrospective is currently being organized in New Zealand by Roger Collins.) Thomas Merton was an astute observer of the arts and his close friendship with the New York painter Ad Reinhardt and the Lexington, Kentucky photographer, Eugene Meatyard, suggest that he kept reasonably up to

date. While the 1958 project for a book entitled *Art and Worship* never saw fruition, it is clear that art had a very central place in his life: as a source of creative pleasure, as an aid to meditation, as a way of celebrating God's creativity in nature, as a stimulus to his writing and thought, and as an aspect of familial identity.

Which brings us around to *Dialogues with Silence: Prayers and Drawings*. Jonathan Montaldo has made a selection of 92 drawings by Merton, which he has accompanied by an equal number of prayers or addresses to God, drawn from many examples of Merton's writing. The drawings he has selected come mainly from the 1950s, and are primarily drawings of heads. Most are done in a style strongly reminiscent of Matisse's graphic works and more particularly, his black and white decorations for the chapel of St Paul de Vence. As may be evident from the remarks above, I do not think that these representational drawings are consistently the best of Merton's practice. It is true, they do often possess an engaging economy of line and a nice balance of accents, but overwhelmingly, they look like pale reflections of the styles they are descendents of. Many are of women—there is a Mary Magdalene which looks appealingly like the singer Connie Francis—but for the most part these large-eyed, sentimental Virgin Marys, nuns and saints do not reward repeated examination. In many instances the sweetness of the drawings seem at odds with the gritty message of the prayers—the struggle for faith, for worthiness in the eyes of God, for religious authenticity. In other cases, the effort to match word to text falls short: a drawing of a featureless face is awkwardly and almost comically matched with a prayer starting 'Oh God, my God, why am I so mute?'

Montaldo describes the heads of women as 'powerful and mysterious' and argues that they reflect Merton's 'growing appreciation of women and the feminine in his life'. I find it hard to reconcile that view with the dull, placid, passive visages that fill these pages.

There are many Thomas Mertons. The Merton presented in *Dialogues with Silence* happens not to be one that resonates with me. The drawings illustrated in the book are tentative precursors to those housed at Bellarmine done in the 1960s, many of which show a more authentic, energetic and spiritually mature artistic expression. More work needs to be done in this fascinating area of Merton studies.

Peter Morrin

LAUGHLIN, John, *Reading Thomas Merton: A Guide to His Life and Work* (Philadelphia: Xlibris, 2000), pp. 218. ISBN: 0-7388-5613-4. $31.99.

As the title of this book suggests John Laughlin's book has been written to introduce readers to Thomas Merton, both to his life and his writings, and to provide some evaluation of the books and other materials available by, and about, Merton. Laughlin's approach is broad, including sections on Merton websites, tapes of Merton's conferences, dissertations about him, the best places to purchase books, and what to expect when visiting a monastery. It is described in the publisher's blurb as 'an enticing guide through the forest of Merton literature' and as 'the perfect starting place for anyone who wanted to read Merton but did know where to begin'. The error in the publisher's blurb, surely it should read 'didn't know where to begin', is a foretaste for the reader of what is to come on opening the pages of this book.

Reading Thomas Merton is littered with errors, factual and grammatical, from beginning to end. The opening paragraph of Laughlin's biographical section about Thomas Merton begins by describing him as 'a French nationalist' (p. 13), as opposed to a French citizen because of his birth in France; he gives his reader the date of Owen's death as 'October 4, 1931' (p. 28) instead of January 1931, although he later uses the correct date in his chronology of Merton's life (p. 86); the spelling of Gethsemani is correct in the caption of one photograph and wrong in another; more than once he describes the Merton scholar, and founding editor of *The Merton Annual*, Victor Kramer as 'a longtime friend' of Merton's (pp. 46, 173) and yet Kramer never met or corresponded with Merton. Similarly almost every single website address (url) and e-mail address quoted is either out of date or wrong. Everyone who uses the Internet is familiar with the speed it changes and the way websites come and go. However, the number of out-of-date sites, along with the typographical mistakes in an area most unforgiving of such mistakes, suggests a slovenliness that should not have found its way into print.

Besides the problem with the errors in this book I did not find that it was a book that would inspire me to go away and read more about Thomas Merton. Laughlin's style of writing is tedious and torpid and really at no point does he allow the genius of Merton's work and thought to shine through. His biography of Merton, largely based on Michael Mott's biography, is unbalanced. Laughlin includes a complete chapter on Merton's 1966 affair with the student nurse, but only a paragraph on Merton's interest and involvement in the social issues of his day.

The lack of balance in Laughlin's biographical account of Merton is evident throughout the book. In the second part of the book, as Laughlin looks at Merton's work, and works about him, I found the book became more and more unreadable, presenting lists of Merton's books, of books and dissertations about him, cassette recordings of his conferences and organizations which bear his name with a decreasing amount of evaluation of the resources being presented. His section on tapes and videos by and about Merton reads like a Credence Cassettes catalog with no attempt to evaluate any of the selection he has included.

Items are placed in the wrong categories — the audio version of Nicki Verploegen Vandergrift's book *Meditations with Merton* and the Paul Wilkes film, *Merton: A Film Biography*, were included in the section on tape and videos by Merton. Similarly, John Blattner's book, *Mornings with Thomas Merton: Readings and Reflections*, was included in the section on Merton's poetry yet it does not include any poetry just selections from three early prose works, *The Waters of Siloe*, *The Seven Storey Mountain*, and *The Sign of Jonas*. The further I delved into this book the more I was left with the feeling that the author had not properly researched his material.

The overall idea of this book is laudatory but it falls far short of that ideal. The publisher of *Reading Thomas Merton*, Xlibris, is a vanity press and the lack of an editorial pen is only too evident in this book. William H. Shannon's book *'Something of a Rebel': Thomas Merton, his Life and Works* still remains the best introduction for newcomers to Merton and the most 'enticing guide through the forest of Merton literature' currently available.

Paul M. Pearson

McGINN, Bernard, *The Mystical Thought of Meister Eckhart: The Man from whom God Hid Nothing* (New York: Crossroad, 2001), pp. xiii + 305. ISBN: 08245-1914-0. $45.00.

Thomas Merton would have savored every page of this book that so ably puts Meister Eckhart's writings into contexts that greatly clarify the Dominican's complex thought, but as McGinn says, '...nothing is ever that simple in Eckhart' (p. 151). Merton's interest in Meister Eckhart (c. 1260–1328) was longstanding; he had encountered Eckhart's writings before he became a monk at Gethsemani, in fact, he had read Eckhart when he was a student at Columbia University.[6] Yet, like other of his contemporaries, Merton was at first cautious about Eckhart's orthodoxy. In *The Seven Storey Mountain*, Merton wrote, commenting on Aldous Huxley's *Ends and Means*, that Huxley, '...quoted St John of the Cross and St Teresa indiscriminately with less orthodox Christian writers like Meister Eckhart...'[7] McGinn explains why Eckhart should not now be considered a heretic, even though a papal commission condemned 28 propositions drawn from his writings. That conclusion is based on documentation from the Avignon investigation into Eckhart's writings that 'confirms that a basic shift had taken place in Eckhart's case—he was no longer on trial as a heretic, but was being investigated for the possible censure of various articles he had once taught, which, *if judged heretical*, he had promised to renounce' (p. 18).

Merton eventually learned to read Eckhart on the Dominican's own terms. By 1963 he wrote without any cautionary qualifier to Etta Gullick: 'I think Western mysticism, and particularly the Dionysians in the West, tend to get departmentalized. Except the really great ones like Eckhart. I think more and more of him. He towers over all his century'.[8] Merton's interest in Eckhart grew and matured. After his return from that fateful stay in the hospital during Lent of 1966, the Trappist hermit wrote the following about this hospital sojourn: 'The best thing of all was lying reading Eckhart, or sitting up, when I finally could, copying sentences from the sermons that I can use if I write on him. It was this that saved me, and when I got back to the hermitage last evening to say the Easter offices everything else drained off and Eckhart remained as real'.[9] Merton's understanding of Eckhart's theology and mysticism would have matured earlier than it did if he had the advantage of an Eckartian guide like Bernard McGinn. Eckhart's texts bristle with profound and powerful insights; yet, as is well known, his texts often contain problematic expressions of his understanding of the intersection of the human and the divine. Merton's growing understanding of Eckhart eventually enabled him to claim the Dominican as a kindred spirit from the mystical tradition whose insights stretched his own perceptions of the human encounter with the divine.

6. See Erlinda Paguio, 'Blazing in the Spark of God: Thomas Merton's References to Meister Eckhart', *The Merton Annual* 5 (1992), pp. 247-62.

7. Thomas Merton, *The Seven Storey Mountain* (New York: Harcourt Brace Jovanovich, 1948), p. 186.

8. Thomas Merton, *The Hidden Ground of Love: The Letters of Thomas Merton on Religious Experience and Social Concerns* (ed. William H. Shannon; New York: Farrar, Straus & Giroux, 1985), p. 356.

9. Thomas Merton, *Learning to Love: Exploring Solitude and Freedom* (ed. Christine M. Bochen; San Francisco: HarperSanFrancisco, 1997), p. 38.

For a long time the only English translation of Eckhart was the Raymond Blakeney version published in 1941.[10] This translation was McGinn's introduction to Eckhart as it was almost certainly for Merton. McGinn's study of Eckhart has been lifelong and, as with his other far-reaching interests, very productive. One needs only inspect the list of translations (p. xii) and the bibliography (pp. 285-86) to see McGinn's contributions, direct and indirect, to a better understanding of Meister Eckhart's legacy. The book under review represents a pause in McGinn's publication of his epoch-making, multi-volume study of the history of Western Christian Mysticism.[11] The fourth volume of this series will be entitled *The Harvest of Mysticism: 1300–1500*; it will be enriched by this study of Eckhart's mystical thought. This volume on Eckhart is an indispensable resource for the study of Eckhart as a mystical author and theologian. McGinn's endnotes constitute an invaluable map to the writings by and about Eckhart. These carefully prepared notes provide an especially helpful guide to the modern secondary literature in German about Eckhart.

For too long readers have been living on snippets of Eckhart's wisdom, powerful sayings that have often been torn out of context. Though Eckhart did not mind shocking his hearers, his audiences heard his sermons or read his treatises in contexts that moderns often lack. Readers over the last three decades have been too much like the fourteenth-century investigators at Cologne and Avignon who were willing to wrench propositions out of the fuller context in which Eckhart had presented them. All mystics must be read in context, and it is especially important not to take Eckhart out of context, whether it be the historical context or the textual contexts. In this regard McGinn reminds his readers that Eckhart's sermons must be understood in their biblical and liturgical contexts. Eckhart was a friar who belonged to the Order of Preachers. He took to heart the Dominican mission of preaching. Eckhart preached within the context of the liturgy's biblical texts. McGinn makes this crucial point in the following words: 'Eckhart the exegete and Eckhart the preacher are inseparable in the sense that his preaching always took its departure from a biblical text found in the liturgy and therefore must be understood within this biblical-liturgical context' (p. 29). McGinn reminds us that Eckhart preached and wrote 'in an age when the liturgy still played a role in society almost impossible to conceive of today', p. 29.

Eckhart often turned to the patristic saying, 'God became man so that man may become God'. This statement is a foundation for Eckhart's 'functional Christology', by which Eckhart meant that his hearers and readers were to live the meaning of the Word become Incarnate so that 'man may become by the grace of adoption what the Son is by nature' (p. 117). Eckhart's call for the imitation of Christ embraced a deeper theological sense than this imitation meant for his contemporaries. In our present search to overcome compartmentalization in theology, we can turn to Eckhart's Trinitarian theology which shows how he sought integrative theological meaning. McGinn writes that, for Eckhart, 'all activity is essentially trinitarian in its dynamism' (p. 76). Eckhart was never far from the Trinity or the Incarnation, mysteries that he sought to penetrate as far as his philosophical and theological skills could take him.

10. *Meister Eckhart: A Modern Translation* (trans. Raymond B. Blakeney; New York: Harper & Row, 1941).
11. Bernard McGinn, *The Presence of God: A History of Western Christian Mysticism* (3 vols.; New York: Crossroad, 1991, 1994, 1998).

McGinn puts to rest the all-too-simplistic misconception that Eckhart's vernacular sermons contained imprecise, suspect positions while his Latin scholastic writings in their academic precision avoided statements that could be construed as dangerous, suspect or even unorthodox. A fruitful conversation between Eckhart's academic and vernacular writings is crucial to an understanding of Eckhart's mystical teachings. McGinn notes the importance of this conversation: 'What is all too often overlooked is the striking fact that Meister Eckhart is the *only* major figure in the history of Christian mysticism in whom we can observe the full dynamics of the interplay between Latin mysticism (almost a millennium old by the time he wrote) and the new vernacular theology (still aborning, despite the achievements of the thirteenth century' (p. 34).

Meister Eckhart had his hand in many intellectual and pastoral enterprises. He was a metaphysician, a theologian, a biblical exegete and a preacher, besides serving as an administrator in his order. McGinn shows how his role as a *lesemeister* (master in theology) and his activities as a *lebemeister* (a spiritual master or spiritual guide) have to be seen in creative tension with each other. Only someone as brilliant as Eckhart could keep these diverse activities in dialogue with one another. It is incumbent on Eckhart's readers to keep in mind that his vision of reality and his multi-faceted insights into the nature of God as expressed in his various writings were never for Eckhart fragmentary or disconnected positions even when he made seemingly contradictory statements.

Although Eckhart did not emphasize externals or even the interior significance of the sacraments, I would like to have heard more about what Eckhart's theology and mysticism meant for Eckhart's understanding of the sacraments. What, for instance, were the sacramental implications of Eckhart's teaching on the eternal birth of the Word in the ground of the soul? This rich theme that Hugo Rahner studied in the theology of the fathers should receive much more attention in contemporary sacramental theology than it does.[12] McGinn devotes an entire chapter (4) to 'The Preacher in Action: Eckhart on the Eternal Birth'.

Our era is much concerned about healing the divorce between theology and spirituality. On this theme Eckhart can be very useful. He brought integration to a whole new level. Eckhart was forever pushing forward his horizons to discover the ultimate meaning of reality. One cannot conceive of a divorce between spirituality and theology in a theologian who understood the fullest human integration to be the ground of God being our ground, an integration rooted in the Incarnation. This is what McGinn refers to as Eckhart's Afunctional Christology' (p. 50) The divorce of spirituality from theology has roots that go back further than Eckhart's time, perhaps into the twelfth century. Yet, Thomas Aquinas, Bonaventure and Eckhart and some of Eckhart's followers held spirituality and theology in a creative tension that by the late fourteenth century was no longer the norm.[13] There is much to learn from these theologians that could contribute to a more unified vision of theology and spirituality, a unity we can ill afford to be without during this time when we struggle to foster a

12. Hugo Rahner, 'Die Gottesburt: Die Lehre der Kirchenväter von der Geburt Christi aus den Herzen der Kirche under Gläubigen', in *idem* (ed.), *Symbole der Kirche: Die Ekklesiologie der Väter* (Salzburg: Müller, 1964), pp. 7-41.

13. Keith J. Egan, 'The Divorce of Spirituality from Theology', in *Theological Education in the Catholic Tradition: Contemporary Challenges* (eds. Patrick W. Carey and Earl Muller; New York: Crossroad, 1997), see esp. pp. 297-301.

more contemplative Christianity that is not divorced from the search for justice and peace nor from speculative theology.

Meister Eckhart was a youth, perhaps as young as 14, when Thomas Aquinas died in 1274. McGinn's mastery of Eckhart's thought, which is extraordinary, clarifies the relationship of Eckhart's theology to that of Thomas Aquinas, a relationship about which not all writers have been nearly so clear.

> The Meister cites his Dominican predecessor with unfeigned reverence, and only rare explicit disagreement. There is no question of how much his years of studying St. Thomas meant for the development of his thought. Nevertheless Eckhart is not fundamentally a Thomist. He was an independent thinker who, given his historical context, was formed by a 'dialogue' with Thomas, but who used the Angelic Doctor for his own purposes (p. 166).

Yet, Eckhart, like Thomas Aquinas, gave 'priority to intellect over will, against the Franciscans' (p. 5). Moreover, both Dominicans knew how to draw effectively on the Platonic tradition. But once again Meister Eckhart never simply reproduced his sources. He exhausted them for meaning and transformed them. McGinn shows how Eckhart was an original reader of the tradition. 'His form of dialectical Christian Neo-platonism…is not really reducible to its sources — it is a new rendition of an old theme designed to fit a changed situation' (p. 93). In an age like ours, which has often failed to see the wisdom and strengths of Christian Neoplatonism, the ways that Thomas Aquinas, Meister Eckhart and others integrated Neoplatonic insights into their world views awaits further exploration. I would have liked some further help from McGinn on Eckhart's integration of Neoplatonic elements in the Meister's explorations of the radical transcendence of God that so attracted the Dominican's fiery intellect. Apparently Eckhart was not greatly interested in beauty as a transcendental; at least McGinn does not record any such preoccupation.

Meister Eckhart emerges from McGinn's study as one of the most eloquent exponents of Christian apophatic theology. McGinn lucidly leads his readers into a firmer grasp of Eckhart's 'radical apophaticism, that is, the recognition that no human word is *really* adequate for speaking about God' (p. 99). In the service of this apophaticism, Eckhart used language to its utter limits including his creative and 'explosive' metaphors about divine life. To appreciate Eckhart's soul-stirring language, one need only turn to his sermons. There is no substitute for 'listening' to Eckhart's sermons in his exquisite Middle High German. Yet, these sermons retain much of their vibrancy even in English translation.

Eckhart's bold language not only shocks his readers but so rivets attention on the expression of his insights that one can easily forget the contexts that are necessary to keep those insights within the saving totality of his theology. McGinn's study will not permit one to fall into that trap. This very accessible presentation of *The Mystical Thought of Meister Eckhart* would not only have delighted Thomas Merton, it serves well anyone who is interested in gaining a better grasp of the complex theology of one of the giants in the Western Mystical tradition. I shall keep close at hand McGinn's concise and orderly study of the themes that pervade Eckhart's sermons, his biblical commentaries and his scholastic treatises. All who look for meaning and wisdom in the Western Mystical tradition are in debt to Bernard McGinn for this volume on Eckhart and for much else besides.

Keith J. Egan

HANSEN, Ron, *A Stay against Confusion: Essays on Faith and Fiction* (New York: HarperCollins, 2001), pp. i-xvii + 267. ISBN 0-06-019666-1 (hardcover). $25.

One of the many graces of Ron Hansen's recent book of essays is his ability to look back at his childhood, not without a certain nostalgia, but more importantly, with a recollection of an upbringing that was central to his development as a writer and a Catholic. If, as Wordsworth says, 'The child is father of the man', it is apparent that Hansen's childhood in pre-Vatican II Omaha, Nebraska, was instrumental in his becoming a writer, a teacher and a Catholic apologist.

Hansen recalls in the preface of the book that, as a young child, he was fascinated with the storytelling of the Gospels and the narrative of the Mass. As he learned to read, he worked his way through children's books and authors and eventually realized he too wanted to write fiction, but he could barely discuss 'a vocation that seemed so exalted and sacred and beyond me'. In the preface, he shares the views of fellow writers James Carroll, who claims, 'story-telling... arranging memory and invention according to the structure of narrative is, by definition, holy', and Alice McDermott, who recalls that 'fiction made the chaos bearable'.

In the book's first essay, Hansen writes, 'Writing...can be viewed as a sacrament insofar as it provides graced occasions of encounter between humanity and God'. He refers to Flannery O'Connor, who notes in *Mystery and Manners* that novelists could 'approach the infinite' only by penetrating the 'natural human world'. Hansen did just that as he wrote his way through his first four novels: *Desperados*, with a biblical theme; *The Assassination of Jesse James by the Coward Robert Ford*, which explores a Christian perspective on sin, redemption and forgiveness; *Mariette in Ecstasy*, which is an expression of his feeling that 'Christianity is difficult...but worth it', and *Atticus*, a retelling of the parable of the prodigal son, 'a parable of God's continuing quest for an intimate relationship with us'. Students of Merton should note that *Mariette in Ecstasy* is the story of a stigmatic whose fictitious religious order is modeled after Merton's description of Cistercian life in *The Waters of Siloe*. While discussing his novels, Hansen claims that 'fiction is far better experienced than interpreted' and as such is analogous to the symbolism of the sacraments. He writes, 'To fully understand a symbol is to kill it'.

Another essay, 'Faith and Fiction', provides insight into Hansen's fascination with language and its interplay with his religious experience. He recalls kindergarten at Holy Angels School, where he was the narrator of the Christmas pageant. Since he could not yet read, his mother read to him from Luke. With little practice, the lines were etched in his memory, and he could recite lines that he barely understood: 'And she brought forth her firstborn son, and wrapped Him in swaddling clothes'. Later, when asked what made him become a writer, Hansen spoke of the magnificent language of the Gospels. He sees a variation of Gospel themes in the fiction of William Faulkner, Harper Lee, Willa Cather and others, but he dismisses 'so-called Christian fiction' as 'pallid allegory', which is all too often a formulaic attempt to express conservative political views.

While memories from his childhood take up several essays, others are more contemporary, reflecting a grown man, still in awe of religion and mystery but at ease as a writer and a teacher. Still, past is present. Essays pay tribute to his grandfather, who provides hints of characters in several of his novels, and his literary mentor, John Gardner, whose generosity to young writers is legend. Jesuits loom large in Hansen's

278 *The Merton Annual 15 (2002)*

work, with essays on Ignatius of Loyola, Gerard Manley Hopkins, and the Jesuit martyrs of El Salvador. Not surprisingly, his twin brother Rob entered the order, and Hansen himself is the Gerard Manley Hopkins, SJ, Professor in the Arts and Humanities at Santa Clara University. He acknowledges the importance of film in developing his own craft, singling out *Babette's Feast* as a masterpiece with overtones of the wedding at Cana and the Last Supper.

It is in the book's final essay perhaps that Hansen most readily gives a clarification of his life. It reconciles his youth, his family, his profession and his church, and its title is simply 'Eucharist'. It begins with recollections of Monsignor Patrick Aloysius Flanagan, the bigger-than-life parish priest from whom Hansen received his First Communion. Of that experience, he recalls wondering in what ways it would change him – he thought perhaps a 'chemical reaction' or an 'infusion of wisdom'; instead his sensation was that 'whoever I was was fine with Jesus'. Later, as an altar boy, Hansen remembers that although his theology and Latin were rudimentary, he felt privileged to observe the mystery of the consecration and the great faith of Flanagan.

His family life seemed a Catholic version of *Ozzie and Harriet*, revolving around church and school, novenas, rosaries, Forty Hours and the *Saint Joseph Missal*. He and his twin brother and their three older sisters shared their daily experiences at family dinners, which featured prominently in their routine. While mild boredom with the Church set in during his adolescence and he expressed some displeasure with the changes of Vatican II, particularly with what he refers to as 'roll-your-own liturgies', Hansen emerges as an adult thoroughly reconciled with his church and its changes.

As an apologist, the mature Hansen explores the development of the Mass (the Eucharist), tying together Judaic tradition, the meals Jesus shared with his disciples, the Last Supper, his disciples' replication of the traditions and the ritual that evolved. He recognizes Constantine's alterations of the nature of Christianity. No longer persecuted, the Church was 'legally sanctioned, privileged...wealthy, but shackled by its too cozy alliance with...monarchies'. Hansen regrets that the Eucharist moved away from the assembly and became 'the sole and private action of a priest'; that, to the 'illiterate and uncatechized masses...was no less than magic and sorcery'. He understands the protest of the Reformation and recognizes that the Council of Trent may have erred 'on the side of inclusion, embellishment, redundancy, and piety'. At the same time, Hansen sees that the emergent Tridentine Mass 'inspired awe and reverence and a sense of holy mystery'. Looking back, Hansen recognizes that the changes of Vatican II have helped the Church to get back to the celebrations of the early Christians; the *aggiornamento* has succeeded in a way that hadn't been seen since Trent.

Hansen concludes the essay and book as he becomes a Eucharistic minister. He had been a lector for many years – the position was comfortable for a college professor who often read his own works in public, but he felt too unworthy to administer Communion. His theological realization that although he was a sinner, he was loved in Christ served as the impetus that gave him the courage to give Christ to his fellow parishioners. Like his writing, his ministry is a gift that gives him a sense of why Jesus 'established this gracious sacrament of himself'.

Hansen's writing reveals his religious passion. His style reveals a gifted writer. His audience benefits from a book that reveals both.

Elizabeth Cahaney

[TMA 15 (2002) 279-282]
ISSN 0894 4857

Contributors

Virginia Bear received a Master's degree in Japanese from the University of Southern California, speaks Japanese and Spanish, and is now studying French. She currently works in a Catholic health care system in Bellevue, Washington. gbear@peacehealth.org

Leonard J. Biallas is Professor of Religious Studies at Quincy Univeristy, Quincy, Illinois. His most recent book is *Pilgrim: A Spirituality of Travel* (Franciscan Press, 2002). He is also the author of *Myths: Gods, Heroes and Saviors and World Religion; A Story Approach*. he received his doctorate from the Catholic Institute in Paris, France. biallas@quincy.edu

Claire Hoertz Badaracco is a Professor in the College of Communication, Marquette University. She has contributed articles in previous volumes of *The Merton Annual* and teaches Media, Religion and Cultural Identity, as well as Media Ethics. She has written several books and is widely published in the History of the Book. BadaraccoC@marquette.edu

Elizabeth Cahaney is a Professor in the Division of Fine Arts and Humanities at Elizabethtown Community College in Kentucky, where she teaches English and Religious Studies. She is a graduate of the MALS program at Bellarmine University, having written her thesis on Thomas Merton. bethcahaney@juno.com

John Collins is a Lecturer and former Director of the Teacher Certification Program at the College of the Holy Cross, Worcester, MA. He presented a Merton/Percy paper at the ITMS Conference, Bellarmine College, June, 2001. Recently he presented a paper at a Symposium (The Anatomy of Evil) held at the Holy Cross

entitled 'We are Prodigals in a Distant Land-A Perspective on Evil by Thomas Merton.' He holds a Ph.D. from Boston College. jcollins@holycross.edu

Keith J. Egan holds the Joyce McMahon Hank Aquinas Chair in Catholic Theology at St. Mary's College, Notre Dame, IN, and is Adjunct Professor of Theology at Notre Dame University. kegan@ saintmarys.edu

George A. Kilcourse, Jr is Professor of Theology at Bellarmine University and the author of *Ace of Freedoms: Thomas Merton's Christ* (University of Notre Dame Press) and *Flannery O'Connor's Religious Imagination* (Paulist Press, 2002). He has been co-editor of *The Merton Annual* since 1993. gkilcourse@bellarmine.edu

Victor A. Kramer is Director of the Aquinas Center of Theology at Emory University and Adjunct Professor of Catholic Studies within the Candler School of Theology at Emory. His most recent book is *A Consciousness of Technique in 'Let Us Now Priase Famous Men' With 31 Newly Selected Photographs* (Whitston, 2001). vkramer@emory.edu

Alan M. McMillan has taught at the Faculty of Education, Nipissing College, and the Catholic Ministries Program of the Diocese of Sault Ste-Marie. He is a co-founder of the Association Ministries Program (of Canada). He has worked with the Canadian Conference of Bishops' committee on adult faith development, and ministers in chaplaincy with the deaf, hospitals, prisons, police, and Critical Incidence Stress Management. He is pastor of two parishes in Espanola, Ontario and occasionally lectures on his favorite Merton topics at the University of Sudbury. almcmillan73@hotmail.com

Gray Matthews is Assistant Professor of Communications at the University of Memphis, Memphis, Tennessee. He teaches courses in listening, community and place, dialogue, and conflict resolution. matthews@memphis.edu

Susan Merryweather served as Humanities Secretary as Bellarmine University, where she is completing her MA in Teaching. This year she is teaching at Community Catholic School in Louisville. smerryweather@bellarmine.edu

Jeannine N. Mizingou is an Assistant Professor of English at Nyack College in New York City. She has published various articleson religion and literature in the journals *Logos: A Catholic Companion to Literature*, *Christianity and Literature*, and *Religion & Literature*, as well as poetry and stories in national magazines and journals. She received her BA from Waynesburg College, and her MA and PhD from Duquesne University. Jeannine. Thyreen-Mizingou@ncmc.nyack.edu

Peter Morrin has served since 1986 as Director of the Speed Art Museum, Louisville, Kentucky. He has also been Curator of 20th Century Art at the High Museum of Art in Atlanta. His AB is from Harvard Univeristy and his MFA from Princeton University. He was Director of the Art Galley at Vassar College and Assistant Professor in the Art Department. Mr. Morrin has also taught Art History at Emory University and the University of Louisville. His publications include work on photography, 19th and 20th Century American Art, Modern European Art and the work of self-taught artists. pmorrin@speedmuseum.org

Paul M. Pearson is Director and Archivist of the Thomas Merton Center and Assistant Professor in the Faculty of Arts and Sciences at Bellarmine University. He completed his PhD on Merton at Heythrop College, University of London. He is editorial adviser to *The Merton Journal*, published by the Thomas Merton Society of Great Britain and Ireland. He edited *Thomas Merton: A Mind Awake in the Dark* (Three Peaks Press, 2001), and is one of the compilers of *'about merton': Secondary Sources 1945-2000* (The Thomas Merton Center Foundation, 2002). ppearson@bellarmine.edu

Paul Quenon is a monk of the Abbey of Gethsemani, Trappist, Kentucky. For details of his publications see above, pp. 212-13. paulquenon@monks.org

Johan Seynnaeve is an Associate Professor of Linguistics at West Virginia University. He has written about such diverse topics as the medieval Flemish mystics, the Carthusians of America, Merton's poetry, and the older Germanic dialects. jsyennae@mail.wvu.edu

Bradford T. Stull is Associate Professor and Chair of the English and Communications Departments at Rivier College. He is the author of *Religious Dialectics of Pain and Imagination* (New York: State University Press, 1994) and *Amid the Fall, Dreaming of Eden: Dubois, King, Malcolm X and Emancipating Composition* (Carbondale, IL: Southern Illinois University Press, 1999). bstull@riviere.edu

Lynn Szabo is Associate Professor of English Literature and Creative Writing at Trinity Western University, British Columbia. Her publications have appeared in *The Journal of Theology and Religious Studies* and *Canadian Book Review Annual*. She is currently writing a book on the language of silence in Thomas Merton's poetry, funded in part by the Social Science and Humanities Research Council of Canada. lszabo@twu.ca

J. Milburn Thompson is Professor and Chair of the Theology Department at Bellarmine University. He earned the PhD from Fordham University and concentrates on ethics, social justice, and peace studies.His book, *Justice and Peace: A Christian Primer* (Orbis, 1997), will be published in a revised edition in Spring 2003. jthompson@bellarmine.edu

Index